E. H. GOMBRICH

NORM AND FORM
STUDIES IN THE ART OF
THE RENAISSANCE
I

Norm and Form
Studies in the art of the Renaissance

by E. H. Gombrich

with 186 illustrations

PHAIDON · LONDON AND NEW YORK

PHAIDON PRESS LIMITED, 5 CROMWELL PLACE, LONDON SW7

PUBLISHED IN THE UNITED STATES OF AMERICA BY
PHAIDON PUBLISHERS, INC.
AND DISTRIBUTED BY PRAEGER PUBLISHERS, INC.
111 FOURTH AVENUE, NEW YORK, N.Y.10003

FIRST PUBLISHED IN VOLUME FORM 1966
SECOND EDITION 1971

ISBN 0 7148 1294 3 (CLOTH)
ISBN 0 7148 1494 6 (PAPER)
LIBRARY OF CONGRESS CATALOG CARD NUMBER: 64-31909

PRINTED IN GREAT BRITAIN BY R. & R. CLARK LIMITED, EDINBURGH

CONTENTS

PREFACE

IN the Preface to my volume *Meditations on a Hobby Horse and other essays on the Theory of Art* I expressed my gratitude to the publishers for their intention to let it be followed by a collection of my essays on the Italian Renaissance. It turned out that there were more of these than could conveniently be accommodated in one volume, and I accepted the suggestion of the editor, Mr. Michael Baxandall, to divide them into two groups: one dealing with Renaissance symbolism (which is in preparation), the other with problems of style, patronage and taste. It is this latter volume which is in front of the reader. I believe that a more unified theme can be seen to run through these various essays than this cursory description suggests. They all deal with what may be called the Renaissance climate of opinion about art and with the influence this climate has exerted on both the practice and the criticism of art. This approach runs rather counter to a current assumption that art is always far ahead of systematic thought, with the critic distantly following the artist and trying as best he can to record and explain what has emerged by unconscious creation. This book attempts to test the opposite hypothesis from various angles. Not that it seeks to minimize, let alone deny, the artist's creativity, but it does try to show that this creativity can only unfold in a certain climate, and that this has as much influence on the resulting works of art as a geographical climate has on the shape and character of vegetation. It will be noticed that this metaphor discourages a rigid determinism. The best climate in the world cannot produce a tree in the absence of a healthy seed or sapling. Moreover, a climate that is good for trees, which we like, may also favour the spread of weeds or pests, which we abhor. Any number of weather charts, therefore, will not allow us to predict the flora of a region, let alone the form of individual plants. And yet—to abandon the metaphor—it seems legitimate to study the explicit and implicit critical standards accepted within a given tradition by artists and patrons alike, and to ask what influence these norms may have on the forms produced by masters of varying gifts.

So the first essay in this volume, *The Renaissance Conception of Artistic Progress and its Consequences*, asks what concrete influence an idea such as this may have had on sculptors and painters. *Renaissance and Golden Age* raises a similar question about the effect a literary myth may have had on the patrons and thus indirectly on the arts of the time. *Leonardo's Method for Working out Compositions* (first published in French) attempts to show how closely this master's abiding style was bound up with his convictions about the claims of painting to be a Liberal Art. A fourth essay, *The Renaissance Theory of Art and the Origins of Landscape Painting*, seeks to demonstrate that Renaissance humanists talked about landscape painting before artistic practice caught up with them; and the paper on *The Style* all'antica: *Imitation and Assimilation* examines the humanist theory of 'imitation' as a road to

artistic perfection and illustrates the way it worked in practice. I thought it right also to include an article on *Reynolds' Theory and Practice of Imitation*, which traces the last link in a tradition deriving from the Renaissance and belonging in its orbit.

Sandwiched between these six studies are two which turn on taste rather than formulated theory. That on *Apollonio di Giovanni* deals, as the subtitle states, with a Florentine cassone workshop seen through the eyes of a humanist poet. I hope it throws some light on the taste of a minor humanist who found nothing irreconcilable between a love of Virgil and an admiration for late Gothic illustration. The other, on *The Early Medici as Patrons of Art*, is concerned with the influence the different personalities of three members of the Medici family seem to have had on the works of art they commissioned.

If these last two essays deal with unformulated norms, the three remaining studies in this volume deal with the other end of the spectrum. They are devoted to an examination of the norms themselves. The title essay, *Norm and Form* (which appears here in English for the first time), analyses the hold which the Renaissance norm still exerts on our notions of style, even among critics who (like Wölfflin) contested its claim to general validity. The brief paper on the historical background of the concept of *Mannerism* discusses the special case of the emergence and evaluation, in the light of this norm, of one particularly controversial category of style, while the lecture on *Raphael's Madonna della Sedia* investigates the meaning and some of the philosophical and psychological implications of the norm through a once famous example. There are links backwards and forwards from this lecture to some of the other studies in the book, and I was pleased to find that many of the themes interact and that a number of cross-references were necessary. But I would not want to claim that this volume lives up to the classical norm of forming 'one harmonious whole'. I am aware of the many gaps in its structure and argument and I am still trying to close them. I continue to work on the two fronts of the theory of art and of its practice, and I hope to show in further studies that the two are really inseparable.

It remains only to thank the many friends and colleagues who have helped me over the years in which I have been working on these subjects, the Committees who invited me to read papers at congresses or to lecture, the publishers who allowed the articles to be reprinted, among them my fellow editors of the *Journal of the Warburg and Courtauld Institutes*; my colleague Michael Baxandall undertook the thankless task of seeing the book through the press, and Dr. I. Grafe of the Phaidon Press proved as unfailing as ever in finding illustrations and generally furthering the whole enterprise. Finally I would like to repeat my thanks to Mr. Harvey Miller for his interest in these studies.

London, May 1966 E. H. GOMBRICH

The Renaissance Conception of Artistic Progress and its Consequences

THE Renaissance conception of artistic progress is familiar to all of us from Vasari's *Lives*. There we read of the rise of the arts from rude beginnings to their perfection, first in classical antiquity and then once more, after the Gothic disaster, through the three stages of 'good', 'better' and 'best' to the pinnacle of Michelangelo's art. It is a picture of history that still exerts its spell even though its validity has been questioned for a century and a half. The Romantics, Nazarenes and Pre-Raphaelites attacked the underlying scale of values which equates greater skill with better art; Alois Riegl and his followers have even made us doubt whether we have much right to speak of an advance in skill where intention itself is subject to change; he replaced 'Können' by 'Kunstwollen'. Finally the Croceans have questioned whether art can be said to have a 'history' at all. They have insisted on the 'insularity', the uniqueness of each genuine work of art, which should not be degraded into a mere link in a chain of 'development'. And yet the very critics who take the most extreme stand in these matters are frequently fond of speaking of 'progressive' movements in art—by which they usually mean those movements which are in revolt against the Renaissance ideas of progress.

It cannot be my intention here to pose, let alone to solve, the various problems arising from these paradoxes. I do not want to ask whether there is such a thing as artistic progress or not—I suppose that depends largely on how one agrees to use one's terms—nor even whether the Renaissance concept was quite free of contradictions. My question is a historical one. I shall therefore take as my starting-point an early Renaissance text which shows us Vasari's idea *in statu nascendi* and then ask what effect such an idea (whether true or false) must have had on the artists who shared it. My text comes from a dedicatory epistle written by the Florentine humanist Alamanno Rinuccini in May 1473 to preface a translation from Greek into Latin of Philostratus' *Life of Apollonius* made for Federigo da Montefeltre. Though it was printed in the late eighteenth century,[1] art historians have apparently overlooked it. I shall quote only the passages relevant to the present argument and refer the reader to an appendix for sections from the original text and some additional notes:

Whenever I have looked at the men of our own age and compared them with those of the past—my most generous Prince Federigo—I have always found the opinion of those utterly absurd who think they can never adequately praise the exploits and the wisdom of the ancients unless they decry the manners of their own time, condemn its talents,

This paper was a contribution to the *XVIIᵉ Congrès International d'Histoire de l'Art*, Amsterdam, July 1952.

belittle its men and deplore their misfortune which made them be born in this century so lacking in probity, so devoid of industry and—as they put it—quite without the pursuit of the polite arts. . . . As for me, I sometimes like to glory in the fact that I was born in this age, which produced countless numbers of men who so excelled in several arts and pursuits that they may well bear comparison with the ancients.

To begin with minor things and proceed to weightier matters: The arts of Sculpture and Painting, graced in earlier times by the genius of Cimabue, of Giotto and Taddeo Gaddi, have been carried to such greatness and excellence by painters who flourished in our own age, that they may well deserve to be mentioned beside the ancients.

Nearest to our own period there was Masaccio, whose brush could express the likeness of anything in nature to such perfection that we seem to look not at images of things but at the very things themselves.

And what could be more cunning than paintings by Domenico Veneziano? What more admirable than the pictures by Filippo the Monk [Filippo Lippi]? What more ornate than the images wrought by John of the Predicant Order [Fra Angelico]? All these differ from each other in their various manners and are yet considered quite alike in excellence and quality.

As to sculptors, though I might mention many who would be rated outstanding if they had happened to be born a little before our time, the one Donatello surpassed all the rest to such an extent that he is almost the only one to count in that field. Still, Luca della Robbia and Lorenzo di Bartoluccio [Ghiberti] were not to be despised either, as the great renown of their works bears witness.

I must leave aside Rinuccini's praise of Brunelleschi and Alberti both as engineers and as architects and select from his lengthy account of the rise of the Liberal Arts in his age only one more passage in which the idea of progress is particularly clearly expressed:

The usage of classical oratory and of a flawless Latin style was born again shortly before our age: in our age it has now been so cultivated and refined as it never flourished after the times of Lactantius and St. Jerome. This can easily be seen from the writings of those who pursued the knowledge of many great subjects in the period between the aforementioned ages but had a harsh manner of writing—a fact which does not surprise me, since several of Cicero's books were hidden in obscurity and thus afforded no opportunity of imitation. At first, then, Coluccio Salutati lifted himself up a little and adumbrated a somewhat more elegant mode of speech, which truly merited high praise because he had opened the way to eloquence which had been closed for such a long time and had shown those after him the path they would have to ascend. He was followed by Poggio and Leonardo Aretino, who called back to light that eloquence that had been interrupted and almost abolished.

After a review of Greek scholars and of statesmen Rinuccini gives his letter the expected elegant twist: Why should I prove so laboriously that we are as good as the ancients? We need only look at you, my Lord Prince, and find the greatness of our age confirmed.

Rinuccini certainly did not aim at originality. His dedicatory letter merely offers fresh variations on themes current in his time and *ambiente*. One is the idea that

the state of eloquence and the state of the arts are somehow bound up and that both are an index to the greatness of an age.[2] It is this conviction which colours the outlook of so many Renaissance humanists and still influences our view of their age. Not only of theirs, in fact. We are still inclined to accept the state of the arts as the surest token of the greatness of an age, even though, on reflection, we may have to admit that it is a test of most doubtful validity.

As far as the arts are concerned this momentous idea probably first occurred in the famous introduction to Alberti's *Della pittura* which clearly inspired Rinuccini's letter. Alberti tells us that he had shared the melancholy belief that Nature was in decline and no longer produced giants or great minds till, on his return from exile to Florence, the mere existence of Brunelleschi, Donatello, Masaccio, Ghiberti and Luca della Robbia restored his faith in life.[3] But Alberti sees these artists in isola-ion. Rinuccini views them as part of a movement which he sees continuing into his own time. The possibility of such a movement must have been familiar to every humanist. Not only Pliny but those great newly rediscovered treatises on eloquence, Cicero's *Brutus* and Quintilian's *Institutio Oratoria*, described the slow and gradual growth of the arts in antiquity from primitive beginnings to polished perfection.[4] The image, therefore, lay ready at hand. Moreover it was almost a matter of course that it could be applied to Florentine conditions. Had not Dante affirmed that Giotto's fame had obscured Cimabue's?[5] And were not the Florentine artists especially proud, as we know from Cennini, to cultivate the living tradition of that giant among the artists?[6] Here, then, we find Vasari's conception of history pre-figured in the Quattrocento. It was obviously an idea that had been 'in the air' for quite some time. It could never have arisen without the fact of Giotto's or Masaccio's actual progress in the direction of realism. But I believe that the idea of progress is not only a consequence of the actual happenings in the field of art but that it must have reacted back on art and artists in a way which deserves closer study.

It is not the psychological effect of this belief I have in mind. No doubt it must have been exhilarating for a young artist to live in an age and in a city that prided itself in its art; no doubt the idea of progress could act as a spur and a challenge. 'He is a wretched pupil who does not surpass his master', wrote Leonardo,[7] who still only had such wretched pupils. The point I wish to make is that quite apart from any psychological effect the idea of progress resulted in what might be called a new institutional framework for art. In the Middle Ages, as social historians always remind us, the artist was really a craftsman, or rather—since this word has acquired a certain Romantic lustre—a tradesman who made paintings and sculp-tures to order and whose standards were those of his trade-organizations, of the guild. The idea of progress brings in an entirely new element. Now, if I may put it epigrammatically, the artist had not only to think of his commission but of his mission. This mission was to add to the glory of the age through the progress of art.

We all know that the contrast between the Middle Ages and the Renaissance can easily be overdrawn. But this frame of reference really seems to have created a new context for art. New, at least, if we take the word 'art' in our, the modern sense. The noble adage *ars longa*, *vita brevis*, reminds us that this meaning itself is of comparatively recent date. For the 'art' which is longer than human life is Aesculapius's; the saying and the sentiment come from Greek medicine.[8] It may be true that the notion of progress prevalent in the ancient world differed from ours.[9] Our idea is derived from the machine with its promise of infinite perfectability, theirs from the organism whose growth comes to a stop once its 'potentialities' are realized. The *locus classicus* for this conception is Aristotle's account of the evolution of tragedy. But even this idea lifts those who share it out of the petty realities of life. The artist who believes that the arts progress is automatically taken out of the social nexus of buying and selling. His duty lies less with the customer than with Art.[10] He must hand on the torch, make his contribution; he stands in the stream of history—and this is a stream which the historians set in motion.

I should like here to follow the impact of this new conception of art in an example familiar in itself—the change from Ghiberti's first Baptistry door to his second. There is no evidence that while he worked on his first door (the second of the Baptistry), Ghiberti saw himself as anything but a craftsman who had received an important commission. To be sure the competition arranged for the selection of the artist in 1401 is symptomatic of the pride of the Florentines in the standard of their art and of their wish to live up to their great tradition.[11] But the form which the commission took must still have conformed to the traditional conception of art. We may infer that Ghiberti was to match the existing door by Andrea Pisano (Figs. 2–3) and to regard it as his '*simile*', his pattern. We know from the documents that Andrea Pisano in his turn had also been given such a pattern. He was to emulate the Bonannus doors of Pisa in general lay-out (Fig. 1), while he used the Baptistry Mosaics (Figs. 8–9) and some of Giotto's frescoes as his authority on how to tell the episodes of the Baptist's life.[12] Ghiberti's main aim seems to have been to live up to the high standard set by his famous predecessor (Figs. 4–5). Originality and progress, at any rate, were certainly no values he felt called upon to satisfy. Like all artists of his time he relied on the traditional formulas for the individual scenes of the life and passion of Christ and concentrated his ambition on rendering them with the utmost refinement of 'love and diligence', as he himself puts it in his autobiography. Naturally this does not exclude a certain expression of personal preferences in the mode of execution. Ghiberti's ideals, at the time, seem strongly influenced by the leading goldsmiths of the International Style, perhaps by the Burgundian 'Gusmin' whose existence has been proved by the brilliant detective work of Prof. Krautheimer.[13] But the picture of Gusmin himself, as it lives in the pages of Ghiberti's *Commentarii*, shows

that the ideal of Ghiberti's youth was an artist who entered a monastery to do penance for his vain pursuit of glory.

I need not enlarge on the tremendous revolution embodied in Ghiberti's second door (Fig. 13). It is a change that far transcends such stylistic modifications as artists may undergo after contact with other artists. It seems to me that the very frame of reference within which Ghiberti was working had changed. For here he was clearly out not only to reach the high standard of the past but to make progress, progress even beyond his own earlier work. His intention was fully grasped and accepted by his contemporaries. Already his first effort had been felt to be an improvement on old Andrea Pisano, whose door had to yield to Ghiberti's the place of honour facing the Cathedral. Now Ghiberti's own first door had to be removed to give way to the masterpiece we know by the name of the 'Gates of Paradise'. I submit that these Gates owe their existence to Ghiberti's contact with the new humanist idea of artistic progress. I realize that such a hypothesis accords rather ill with the traditional picture of Ghiberti's personality. This picture is certainly coloured by the partisan version of Ghiberti's clash with Brunelleschi circulated by the latter's biographer and mitigated, but not eradicated, by Vasari. Even Schlosser, who has done more than any scholar to resurrect the master's art and writing, still represents him somehow in the light of a self-taught craftsman trying hard in his declining years to catch up with humanist learning.[14] It must be admitted that the text of the *Commentarii*, such as we have it, supports this reading, but this text is a copy and we may never know how much of the ignorance it betrays should be laid at the door of the scribe rather than the author. In this connection a brief contemporary reference to Ghiberti, hitherto overlooked by art historians, may acquire some importance. It occurs in the correspondence of Aurispa, the great collector of Greek manuscripts.[15] In 1424 Aurispa had among his treasures 'a large volume on siege machines with illustrations of the machines . . . an ancient codex, the figures not very well drawn but easily intelligible'. Now in 1430 (January 2) Aurispa writes to Ambrogio Traversari, the great humanist monk:

'I shall send to Laurentius, that outstanding sculptor, the volume of siege machines, but I want in return that ancient Virgil I have always desired to have and the *Orator* and *Brutus*, which seems to me a fair bargain'; and on March 15, 1430: 'I have the siegecraft with me and so, if that sculptor could give me in return that ancient Virgil you have in your monastery and the perfected copy of Cicero's *Antoniana*, recently discovered, I shall send the Athenaeus.'

We do not know what became of the bargain, but we do know—as Schlosser knew too—that Ghiberti opens his *Commentarii* with a long rhetorical introduction which is a translation from the very Athenaeus he coveted.[16] There is no need to overrate this reference, but it does show that Ghiberti's humanist interests go back into the period of his life when he was at work on the reliefs for the 'Gates of

Paradise'.[17] To see him in 1430 a member of that codex-swapping crowd that included Aurispa, Traversari, Niccolò Niccoli and Poggio Bracciolini is to see a somewhat different Ghiberti.[18] In this alone lies my justification for discussing this document in the present context. It should strengthen my thesis that when he made the second door Ghiberti, like his humanist friends, saw himself in the stream of history, deliberately re-evoking and reliving the past and striking out towards a new future. I believe that there is some evidence in Ghiberti's own writings to bear out such an interpretation of his change of style.

The first book of Ghiberti's Commentaries is, of course, little more than a paraphrase of Pliny's account of the rise of ancient art. It was in Pliny that Ghiberti could read of the contribution every artist made to the progress of art and he must have read with particular interest Pliny's rather cryptic account of the greatest of ancient sculptors in bronze, Lysippus.[19] The very beginning of this paragraph would confront Ghiberti with a conception of art in violent contradiction to all he had practised and learned. For Lysippus is credited with the saying (later attributed to Caravaggio) that Nature alone should be imitated and not the work of other artists. Pliny continues (paraphrasing in his turn the work of a lost critic on the progress of art):[20]

His chief contri butions to the art of sculpture are said to consist in his rendering of the hair, in making the heads smaller than the older artists had done and the bodies slimmer and less fleshy, which made his figures look taller. The Latin language has no term for that *symmetria* that he was at such pains to cultivate, changing the square proportions of the older artists without disturbing the harmony; he often said that they had represented men as they were, while he represented them as they appeared to be.[21]

Now if we look at the strangely elongated proportions of figures from the second door and compare them with figures from his first door (Figs. 11–12), or his Adam with Andrea Pisano's rendering of the same scene (Figs. 6–7), we will find it hard to avoid the suspicion that Ghiberti was here deliberately trying to emulate the role of Lysippus and to change the canon. I believe that the suspicion may be strengthened by a significant detail in the famous passage on Gusmin. Among all the words of praise Ghiberti finds for the saintly Northern artist there occurs one word of slight stricture—'*le sue statue erano un poco corte*', his statues were somewhat squat. This fits with Krautheimer's identification of Gusmin as Burgundian, since in Burgundian art the figure can so often be described as, precisely, *un poco corte* (Fig. 10). Gusmin being the artist whose life precedes his own in the second book of the Commentaries, it looks as if Ghiberti had been anxious to reserve the role of the second Lysippus for himself.

If Ghiberti really adopted a new canon to follow in the direction of progress he found indicated in Pliny, his changing the whole framework of the second door becomes more intelligible. We know that it was not a change provided for in the

original commission. Leonardo Bruni's written programme envisages a door on the pattern of the two earlier ones,[22] and Ghiberti's proud statement that he was given leave to make it in any manner that seemed to him most perfect, rich and ornate, may possibly hint at a preceding clash of opinions.[23] But Ghiberti had now learned that 'nature was to be followed and not any other artist' and that he should represent men 'not as they are but as they appear to be'. If we read Ghiberti's own description of the method he adopted with these words in mind the conclusion that he felt another Lysippus becomes almost inescapable.

'*Ingegnai cercare imitare la natura quanto a me fu possibile*', he says, and lest we might take this as no more than a routine expression of Renaissance aesthetics he seems at pains to explain with an undeveloped terminology that what he strove for was precisely the imitation of 'appearance' and of 'symmetria', a concordance of measurements.

' strove in all the measure to imitate nature as far as I could with all the lines that result in it . . . they are all in frames so that the eye measures them and so true that standing at a distance they appear to be in the round. They are in very low relief, and in the plane the figures which are near appear to be larger and those which are far off smaller, as in real nature. And I carried through the whole work with these measurements (*con dette misure*).'[24]

And while in the earlier work he stresses his 'love and diligence', when he sums up the account of his *chef'dœuvre* he stresses again that '*con ogni arte e misura e ingegno è stata finita*' (It was finished with every skill, harmony and invention at my command).

Let us turn once more to Ghiberti's Pliny paraphrase to see what this implies. It contains a passage in which the artist proposes an emendation of his source. Ghiberti read in Pliny how Apelles and Protogenes had competed with each other as to who could draw a finer line. 'Speaking as an artist,' he says, 'I consider this a poor test.' He thinks what probably happened was that the two had competed in demonstrating solutions for a difficult problem of perspective. And he is sure that the panel on which Apelles had finally demonstrated the solution that made Protogenes declare himself beaten must have been praised and admired by all and sundry, but 'most of all by painters, sculptors and other connoisseurs'.[25]

It seems to me that this revealing emendation by Ghiberti introduces us most vividly into the mentality engendered by the idea of progress. The artist works like a scientist. His works exist not only for their own sake but also to demonstrate certain problem-solutions. He creates them for the admiration of all, but principally with an eye on his fellow artists and the connoisseurs who can appreciate the ingenuity of the solution put forward. We are reminded of Brunelleschi's lost panels with views of Florentine buildings, which were made with no other purpose in mind than to prove the validity of his perspective construction. Alberti, too, devised some

kind of peepshows to display the powers of art in creating illusions. He and his biographer call these exercises '*dimostrationi*', demonstrations.[26]

Something of this spirit of experimentation is also exemplified in the Second Door. The round building in the story of Joseph (Fig. 14) contributes nothing to the narrative. On the contrary, it rather muddles it. But it is displayed in the centre of the work as a *dimostratione*, a token of the master's skill in applied geometry which, we may assume, surpassed anything done before along these lines.

I would not say that demonstrations of skill did not occur outside the magic circle of humanist art. We need only read Facius on Jan van Eyck to realize that the Northern artists, too, were seen as introducing features into their work to display virtuosity rather than to add to the narrative. But the difference is, perhaps, that the solutions envisaged and exemplified by Ghiberti are demonstrable; they really contribute to the body of knowledge. Once Ghiberti had shown the perspective construction of a round building it could and did become common property. In other words, the stronger the admixture of science in art, the more justifiable was the claim to progress.

Ghiberti himself hardly realized that this new conception of art which he embraced with such enthusiasm spelt the doom of his own beloved craft. A demonstration, an intellectual problem-solution, stands in no need of the marvellously chased surface and the costly gilding of the Second Door. Apelles' panel was treasured without such outward attractions. Thus Ghiberti's door really stands on the watershed of the two worlds. It is the last goldsmiths' work to be quite in the van of artistic progress. Henceforward there will be a growing gulf between the intellectual pursuits of Art and the 'applied art' of the craftsman. A new hierarchy is created by which true nobility in art has no need to 'flatter the eye' or to rely on surface attractions. On the contrary—such attention to a polished surface is in itself the symptom of a less aspiring mind. One may fancy that this scale of values was grasped by Donatello, whose austere art stands unambiguously on our side of the crest and who thus became 'the only one who counts' as Rinuccini puts it, already somewhat uncertain about Ghiberti's position in history.[27]

I have deliberately chosen an early example to illustrate what I believe to be the decisive influence of the Renaissance idea of artistic progress. We all know, of course, that the concept of art underwent a profound change during the High Renaissance, but hitherto this change has mostly been described in terms of Neo-Platonic aesthetics and indeed attributed to the influence of Platonism, which hardly existed in Ghiberti's time.[28] Of course this influence became important, but it seems to me that it could only take effect on artists who felt already part of the ideal community of illustrious minds. There is an episode in Leonardo's life which illustrates this attitude. Vasari tells us that Filippino Lippi had received the commission to paint a *St. Anne* for SS. Annunziata in Florence but stood down when

he heard that Leonardo, back from Milan, was willing to undertake such a picture.[29] Filippino may have had a reason for this unusual act of generosity,[30] but we may take it as a symbol of the awareness that a Leonardo must be given an opportunity to make his contribution, commission or no commission.

For Leonardo, in turn, it was a matter of course that the artist creates not to satisfy his customers but, as he puts it, 'to please the first painters' who are the only ones capable of judging his work. 'Those who do not, will fail to give their pictures the foreshortening, relief and movement that are the glory of painting.'[31] The *St. Anne* (Fig. 15), of course, has all this and it did not apparently detract from the importance of the picture that it was never delivered to the altar for which it had been commissioned. The cartoon, even the 'invention', sufficed.

In some respects, then, a work such as Leonardo's *St. Anne* partakes of the spirit of the '*dimostratione*'. It is meant to show the unusual and ingenious way in which the great master solves the artistic problem of this traditional subject. It is the same ferment of the '*dimostratione*' that is responsible for much of what we call 'Mannerism'. For Mannerism comes to its climax at the moment when the inherent ambiguities of the Renaissance idea of artistic progress become apparent—at the moment when, by common consent, Michelangelo has achieved 'perfection' by realizing the highest potentialities of his art. On this reading it is a crisis in the conception of art rather than one rooted in the 'spirit of the age'.[32]

But the consequences of the Renaissance idea of progress extend far beyond this local disturbance of Mannerism. For it belongs to the class of ideas which act like eating from the tree of knowledge—once you have a notion of good and evil you are for ever cast out of the Paradise of Innocence. We know that the idea of progress had such a fateful effect in the field of politics. As soon as it gained its hold at the time of the French Revolution you could only declare yourself for it, or against it, right-wing or left-wing, and however much we may protest against this one-dimensional arrangement of the *terribles simplificateurs*, we will find it hard to get away from it.[33]

The history of art, I submit, shows a similar process of polarization. Once the rules of the game called art had been revised in Florence to include the demand for a 'contribution', a problem-solution, no other conception of art had much chance against it. Thus, when Vasari identified the history of art almost entirely with the history of art in Florence (allowing for such tangible contributions from the North as the 'invention' of oil painting), he was not only prompted by a parochial patriotism. He was writing the history of the new game that had actually sprung up in Florence. And this new conception acted like a vortex with ever widening range and momentum. The Sienese school, for instance, ceased to preoccupy itself with the problems of the centre and it became provincial, a backwater, very charming no doubt, on the surface, but paying for its refusal to go Florentine as Urbino had

B

done, by being unhitched from the train of progress. Venice, it is true, refused to knuckle under, but then it created its own ideology, its own specific contribution to colour which the Keepers of the Book of Rules grudgingly admitted, even though this variety had to take its place below the more intellectual, and therefore more 'noble' contribution to problems of '*disegno*'. Despite some abortive revolts the main idea, the idea that art had begun again with Giotto and that the great Florentines were its torch-bearers, had all dynamic force on its side. Dürer repeats and endorses it,[34] and so do the courts and patrons who cannot afford to be thought 'Gothic' and 'backward'. Soon you are either in contact with this main stream of progress or you are 'out of touch' altogether. And so the Italian journey became a necessity because here was the point of reference against which all art was measured. It might be possible to react against it, to insist on such neglected potentialities of painting as the art of *genre* and landscape peculiar to the North,[35] but even such protests as we might read into the art of Breughel still refer *as protests* to the line that began in Florence. It has remained so ever since. The centre of the vortex might shift from Florence to Rome, from Rome to Paris, from Paris to New York, the problems of interest might change from realism to expression or the articulation of the unconscious, but the momentum of the revolution that started in Florence was never spent. It is a revolution which has its martyrs who produced art for art's sake in increasing isolation from public demand.[36] And for all its weaknesses this idea of mankind being engaged in building up an autonomous realm of values which can somehow be conceived to exist beyond the individual's contribution and comprehension remains inspiring. It is linked up with the idea of the 'contribution', the '*dimostratione*'. There is an element of the '*dimostratione*' in a hayrick by Monet no less than in a cubist still life by Picasso. Even the wildest product of Dadaism derives such meaning as it may have from the gesture of defiance to the world at large, that is, from its reference to the idea of Art it derides. Even in 1951 an influential spokesman of the Modern Movement such as Herbert Read could write that 'for a painter to ignore the discoveries of a Cézanne or Picasso is equivalent to a scientist ignoring the discoveries of an Einstein or a Freud'.[37]

This, I suppose, is as far as the historian need and can go. He cannot arbitrate between this extreme view and that of Hazlitt, who denied in 1814 that the arts can be 'progressive' because this idea 'applies to science, not to art'.[38] Perhaps art progresses less like science than in the way a piece of music can be said to progress, each phrase or motif acquiring its meaning and expression from what has come before, from the expectations that have been roused and are now fulfilled, teased or denied.[39] Without the idea of One Art progressing through the centuries there would be no history of art. We art historians might therefore do worse than remember such men as Alamanno Rinuccini, the Florentine humanist with whose passage I began.

Apollonio di Giovanni

A Florentine cassone workshop seen through
the eyes of a humanist poet

ARLY in this century a copy of the records of a Florentine cassone workshop
was found by Heinrich Brockhaus among the *Carte Strozziane*. It contained a
complete list of the marriage chests and other work furnished during seventeen
years, between 1446 and 1463, by the owners of the shop, Marco del Buono Giam-
berti and Apollonio di Giovanni.[1] Knowing that Warburg was particularly inter-
ested in cassoni, those eloquent documents of the taste and outlook of the Florentine
merchants, Brockhaus drew his attention to the document.[2] Warburg had it copied
and hoped that it would be possible to identify products of the workshop concerned
among extant cassoni. The list always gave the names of the brides whose trousseaux
were to be contained in the chests and also those of their prospective husbands.
Since it was the custom to place the coats of arms of the intermarrying families on
these showpieces the prospects of identification seemed good. Warburg, in fact,
proceeded to identify the marriages enumerated in the list from other sources. He
produced a fully annotated version of the list, but despite these labours luck seemed
against him; the workshop remained elusive. By the time P. Schubring prepared
his corpus of cassoni, Warburg's interests had shifted to more exciting visual docu-
ments. He readily gave permission for his annotated list to be printed in Schubring's
corpus.[3] But even then it remained suspended in the void. No cassone could be
shown to have been the product of what was obviously one of the busiest and most
fashionable firms of this kind, a firm which had on their books all the great families
of Florence, the Medici, the Rucellai, the Albizzi and the Strozzi. It remained
pure guesswork which of the groups of cassone paintings Schubring attempted
to distinguish was to be attributed to Marco del Buono and Apollonio di
Giovanni.

This situation was all the more tantalizing as Schubring was able to trace the
record of at least one cassone which had the requisite coats of arms. It corresponded
to one of the last entries in the list—the marriage, in 1463, of the daughter of
Giovanni Rucellai with Piero di Francesco di Pagolo Vettori. The sales catalogue
of the Toscanelli collection, Florence, 1883, listed cassoni with the coats of arms
of these families, but their whereabouts were unknown. They changed hands
several times and when their connection with our workshop was at last recognized

This study appeared in the *Journal of the Warburg and Courtauld Institutes* in 1955.

the war prevented publication. One of these pieces, brought from Budapest to England by its owner, Dr. Wittman, was destroyed in a German raid on Bath and nothing remains of it but a photograph (Fig. 17). The other was bought by the Allen Memorial Art Museum at Oberlin, Ohio, and published in an exemplary fashion by Professor W. Stechow in the Bulletin of that institution (Figs. 16, 18).[4] It was Professor Stechow who first publicly drew attention to the importance of this one surviving piece for all who are interested in the brittle charm of the Florentine furniture painters.

The Oberlin panel, with the arms of the Vettori and Rucellai scattered profusely over the scene, proved beyond any reasonable doubt that Marco del Buono and Apollonio di Giovanni were indeed the masters of some of the most famous and attractive pieces of the whole *genre*. As Professor Stechow pointed out, it fits into the stylistic group which Schubring called that of the 'Dido Master', who is also referred to in the literature as the 'Virgil Master' or the 'Master of the Jarves cassoni'.[5] All these names are derived from the most elaborate work of the group, two cassone fronts with scenes from Virgil's *Aeneid*, preserved in the Jarves Collection of Yale University, New Haven, Conn. (Figs. 19–20). The stylistic mannerisms of this master are so pronounced that his gesticulating mannikins crowding together in large panoramic landscapes cannot easily be mistaken. Only one question remained open. The workshop having been owned by two masters, Marco del Buono and Apollonio di Giovanni, which of the two is the 'Dido Master'?

The answer to this question is supplied by a poem contained among the epigrams and elegies of one of the most productive Latin versifiers of the Florentine Quattrocento—the notary and humanist Ugolino Verino (1438–1516).[6] His first work, a slim volume of love elegies and other epigrams entitled *Flametta*, was written between 1458 and 1464.[7] It contains a laudatory epigram on 'The outstanding painter Apollonius':

Once Homer sang of the walls of Apollo's Troy burned on Greek pyres, and again Virgil's great work proclaimed the wiles of the Greeks and the ruins of Troy. But certainly the Tuscan Apelles Apollonius now painted burning Troy better for us. And also the flight of Aeneas and the wrath of iniquitous Juno, with the rafts tossed about, he painted with wondrous skill; no less the threats of Neptune, as he rides across the high seas and bridles and stills the swift winds. He painted Aeneas, accompanied by his faithful Achates, entering Carthage in disguise; also his departure and the funeral of unhappy Dido are to be seen on the painted panel by the hand of Apollonius.[8]

It is always satisfactory to see that the detective methods of history sometimes lead to results which can thus be confirmed by independent evidence. The four-step argument, leading from the seventeenth-century copy of a Quattrocento document, through heraldic evidence to the identification of the Oberlin panel and from there, by purely stylistic comparisons, to the Virgilian paintings of the 'Dido

Master' in the Jarves Collection is confirmed by this literary testimony hailing Apollonio as the painter of Virgilian scenes. Most of the incidents enumerated by Verino as forming the subject of Apollonio's painting actually occur on the two cassone fronts of the Jarves Collection. In the poet's words they are: (1) the wrath of iniquitous Juno with the rafts tossed about, (2) the threats of Neptune as he stills the winds, (3) how Aeneas, accompanied by Achates, enters Carthage in disguise. What is missing on the Jarves cassoni no less than on their sister panels in Hanover,[9] are the first and the last of the scenes. 'Burning Troy and the flight of Aeneas' at the beginning of the cycle, and 'Aeneas' departure and the funeral of unhappy Dido' at the end. Instead, the Jarves cassone selects Aeneas' arrival in Latium and the foundation of Rome.

Now the scenes of the destruction of Troy and the flight of Aeneas as visualized by Apollonio are in fact preserved. They form the bulk of the illustrations to the Virgil Manuscript in the Riccardiana (Cod. 492), which has long been recognized as a work of the master who painted the Jarves cassoni.[10] The connection is not only one of style or subject-matter. Some of the scenes from the cassoni recur without significant alterations in the codex.

It is this fact—that we know Apollonio to have repeated his Virgilian scenes several times and in various media—which raises an interesting question. Verino describes not several panels but one '*picta tabella*' combining a long sequence of episodes. Is the singular he uses just poetic licence, or may such a large panel really have existed? If there was such a painting it is not listed in the workshop records, which do include at least one other work executed by Apollonio alone ('Apollonio fa il Ritratto al naturale in su la Cartapecora di Giovanni Bartolomeo Quaratesi') and are not confined to cassoni ('A Giovanni di Pagolo Rucellai dipingono nel Cielo della Loggia 1451, Fl 97'). On the other hand the list is also silent about the illustrations to the Virgil of the Riccardiana, which might be explained by the fact that they were never completed. But in all these matters we have to make use as far as we can of internal evidence, for the workshop records appear to break off some two years before Apollonio's death;[11] and who knows whether it was not in these two last years that he began to branch out into new fields?

In one respect, however, the identification of the 'Virgil Master' with Apollonio must completely upset the picture of the situation as it was mapped out by Schubring some forty years ago. Schubring thought of the 'Dido Master' as primarily a miniature painter whose starting-point was the Virgil codex in the Riccardiana and who then applied his narrative skill to a few cassoni. This hypothesis can no longer be maintained. It is clear that Apollonio's main line of trade was cassoni and it is more than likely that it was in this that he had received his training. This fact alone makes it very unlikely that Schubring was right in dating the codex *before* the cassoni with Virgilian scenes. A comparison of the two, moreover, confirms the

priority of the cassoni. On the first Yale cassone, for instance, we have a perfectly balanced continuous narrative which extends from Juno's visit to Aeolus, to the storm and the 'Quos ego', and beyond to Venus' intervention on the shore (Fig. 19). In the codex (Fig. 21) Juno's visit to Aeolus is adapted to the rectangular form of the miniatures by adding the prison of the winds, but all the winds blow towards the right—as they do naturally on the cassone where they cause the storm. The resulting composition almost cries for a continuation to the right, and suggests, as do other instances, that the cassone is the version originally conceived.

Schubring, of course, had no means of knowing that the painter of the Virgil codex was really one of the busiest masters of cassoni. But he had an additional reason for suggesting the primacy of the miniatures. He believed that he had discovered a clue in the codex which allowed him to date it into the early 'fifties. If the Virgilian cassoni had had to precede the codex their date would have had to be moved into the 'forties, which even Schubring, whose dates are generally too early, must have seen to be impossible. But Schubring's method of dating the codex hardly stands up to criticism. He argued that the building of Carthage, illustrated in the background of one of the miniatures (Fig. 22), represented the erection of the Palazzo de' Medici. Since these operations must have been completed by 1452 at the latest,[12] the codex must date from before that time. Schubring knew that this argument was precarious, because we happen to know, through Warburg, that the scribe who wrote the text of the codex and signed himself in the colophon 'Nicolaus Riccius, Spinosus vocatus' was born in 1433.[13] Unless we assume he was an infant prodigy we cannot move the date of the codex back beyond, say, 1450, when the scribe was seventeen. But Schubring's argument is mistaken. It is one of many put forward by scholars of his generation who longed to see the 'real life' of the Quattrocento reflected in its art. Here, as often happened in such cases, the wish was father to the thought. Quattrocento art offers no reportage of the places and personages of the time, for it operates with types and patterns, not with individualistic portrayals.

The stereotypes and formulae used in architectural backgrounds are no exception. It is interesting, in this connection, that a palace with rusticated ground floor somewhat in the manner of the Medici palace type occurs already in the background of Gentile da Fabriano's predella in the Louvre (Fig. 24). In bringing this formula up to date for the representation of buildings—both complete and incomplete—in the noble city of Carthage, Apollonio may well have made use of the type of the Medici Palace (Figs. 22–3), but this fact does not turn his miniatures into topographical views. Least of all need we think that the degree of incompleteness of Carthage allows us to refer back to the building history of Florence.

The only safe *terminus ante*, therefore, which we can accept for the Virgil codex is that of Apollonio's death in 1465. Actually it seems much more likely that the

miniatures belong to a late date; for the most natural explanation for the incomplete state of the miniatures would be that Apollonio died over this work. We can see that he planned their continuation, some existing only in pen drawings, others with some of the colours applied. If all this had been done in the early 'fifties why should he never have gone on? It must have been the success of the Virgilian cassoni which gave one of his patrons the idea of commissioning these illustrations from Apollonio. Did the same success give rise to the idea of a panoramic painting, the '*picta tabella*' of Ugolino Verino's poem? Or did Verino simply write from memory and supply the scenes he expected to find? In the absence of any evidence to the contrary it seems safer, on the whole, to assume that he meant what he said and that such a painting existed. We might perhaps imagine it set above some wainscot, where Florentines were used to seeing Flemish hangings with similar episodes from the Story of Troy. Apollonio himself gives us an idea of the possible appearance and arrangement of such a painting when he illustrates the Temple of Juno in Carthage in which Aeneas and Achates discover representations from the Iliupersis (Figs. 20, 22). The painting referred to by Verino must have been finished by 1464, the year in which the poet finished the compilation of the *Flametta*. To Apollonio, therefore, may go the credit of having painted the earliest mythological painting on a monumental scale.

In his publication of the Oberlin panel Professor Stechow suggested that of the two owners of the workshop Marco del Buono appeared the more likely candidate for the name of the 'Dido Master'. The reason he gave was that we know a good many cassoni of that group which, for stylistic reasons, should be dated later than 1465, the year of Apollonio's death. Verino's epigram makes it possible for us to rectify the hypothesis. We now know what Apollonio's style was like. Does it also help us to form a picture of his partner's? Here the problem is considerably more complex. Professor Stechow has rightly warned us against any attempt at disentangling the existing chaos of cassone attribution on the basis of photographs alone. It is certainly true that photographs are nearly always too small and too indistinct to allow a detection of individual characteristics in these teeming crowds of triumphs and battles. It is also most likely that the nineteenth-century restorers who furbished up cassone fronts for collectors must have had a levelling effect on such peculiarities of manner as may have existed. But even when all this is taken into account, there remains a problem of method: is it altogether certain that the style of cassoni was ever as clearly circumscribed as that of altar paintings? Judging by their workshop records Marco del Buono and Apollonio di Giovanni supplied cassoni for up to 23 trousseaux a year.[14] Most of the commissions must have been for a pair of them,[15] which means that one or two finished products must have left the workshop on an average every week. Such an output, of course, presupposes a good many fairly independent assistants, some of whom may have perhaps set up

a workshop of their own later on, taking patterns with them or copying Apollonio's formulae. Perhaps patrons also commissioned copies of their favourite pieces from other workshops. Add to these various possibilities the documented fact that our workshop was headed by two masters who may have collaborated in any number of ways, and we can hardly wonder that cassoni so often elude the tidy pigeon-holes beloved of collectors.

One point, however, is clear. Schubring's divisions can no longer stand. It will be remembered that he had only a short list of cassoni which he gave to the 'Dido Master'—nine items, of which three formed pairs. As far as this master is concerned, Professor Offner[16] challenged this list long ago on purely stylistic grounds. He argued, and argued convincingly, that two other fine cassoni in the Jarves Collection must be attributed to the same workshop. One is the panel with a Tournament on the Piazza S. Croce (Fig. 25), which Schubring identified with a joust held in 1439 in honour of the Council of Union. There is no evidence for this identification and everything speaks against so early a date.[17] Schubring gave eight items to the master of this panel, but they form a rather ill-assorted group. The tournament itself, however, is certainly a *chef-d'œuvre* of our workshop. Finally, there is the beautiful panel in the Jarves Collection of the Queen of Sheba's visit to Solomon (Fig. 26). This accomplished piece was given by Schubring to yet another workshop, which he called that of the 'Cassone Master' and to which he gave twenty items of his *corpus*. Here, too, Offner has dealt a blow to Schubring's nomenclature by claiming the panel for the same workshop as also produced the Virgilian scenes and the Tournament. At first glance this identification looks less convincing. The figures of this cassone are arranged on a conventional Quattrocento picture stage, rather unlike the panoramic compositions of Apollonio. The floor is squared to display the perspective and the background is crowded with architectural stage-props which testify to a great interest in decorative forms *all' antica*. But similar features can also be observed in the panel with the Murder of Caesar (Fig. 27) which Offner gave to the same master and which, in fact, leads back to the miniatures of the Riccardiana Virgil. The similarities are striking, both in decorative details and in the disposition and attitudes of the figures (Fig. 29). The identification of his Virgil master with Apollonio also strengthens Offner's attribution of a group of Madonnas to the same master. At least one Madonna is listed among the products of the workshop, *una nostra Donna in un tondo*, made in 1455 for Pierfrancesco di Lorenzo de' Medici, the father of Botticelli's patron. Moreover this identification also explains why, as Offner says, 'One meets with cassone fronts stamped with [this workshop's] style in almost every museum, disguised, it is true, under a variety of designations'. After all, our workshop records list some 170 commissions which may correspond to some 300 cassoni. It may well have monopolized the market to a considerable extent. The only other group which appears to have a distinct physiognomy of its

own is that of Schubring's 'Anghiari Master', though even here a fairly featureless no-man's-land extends between his workshop and ours.

The group assembled by Offner would certainly appear to be the most secure strategic base from which to explore once more the material assembled by Schubring. It is beyond the scope of this paper to attempt such a re-examination. But two examples of fair quality which were not discussed by these authors may here be included to demonstrate the range of the problem. One is the cassone with yet another Virgilian scene (Fig. 28), Aeneas' landing in Latium, the meal on the shore and the reception by Latinus from *Aeneid* book VII.[18] Judging by the landscape and the figures (Latinus recalls the Kings of early playing cards) this cassone exemplifies the most archaic version of the style, and may well date from the 'thirties or 'forties. By contrast the painting with Caesar's triumph (Fig. 30)[19] represents a phase close to that of the Oxford cassone and also, perhaps, of the S. Croce Tournament with which it forms another link. The figures are larger, the spatial framework much firmer. Thus it would be tempting to divide the groups again between the two owners of the shop, Apollonio and Marco del Buono.

Unfortunately the facts contradict this tidy division. Despite Berenson's doubts,[20] the miniatures of the Riccardiana seem to me the work of one master; and this master, who can only be Apollonio, had a repertoire that included the frieze-like designs of epic illustrations and the more compact stage settings of the Caesar panels. The question, therefore, of where Marco del Buono may be fitted in still awaits solution. Professor Stechow certainly pointed the way when he said that any product of our workshop that can be proved to have been painted after 1465, the year of Apollonio's death, would be a candidate for attribution to his partner. There are cassoni which answer to this description but no very clear picture has emerged from them. There is the cassone in the Perry collection at Highnam, for instance,[21] which Schubring gave to the master of the S. Croce Tournament, but which shows figures of archers looking suspiciously as if they had been borrowed from Pollaiuolo's *S. Sebastian*, painted in 1475. But this work hardly shows a sufficiently pronounced artistic character to make it the centre of a group. The same applies to the sumptuous marriage chests from Lord Lee's collection.[22] Their style certainly points to a date considerably after 1465; but some of their motifs, such as the Brennus episode (Fig. 33), recall the Roman scenes and settings of our workshop. There is little doubt, in fact, that these inventions continued to be exploited for quite some time after Apollonio's death[23] and Marco del Buono must be expected to have carried on the joint tradition. But though he survived Apollonio by twenty-four years it is well to remember that he was fifteen years older and may have influenced his junior partner in earlier years. The situation resembles more famous partnerships, such as those of Hubert and Jan van Eyck or Masolino and Masaccio. *Vestigia terrent.*

With Apollonio emerging as a leading master of the cassone trade, it may be more profitable to re-examine briefly the sources of his style. Such an examination might lead us to revise an opinion frequently voiced in discussions of Quattrocento art—the opinion that the style of cassoni reflects the achievements of the great masters, notably of Uccello and Domenico Veneziano. It is true that borrowings occur, but by and large it is remarkable how independent their idiom remains from what we consider the main stream of Florentine art. It is as if Masaccio or Donatello had never lived and the International Style, as exemplified by Gentile da Fabriano, had been allowed to develop, undisturbed, into the next generation.[24] It is instructive, in this connection, to compare the hunting scenes from the Jarves cassone (Fig. 31) with Uccello's hunt (Fig. 32). Apollonio, with his graceful silhouettes of stags in flight and dogs in pursuit, completely preserves the tapestry character of International Gothic, while Uccello is visibly intent on translating the same formulae into the idiom of the new three-dimensional style. It is this same three-dimensional character which distinguishes Uccello's lively hunters from Apollonio's gesticulating manikins. For while Uccello turns his figures away from the beholder and lets them chase their game into the depth of the forest, Apollonio's efforts are always directed at preserving an easily legible silhouette. It is this effort to avoid difficult foreshortenings in the rendering of figures endowed with a truly Italian temperament that accounts for the curious contortions so frequent in Apollonio's compositions. There is something almost Egyptian in the way his manikins are spread out in full view; wherever possible they have to show both arms and legs and this strain gives to his figures in motion the curiously restless and unstable appearance that is one of the hallmarks of his style. For Apollonio's narrative purpose, however, this device served admirably. It enabled him to make his key figures stand out clearly in the bustling panoramas of his picture stories and to guide the spectator from scene to scene. Certain of these postures recur with a naïve monotony that makes one think of someone moving tin soldiers around. Thus the stereotype of the man with straddling gait and marionette hands, always seen from behind, does service as Ascanius embarking from Troy (Fig. 34), or as a waiter carrying dishes at Dido's meal (Fig. 35). It is used with slight variations for a sailor on the prow of Aeneas' boat (Fig. 31) and for an onlooker peeping through the fence at the Tournament (Fig. 36). But perhaps it is not quite fair to hold these repetitions of formulae against the artist. For here, too, he was only following a traditional practice. His very method, which we have observed in the Virgilian scenes, of using and adapting the identical pictorial formula in different media and contexts betrays the outlook of the mediaeval craftsman who knows how to husband his resources.

The process of workshop production on such a scale depended on the existence of a ready stock of patterns for the rendering of cities, ships, camps, triumphal

chariots, fallen horses or fighting men. Naturally there are cassoni where the more obvious dangers of mass-production make themselves felt; but these dangers lie less in lack of original invention than in thoughtless or hasty execution by assistants insufficiently conversant with the master's intentions. In the more ambitious compositions from the workshop, such as the scenes from the *Aeneid* or the *Odyssey*, the standards of craftsmanship are generally high. Yet it might be argued that the very attention to detail, the very liveliness of the narrative sometimes makes the stereotypes and mannerisms of the style more obtrusive.

An illustrator of a fourteenth-century romance could afford to repeat his clichés with impunity because we accept them as pictographs. But Apollonio's world, decked out as it is with all the realistic detail accumulated by International Gothic and reaching out towards the rational plausibility of the Renaissance picture-stage, partakes too much of the character of the real world for us to overlook its inconsistencies and mannerisms. It is this surface realism, his attention to fabrics and stage-props and the intrusion of such realistic features as cast shadows, that makes his narrative look 'naïve'. For this reason this impression recedes when we look at the unfinished miniatures of the Virgil MS. (Fig. 37). Here, where there is less realistic detail to trick us into a different approach, Apollonio appears as a true practitioner of the International Style using the Gothic conventions with skill and charm, and by no means lacking the ambition to transcend them, even at some risk. The group of horses (Fig. 38) is a case in point.

The skill with which Apollonio uses the patterns of the Gothic tradition for a plausible portrayal of the real world becomes nowhere more apparent than in the *Tournament of S. Croce* (Fig. 25). We have seen that Schubring treated it as a *reportage* and it is indeed quite possible that the devices and the names of the horses identify a real joust.[25] But for all its witty episodic detail the basic formula only develops a traditional scheme for jousts which was employed by the illustrators of romances (Fig. 39).[26] In view of this traditionalism it is interesting to see that Apollonio is by no means indifferent to the spell of the classical world. Not only did his workshop possess views of Rome and Constantinople which betray a considerable interest in the classical landmarks of these cities,[27] he could even improvise a relief *all'antica* where the context suggested it, as in the Caesar panel (Fig. 41). But his figure style is free of such visible adaptations.[28] Here the archaeological interest only results in the adoption of a 'Greek' (that is, Byzantine) costume for men—a convention that is also known from Gozzoli and Piero della Francesca and is explained by Vespasiano da Bisticci's remark that the fashions of dress had not changed, in the East, since ancient times.[29]

For all this it is not without a certain piquancy that one of the first Florentine masters to receive a poetic tribute from the pen of a Florentine humanist should turn out to be a representative of what appears to us a rather 'backward' style. We

still like to think of the Renaissance in terms of an even 'progress' and this image places the humanists and the anti-Gothic artists together in the vanguard. In Warburg's complex analysis of the situation around 1460 the Gothic manner, to which he liked to affix the label '*alla franzese*', represents the retarding element against which the true humanism '*all'antica*' has to use all its energies. But Warburg also knew how inextricably these trends and tendencies were mixed up in the minds of the people who were subject to these tensions. He emphasized the presence in Gothic art of a genuine desire to see the ancient stories re-enacted as if they were contemporary events, and he noted the attempts in the Virgil manuscript and the corresponding cassone scenes to give Venus an authentic classical look. Warburg would thus have enjoyed the alliance between a painter who told the Virgilian story in mediaeval modes and a poet who so often employs Virgilian forms for the telling of a mediaeval story. For just as the Virgil scenes are Apollonio's *chef-d'œuvre*, Verino's lifework was the *Carliades*, an epic in imitation of the *Aeneid* celebrating Charlemagne and his paladins. The mixture of styles in both artists is strikingly similar. A poet who could write[30]

'En ille Orlandus, Francorum magnus Achilles'

could also praise Apollonio as the equal of Homer and Virgil. Ideas of propriety or fitness in applying form to content never seem to have troubled the minds of either. If Apollonio's style continued the Gothic tradition, the same was true of Gozzoli, then decorating the Medici chapel. Moreover, Facius' famous praise of van Eyck, Rogier, Gentile da Fabriano and Pisanello warns us against identifying the taste of the humanists with an art *all'antica*. If it sounds strange to us to hear Apollonio praised as 'a second Apelles' it may be well to remember that two other Florentines who had this label affixed to them in Latin epigrams were Fra Angelico and Benozzo Gozzoli.[31]

There need be no question, then, of Verino being out of step with his fellow humanists so far as his taste for the arts was concerned. We have good evidence, in fact, that he was more genuinely interested in painting than any of his literary contemporaries. Unlike Manetti and Rinuccini he made a point of dedicating his literary skill to the living artists of his time and he has perhaps received less credit than he deserves for having discerned, at an early date, that 'perhaps Leonardo da Vinci surpasses all others'.[32] But if humanists employed any conscious standard of criticism it was, of course, that of truth to nature, of which they could read in the ancient authors. This standard seemed well satisfied by Gothic realism. But on the whole their interests were predominantly literary, and the subject of illustration was notoriously more important in their eyes than what we call the formal treatment. The most telling document we have, from the hand of an early humanist, concerning the principles that should govern the choice of these subjects may not

be out of place in this context. It is Leonardo Bruni's famous letter of advice on the 'programme' to be adopted for the third Baptistry door.

> It is my opinion that the twenty stories of the new doors, which—as you have decided —should be chosen from the Old Testament, should mainly have two qualities; one that they should show splendour, the other that they should have significance. By splendour I mean that they should offer a feast to the eye through the variety of design; significant I call those which are sufficiently important to be worthy of memory . . . it will be necessary for the person who is to design them to be well informed about each story, so that he may well distribute the figures and their actions, and that he should be graceful and understand ornament. . . .[33]

If we compare Apollonio's art from these points of view, that is from those of the paragon of humanism, with the art of his more progressive colleagues he easily wins. Not only is there in his works more 'splendour' offering 'a feast to the eye' than, say, in the works of Castagno or Uccello; they may even show a greater understanding of 'significance' than those artists whose works were so often confined to traditional themes. For in the case of cassone painting the humanist demand for subjects 'worthy of memory' was met half-way by the popular demand for a subject appropriate to the auspicious occasion. The cassone, after all, was not only a gaily decorated piece of furniture; its commissioning and delivery formed part of the marriage customs of educated Florentines. It must therefore have been thought of as a carrier of happy auguries, if not of lucky charms. This private significance is particularly apparent from the paintings inside the lids (Figs. 42–3) representing the ideal figures of a beautiful youth and maiden, sometimes marked 'Paris' and 'Helena'.[34] What else could be the purpose of displaying those exemplars of beauty to the eyes of the bride alone than that of a lucky spell for fair offspring? The belief that pictures seen during pregnancy would influence the child is universal.[35] In the society of Quattrocento Florence this confidence in the 'effect' of images would merge imperceptibly with astrological and philosophical views concerning the efficacy of such action at a distance.[36] In other words, in these images of beauty 'splendour' and 'significance' would coalesce.

But even the paintings on the outside would always be chosen as appropriate to the hopes and aspirations of the family. Two of Apollonio's works of which the subject has not so far been completely elucidated may serve to illustrate this point. One is the cassone of which a fragment is in the Ashmolean Museum at Oxford.[37] It is there labelled as a group of performing acrobats (Fig. 44). The catalogue points to another piece from the same panel, now preserved in the National Gallery of Scotland,[38] which is described as *The Venetian Brides* (Fig. 45). The tradition of 'significance' for cassone paintings makes it easy to identify the true subject. It is the Rape of the Sabines, so often represented on bridal chests as an auspicious topic for the foundation of a new line. We find the performing acrobats represented

in a similar way on the cassone in the Harewood Collection[39] (Fig. 46) where they entertain the unsuspecting Sabine women. The Edinburgh panel, of course, represents the actual raid on the party.

Of even greater interest is the 'significance' patron and artist must have found in the pair of cassoni which became the starting-point for the identification of the workshop—the Oberlin panel with the invasion of Xerxes and its lost companion piece with the triumph of Greek leaders (Figs. 17–18). To look at them merely as historical illustrations is to miss their general import. History, in fact, is rather telescoped and at times yields to romance. If we can trust the inscriptions, not only Cimon and Themistocles appear among the defenders of Greece against the Persians, but also Pericles. But some amount of telescoping was necessary if Apollonio was to bring out not only the 'splendour' of Xerxes' invading armada but also the 'significance' of his downfall. For the fate of Xerxes was a famous *exemplum* of humbled pride. From material handed down by such authors as Justinus and Orosius, Boccaccio had eloquently told the story of the Persian ruler's hubris and ultimate downfall;[40] what could be more suitable to the general theme of the 'Fall of Princes' than the story of this spectacular failure? And so Boccaccio pulls out all the stops to tell of the assembly of an army of more than a million, of the crossing of the Hellespont on a pontoon bridge and the descent into Greece. For the greater the enterprise, the more shameful its wreck. First Xerxes was resisted by Leonidas' men and, wounded on his ignominious flight, had to drink with his bare hands from a river fouled by the putrid blood of his own fallen soldiers; a drink which his need made appear to him sweeter than anything he had tasted before. Then his men, trying to destroy the temple of Apollo at Delphi, were scattered; and finally he was trapped with his fleet at Salamis and defeated by Themistocles. He returned home alone, trembling in a fisherman's barge. There he received news of the fate of his army under Mardonius, the flight of his fleet and the final destruction of the remnants of the Persian army by Cimon near the river Eurymedon. Powerless and unnerved, he was murdered by his captain Artabanus. To this tremendous tale, in which everything is subordinated to the moral lesson, Boccaccio still appends a sermon 'against the blindness of mortals' in which he dwells on each of these indignities as a warning example. 'If we searched through the whole of history, we could not find anyone more famous for regal pomp, for greater riches or the obedience of more peoples . . . puffed with the pride of such unique grandeur he was despoiled by Leonidas' small band . . . and by Themistocles and Cimon deprived of all those ships with which he had covered the whole sea . . . he who was used to commanding Kings meekly begged of the bargemen to take him across, he who shortly before was at the head of such a grand army crossed the sea alone in a tiny fisherman's barge . . . what more should we say? what more ask to see of what avail are riches, power and temporal domain? . . . would it not have been

better for Xerxes to be without them? . . . why, then, do we not dispel from our eyes the fogs of ignorance . . . and, lifting the eyes and the mind heavenwards, open our ears to the words of God . . . for God disposes of many Themistocleses and Leonidases—even if we possessed more men than ever Xerxes had we would be despoiled of worldly armies, put to flight, and, struck down, would in vain beseech the inexorable ferryman not on the shores of Hellespontus, but, naked, on that of Acheron, where we would sit alone and afflicted, and weep for ever over the loss of the better life.'

There can be little doubt that Boccaccio's version provides the general setting for the Oberlin panel. We see, on the right, Xerxes on horseback, crossing the Hellespont with a fabulous army of carts and camels. In the background, to mark the Black Sea, we can discern Constantinople with some of its principal landmarks such as the column of Theodosius. The old man in the fisherman's barge, placed so prominently in the foreground, may well be Xerxes again, on his ignominious flight. Meanwhile, on the left-hand side the tragedy of the Persian army unfolds. Cimon, in front of his tent, receives a group of noble Persian prisoners. In the foreground one of the Persians appears to stab himself, perhaps on receiving a message. The only puzzling feature is the presence of Pericles among the Greeks, but to the tradition of the world chronicles Pericles was in fact known as an Athenian general who lived at the time of Sophocles[41] and since the panel sums up the triumph of Greece his presence is not altogether illogical. The companion piece, we are told, appropriately showed the triumph of Cimon and Themistocles and a third leader (Fig. 17). Maybe this was again Pericles, who did service for Leonidas; since the latter, having been killed at Thermopylae, could not be shown in this manner. The left-hand side and background was apparently intended to show the battle of Salamis.

If the Rucellai commissioned the story of the downfall of Xerxes and the triumphs of the Greeks, they probably thought of a 'significance' which even transcended that of the world's most dramatic cautionary tale. For in 1463 the story and its geographical setting would not only remind the onlooker of the passage across Styx, as it did Boccaccio, but of a menace nearer home. What could be more comforting, in the decade when Constantinople fell, than a reminder that proud Asiatic conquerors are apt to overreach themselves?[42]

Luck will have it that this moralistic conception of history painting can also be paralleled from the works of our chief witness, Ugolino Verino. His *Carliades* opens with an adaptation of the first book of the *Aeneid* which does honour to the admirer of the 'Dido Master'. The whole machinery is identical, except that it is not Aeneas' fleet which is harried by Juno's wrath, but Charlemagne's, whose victorious return from the conquest of the Holy Land is hindered by the Devil.[43] Once more the exhausted sailors land on an unknown shore and find a rich and

friendly city—Butroto in Epirus, ruled over by Justinus. In describing the walls of Justinus' residence the poet cannot omit the obligatory *ekphrasis*, and so Verino uses the opportunity of paying a little tribute to the artists of his time which has previously been overlooked. The 'emblems' on the left, he says, were painted by 'Alexander, Apelles' successor' to which in the Paris manuscript is added the marginal note, in Verino's hand, 'Alexander pictor florentinus', that is, Botticelli. The story on the right, we read, was painted by the Tuscan Pullus, viz. (as the marginal note explains) 'pictor pullus florentinus' or Pollaiuolo.

The reference (without the marginal notes) occurs already in the first draft of the poem which is known to us—the autograph in the Magliabecchiana. The colophon of this first version tells us that the 15th and last book was completed at Pisa on December 3, 1480, at two o'clock at night. Its beginnings go back into the late 1460's.[44] Somewhere between these two dates, then, must be placed this reference to Botticelli and Pollaiuolo which provides a welcome confirmation of the growing fame of the two masters at a comparatively early point in their career. It is thus not without interest to see what Ugolino imagines these artists to have painted (or designed) for the walls of Justinus' fictitious residence. Here is the text of the earliest version:[45]

On the left-hand side, Alexander, the successor of Apelles of Cos, painted Xerxes, bridling the Ocean with a bridge, and the piercing of Mount Athos, also the dried up river beds and the Persians drinking from exhausted streams; and the ferocious Athenians, after the overthrow of Pallas' city avenging the ruins of their ancestral town at sea. Plataea, streaming with abundant blood, and the wealth of the Medes vanquished, and not far away the Greek war leader [Themistocles], expelled from Athens, came to the court of his enemy.

On the right-hand side the great hero of the Pelleian race [Alexander the Great] had destroyed Darius, captured his wife and children in a triple campaign, and consigned the regal train and spoils to the flames; he was the first to menace the placidly flowing Hydaspes, and here the King risked himself from the high ramparts of the wall. Elsewhere the fierce Porus, on the back of a dark elephant, covered by a scaly serpent, rushed into battle and inflamed the unnerved Indians to war. Not far from there Euphrates cuts right through the middle of Babylon where before the gates of the palace lay the war-leader, a livid corpse, without honour, defiling the ground: he, to whose victories once the whole world had yielded. This the Tuscan Pullus had painted with wondrous skill.

Botticelli's imaginary painting, then, represented episodes from the conquests and the defeat of the Persians under Xerxes, Pollaiuolo's scenes from Alexander's campaigns. The way the two are balanced makes it clear that Verino here follows the tradition which sees in Alexander's victories the final retribution for Persia's invasion of Greece. The spirit of the whole narrative, moreover, is close to that of Boccaccio.[46] Each triumph is followed by a downfall; each moment of glory turns out to be vain and futile. If we ask ourselves how Verino can have visualized

these scenes we realize with a slight shock that he must have imagined them in terms of Apollonio's cassone style. Only in this manner was it possible to crowd these disparate episodes into two confronting paintings. The one with the conquests of Xerxes is indeed surprisingly similar to Apollonio's pair with the bridge over the Hellespontus and the battles of Plataea and Salamis. Alexander's meeting with the family of Darius also forms part of large panoramic cassone compositions in Apollonio's style (Fig. 47).[47]

Having noted the relative independence of the cassone tradition *vis-à-vis* the achievements of monumental art, it may seem doubly incongruous to see Verino mixing the names of Botticelli and Pollaiuolo with the modes and subjects of these illustrators. But is there really no link whatever between our Apollonio, 'tuscus Apelles' and Botticelli 'choi successor Apellis'? Strangely enough the documents tell us that some sort of bridge, however fragile, must in fact have existed. For in the spring of 1481, shortly after Verino had completed the first draft of the *Carliades*, Botticelli entered into a contract with the church of S. Martino for the painting of a fresco of the Annunciation, now recovered from under the whitewash.[48] The witnesses to this agreement were Marco del Buono, Apollonio's former partner, and one Francesco di Michele, woodworker, who may well have been Marco's new companion in the cassone trade. Whatever this personal acquaintance may imply, it shows Botticelli on the eve of his departure for Rome in some kind of contact with the surviving owner of the cassone workshop that specialized in classical illustrations. The connection, like Verino's choice of names, may indeed be fortuitous, and yet it may sharpen our eyes for certain aspects of Botticelli's art—his narrative style. We do not know who was responsible for the plan and programme of the frescoes in the Sistine Chapel; but it is noteworthy that, of all the artists employed there, Botticelli adopted the most episodic treatment. His story of Moses unfolds not unlike a cassone painting with a main scene in the centre and a garland of six other incidents arrayed around it. A similar disposition of the Temptations of Christ (Fig. 48) even compelled him to insert a centrepiece which has no overt connection with the main subject of the cycle, the life of Christ. Having placed Christ on the pinnacle of the temple, he fills the space in the foreground with a scene of 'splendour and significance' which is very difficult to interpret.[49] Of course there is a world of difference between this enigmatic composition, which even Raphael studied with profit,[50] and the tricks of the trade employed by Apollonio when he arranged his compositions round a meeting pair (Fig. 37). And yet if a return to 'Gothic' sympathies can be observed in Botticelli, it may be due among other things to that survival of the International Style that is represented by Apollonio's workshop.

If Verino's choice of Botticelli is thus less incongruous than it might appear at first, how can we fit in his mentioning Pollaiuolo as the master of the companion

C

piece? Can Pollaiuolo have meant just as much to the admirer of Apollonio? Curiously enough there are indications that he did not, and that Verino felt a little uneasy over the choice of this name. Only the first two drafts of the *Carliades* contain it: when he came to revise the poem, possibly in the 'nineties, he retained Botticelli's name, but changed that of 'Pullus' to 'philippus'—Filippino Lippi.[51] Verino's admiration for that artist is well known from the epigrams.[52] Moreover the Pollaiuolo brothers had gone off to Rome and their fame centred increasingly on sculpture rather than on painting. Nevertheless it seems strangely fitting that, in trying to keep his epic up to date, Verino should have selected the name of an artist in whose style Gothic and classical elements are again so intimately fused as to elude the tidy categories of evolutionist historians.

Verino's *ekphrasis* is a typical literary exercise and any attempt to look for parallels in the living art of the time may appear somewhat strained. And yet it is worth recalling that his vision of two confronting history pictures painted by the city's two leading masters did not remain a private dream. It all but came true in the Hall of the Great Council, where Leonardo and Michelangelo were to represent momentous episodes from the city's past.[53] Need it be purely an accident that the first subject to be selected, the Battle of Anghiari, had started its life on a Florentine cassone?[54]

Ugolino Verino survived the *débâcle* of this grandiose commission by many years. He lived to welcome his former pupil Leo X back in Florence late in 1515. It has been conjectured that the Pope's entourage at the time included Raphael, who had just completed his *Incendio del Borgo* with its many Virgilian reminiscences. One wonders what the aged humanist thought when he looked through his *juvenilia* and came across his epigram in praise of Apollonio, *tuscus Apelles*.

Appendix: Extracts from Ugolino Verino's works

I. From *Flametta*, Book II

De Apollonio Pictore insigni

Maeonides quondam phoebeae moenia Troiae
Cantarat grais esse cremata rogis,
Atque iterum insidias Danaum Troiaeque ruinam
Altiloqui cecinit grande Maronis opus.
Sed certo melius nobis nunc tuscus Apelles
Pergamon incensum pinxit Apollonius;
Aeneaeque fugam atque iram Iunonis iniquae
Et mira quassas pinxerta arte rates,
Neptunique minas summum dum pervolat aequor,
A rapidis mulcet dum freta versa notis;

Pinxit ut Aeneas fido comitatus Achate
Urbem Phoenissae dissimulanter adit,
Discessumque suum, miserae quoque funus Elissae
Monstrat Apolloni picta tabella manu.

II. From the *Carliades*, Book I

(a) First version, Florence, Bibl. Naz. (Magl. 7–977, ff. 8r–8v)

Regia porphireis spectabat nixa columnis,
Undique quam pario cingebat porticus ingens
Subfultus lapide: et paries embremate pictus:
A leva xerxem frenantem nerea ponte
Pinxit alexander choi successor apellis
Subfossumque athon: siccoque arentia fundo
Flumina: que exhaustas persis potantibus undas.
Thesidasque feros: subversa palladis urbe
Insunt et pelago patrias pensare ruinas:
Et largo undantes plateas sanguine: caesis
Medorum numis: nec longe expulsus athenis
Hostilem graius ductor migrabat in aulam.
A dextra magnus pellei seminis heros
Exuerat ternis castris: et coniuge capta
Cum natis darium: carrusque et regia flammis
Mandabat spolia: et placidum minabat idaspem
Primus: rex alto sese dabat aggere muri
Parte ferox alia super atri tergera barri
Squamosa tectus serpente in bella ruebat
Porus: et exanimos in proelia concitat indos:
Nec procul euphrates mediam babilona secabat
Pro foribusque aulae liventi corpore ductor
Exanguis foedabat humum: sine honore iacebat
Cui victus quondam bellanti cesserat orbis:
Haec mira pullus tyrrhenus pinxerat arte.

(b) The revised version in the dedication copy for Charles VIII

(Florence, Bibl. Riccard. 838)

Regia marmoreis spectabat nixa columnis
Undique quam pario cingebat porticus ingens
Marmore suffulta et paries embremate pictus
A leva xerxem frenantem nerea ponte
Atque athon effossum. siccoque haerentia fundo
Flumina et exhaustos persis potantibus amnes.
Palladaque iratam subversis pinxit athenis

Tuscus alexander choi successor apellis:
Cecropidasque feros pelago pensare ruinas
Pulsus ut invidia (populus sic premia reddit)
Hostilem graius ductor migravit in urbem.
A dextra magnus pellei seminis heros
Persepoli capta flammis ultricibus aulam
Persarum urebat: mox fulminis instar ad indos
Pervolat affectans ortum transcendere solis:
Parte ferox alia super atri tergore barri
Squamosa tectus serpente in bella ruebat
Porus et in pugnam extremos ductabat eoos.
Nec procul euphrates mediam babylona secabat:
Pro foribusque aulae liventi corpore princeps
Exanguis foedabat humum sine honore iacebat
Cui victus quondam bellanti cesserat orbis
Haec mira etruscus depinxerat arte philippus.

Note.—Verino's version of the Alexander story, particularly in his first draft, is rather obscure and I am greatly indebted to Dr. D. J. A. Ross for the following suggestions: 'ternis castris' may refer to Alexander's three pitched battles against Persia (Granicus, Issus and Arbela). 'Rex alto sese dabat aggere muri' alludes to his conquest of the city of the Mandri and Sudracae (cf. Justinus XII, 9). For the concluding lines Verino may have drawn on Plutarch, Alexander, LXXVII, 4 or Curtius X, 10, 9–13.

Renaissance and Golden Age

I N his *Relazione* on the periodization of the Renaissance, written for the Tenth International Congress of Historians in Rome,[1] Professor Delio Cantimori pointed to the notorious difficulties which the historian experiences when he wants to define the links between economics, politics, literature and the arts. 'It would help us to understand these connections,' he said, 'if we could again focus our investigations on individual statesmen and their activities without, of course, idolizing their patronage *à la* Roscoe—but so far we have not even got a critical edition of Lorenzo de' Medici's correspondence, and'—he said so wisely—'*in queste cose . . . si può far così facilmente della retorica.*'[2]

Perhaps the historian can best cope with this type of rhetoric if he makes it, in turn, an object of rational investigation. I should like to follow Ernst Robert Curtius rather than Konrad Burdach[3] in my approach to the formula of the Golden Age. And I propose briefly to illustrate this aspect by drawing attention to the rhetorical roots of that idolizing of Renaissance patronage mentioned by Professor Cantimori. I believe it to be the reflection of a Virgilian formula. In Virgil, the Golden Age is the age of a particular ruler. It is the divine child of the Fourth Eclogue who will bring the Empire of peace and magic prosperity, and it is Augustus who, in the Sixth Book of the *Aeneid*, is prophesied to do the same:

> Hic vir, hic est, tibi quem promitti saepius audis,
> Augustus Caesar Divi genus, aurea condet
> Saecula . . . (VI, 793–5)

> Augustus, promis'd oft, and long foretold,
> Sent to the realm that Saturn rul'd of old;
> Born to restore a better age of gold. (Dryden)

Perhaps the best example of this link which exists in historiography between the person of a ruler and the character of an age is the case mentioned by Professor Cantimori—what, for want of a better label, may be called the Medici myth, which makes the Medici in general, and Lorenzo in particular, directly responsible for a magic efflorescence of the human spirit, the Renaissance.

To do William Roscoe justice, it was not he who invented in his *Life of Lorenzo de' Medici* what a later popularizer, Selwyn Brinton, called the 'Golden Age of the Medici'. When Roscoe wrote he had, among others, the example of Voltaire who, as Professor Ferguson has shown us,[4] brought the idea of Great Ages under Great

This study appeared in the *Journal of the Warburg and Courtauld Institutes* in 1961.

Rulers into the stream of historiography. In his *Siècle de Louis XIV* Voltaire lists three ages preceding that of his hero as the only other eras worthy of attention to men of taste: those of Alexander, of Augustus, and of the Medici, 'une famille de simples citoyens' who did what the kings of Europe ought to have done, and gathered in Florence the scholars whom the Turks had driven from Greece.

But of course the link is older. Think of the beautiful inscription of 1715 in the Palazzo Medici Riccardi, which Roscoe quotes: 'Hospes—aedes cernis fama celeberrimas . . . hic litterae latinae graecaeque restauratae, mutae artes excultae, Platonica philosophia restituta . . . aedes omnis eruditionis quae hic revixit.' (Stranger, you see a house most rich in glory . . . here were Latin and Greek learning won back again, the silent arts perfected, the Platonic philosophy restored . . . the home of all knowledge that has here revived.) Or think of the early seventeenth-century fresco cycle in the Palazzo Pitti by Giovanni di San Giovanni and Furini dedicated to Lorenzo de Medici's glory (Figs. 50, 51), where he is seen providing a safe haven for the Muses fleeing from Mohammed's hordes and establishing the Golden Age. At his death, as the rhymes below explain, Peace and Astraea return sorrowful to heaven. But this cycle, too, only continued a tradition which had been established in the sixteenth century by Giorgio Vasari. It was Vasari who, in his enormous fresco cycles in the Palazzo Vecchio, which are still largely unpublished, developed the pictorial tradition of dynastic pride which linked the ruling Medici, Cosimo I, with the age of Saturn and the Horoscope of Augustus, and wove a subtle net of mythological references between the glories of his ancestors (Fig. 49) and the offspring of Saturn which he explained in his *Ragionamenti*. It was Vasari, further, who inspired the idea of the first *Accademia del Disegno* under the patronage of the ruling Medici Duke and thus even provided an institutional framework for the ruler to exercise a tutelage over the arts as was postulated in the myth. And it was of course Vasari who contributed most to the popularization of the Medici myth in his *Vite de' pittori, scultori ed architetti*, first published in 1550 and dedicated to Cosimo I in words which anticipate the inscription on the Palazzo: 'si puo dire che nel suo stato, anzi nella sua felicissima casa, siano rinate (le arti)' (it can be said that in your state, even in your own most blessed house, the arts have been reborn). Throughout his biographies Vasari is at pains to give the impression that the arts owed their rise and prosperity directly to the intervention of the Medici—the climax comes in the story, for which there is no contemporary evidence, that Lorenzo founded an art school for the study of antiques in his garden and there discovered the genius of Michelangelo, who outstrips the ancients.5 In Vasari's Life of Botticelli we also meet the tell-tale phrase: 'Ne' tempi del magnifico Lorenzo'—it opens—'che fu veramente per le persone d' ingegno un secol d' Oro'. (In the time of the Magnificent Lorenzo, truly a golden age for men of genius . . .)

It was my interest in Botticelli's life which first brought home to me how

important it was to discover the true Lorenzo under the incrustations of the rhetorical formula, for in that instance Horne had shown[6] that the painter's real patron was not the Magnifico but his cousin and rival Lorenzo di Pierfrancesco. Such facts about Lorenzo's patronage of the arts as are known, pending that edition of his correspondence which might throw fresh light on this problem as well, are conveniently listed in Wackernagel's book on the *Lebensraum* of artists in Quattrocento Florence.[7] We would need similar sober assessments of his patronage and expenditure for letters, music and pageantry and such data as we might gather about the relative costs of horses, falcons and humanists, to penetrate the cloud of incense. But I do not want to be misunderstood. It would not serve our purpose if the somewhat sycophantic tone of court historians, past or recent, provoked the modern historian into an attitude of sceptical debunking. The Medici myth was not merely the product of flattery and nostalgia, though nostalgia, as Professor Felix Gilbert has shown,[8] certainly played its part in the early sixteenth century, the time of Macchiavelli and the Orti Rucellai. It is precisely my point that the myth can be traced back to Lorenzo's own age in the lines dedicated to him by the poets and poetasters of his circle. Here is Bartolomeus Fontius:[9]

> Tempora nunc tandem per te Saturnia surgunt . . .
> Nunc surgunt artes, nunc sunt in honore poetae . . .
>
> Through you the age of Saturn now at last arises . . .
> Now rise the arts, now poets live in honour . . .

or Aurelio Lippi Brandolini:

> Aurea falcifero non debent saecula tantum,
> Nec tantum Augusto saecula pulchra suo
> Quantum nostra tibi, tibi se debere fatentur
> Aurea, Laurenti, munere facta tuo . . .[10]
>
> The golden age owes less to Saturn, and Augustus's
> glorious age less to him, than ours, made golden by
> your bounty, acknowledges to you, to you, Lorenzo . . .

When we call these tributes flattery on Virgilian lines we do not, perhaps, say very much. For may they not rather have been propaganda? Propaganda, as we know to our cost, is the art of imposing a pattern on reality, and to impose it so successfully that the victim can no longer conceive it in different terms. Such a pattern will be the more likely to exert its spell the deeper it is rooted in tradition, the more affinity it has with the typical nightmares and dreams of mankind. The Messianic Ruler who brings back the Golden Age is precisely such a perennial dream,[11] and we have seen that it did exert a spell on subsequent generations who saw the teeming life of the real Quattrocento fall into this deceptively simple configuration. When did this spell begin to work? For, unlike flattery, propaganda need not be cynical. Those who propound it may be its first victims.

Now it certainly was in the interest of the humanists and writers who surrounded Lorenzo to hold up to him this ancient image of liberality and bounty as the surest way to the people's heart. As Poliziano wrote to him from Venice: 'Questa impresa dello scrivere libri Greci, e questo favorire e docti vi dà tanto honore e gratia universale, quanto mai molti e molti anni non ebbe homo alcuno'.[12] (That enterprise of writing Greek books and the favours you bestow on the learned brings you so much fame and universal goodwill as no man has enjoyed for many many years.) Was this the golden age, or was it rather the discovery of the power of public opinion? Of a class of supporters much easier to buy and keep happy than soldiers ever were? That Lorenzo tried to live up to this image there can be no doubt. May he not even have accepted it as true? He certainly used it in his own poetry:

> Lasso a me! or nel loco alto e silvestre
> Ove dolente e trista lei si truova
> d'oro è l'età, paradiso terrestre,
> e quivi il primo secol si rinnuova . . .[13]

> Alas! now in that high and rugged place where you
> grieve and sorrow the age is golden, earthly paradise,
> and there that first age renews itself again.

One cannot help suspecting that love conventions and political aspirations were fused in his mind when he selected for his joust the motto, 'le tems revient'—the French and chivalrous version of Dante's 'il tempo si rinnuova'.

As a matter of fact Lorenzo could hardly help seeing himself in the role of a second Maecenas or Augustus. He had been cast for this role by the poets while he was still a little boy; he had inherited it from his father Piero,[14] whose patronage, at least of the arts, may have been much more substantial than his own, and, most of all, from his grandfather Cosimo of whom Ugolino Verino sang:

> Hic sacros coluit vates, his aurea nobis
> Caesaris Augusti saecla redire dedit [18]

> He cherished the sacred poets, gave us
> back the golden age of Augustus Caesar

and Naldi:

> Iam mihi, iam, Medices, te consultore redibant
> Aurea Saturni saecla benigna senis . . .[16]

> Now to me, now, Medici, under your guardianship, returns
> the benign golden age of old Saturn

With Cosimo Pater Patriae we may come a little closer to the heart of the problem. Why was he addressed in such terms? One answer might be that the claim was true, so far as such claims ever can be. There is no doubt that Cosimo, no less than

Lorenzo, or perhaps more so, was a real patron of learning and the arts. But even if we accept all the calculations of Vespasiano da Bisticci about the money Cosimo spent on buildings, did he spend more on pious foundations and on the support of learning than, say, Chancellor Rolin, his exact contemporary in the north, founder of Beaune Hospital and the University of Louvain, patron of Jan van Eyck and Rogier van der Weyden?

My feeling is that there may be an additional reason for this strange and incongruous phenomenon of an 'uomo disarmato', as Macchiavelli calls Cosimo, a mere banker and city boss, being suddenly invested by the poets and orators with all the panoply of an ancient Imperial Myth which in Dante's Monarchy, for instance, applies to the World Ruler alone.[17] Let us put ourselves into the shoes of a poet wanting to praise Cosimo. Conventionally there were two themes to enlarge upon in the eulogies of the mighty: the fame of their ancestors and their heroism in battle. The very fact that these well-worn formulae could not be used seems to me significant. It is always the illegitimate ruler who needs most metaphysical props for his power and propaganda. It may be no accident that before Cosimo the Virgilian claim is applied to the notary Rienzi by Petrarch, just as self-appointed leaders in our days have surrounded themselves with the mystique of ancient prophecies fulfilled.

I do not claim that the novelty of his situation alone explains the frequency of Virgilian references to Cosimo. The image, as we know, came naturally to a generation used to the topic of *laus saeculi* and to metaphors of a new era. But in one sense Cosimo did represent such a new era. The *uomo disarmato* without ancestors and without claim to warlike prowess, indeed even without overt claim to power, would make the poet cast about for some extraordinary formula. And was their feeling quite unjustified, in the face of such a person, that the age of iron had begun to yield to the age of gold—albeit in a slightly different sense? To quote Professor Jacob's *relazione* on that very point: 'The Europe of chivalry had gone, the armies were paid and the risks of war calculated in financial terms.'[18] No wonder that Cosimo, in Giovanni Avogadro's eulogy, is made to say: 'Si numi vincunt, hercle est fas vincere nobis'[19]—'If money can conquer, by jingo we shall'. It is a thoroughly unheroic picture. But this is precisely the aspect of the Renaissance which Professor C. Backuis so aptly characterizes as 'civism'.[20] Wars, of course, there were, but by and large in the eulogies of Cosimo's circle the pleasure of battle gives way to the romance of peace. And in this ancient dream of *aurea pax* I see one of the roots of the historiographic stereotype of an age where the arts of peace prospered under the tutelage of a beneficent genius. As Naldo Naldi makes Cosimo prophesy in a speech to the Milanese envoy:

> Hoc duce sic Iani templum claudetur et intus
> Mars fremet atque iterum vincla molesta geret.

Tunc et prisca Fides ad nos pariterque redibit,
 Quae lances iusta temperat arte pares,
Hinc Pax purpurea frontem redimita corona
 Grata per Ausonias ibit amica domos,
Turba nec in Latiis ulli tunc fiet in agris,
 Opilio tutas quisque tenebit oves.[21]

The temple of Janus will be closed,
Frenzied Mars chained,
Ancient Faith will return and dispense Justice;
Peace, with her purple wreath, will visit the
 dwellings of Italy,
And the sheep will graze safely in the fields.

It is the theme of *pax et libertas* that appears on the reverse of the famous post-humous medal of the Pater Patriae (Fig. 52).

We may no longer be able to accept these claims at their face value as Roscoe did. There was less liberty, less peace and less plenty in the Medicean age than the poets proclaimed; nor for that matter were lambs born with scarlet wool, as in the Fourth Eclogue. But could all the villas have been built in the countryside if the milder forces of influence and affluence had not gradually replaced the violence of local feuds symbolized in the mediaeval towers of San Gimignano? The Renaissance did not have to 'discover man'; and yet, there may be some truth in Vico's vision that every time the Age of Heroes ends an Age of Man may dawn at last.

The Early Medici as Patrons of Art

Aliud est laudatio, aliud historia. The historian of the Italian Renaissance does well to remember this distinction, which Leonardo Bruni put forward in his defence when a Milanese humanist had criticized his panegyric for having exaggerated the beauty and grandeur of Florence.[1] Exaggeration, *amplificatio*, was a legitimate rhetorical trope.[2] For obvious reasons patronage was a particularly suitable object for these rhetorical exercises. Even our own letters of thanks and 'Collinses' are rarely as accurate as police protocols. These changing forms of praise and flattery are in themselves an interesting subject of study;[3] but they will not be the concern of this essay. Its aim is *historia* rather than *laudatio*—not, be it said at once, in order to 'debunk' a glorious legend, but rather to see the past as we want to see it, in human and not in mythical terms.

Nowhere is this need felt more urgently than in the story of the early Medici. We seem to know them so well through countless portrayals, and yet their humanity so easily eludes us. The conventional phrases of *laudatio* which were heaped on them ever since their descendants rose to eminence among the princely families of Europe fail to hold their image; and so do the clichés of denigration. We must grope our way back every time to the primary sources, and try to see them as human beings, acting under the pressure of events, sometimes resisting the image created by their previous actions and sometimes succumbing to it. Only then, also, can we see them as patrons.

The Oxford English Dictionary defines a patron as 'one who offers his influential support to advance the interests of a person, cause, art, etc. . . . also, in tradesman's language, a regular customer'. In the image of the Medici which they themselves created and which was reinforced by nostalgia and propaganda all these meanings fuse into a glorious vision of beneficent bounty. No wonder; for patronage was indeed one of the chief instruments of Medici policy during the century when they had no legal title of authority. The calendars of their correspondence[4] show that they were always expected to 'offer their influential support to advance the interests of a person' and that they can rarely have refused to intervene on behalf of anybody who might be won over to their camp. Nobody felt too humble to ask for such intervention. When Benozzo Gozzoli's apprentice got into trouble for purloining three old bedcloths from a monastery the painter turned to Lorenzo, who made it all come right.[5] In return these people might be expected to vote for Medici

This paper was originally published in *Italian Renaissance Studies: A Tribute to the late Cecilia M. Ady*, 1960.

interests in the innumerable committees of the guild and city government. We have a letter from the son of Cennini the goldsmith humbly apologizing to Lorenzo because for once the vote in the *arte della lana* had gone against his patron's wish.[6] Some of his fellow-consuls who were Lorenzo's supporters were out of town, and though he had implored the meeting not to turn *patronum artis Laurentium* into an enemy he had failed. *Patronum artis,* of course, means the patron of the guild. For the writer thought in terms of people and communal institutions. The idea of Lorenzo offering his support to the cause of 'art' as such, which so appealed to later generations, would very probably have left him cold. Indeed, it is doubtful if he could easily have expressed it in his language. The support of studies, of learning, of the Muses was easily understood and the Medici were continually praised for their *largesse* in these causes. But the point is precisely that the Nine Sisters were not then thought of as extending their tutelage to builders, sculptors and painters.[7] The emergence of a deliberate patronage of 'art', such as Vasari celebrates, is impossible without the idea of 'art'. It is this shift of emphasis which has yet to be investigated and which may here be exemplified in the three types of patronage offered by Cosimo, Piero and Lorenzo de' Medici. The material for this interpretation is familiar. It has been collected by such pioneers as Roscoe, Gaye,[8] Reumont[9] and Eugène Muentz.[10] It was finally surveyed in an exemplary fashion by Martin Wackernagel in his book on the *ambiente* of Florentine Quattrocento art.[11] In many places this essay merely follows up and expands his references to see how far they lead towards an interpretation.

When the Medici first appear in their role as patrons their activity still fits completely into the age-old traditions of communal religious life. Towards the end of 1418 the prior and chapter of the church of San Lorenzo applied to the *signoria* for permission to pull down some houses, since they desired to enlarge the church.[12] The plan was apparently the prior's and the money was to come from the wealthier members of the parish. Eight of them were to take over the building of one chapel each, which would then, of course, have been assigned to them for their family burials and the masses to be read for their dead. It is in this connection that we hear that Giovanni Bicci de' Medici, the richest man in the quarter, undertook not only to build a chapel but also the sacristy. It was a momentous decision for the history of art, for the design of this part of the building was commissioned from Brunelleschi (Fig. 53). At the time of Giovanni's death the sacristy was already vaulted. His son Lorenzo, so it seems, then carried on the support of the scheme in honour of his own patron saint.

Cosimo, Giovanni's elder son, first appears as a patron in a similar collective enterprise. That grand communal scheme, the erection of statues to the patron saints of the Florentine guilds, had in 1419 reached a point where the wealthy guild of the bankers felt it necessary to act.[13] They applied for the niche originally

assigned to the bakers, who were short of funds, and having obtained it appointed a small committee of ex-*consuli* to commission a statue of the bankers' patron, St. Matthew the publican. One of the members of this committee of four was Cosimo de' Medici, who thus had his share in assigning the work to Ghiberti (Fig. 54). Once more the money was raised collectively and it is interesting to see that Cosimo was careful to show through the amounts he contributed that he was both aware of his superior wealth and of the need not to flaunt it. Where others contributed two florins he gave four; on another list where others gave up to sixteen he contributed twenty florins.

Accident has preserved for us the record of another pious foundation of the Medici brothers in these early years. Ghiberti mentions in his tax returns of 1427 that he has been commissioned by Cosimo and Lorenzo to make a shrine for the martyrs Hyacinthus, Nemesius and Protus.[14] It is one of the few Medici commissions not marked in any way by their emblem or coats of arms, though Vasari tells of an inscription.

Perhaps it was at the same time that Cosimo performed the duties of the local squire in his native Mugello and saw to the restoration of the Franciscan church San Francesco al Bosco (Fig. 55), a rather traditional design which is attractive precisely because of its rural simplicity.[15] But it was only after Cosimo's return from exile that his pious donations assumed larger proportions.

The most lively and convincing account of this development can be read in Vespasiano's beautiful memoir of his beloved patron.[16] Vespasiano still knew Cosimo, and though his recollection was certainly coloured by gratitude towards a 'regular customer' his account should still rank as a primary source if it is used with caution. Such caution seems particularly necessary when he describes an event which happened when he was only thirteen years old, as in the following passage which is always quoted by Cosimo's biographers:

When Cosimo had attended to the temporal affairs of his city, in which matters he was bound to burden his conscience a good deal, as do most of those who govern states and desire to advance beyond others, he realized that he had to turn his thoughts to things devout if God was to forgive him and maintain him in the possession of those temporal goods; for he knew full well that otherwise they could not last. In this connection it appeared to him that he had some money, I do not know from what source, which he had not come by quite cleanly. Desirous of lifting this weight from his shoulders, he conferred with his Holiness Pope Eugenius IV who told him . . . to spend ten thousand florins on building.

It is thus that Vespasiano introduces the story of the foundation, or rather rebuilding, of the monastery of San Marco. It would certainly be in keeping with tradition to expiate a sin in such a way. But Vespasiano's account may still be a mere reconstruction. Particularly his reference to those who 'desire to advance beyond

others' may be his addition. There was only one statesman Vespasiano was more fond of than Cosimo and that was Palla Strozzi, the earlier patron of learning whom Cosimo had ousted and exiled. No doubt Vespasiano would have liked to feel that Cosimo was troubled in his mind about this act of political revenge. Cosimo's opponents may altogether have liked to read into his pious foundations some guilt feelings for particular crimes. We cannot rule out this motive, but it was hardly the overriding one. For a pious man, such as Cosimo proved himself, the besetting sin may not have been any particular crime but rather his mode of life. His very riches cried out against him. It was not possible to be a banker without breaking the injunction against usury, whatever technical means of evasion were employed.[17] We know from the correspondence of Francesco Datini, so vividly brought to life by Iris Origo,[18] how strong were the religious and social antagonisms aroused by the banking business. The only way of escaping the stigma of usury was to seek to 'return it all to the poor', as Domenico di Cambio puts it in a letter to the merchant of Prato.[19]

There is evidence that this is precisely what Cosimo tried to do. In an unpublished letter of condolence to his son Piero he is quoted as frequently saying in jest, 'Only have patience with me, my Lord, and I shall return it all to you'.[20] It must have been a phrase he had heard all too often when his debtors came to ask for a period of grace. That he felt himself God's debtor we also know from Vespasiano, and perhaps in a surprisingly literal sense. This would explain the emphasis on the exact amounts spent on his various foundations which we find in Vespasiano and which the Medici tried to keep before the public mind. Lorenzo de' Medici, as is well known, writes in his *memorial* to his sons:[21]

'I find we have spent a large sum of money from 1434 up to 1471, as appears from an account book covering that period. It shows an incredible sum, for it amounts to 663,755 florins spent on buildings, charities and taxes, not counting other expenses, nor would I complain about this, for though many a man would like to have even part of that sum in his purse I think it gave great lustre to the state and this money seems to be well spent and I am very satisfied.'

The sum mentioned covers mostly Cosimo's lifetime. Could it be that the account book was concerned with the settling of debts to the Supreme Creditor? That it has nothing direct to do with the patronage of art is clear from the way buildings are lumped together with charities and even taxes—anything, that is, which did not benefit the owners directly.

It is difficult to be clear about figures of this kind. Vespasiano seems more precise, but he too must have taken his round figures from some *ex parte* statement. Adding up what Cosimo is said to have spent on pious foundations we arrive at 193,000 florins. The family fortune, according to one reckoning, was something over 200,000 florins,[22] and Vespasiano actually states that Cosimo regretted not having started

on this activity earlier. He also makes Cosimo chide the builders of San Lorenzo for having managed to spend less than those of the Badia. Even Cosimo's palace is represented by Vespasiano as part of his effort to spend, for all these moneys remained within the economy of the city.

These economic and moral arguments only emphasize the pressures under which Cosimo had to act. We are lucky to have a text which specifically sets out to answer Cosimo's enemies, who were not so soon appeased by pious donations. The last recipient of Cosimo's bounty, Timoteo Maffei of Verona, abbot of the Badia of Fiesole, wrote a little Latin dialogue 'Against the Detractors of Cosimo de Medici's Magnificence'.[23]

The detractor takes his stand on Aristotelian ethics: Magnificence such as Cosimo's is an excess of liberality and every excess is vicious.

The argument is easily disposed of. In his monasteries and churches Cosimo modelled his magnificence on Divine excellence. In his palace he thought of what was due to a city such as Florence, indeed he would have appeared lacking in gratitude to his native city if he had been less sumptuous. The detractor now comes out with a stock complaint, which we also know from other anti-Medicean sources.[24] The Medicean coats of arms which are displayed on all Cosimo's ecclesiastical foundations smack more of thirst for glory than of divine worship. Had not Timoteo himself frequently preached against such worldly aspirations? The charge is admitted with qualifications, but Timoteo takes recourse to the distinctions of moral theology: there are only four conditions under which love of glory becomes a mortal sin, and Cosimo is guilty of none of them. He loves to do good in secret. But let it be granted that he affixes his device to his buildings so that those born after him may remember him in their prayers and that those who see his buildings are inspired to emulation. What is wrong with such motives? Was not Caesar inflamed to great deeds by paintings of Alexander's exploits? Were not Scipio and Quintus Fabius inspired by the images of their ancestors? Why should not men who now see the churches dedicated to God, the monasteries of Christ's servants, the painted and sculpted images, not also strive to make posterity pray for them? Are we not enjoined not to hide our light under a bushel? Let his detractors at length cease!

But the opponent has another bolt *in petto* and it is meant to wound:

'What you have just pronounced at such length in Cosimo's praise will only be in the way of his fame with posterity.' According to the philosophers art means the theoretical knowledge of reasons. Magnificence, however, is (by etymological definition) merely 'the making of large things'. 'Hence posterity will count a magnificent man among the manual labourers, that is among the menial craftsmen.' Timoteo pays a compliment to his adversary for the subtlety of this argument. But he can counter it. You must look to the moral motive, for it is virtue which prompts Cosimo to build. Moreover a handy Ciceronian quotation goes to prove that

magnificence is a mental disposition. There are many rich men but they love their riches too much to spend them. Cosimo only desires riches to be able to give them away. But the moral argument does not go down too well with the detractor. Magnificence must be a strange kind of virtue since it can only be practised by the rich. Timoteo cannot admit this; it is only the exercise of magnificence which is a gift of fortune; the virtue is inherent in the soul and may be possessed by the poor. The very weakness of this concluding argument, which is followed by a conventional eulogy, brings home to us the precariousness of Cosimo's moral position in a world of Christian standards which he thoroughly shared. If even his own spiritual adviser could not do better, what could he tell himself in the solitude of his study?

But in a way the dialogue is as interesting for the arguments it omits as for those it uses. There is no mention of art or artists. On the contrary, it is Cosimo himself who is seen as the 'maker' of his buildings—with little thanks for his labours. The coats of arms, the Medici *palle* are his signature, as it were, through which he wants to be remembered by posterity (Fig. 56). There may be more in this argument than we are inclined to concede. It is hardly fanciful to feel something of Cosimo's spirit in the buildings he founded, something of his reticence and lucidity, his seriousness and his restraint. To the fifteenth century this would have been obvious. The work of art is the donor's. On Filippo Lippi's *Coronation of the Virgin* in the Uffizi, we see an angel pointing to a kneeling monk with the words *iste perfecit opus*. It used to be thought that we must here have the self-portrait of the painter, but it is now accepted that the donor must be meant. Of course the situation was slowly changing in Cosimo's own lifetime. Filippo Villani, Alberti and others were busy, as we know, propagating the 'liberal' status of painting. But the art-historian's perspective in these matters is easily distorted by his knowledge of a few selected texts which are quoted and requoted. Compared with the mass of writings produced during the early Renaissance, references to the arts are surprisingly scarce. One may search the correspondence of many a humanist without finding a single allusion to any of the artists whom he must have constantly met on the *piazza* and who loom so large in our picture of the period. I know only one humanist writer who includes the names of two artists among Cosimo's beneficiaries, Antonio Benivieni who writes in his *Encomium* that Cosimo 'bestowed both honours and countless rewards on Donatello and Desiderio, two highly renowned sculptors'.[25]

Even Vespasiano, who, after all, belonged to the same class as many artists, rarely finds occasion to refer to an architect, sculptor or painter by name. Niccolò Niccoli is mentioned by him as an expert on the arts and a great friend of Brunelleschi, Donatello, Luca della Robbia and Ghiberti. Cosimo's universality of interests is praised by Vespasiano in similar terms:

When he had dealings with painters or sculptors he knew a good deal about it and possessed in his home something from the hand of the outstanding masters. He was a

great expert on sculpture and much favoured the sculptors and all the worthy artists. He was a great friend to Donatello and to all the painters and sculptors, and since in his time the art of sculpture suffered some lack of employment, Cosimo, to prevent this happening to Donatello, commissioned him to make certain pulpits of bronze for San Lorenzo and made him make certain doors which are in the Sacristy, and gave orders to his bank to allow him a certain sum of money every week, enough for him and his four apprentices, and in this way he kept him. Since Donatello did not dress as Cosimo would have liked him to, Cosimo gave him a red cloak with a hood, and a gown under the cloak, and dressed him all afresh. One morning of a feast day he sent it all to him to make him wear it. He did, once or twice, and then he put it aside and did not want to wear it any more, for it seemed too dandified to him. Cosimo used the same liberality to anybody who possessed some *virtù*, because he loved such people. To turn to architecture: he was most experienced in it, as can be seen from many buildings he had built, because nothing was built or made without his opinion and judgement being asked; and several who had to build something went to him for his opinion.

To the art historian who looks at the Quattrocento through the eyes of Vasari this passage raises some puzzles. Why does Vespasiano mention only the ecclesiastical commissions from Donatello, and not the two large bronzes we know once stood in the Medici palace—the *David* and the *Judith*? Could it be that Cosimo himself preferred to keep them in the background? The commissioning of life-size bronze statues for a private palace could certainly invite the criticism of vainglory. It looks indeed as if it was to forestall this reaction that the *Judith* (Fig. 58) was displayed with a Latin couplet attributed to Piero, Cosimo's son, and explaining its significance as a warning against the sin of *Luxuria*:

> Regna cadunt luxu, surgunt virtutibus urbes
> Caesa vides humili colla superba manu*

> Kingdoms fall through licence; cities rise through virtue.
> See the proud neck struck by a humble hand.

More puzzling for the art historian than Vespasiano's silence about these statues is his failure to mention the architect whom we have come to know as Cosimo's right-hand man, Michelozzo, who was said to have accompanied his master into exile and to whose palace design he gave preference over that of Brunelleschi because it was less ostentatious[26] (Fig. 57). In his detailed account of Cosimo's building operations Vespasiano speaks a good deal about contractors, fraudulent ones and over-confident ones. But no name of an architect occurs. Nor is Vespasiano alone in this omission. Filarete[27] is equally silent, and so are the various humanist poets in whose panegyrics the foundations of Cosimo are listed.[28]

* The source is the same letter by *Franciscus cognomento padovanus* quoted above. It is addressed to Piero on Cosimo's death and develops the theme of Cosimo's humility: 'Quam multos non memoria nostra retinet . . . qui tumore elati aliud quam homines esse putabant exitu tandem suo nos docuisse quod fuerint. Ut enim per te didici. Regna cadunt etc.' On the margin: 'In columna sub Judith, in aula medicea'. Cf. my *Meditations on a Hobby Horse* (London, 1963), p. 170.

D

Apparently nobody questioned the fact that the credit for these buildings, even for their invention, had to go to Cosimo. But there may be an additional reason which is suggested by a study of the documents: Cosimo's intervention in these matters, his contribution to pious foundations, was a much more improvised and piecemeal affair at first than Macchiavelli's or Vasari's accounts make one suspect.

Conflicting as are the accounts of the building history of the monastery of San Marco (Fig. 62), they add up to the picture of a gradual extension and renovation of the monastery, which had once belonged to the Selvestrini and was then transferred to the Dominican Observants, whom Cosimo favoured.[29] This first of the post-exile enterprises grew under Cosimo's hands, as it were, till its growth was abruptly halted through the resistance of the families who owned ancient rights to the chapels of the church and refused to surrender them.[30] This thwarting of Cosimo's more ambitious plans is mentioned by both Filarete and Vespasiano. The inscription of 1442, therefore, may well mark the end of the renovations, though some parts may have been added later. It was in that year, by the way, that Michelozzo reported to the *catasto* that he had been and still was without any employment or income from his trade.[31] Tax declarations are notoriously pessimistic about incomes, but if Michelozzo had been known at that time to be engaged on a Medicean enterprise as famous as San Marco the official would have laughed in his face.

Cosimo certainly was not the man to rouse antagonism by forcing the owners of rights in San Marco to give up their burial places and the masses to be read there for their dead. But he may have had an additional reason for shifting the centre of his patronage elsewhere. His brother Lorenzo had died in 1440, and the need to care for the rebuilding of the main church of his parish may have been impressed on him. We have the minutes of the meeting of the chapter of San Lorenzo of 1441 in which this intervention is recorded.[32] Reading it in its context it is possible to detect a note of apology. Many members of the chapter might have preferred the original collective arrangement; but it had broken down, and nothing had been done to further the building of the church which had been pulled down in vain more than twenty years before. Cosimo, in his turn, knew that he held a strong hand, and imposed his conditions accordingly. One may hear an echo of the difficulties at San Marco in his stipulations:

'. . . provided the choir and nave of the church, as far as the original main altar, were assigned to him and his sons, together with all the structures so far erected, he would pledge himself to complete that section of the building within six years out of the fortunes that God had granted him, at his own expense and with his own coats of arms and devices; it being understood that no other coats of arms or devices or tombs should be placed in the aforesaid choir and nave, except those of Cosimo and of members of the Chapter.'

There is no more striking illustration of the difference between the legend created by pragmatic historians and the slow and complex course of real events than a fresco in the Palazzo Vecchio in which the court painter of Duke Cosimo I, Giorgio Vasari, extolled the memory of his patron's collateral ancestor (Fig. 59). We see Cosimo, with a magnificent gesture of power, pointing to the building of San Lorenzo, while in front of him kneel two submissive figures presenting the model of the finished church. They are meant to portray Brunelleschi in collaboration with Ghiberti, who is here added for good measure presumably because Vasari remembered the joint enterprise of the Florentine Cathedral. It is not only the document quoted which belies this dramatic account of a ready plan, speedily executed on Cosimo's command. Cosimo, as we have seen, was too cautious to pledge himself to build the whole church. Moreover such an offer might really have looked like an act of vainglory on the part of a private citizen. Perhaps it was to allay this opposition that Cosimo began with the restoration of the priests' dwellings, if we can trust Vespasiano's account. There would always be some who would want to gain glory by building the church, his biographer makes him say, but they would not see to the utilitarian structures.

To us, of course, as to Vasari, San Lorenzo (Fig. 60) is the creation of Brunelleschi's mind. But the documents indicate that Cosimo's piecemeal methods considerably restricted the power of the architect. Brunelleschi's anonymous biographer, as is well known, blames a carpenter-builder for having failed to carry out Brunelleschi's design;[33] but did he really leave a design or a model when he died in 1446? There is a curious document which speaks against such an assumption. It tells of jealousies and brawls among the carpenters of Florence who were or wanted to be concerned with the completion of San Lorenzo.[34] One of them, Giovanni di Domenico, complained to Cosimo's son Giovanni because the men of his competitor Antonio Manetti had beaten him up in the street. By the standards of professional conduct he may well have deserved it. He had happened to be present when Cosimo inspected and criticized Manetti's model for the cupola over the crossing. Cosimo wondered whether the choir would get enough light and whether the cupola was not 'two millions of weights too heavy'. Needless to say Domenico agreed with all Cosimo said and ultimately produced a model himself which he evidently claimed to be 'in the manner of Filippo, which is light, strong, well-lit and proportioned'. When warned to mind his own business, he produced the rather flimsy plea that he owed his livelihood to Cosimo and therefore was bound to proffer him advice. He was on his way to Cosimo when his rival's revenge overtook him.

The interpretation of the story hinges on the expression *nel modo di Filippo*. If Brunelleschi's intentions had been known, Domenico would probably have said so. All he claims for his cupola is that it follows Brunelleschi's method which was, no

doubt, the method applied on the cathedral. Like his competitor Manetti, Domenico had been working for the Opera del Duomo.

Whatever our interpretation, the document confirms Vespasiano's account of Cosimo's practical experience in architectural matters. It also shows that fifteen years after his intervention the problems of the vaulting of San Lorenzo were still undecided. It is perhaps fruitless to speculate about the reasons, but one possibility springs to mind. According to a tradition which is older than Vasari—though we do not know how old—Cosimo had originally commissioned Brunelleschi to design his new palace, but had rejected the model as being too showy.[35] We have seen how necessary it was for Cosimo to proceed with caution in any show of magnificence, but for Brunelleschi the rejection may have been a heavy blow. It must have happened early in the 'forties[36] and in consequence Brunelleschi may well have withdrawn *his* patronage from Cosimo. Was that an additional reason for starting with the priests' houses, if Vespasiano is here correctly informed?

Another utilitarian structure was also erected by Cosimo in the 'forties: the dormitory of the Novices of Santa Croce (Fig. 61).[37] Again the documents are strangely ambiguous. Gaye prints a curious injunction of 1448 forbidding the monks to tamper with the existing building:[38]

Since it is known that a large, noble and ample dormitory has been built by the commune of Florence in the friars' monastery of S. Croce with rooms and other facilities, since there are also other buildings there, and since the aforesaid friars carry out fresh works every day as they please, piercing walls and breaking doors between two rooms, making and widening windows . . . which detract from the beauty, strength and amplitude of the building.

Was this a move to preserve Cosimo's plan or to prevent his builder from carrying on? Whatever it was, it underlines the difficulties of the architectural historian, who will never know how far such arbitrary changes were or could be checked.

This study, of course, is not concerned with these problems of architectural history. It merely aims at throwing into relief the conditions under which Cosimo's architectural patronage operated. This was not a matter of simply commissioning Brunelleschi or Michelozzo to design a church here or a palace there, not even one of merely paying out large sums to contractors. Private patronage on such a scale still had to create its instrument and organization. Vasari makes Michelozzo build Careggi and other villas for Cosimo, but these were surely country houses in which improvements were made as occasion arose. The case of the city palace is different, but even here our information is sadly incomplete. What we know as the Palazzo Medici Riccardi can only have housed Cosimo for the last four or five years of his life. Where was his palace before and what did it look like?

These may be idle questions; but strangely enough we have a detailed and circumstantial description of Cosimo's palace which nowhere tallies with the building

we know. It occurs in a curious panegyrical poem by Alberto Avogadro,[39] who is not, alas, a very reliable witness. According to his execrable elegiacs the building was erected from white marble and soft bitumen

> But the façade is not of marble; what the soft bitumen
> leaves free has stones of three bright colours.
> The top is taken up by shining alabaster,
> the right-hand side by porphyry,
> the left is of the stone which our ancestors called
> serpentine in the vulgar tongue.[40]

There is so much fantasy in Avogadro's description that one might dismiss it all as mere oratorical exercise, all the more since he lived in distant Vercelli. The only trouble is that awkward words such as 'serpentine' are not usually inserted in humanist panegyrics without some pressing need. The red, white and dark green colour scheme fits in well with Florentine traditions. Had Avogadro seen Cosimo's earlier palace? Was there once a polychrome façade on the present one? Or did he dream it all up?

The question becomes more insistent when we turn to Avogadro's description of the Badia of Fiesole, Cosimo's last foundation (Fig. 63).

The documents tell us all about its progress from the first bills of 1456 to those of 1460 which indicate that the monastery was being roofed and furnished.[41] In 1462 there is an entry about a coverlet of French wool 'for Cosimo's room' which shows that a retreat was held in readiness for him in the Badia, as tradition also reports of San Marco. In this case there is no doubt that the utilitarian structures preceded the renovation of the church—and since Vespasiano was connected with the equipment of the Badia's library he may have mixed up the two foundations when he reported Cosimo's remark about San Lorenzo.

Filarete, who had met Timoteo da Verona, the prior whose defence of Cosimo's 'Magnificence' was discussed above, is eager to confirm Cosimo's practical bent:[42]

He told me that the Church has still to be restored, and as far as he gave me to understand it will be very beautiful. In brief, he told me, whenever a distinguished visitor comes to see the place he is first shown those parts which are usually kept out of sight, such as the stables, the poultry run, the laundry, the kitchen, and other workshops.

Filarete is particularly impressed by the ingenious arrangement of the fish-pond, which is surrounded by fruit trees so that the fruit falling into the water feeds the fish —one of the many instances in Filarete's *Trattato* where one wonders about his I.Q.

But if this story is to be taken with a grain of salt, what are we to say of Avogadro's description in which again Timoteo da Verona is addressed? 'You, Timoteo, were the first cause of this pile being erected; your words moved him to overturn mountains.' For in the poet's *amplificatio* the gentle hills of Fiesole turn into 'savage mountains and rocky wilderness'.

But though the prior gave Cosimo the idea it is the patron, again, who is seen as the artist, this time, of course, in a laudatory sense, but all the more explicitly:

Cosimo, you have followed the example of the skilled [*doctus*] painter who desired eternity for his name. The years of his youth he spent on learning, and his skill increased with his age. But when he grew old and felt that time was running short, he exclaimed: 'Should I not rather create an image drawn from my brain or mind which would secure a long memory to my name?' No sooner said than done. The old man created something worthy of eternal fame. You too while you were young erected youthful buildings. . . .[43]

Cosimo now 'wants speedy and skilled masters who should erect the church and the house in his manner [*more suo*]. Such a skilled master notes it all down on his papers; he marks the house, here will be the porphyry gates, let there be a wide portico here, and here the first step of marble stairway. He traces the cloisters, to be so many steps long; in the centre there will be a tree, but it must be a cypress. He wants the cloisters to be vaulted and supported by twin columns, the one to be coloured and the companion of snow-white marble. "Let there be the tailor's workshop here, and there the chapter, here the ward for the sick. Turn round; here I want a cookhouse worthy of a duke." . . .'[44]

The architectural fantasy that follows is hardly of sufficient historical value to deserve analysis in the present context. It only helps to show that geographical distance, like distance in time, furthers *amplificatio* when the theme is as inviting as 'magnificence'. But it will have been observed that the architect is *ille quidem doctus* who merely notes down Cosimo's instructions. No architect's name occurs in the many documents of the Badia; tradition ascribed the plan to Brunelleschi, who had been dead ten years when operations began. Handbooks now speak of an 'anonymous follower of Brunelleschi', but may not the style of that simple structure really be called 'in the manner of Cosimo'? Admittedly the church was brought to a rapid completion after Cosimo's death under Piero, whose name is recorded in its humanist inscription. And yet most of the building breathes the spirit of the man who was deeply concerned, to the end, that his riches should not stand in the way of his salvation, and who stipulated that he wanted to be buried in a wooden coffin.

It is particularly against the foil of his son's own commissions that this character of Cosimo's buildings becomes discernible. From the outset there seems to have been a clear division of labour between Cosimo and his two sons in matters of patronage. The royal art of architecture was Cosimo's preserve, and so, perhaps, was contact with a master of bronze founding when he was of Donatello's fame and excellence (Fig. 58). Painters stood lower in the estimates of the time and Cosimo seems to have left negotiations with painters and decorators to Piero and Giovanni.

Already in 1438, when Piero was only twenty-two years old, it was to him that Domenico Veneziano addressed his well-known letter asking for the commission

of the altar painting for San Marco.[45] Perhaps he did not dare to write to Cosimo directly, for even his approach to the young man is extremely humble: 'In my low condition, it is not for me to address your Excellency [*gentiliezza*].' But he knows that both Fra Angelico and Fra Filippo are busy and so he would like to undertake the work, having heard that Cosimo wants something magnificent. He did not get the commission, of course, for Fra Angelico did find the time to paint the first real *sacra conversazione* (Fig. 65) for the high altar of his monastery.[46] It has been suggested on good evidence that Cosimo and his brother Lorenzo disposed of the previous altar painting by giving it to the Dominicans of Cortona, who thanked them profusely.[47]

A year later Piero was addressed by Filippo Lippi and we learn that Piero had not accepted a panel he had painted.[48] It is a real tear-jerker in the best tradition of begging letters:

> I am one of the poorest monks there are in Florence, that is me, and God has left me with six nieces on my hands, all sick and useless. . . . If you could only send me from your household a little grain and wine which you might sell to me, it would be a great joy and you might debit my account for it. I get tears in my eyes when I think that if I die I can leave it to these poor children. . . .

No wonder that, despite Browning, Cosimo felt he had no time to deal with such artists.

If these two letters happen to tell us of commissions the Medici did not give, we are compensated by a third written to Piero two years later, in 1441, which gives us a first glimpse of his taste. It is written by Matteo de' Pasti, from Venice, and deals with a commission to paint the *Trionfi* of Petrarch, which were destined to become so popular in decorative art[49] (Fig. 64):

> I want to tell you that since I arrived in Venice I have learnt something which would be particularly suitable for the work you commissioned me to do, a technique of using powdered gold like any other colour; and I have already begun to paint the triumphs in this way so that they will look different from anything you have seen before. The high-lights on the foliage are all in gold, and I have embroidered the costume of the little lady in a thousand ways. Now please send me the instructions for the other triumph so that I can go ahead. . . . I have got the instructions for the Triumph of Fame but I do not know if you want the sitting woman in a simple dress or in a cloak as I would like her to be. The rest I know: there are to be four elephants pulling her chariot; but please tell me if you want only young men and ladies in her train or also famous old men.

De' Pasti clearly knew how to appeal to Piero, with his tale of powdered gold and his qualms about including old men in his picture.

We find the same preoccupation with the pleasing and the magnificent in a letter which the Medici agent Fruoxino addressed to Piero's brother Giovanni from Bruges in 1448.[50] Like the preceding document it was a text much beloved of Warburg, who frequently alluded to its content. The agent had obviously been

charged with finding sumptuous hangings for the Medici. He had looked round at the Antwerp fair but had found nothing suitable. The only set of tapestries that was very well worked was somewhat too large for the room for which it was required. Moreover, it represented the story of Samson with a great quantity of dead bodies, which was not what one would like in a room. Another set, with the story of Narcissus, would have been right in the measurements, but he would only have bought it 'if it had been of somewhat richer workmanship'.

For the same year of 1448 we can at last point to a surviving monument which testifies to the same love of splendour: the marble tabernacle over the miraculous crucifix in San Miniato al Monte (Fig. 66).[51] The documents show that there was the familiar tug-of-war over the Medici arms: in June 1447 the Guild of the Calimala reports that a 'great citizen' (*cittadino grande*) has offered to build such a tabernacle with great splendour and cost and that permission would be granted provided no other coats of arms were shown except those of the guild. A year later the great citizen had his way. Piero was granted the express permission to add his own coats of arms to those of the guild. He did not choose the offensive *palle* but rather his private *impresa*, the three feathers and the diamond ring with the device *semper*. This type of private heraldry was in itself in tune with the taste for chivalrous display, which Piero may well have acquired in his contacts with his Burgundian customers.

It was probably in the same year, or soon after, that he commissioned another tabernacle over a miraculous image, this time in SS. Annunziata (Fig. 67). Its sumptuous structure, no doubt originally gilt, carries the truly astounding inscription *Costò fior. 4 mila el marmo solo*; the marble alone cost 4,000 florins.[52] This is worthy of remark by those who still believe that this type of announcement was invented by American tycoons. If the general assumption is right, that the two tabernacles were designed for the Medici by Michelozzo, who was also Cosimo's right-hand man, it becomes even clearer how far in works of these kinds the patron rather than the artist expressed himself.

There is one more famous instance which allows us to gauge the influence of Piero's taste on a work of art he commissioned: that best-remembered of all monuments to Medicean taste, Gozzoli's frescoes in the Medici chapel. There are three letters from the artist to Piero from the year 1459.[53] Their tone is very different from the earlier letters quoted. The painter addresses Piero as *Amico mio singholarissimo*, my greatest friend. But the theme is strangely similar to the letter of De' Pasti's, who worried about including old men, and the letter of Fruoxino, who had his qualms about dead bodies:

Yesterday I had a letter from your Magnificence through Ruberto Martegli from which I understand that you think that the serafims I made are out of place. I have only made one in a corner among certain clouds; one sees nothing but the tips of his wings, and

he is so well hidden and so covered by clouds that he does not make for deformity at all but rather for beauty. . . . I have made another on the other side of the altar but also hidden in a similar way. Ruberto Martegli has seen them and said that there is no reason to make a fuss about them. Nevertheless, I'll do as you command; two little cloudlets will take them away. . . .

Once more the letters also report on the quantities of gold and ultramarine needed by the artist, which he hopes to get at a favourable price if only Piero advances him money in time.

We need only compare the famous cavalcade of the Magi (Figs. 68–70) with Gozzoli's earlier works to see how far the influence of the patron extended. One wonders what old Cosimo may have thought of this work by Fra Angelico's favourite pupil. Not that it is lacking in piety. A true appreciation of this aspect of the work has become difficult due to a number of unsupported legends that have come to overlay its original meaning in the minds of most visitors to Florence. A French guide-book of the late nineteenth century[54] spread the story that the journey of the Magi represented the arrival of the Emperor and Patriarch of Byzantium in Florence for the Council of Union in 1439 and that the youngest king (Fig. 79) was a portrait of young Lorenzo il Magnifico. Always eager to give life and substance to the shadowy events of the past, tourists and even historians have seized on this interpretation without reflecting on its improbability. At the time when the chapel was painted the Council of Union was twenty years away. It had of course ended in failure and strictly speaking both the Patriarch and the Emperor, having failed to get ratification for their submission to the Pope, were most unsuitable personages to be represented as saints. To single out one ten-year-old boy, young Lorenzo, as the only member of the family thus portrayed would hardly seem more tactful. The radiant head of this young prince charming is not a portrait. It repeats and develops the formula for young pretty heads of angels and youngsters which Gozzoli also used elsewhere in the chapel.

These generalized heads differ in fact quite markedly from the real portraits which Gozzoli introduced into the cycle where we would expect them, and where they belong—not in the centre but on the margin, among the retinue of the eastern kings where the group of the household devoutly follows the saints, as befits the donors and their friends (Fig. 71). It is easy here to identify the profile of Piero de' Medici himself right in the lead of the Cortège on his white horse. It so resembles the bust by Mino da Fiesole in the Bargello that there can be no doubt here. It is less easy to be sure whether the old man riding at his side can be Cosimo (Fig. 74) as has been suggested. His head certainly does not correspond to the Roman profile we know from the medal (Fig. 52). But this posthumous medal which was the prototype of all subsequent portraits of the Pater Patriae probably represents a deliberate approximation of Cosimo's features to the type of a Roman Emperor—

just as its reverse exploits motifs from Imperial coins. There is at least one portrait of Cosimo's that confirms the identification. It comes from a manuscript and shows a similar shrivelled but shrewd old man (Fig. 72). Moreover here we may really be entitled to ask—if this is not Cosimo, who could it be? It may be noticed that Gozzoli has cleverly contrived to leave the question of precedence open. His patron's face comes first, but the old man can also be seen as riding at the head of the procession.

Once we accept this identification one may well begin to ask who the two young men might be who ride abreast of the others. Could they be anything but Piero's sons? Is there not in fact a striking similarity between the boy on the outside and Lorenzo as we know him later (Fig. 73)? Admittedly he looks a little old for his age, but with his father ailing he was being groomed to take on respon-sibilities as soon as possible. Moreover here again the place he is allocated by the painter would fit in with this conjecture. Everybody knew that Lorenzo was soon to be the head of the family which would assemble in this chapel. It would be quite natural to give him this prominent place just a step ahead of his younger brother Giuliano, whose face is really too unformed to allow convincing comparison with the slim, elegant and tightlipped man of Bertoldo's commemorative medal (Fig. 73), but at least does not rule out such a conjecture.

What matters here is not so much a question of identification as a question of *decorum*. For the habit of looking for portraits and even for the portrayal of an actual procession in the narrative part of the fresco has tended to divert attention from both the religious and the historical significance of the chapel. In religious terms it represents a splendid *adeste fideles*: it is Holy Night and the star is visible on the ceiling (Fig. 80). The Magi have started on their journeys from three quarters of the world and are converging on Bethlehem, just as we see them on a famous page of the *Très Riches Heures du duc de Berri* (Fig. 75). We know of mystery plays in Italian cities in which the three kings also made their approach from three sides.[55] The confraternity of the Magi was traditionally favoured by the Medici and there is no reason to think that the sacred episode was ever considered a mere pretext for the portrayal of secular people and events.

Historically speaking this misreading has blurred the strong connections between Gozzoli's fresco and one of the most famous works of art of pre-Medicean Florence, Gentile da Fabriano's altarpiece for S. Trinità (Fig. 76). There is a strange irony in the fact that the decoration of the Medici chapel thus harks back to a work com-missioned by their greatest rival, Palla Strozzi. A comparison shows that Gozzoli has taken over whole groups (Fig. 81). Moreover, a closer inspection of Gentile's three kings, traditionally representing the three ages of man, reveals that many of the alleged traits of portraiture, including the headgear and crowns[56], are prefigured in the earlier work (Figs. 77, 78).

It is quite in keeping with what we know of the taste of the rich Florentines after the middle of the century that Piero should have referred Gozzoli to a masterpiece of the late international Gothic style. His generation sought contact with the aristocratic style of living they knew from their customers in Burgundy and France, and it is for this mode of life that Piero came to enlist the aid of art and artists.

We have a pen portrait of Piero in Filarete's treatise which brings out this atmosphere with particular vividness. Filarete knew that Piero was smitten with arthritis and, so he tells us, he inquired from Nicodemi, the Medicean ambassador in Milan, what such a sick man could do all day, the implication being that all the noble pastimes, such as hunting or war, are barred to him.

He tells me that Piero takes great pleasure in whiling away his time by having himself carried to his studio . . . there he would look at his books as if they were a pile of gold . . . let us not talk about his readings. One day he may simply want for his pleasure to let his eyes pass along these volumes to while away the time and give recreation to the eye. The next day, then, according to what I am told, he takes out some of the effigies and images of all the Emperors and Worthies of the past, some made of gold, some of silver, some of bronze, of precious stones or of marble and other materials, which are wonderful to behold. Their worth is such that they give the greatest enjoyment and pleasure to the eye. . . .[57]

It is not often that we can enter, at least in imagination, into the pleasures and joys of a distant past. But what Filarete says of Piero's books can still be translated into visual terms. Many of the volumes which are clearly marked as having been written and illuminated for him, his Cicero, his Plutarch, his Josephus, his Pliny and his Aristotle (Figs. 82–5), are still in the Laurenziana[58] to 'give recreation to the eye' of those who seek them out. Most of his other treasures, of course, have vanished, but we can follow Filarete for a little when he describes how:

The next day he would look at his jewels and precious stones, of which he has a marvellous quantity of great value, some engraved in various ways, some not. He takes great pleasure and delight in looking at those and in discussing their various powers and excellencies. The next day, maybe, he inspects his vases of gold and silver and other precious material and praises their noble worth and the skill of the masters who wrought them. All in all when it is a matter of acquiring worthy or strange objects he does not look at the price . . . I am told he has such a wealth and variety of things that if he wanted to look at each of them in turn it would take him a whole month and he could then begin afresh, and they would again give him pleasure since a whole month had now passed since he saw them last.[59]

There is a touch of d' Annunzio in this wallowing in gold and precious stones, which cannot be free from *amplificatio*. Yet it is hardly an accident that in this passion for gems and coins Piero had a predecessor in the north who is explicitly mentioned by Filarete, the great Duc de Berri, one of the first men of taste to turn the princely treasure into a real collection of precious objects

In our present context the famous collections of the Medici are of relevance only as rivals to their patronage of art.[60] It is too easily assumed sometimes that the two activities are one. But contemporary and past history knows of many cases in which artists complained about collectors who spent all their money on precious antiques and had nothing to spare for the living. The valuations attached to precious table-ware and stones in the inventory of the Medici collection must indeed make one pause. The scribe or notary who drew up this inventory may not have been a great expert, but he must have known the correct order of magnitude. He valued the engraved gems of the Medici collection at between 400 and 1,000 florins each, the Tazza Farnese (Fig. 86) even at 10,000 fl. Now the average painting by a master of the rank of Filippino Lippi, Botticelli or Pollaiuolo would range between 50 and 100 florins, and even a huge fresco cycle such as Ghirlandajo's *Story of St. John* in Santa Maria Novella only cost about 1,000 florins.[61]

It is particularly interesting to reflect on these figures when considering the patronage of art of the most famous of the Medici and the most enigmatic, Lorenzo il Magnifico.

Novelists and biographers have made us familiar with the typical rhythm of generations in a powerful family: the old man who made the family fortune or secured it, shrewd, reticent and devout, the son who accepts wealth as a matter of course and knows how to enjoy the fruits, a lover of cultured ease but still a man of the world; and his son in turn, burdened with the heritage of fame and responsibility, dissatisfied with mere wealth, striving restlessly for higher things, a gifted dilettante, perhaps the most interesting of the three characters but also the most elusive.

Elusive Lorenzo certainly was. It was not for nothing that Machiavelli, in his famous character sketch, described him as harbouring two persons—what we today would call a split personality. The contradictions of this fascinating mind have presented a perpetual challenge to his biographers, whether they resisted his charm or succumbed to it. The student of his patronage of art is confronted with the same perplexities. The very name of Lorenzo the Magnificent has come to stand for posterity as the embodiment of princely magnificence; indeed it has all but eclipsed the fame of his ancestors. It comes as a shock of surprise to realize how few works of art there are in existence which can be proved to have been commissioned by Lorenzo.

Historical accident may have played a part here. Lorenzo's principal schemes were apparently concentrated outside Florence and were thus more vulnerable to destruction. Vasari tells us of the splendours of the monastery of San Gallo which was razed to the ground during the siege of Florence.[62] Nothing remains of Lorenzo's country house near Arezzo, the Spedaletto, where Filippino Lippi, Ghirlandajo and Botticelli are recorded to have worked.[63] His favourite country

retreat, Poggio a Cajano, was completed and transformed by his successors, and Filippino Lippi's enigmatic fresco in the entrance porch has faded beyond recognition. Perhaps our picture of Lorenzo would have been different if all these works had been preserved; but the historian has to work with such documents as have survived, and these speak a strangely ambiguous language.

The church of the Badia, begun by Cosimo and consecrated under Piero, stood uncompleted, with its mediaeval façade. It is still in the shape in which Piero left it for an impassioned appeal by the abbot calling on Lorenzo to do his duty as a patron remained unheeded. For all its superficial praise there is a tone of exasperated disapproval in this document, which contrasts the vanity of worldly luxury with the eternal benefits Cosimo and Piero acquired by their donations.

'We easily believe and trust that you have long desired the same . . . but we have seen that the times and circumstances stood against your promise. But now when the greatest prosperity favours you . . . set to work and complete our building under a beneficent star and with the aid of our benefactor Jesus Christ.'[64]

The reference to adversities is important. Everybody knew that it was idle to compare the young Lorenzo, struggling at times to preserve his power and mere solvency, with a Cosimo who only worried about how to get rid of his surplus cash. It seems in fact that two years after Piero's death Lorenzo decided to close the Account with God which his father and grandfather had kept, for the sum he mentions only covers the period till 1471.

There must have been times when Lorenzo found his family's reputation for unlimited liberality a burden. Yet his position rested on this very fame.

'That enterprise of writing Greek books and the favours you bestow on the learned brings you so much fame and universal goodwill as no man has enjoyed for many many years',[65] wrote Angelo Poliziano from Venice in 1491. But purely in money terms Greek books were cheap and humanists satisfied with small tips. It was different with major works of art, especially with buildings and works of bronze sculpture.

After the exile of the Medici, Verrocchio's brother submitted to the Florentine authorities a list of works which the sculptor had made for the Medici family, implying that he had never been paid and claiming restitution from the confiscated fortunes.[66] The list comprises the tomb of Cosimo and Piero in San Lorenzo, two works for Careggi (probably the *Boy with the Dolphin* and the *Relief of the Resurrection*), various works for the *Giostra*, a portrait of Lucrezia Donati and, most surprising of all, the bronze *David* (Fig. 88) which Lorenzo and Giuliano had actually resold to the *signoria* in 1475 for 150 florins. Of course it may very well be that the sculptor's brother was simply trying his luck with the authorities, relying on the fact that no records for payments of this kind were likely to be shown in the Medici ledgers, but he must at least have thought his tale a plausible one.

In whatever way we interpret the document, it seems to indicate that it was not shortage of money alone that accounts for the paucity of documented commissions by Lorenzo. Fastidious men make difficult patrons, and Lorenzo had come to think of himself as an arbiter of taste and was so regarded by others.[67]

When the *operai* of S. Jacopo in Pistoia could not make up their minds whether to assign the Forteguerri tomb (Fig. 89) to Verrocchio or to Piero del Pollaiuolo, they sent the two models to Lorenzo 'since you have a full understanding of such and all other things'.[68] His arbitration was sought in the dispute over the sacristy of S. Spirito,[69] and when the commune assigned an altar panel to Ghirlandajo it was stipulated in 1483 that it should be done 'according to the standards, manner and form as will seem good to and please . . . Lorenzo'.[70]

It was to him that foreign patrons turned for advice and recommendations. He sent Filippino Lippi to Rome,[71] and probably Antonio Pollaiuolo to Milan.[72] He was proud to have recommended Giuliano da Majano to the Duke of Calabria and made it his business to look for a successor after Giuliano had died.[73]

He certainly showed an interest, unique in a layman of the day, in the great architectural achievements of his age. In 1481 he asked for the plans of the Palazzo Ducale in Urbino,[74] in 1485 he requested designs of Alberti's San Sebastiano in Mantua.[75] He was reluctant to lend the Duke of Ferrara Alberti's treatise on architecture since this was a book in which he frequently read.[76]

This interest in architecture, we have seen, he inherited from his grandfather Cosimo. But by now it has taken a more theoretical turn. There is a subtle but important difference between the terms in which Vespasiano had praised Cosimo's expertise and those of Filippo Redditi in his eulogy of Lorenzo dedicated to the younger Piero:

How greatly he excels in architecture! In both private and public buildings we all make use of his inventions and his harmonies. For he has adorned and perfected the theory of architecture with the highest reasons of geometry, so that he takes no mean place among the illustrious geometricians of our age; geometry being surely worthy of a prince since our minds and intellects are moved and affected by its power.[77]

Valori enlarges on this praise and tells of 'many' who built 'many majestic structures' according to Lorenzo's advice. In particular he singles out the Palazzo Strozzi (Fig. 87) built by Filippo Strozzi, who consulted Lorenzo about its proportions (*de modulo*).[78] It was perhaps to counter this claim that Filippo's son circulated his own version of how his father had managed to have his proud palace built under the nose of the Medici by exploiting Lorenzo's weakness, if weakness it was. Filippo Strozzi, we read,[79] was more desirous of fame than fortune, and being fond of building hoped to leave as a memorial to his name a magnificent palace. But there was one difficulty: 'He who ruled' might envy him this fame. But Filippo was a Florentine and knew how to handle those in power. Instead of concealing his pro-

ject he talked it over with one craftsman after another, always objecting to their ambitious designs that he wanted utility, not pomp. He was told 'that "he who ruled" desired the city to be adorned and exalted in every way, for just as the good and the bad depended on him so the beautiful and ugly should also be attributed to him'. In other words, Lorenzo wanted control of the building. The bait had worked. He wanted to see the plans and advised an imposing rustic façade. Filippo feigned objections. Such a show would not befit a private citizen. He had rather intended to have many shops and stalls for subletting on the ground floor to earn some extra money. He allowed himself reluctantly to be dissuaded from such a mean practice and agreed to build the very palace he had always hoped to build.

There was not much love lost between the Medici and the Strozzi and the story need not be quite fair. But there is one piece of evidence for the high opinion Lorenzo had of his own architectural knowledge which cannot be gainsaid: he submitted his own design for the façade of the Florentine Cathedral in 1491. The resulting situation cannot have been without its humorous aspects.[80] There were twenty-nine entries for the competition, bearing such names as Filippino Lippi, Verrocchio, Perugino, Botticelli and Ghirlandajo. But once more their great diplomatic tradition did not let down the Florentines. They chose a perfect gambit and asked Lorenzo himself to decide which design was the best. Lorenzo in his turn was not so easily outmanoeuvred. He praised them all, and advised that the matter be adjourned, hoping, no doubt, that the hint would be taken. It looked like a stalemate, and we know that the cathedral had to remain without a façade for another three hundred and fifty years.

Whatever may be the true explanation of this episode, Lorenzo does not emerge from it as the type of patron we discovered in Cosimo and even Piero. We have come to suspect that such moneys as he had to spend on art went into the buying of precious antique gems. Lorenzo certainly knew their value in social life; when Giovanni, the future Leo X, went to Rome as the youngest cardinal Lorenzo wrote to him: 'A man of your kind should use silk and jewellery with discretion. Rather have some exquisite antiques and beautiful books (*qualche gentilezza di cose antiche*).'[81]

Such passion could not but influence Lorenzo's attitude towards the artists of his time. Like so many collectors he looked with a certain nostalgia towards the past. He went out of his way to honour the memory of artists, he erected monuments to Giotto and to Filippo Lippi.[82] But he may have seen his patron's role not as that of a 'regular customer' but—perhaps for the first time in history—as one who offers his influential support to advance the interest not of individual artists but of what he considered the interests of art as such. It has been suggested, for instance, that he deliberately intended to revive the traditional mosaic technique which was to be applied in the Florentine Cathedral.[83] His patronage of the difficult art of cutting

precious stones is even more tangible: in 1477 Pietro di Neri Razzati was exempted from taxation on condition that he taught this lost craft to the youth of the town.[84]

This scanty evidence gains substance and meaning through the work of the one artist whom we know to have been in close touch with Lorenzo, Bertoldo di Giovanni. It was Wilhelm von Bode who first suggested that the *œuvre* of this master of small bronzes reflected what he called Lorenzo's 'artistic policy'.[85] Bertoldo lived in the Medici palace, perhaps as a kind of valet de chambre; we have a letter from him crammed with unintelligible allusions to cookery (or is it to the fear of poisoning?); he formed part of Lorenzo's retinue on a trip to the baths, and when he was ill Lorenzo wrote for the doctor.[86]

It may be hard for us to realize the novelty of Bertoldo's *œuvre*. As far as we know he did not work on traditional commissions for churches or monuments. His art is concentrated on collectors' pieces; indeed, in a certain sense it may be called the birth of art for art's sake. Among his works listed as part of the Medici collection the most startling, from an historical point of view, is the famous bronze relief of a battle which repeats and completes a Roman relief from Pisa (Fig. 90). As far as we know it has no subject, it does not illustrate a religious or moral tale. It is just 'a' battle *all'antica*, an evocation of ancient art. If Lorenzo was bent on reviving this concept of art which he had absorbed from his readings of classical authors and his contemplation of Greek and Roman works, he would indeed have little use for the masters of his time who were steeped in the traditions of the guilds and the church. His patronage had to differ from that of Cosimo or Piero, who accepted the artistic world in which they lived.

Tradition, of course, connects Bertoldo and Lorenzo with precisely such an enterprise, that school for artists which Lorenzo is said to have founded in his gardens. Alas, these famous gardens have proved as elusive as their owner. We do not know where they were or what they contained. No contemporary record mentions the school of which Vasari was to make so much.[87] What is more, the circumstantial account of Michelangelo's transfer to that school in Vasari's first edition was challenged by the aged master, who told Condivi merely of having been taken to the Medici gardens by Granacci. Bertoldo is not mentioned; instead we are told most plausibly that 'the Magnificent Lorenzo was having some marble worked and dressed in that place to ornament the most noble library that he and his ancestors had gathered together . . . now these marbles being worked . . . Michelangelo begged a piece from the masters and borrowed chisels from them.'[88] Condivi's account continues with the famous story of how Lorenzo found Michelangelo copying an antique Faun. It was too good a story for Vasari to miss, and he worked it splendidly into his second edition, making Lorenzo inspect not a building site but a school and notice the promising pupil.

Once more reality may have been less tidy, less planned and less dramatic than

the legend. But however hard it may be for the historian to grope his way through the *amplificatio* of rhetorical exaggerations there is one solid fact which proves that the seeds of a new kind and conception of art were in fact planted in Lorenzo's garden. It was Michelangelo who first challenged antiquity on her own ground; his unrealized visions of a new race of marble, his contempt for the art of painting and his rebellion against the servitude of ecclesiastical commissions reflect a new attitude, which he may well have absorbed in Lorenzo's aura. If that interpretation could be substantiated, *historia* might prove even more interesting than conventional *laudatio*.

E

Leonardo's Method for Working out Compositions

ANYONE who looks through Berenson's Corpus of Florentine drawings[1] must be struck by the novelty of Leonardo's drawing style. He works like a sculptor modelling in clay who never accepts any form as final but goes on creating, even at the risk of obscuring his original intentions. There are drawings such as one for the *St. Anne* (Fig. 94) where we no longer find our way through the welter of *pentimenti*, and may doubt if Leonardo could. In fact we know that Leonardo had to clarify his idea by using a stylus and tracing the line he finally chose through the paper to its reverse (Fig. 95).

There is no parallel for such a procedure in the work of earlier artists. Leonardo knew that the method was his own and in the passage I want to discuss he explains both its novelty and its *raison d'être*:

You who compose subject pictures, do not articulate the individual parts of those pictures with determinate outlines, or else there will happen to you what usually happens to many and different painters who want every, even the slightest trace of charcoal to remain valid; this sort of person may well earn a fortune but no praise with his art, for it frequently happens that the creature represented fails to move its limbs in accordance with the movements of the mind; and once such a painter has given a beautiful and graceful finish to the articulated limbs he will think it damaging to shift these limbs higher or lower or forward or backward. And these people do not deserve the slightest praise in their art.[2]

The polemical note suggests that Leonardo must have argued about his method with fellow artists who took a different view. Their standard, we can gather, was that of the sure, unfailing line which needed no correction and no second thoughts. It is the idea of the perfect draughtsman crystallized in Vasari's anecdote of the King of Naples asking for a token of Giotto's skill: the master drew a perfect circle, the proverbial 'O di Giotto', to prove his skill of hand.[3] It is this quality of the perfectly controlled line that we admire in such mediaeval drawings as have come down to us, for instance in Villard d'Honnecourt's *Swan* (Fig. 92).[4] Nor did this standard of artistic perfection change in the early Quattrocento. Cennini[5] implies that the young apprentice must copy the works of his chosen masters till he can write them down with the same perfect assurance; better still, we have the evidence of the drawings themselves which, despite all the variations of style and technique, show the same concern for 'tidiness' Leonardo attacks. Even Pisanello, who laid

This paper was a contribution to the Congress on Leonardo da Vinci at Tours in 1952.

up such a store of studies from nature in his sketchbooks practised this restrained and careful line; in an unfinished drawing such as his *Hawk* (Fig. 91) the heraldic formula of the patternbook can still be felt. But is it possible that artists before Leonardo never had second thoughts? Did they really believe that *ogni segno di carbone sia valido*? As long as the function of drawing in the mediaeval workshop was not clearly analysed these questions could scarcely be answered with assurance, but since the careful researches of Oertel[6] and of Degenhart[7] we have begun to see that drawing did in fact serve a different purpose in a world where the artist was so much guided by traditions and patterns. Where invention is not expected and demanded of the artist, emphasis must be on his facility in mastering the 'simile', the formula, and fumbling will therefore be frowned on.[8] This is not to say that artists of that period never introduced a correction into an existing drawing. *Negativa non sunt probanda*, as the lawyers say. But it remains remarkable how rare even small *pentimenti* are in drawings. As a rule, if one of these artists did have doubts about which pattern to adopt for a composition he preferred to begin afresh, to draw two or more alternatives side by side.[9] A late Trecento drawing in the Louvre is a good example of an artist trying to select the right composition for an Annunciation without resorting to a pentimento (Fig. 93).

Before this background of an established workshop practice and of rigid standards of propriety we must look at an early drawing by Leonardo (Fig. 96) in order to gauge the revolutionary character of his wayward approach to his calling.

The continuation of the *precetti* of which I quoted the first passage shows the terms in which Leonardo saw and meant to justify this revolutionary departure:

> Now have you never thought about how poets compose their verse? They do not trouble to trace beautiful letters nor do they mind crossing out several lines so as to make them better. So, painter, rough out the arrangement of the limbs of your figures and first attend to the movements appropriate to the mental state of the creatures that make up your picture rather than to the beauty and perfection of their parts.[10]

The appeal to the practice of the poet could not be more significant. We are familiar with Leonardo's insistence on the dignity of painting, on its status as one of the Liberal Arts and its equality with poetry, if not its superiority over it. But here we meet with a tangible and far-reaching result of this insistence. Painting, like poetry, is an activity of the mind, and to lay stress on tidiness of execution in a drawing is just as philistine and unworthy as to judge a poet's draft by the beauty of his handwriting. One feels the pride in Leonardo's argument, but one can also sense the dangers which threatened his art from that direction. Who has not met the intellectual or poet who has tried to justify his illegible handwriting by saying or implying that it does not matter *how* he writes but *what* he writes? The insistence on invention, on the mental quality of art can certainly become destructive of standards of craftsmanship. In Leonardo, as we all know, it was destructive of that

patience that alone could have kept him at his easel. But it is not on this negative aspect of Leonardo's new doctrine of the sketch that I wish to dwell. For good or ill, Leonardo here argues from an entirely new conception of art, and he knows it. What concerns the artist first and foremost is the capacity to invent, not to execute; and to become a vehicle and aid to invention the drawing has to assume an entirely different character—reminiscent not of the craftsman's pattern but of the poet's inspired and untidy draft. Only then is the artist free to follow his imagination where it leads him and to 'attend to the movements appropriate to the mental states of the figures which make up his story'. He needs the most pliable of mediums which allows him to write down quickly whatever he sees in his mind—as a variant of our passage in Leonardo's notes says:

Sketch subject pictures quickly and do not give the limbs too much finish: indicate their position, which you can then work out at your leisure.[11]

We can follow the development of this technique in Leonardo's drawings. The early sketches are still in Verrocchio's tradition, but also show a change of emphasis. One can see that what matters for Leonardo is the *moto mentale*, and that he occasionally even resorts to a plain scrawl (Fig. 94) because his attention is not on the *bellezza e bontà delle . . . membra*.

In the studies for the *Battle of Anghiari* (Fig. 100) we find the new method fully developed. In this technique the inner vision, the inspiration, is 'thrown' on to the paper as if the artist were anxious to strike the iron while it is hot. It is from such works that the new conception of the sketch takes its starting point, a conception which culminates in the eighteenth century when Lemierre wrote in his poem *La Peinture* (1770):

> Le moment du génie est celui de l'esquisse
> C'est là qu'on voit la verve et la chaleur du plan. . . .[12]

But Leonardo's *Precetti* do not end with the comparison between the artist and the poet. The final passage, and the most interesting one, suggests that to him the sketch was not only the record of an inspiration but could also become the source of further inspiration.

For you must understand that if only you have hit off such an untidy composition in accordance with the subject, it will give all the more satisfaction when it is later clothed in the perfection appropriate to all its parts. I have even seen shapes in clouds and on patchy walls which have roused me to beautiful inventions of various things, and even though such shapes totally lack finish in any single part they were yet not devoid of perfection in their gestures or other movements.[13]

Here, then, Leonardo links his technical advice on the best method of sketching with that psychological observation and advice which is also formulated in one of the most famous passages of the *Trattato*, that in which he recommends 'a new

invention for meditation . . . to rouse the mind to various inventions',[14] looking
at crumbling walls, glowing embers, speckled stones, clouds or mould, because in
these irregular shapes one can find strange inventions just as we are apt to project
words into the sound of churchbells. The passage has always fascinated psycho-
logists concerned with artistic creation.[15] It suggests that Leonardo could deliber-
ately induce in himself a state of dreamlike loosening of controls in which the
imagination began to play with blots and irregular shapes, and that these shapes in
turn helped Leonardo to enter into the kind of trance in which his inner visions
could be projected on to external objects. In the vast universe of Leonardo's mind
this invention is contiguous with his discovery of the 'indeterminate' and its power
over the mind, which made him the 'inventor' of the *sfumato* and the half-guessed
form (Fig. 99).[16] And we now come to understand that the indeterminate has to
rule the sketch for the same reason, *per destare l' ingegnio*, to stimulate the mind to
further inventions. The reversal of workshop standards is complete. The sketch
is no longer the preparation for a particular work, but is part of a process which is
constantly going on in the artist's mind; instead of fixing the flow of imagination
it keeps it in flux.

There is evidence that Leonardo did in fact use his sketches as he says one should
use crumbling walls, to help his 'invention' regardless of the subject. It has often
been observed, and recently been emphasized by more detailed observation,[17] that
the sketches for the *St. Anne* (Fig. 94) develop motifs of his *Madonna with the Cat*
(Fig. 101) and other early drawings. What is remarkable in these instances is the
way in which certain motifs which have a clear symbolic significance in the finished
version grow out of entirely different forms—the Lamb of the *St. Anne* composi-
tion which, we know, signifies the Passion of Christ[18] was formerly a cat and even
a Unicorn (Fig. 102). In searching for a new solution Leonardo projected the new
meaning into the forms he saw in his old discarded sketches. Another such instance
suggests itself: we know from Vasari that Leonardo made the famous *Neptune*
sketch for Segni while in Florence engaged on the *Battle of Anghiari*. Does it not
look as if the welter of forms in this *componimento inculto* (Fig. 103) with the figure
rising with upraised arm over the group of horses had evoked in Leonardo's search-
ing mind the image of Neptune driving his sea horses (Fig. 105)? As it was, the
group did not satisfy him; not only do we find countless *pentimenti* in the fantastic
shape of the sea horses—in his constant internal monologue he even calls the
written word to his aid and writes on top of the group: *abasso i cavalli*. One may
imagine that it was with this problem in his mind that he attended the meetings
of the committee for the placing of Michelangelo's *David*, for as he looked at this
towering figure and drew it on a sheet (Fig. 104) he again began to project the form
for which he was searching into the drawing he had made, and tentatively added
some sea horses to the version of the *David*.[19]

There is perhaps nothing more astounding in Leonardo's *œuvre* than this divorce between motif and meaning. We are all familiar with the persistence in his creation of certain images which are given different names according to the context they are made to serve. Only a conception of art so utterly personal and almost solipsistic as Leonardo's could have brought about this most significant break with the past. For ultimately it is the act of creation itself that matters to him: 'If the painter wants to see beautiful women to fall in love with, he has it in his power to bring them forth . . .'.[20] The more the sketch can stimulate the imagination the better can it fulfil its purpose. True, to Leonardo this is only one side of the question. The more personal his art becomes, the more we feel that he is a prey to the obsession of certain stereotyped visions, the more he also insists on the objectivity of his art and on the need of rational variation grounded on observation.[21] There is no contradiction here. Leonardo knew that the fantasies he discovered in the indeterminate could only be made to spring to life by lucid knowledge.

For confused things rouse the mind to new inventions; but see to it that you first know all the parts of the things you want to represent, be it those of animals, of landscapes, of rocks, plants or others.[22]

Our distinction between 'art' and 'science' would have been unintelligible to Leonardo. It could not even be made in a language in which medicine or hawking was an 'art' and painting could be termed a 'science'. But it stands to reason that within the conventions of painting as conceived by the Renaissance any increase in that imaginative freedom we call 'art' demanded an equal intensification of those studies we call 'scientific'. Once the sway of the pattern-book is broken and the painter is enjoined to visualize an infinite variety of groupings and movements, only the most intimate knowledge of the structure of organic form can enable him to clothe his *primo pensiero* with flesh and bones.

The master who would let it be known that he could keep in his mind all the forms and effects of Nature would certainly seem to me graced with much ignorance, insofar as those effects are infinite and the capacity of our memory is not such that it would suffice.[23]

And so the advice to the artist to adopt a new method of sketching leads of necessity to a more exacting standard of procedure:

You will first attempt in a drawing to give to the eye an indication of the intention and the invention which you first made in your imagination, then proceed to take away and add till you are satisfied, and then let draped or nude models be posed in the manner in which you have arranged the work; and see to it that they accord in measurement and scale to perspective so that there should be nothing in the work that is not in accord with reason and natural effects.[24]

But even this exacting work from the posed model was futile unless the painter had full knowledge of what Leonardo calls *l'intrinsica forma*.[25] To give substance

to a figure that had emerged from the artist's *immaginativa* and been adjusted *levando e ponendo*, nothing less would suffice than a knowledge of those laws of growth and proportion by which Nature herself would create it. But what if disappointment awaited even the artist who applied infinite knowledge and infinite patience to the achievement of that complete illusion of tangible reality which—whether we like it or not—seemed to Leonardo indispensable if art was to keep the promise of rivalling the Creator? All the science of painting cannot make a picture 'look real' because, with two-eyed vision we will always perceive the difference between a flat surface and a thing in the round.[26]

There was a flaw in the dream of the painter who could 'make' any creature he desired to see. But if the hubris of his ambition had led to a tragic failure, his belief in the power of art was unshaken. Perhaps it was outside the power of painting to build up a perfect little universe: it could still demonstrate its might in images of chaos and destruction (Fig. 106). The famous passage in the *Trattato* strangely called *piacere del pittore* [27] exemplifies *la deità, ch' a la scientia del pittore* by a verbal orgy of destructive fury in which the elements seem to return to their primeval mixture. There are many aspects to these fantasies of his old age but one of them belongs to our context. For may it not be that Leonardo's mind loved increasingly to dwell on these scenes of utter confusion because here he had found a realm of art where the *componimento inculto* acquired an unexampled force? In these deluge drawings Leonardo's earlier procedure seems somehow reversed. They are based on his scientific views of the laws and motions of the elements, but the spiralling chaos creates that 'confusion' on paper through which the 'imagination is stirred to new inventions'. The chaos of superimposed lines conjures up ever new visions of that cataclysm in which all human striving would come to rest.

These truly titanic tensions are of course personal to Leonardo's genius. But the concept of art which gained shape in his mind lived on and learned to resign itself to its own sphere. We can almost watch this process in the life of the artist destined to give it its canonic form, Raphael. Raphael's early Umbrian period shows him devoted to the traditional standards of tidy draughtsmanship. An early Madonna study (Fig. 114) simply treasures up, for future reference, one of the approved patterns of the sacred theme. In a later drawing (Fig. 97) we can see what happened to him under the impact of Leonardo's genius. He has learned to use the *componimento inculto* as if he had listened to Nietzsche's advice: 'You must be a chaos, to give birth to a dancing star.'

Raphael's Madonna della Sedia

A LECTURE which is to centre on one particular work of art demands a self-sufficient masterpiece. I hope and think that Raphael's *Madonna della Sedia* (Fig. 107), now in the Palazzo Pitti in Florence, fulfils this condition.[1] It is so self-explanatory that it has proved its appeal to many who have never heard the name of Raphael, let alone of the Italian Renaissance. Generations of art lovers have seen in it the embodiment of artistic perfection. Even a critic brought up in a different intellectual climate, such as André Malraux, who says that Raphael does not move him, quotes it as an instance of a masterpiece we would recognize as such if it were found in an attic without any labels attached to it.[2] I think I should warn you from the outset that I have no fresh labels to stick on the frame. I have searched for no new link between the painting and the literature or thought of the Renaissance. My theme is precisely that most elusive of problems—the self-contained classic masterpiece.

But can we still see it in isolation? Is not the popularity it once enjoyed, and our own reaction against it, a disturbing element? I may as well confess to you that, when I approached the Palazzo Pitti this autumn to study the picture in preparation for this lecture, my heart sank as I saw the coloured postcards, box lids, and souvenirs displayed on the stalls in front of the Gallery. Should I really inflict this on you? A fresh encounter with the original removed my doubts. My doubts but not my difficulties. For, after all, you have only my word for it that the painting looks different from those baneful reproductions, that the very brushwork shows a freshness and boldness which banishes all thought of the sugar-box, and that the colours, under the old varnish, have a mellowness and richness which no print and no copy can bring out. I remember in particular the warm golden brown yellow of the Christ-child's garment, as it stands out against the deep blue of the Virgin's skirt, the dark red of her sleeve and the gold-embroidered back of the chair, and, most of all, the blending into the harmony of that daring green scarf which so easily brings a cheap and discordant note into prints. There are some patches of repair and over-painting over cracks affecting St. John and the fringe on the Christ-child's face; but by and large the condition of the picture seems to be good, and the enamel-like finish of the Virgin's head, the spirited, fresco-like treatment of the drapery and the chair with its impasto highlights all appear to me to betoken the master's own handiwork. It is true that even in the Pitti Gallery it is not easy to

This was the Charlton Lecture delivered at King's College in the University of Durham, Newcastle-upon-Tyne, on November 7, 1955.

come to terms with the picture. The vast golden eighteenth-century frame produces a dazzle that all but kills the subtle gradations of tone on which Raphael relied. As soon as you screen it off with your hands the picture comes to life. Even without much detailed analysis it shows its kinship with the Raphael who painted the *Mass of Bolsena* in the Vatican (Fig. 125), with its rich, velvety tones and still unconstrained groups of women and children, conceived in a similar key of dark yellows, blues, and the subdued green of the woman's over-garment in the foreground.

We have to rely on these analogies with a work completed about 1514 for our dating of the *Madonna*, since there is no document connected with the picture. Vasari does not mention it, nor does any contemporary. Perhaps the first evidence we have of its existence is through a copy on a letter of indulgence issued by Gregory XIII, who was Pope from 1572 to 1585.[3] This might be taken to indicate that the picture was then still in Rome. But in 1589 we find it, for the first time, in the inventory of the collection of the Grand Dukes of Tuscany, where it enjoyed a place of honour in the *Tribuna*. Not much later it was engraved by Aegidius Sadeler (Fig. 109) and his careful print suggests that the picture may have been slightly larger all round. Even at that time its fame was against it. In the early seventeenth century a miniature painter obtained it on loan to make a copy, and when it was taken from the wall the picture fell, smashing a number of objects on its way. The entry about its subsequent return says laconically and stoically 'returned, but spoilt'. The cracks I mentioned probably date from this episode.

Early in the eighteenth century the picture was admired in the Palazzo Pitti by that early champion of the classical taste in England, Jonathan Richardson. But its true fame only begins with Raphael's complete ascendancy at the time of Winckelmann and Mengs and the attendant cult of beauty. A flood of engraved copies by the most famous masters of that craft testifies to the growing popularity of the work. The British Museum possesses a whole volume of such copies, numbering more than fifty, from elaborate facsimiles to a woodcut in the *Penny Magazine* of 1833 (Fig. 126). In popular appeal it even outrivalled the *Sistine Madonna* and to those who did not share the Pre-Raphaelite qualms about mature classical form, it became the embodiment of an Italian Madonna.

At the same time the self-sufficient isolation of the picture began to present a problem to the admirers who made their pilgrimage to Italy. Travellers then, as now, found mere looking strenuous and somewhat disconcerting. The mind soon threatens to become a blank unless it is given something to play with—a story, an anecdote, a bit of gossip or background information. Guides and *ciceroni* then, as now, knew of this human frailty to which we art historians owe so much. I suppose the stories which began to be told about the *Madonna della Sedia* to create a link with the familiar world of man must be their collective work, though we find their

first reflection in a German book for children. This book by one Ernst von Houwald, published in 1820, at the height of the Romantic era, contains the first version of a legend with which the guides of Florence still regale the visitors.[4] As I heard it in Florence, it tells of a hermit who fled from a pack of wolves into the branches of an oak tree and was saved by the plucky daughter of a vintner. The hermit prophesied that both the girl and the oak tree would be immortalized for this deed. Many years later the oak tree was felled and its timber turned into wine barrels for the vintner. The daughter married and had two children, when, lo and behold, Raphael came along and saw the beautiful girl with her angelic babies. He reached for his sketching material but found he had left it at home. So, quickly, he took a piece of clay and immortalized the group on the bottom of one of the barrels which stood around.

The explanation of the tondo-form as the bottom of a wine barrel admirably filled the void which Vasari had left when he failed to relate some anecdote about the picture. It quickly gained currency and was even illustrated by a German painter in Italy, August Hopfgarten (Fig. 108).[5] His re-creation of the episode is now forgotten, but you need only visit the Pitti to hear a good many variations on the motif told in any number of languages to forlorn and tired crocodiles of bewildered tourists. One guide I heard tried to revive the flagging interest of his charge by that never-failing device of asserting that the *Madonna* was really the portrait of Raphael's mistress, the notorious baker's daughter. Another, perhaps more prudish and less concerned with historical possibilities, made her into a portrait of Raphael's wife—though there was no such person. But I liked best the English-speaking guide who said in my presence: 'Raphael had no money to buy anything, so they gave him a barrel to paint on'—I may have looked up at that moment and my expression may not have been sufficiently credulous, for the guide continued, 'we have the document here in Florence'. I am afraid I lacked the courage to inquire further. It would have been unkind. The starving genius who has no money for canvas and begs for old barrels which posterity frames in gold is an image to be hugged and taken home like some story from the films, and it may have served to keep alive a faint memory of the picture, which would otherwise have joined the others in limbo.

But whatever the value or otherwise of all the anecdotes and associations which have come to cluster round the *Madonna della Sedia*, a work of art carries with it the barnacles of its voyage through the centuries. It is a frightening thought, and yet, I believe, true, that anything we say or write about a painting may change it in some subtle way. It reorganizes our perceptions, and no one can unscramble them or wipe away the accents which description and interpretation superimpose upon the picture. The anecdote represented in Hopfgarten's picture turns the devotional image into a *genre* piece, the mature composition of a great master into a snapshot-

like improvisation. It is this way of looking at it which endears the picture to the many who are fond of snapshots, but it has also served to alienate those others who have learned to look askance at all anecdotal elements in art. Nor is the critic and historian quite immune to the suggestive power of past interpretations. Even as sensitive and independent a writer as Mr. Paul Oppé must have succumbed to its spell when, in his beautiful book on Raphael, he described our painting as 'a swift and frankly realistic portrait of a mother with her child, palpitating and breathing with the hot life of the Roman sun'.[6] For is this painting realistic? I think it is mainly one element which has led to the feeling that Raphael has here portrayed a woman of the people rather than the Queen of Heaven: the green patterned scarf round her shoulders is indeed unlike the hieratic blue cloak of the Virgin. Whether it is really a peasant scarf, as is often asserted, seems to me a different matter. The chair, at any rate, the *sedia* from which the picture takes its present name, with its elaborate turnery and its backrest of embroidered velvet and golden fringes, would hardly have conveyed the atmosphere of a humble dwelling to Raphael's contemporaries; nor would the serene face of the Virgin have looked to them like that of a working woman with two children on her hands. Raphael was no Caravaggio and the Roman model which inspired his Madonnas is a figment of the Romantic imagination.

There may be some need to remove that misunderstanding, for it threatens the integrity of the work in more than one sense of the term. If we were really meant to relate it to an image of everyday life, we might feel that this relationship is false and prettified. It is this feeling which presents the greatest obstacle in our day to the understanding of Raphael's achievement.

It so happens that the only utterance on art attributed to Raphael in the famous letter to Baldassare Castiglione protests against this very misconception.[7] It answers the question where he had found such a beautiful model as is represented in the *Galatea* with a reference to a certain idea he has in his mind. The letter became the cornerstone of what is called idealizing academic art theory, but it is also possible to look on it as a sober description of the actual procedure of which Raphael's drawings preserve such a precious record.

Raphael was brought up in the tradition of Umbrian painting, which composed its beautiful and serene altar paintings largely of types. We all know the typical Perugino Virgin or Saint, the regular features and the upturned glance repeated with such self-assurance in countless altar-pieces of his school (Fig. 110). Strangely enough this exploitation of a successful convention did not mean an abandonment of nature study. Once in a while, in Perugino's workshop an apprentice posed as a model to clarify an attitude or the position of hands (Fig. 111). Raphael absorbed this dual tradition. His early drawings show the Perugino ideal brought to fresh life by a genius, but still a type (Fig. 112)—side by side with drawings from posing

apprentices (Fig. 113). Nobody would class his graceful early study for a Virgin and Child at Oxford among his life-studies (Fig. 114).

Around the age of twenty-two Raphael left the pleasant backwater of Umbria to try his powers in the forcing house of Florence, where Leonardo and Michelangelo were competing for supremacy. We know the sensation which Leonardo's cartoon for the *St. Anne* (Fig. 116) had caused there and how the interaction of the figures had been admired. 'The figures are life-size', writes a contemporary, 'but they fill only a small cartoon because all are seated or bent and each one is placed before the other'.[8] Leonardo himself had not arrived at this grouping without ceaseless toil, which his drawings record. But there is perhaps nothing more dramatic in the history of art than to watch the impact of these standards on the drawings of the young master from Urbino. Raphael's Florentine sketch-books bear witness to his incredible ability to absorb and assimilate the lesson he had learned.[9] In countless studies for groups of the Virgin and Child he can be seen arranging his elements in ever fresh combinations to rival the miracles of composition achieved by Leonardo and Michelangelo. It is revealing to see the traces of his pen circling on paper and searching for forms to develop, how he starts with simple ovals which become a head (Fig. 115) or how he shifts these elements to try out various formal and psychological relations between Virgin and Child (Fig. 97). These records of the creative process confirm the claim that the figures rise out of Raphael's mind— they are ideas come to life, and once he has clarified them as ideas they achieve that tender lucidity which looks so effortless.

It is out of these experiments in Leonardesque balance and grouping that the three most famous Florentine Madonnas with St. John are developed—the *Belle Jardinière* (Fig. 117), the *Madonna del Cardellino* (Fig. 118) and the *Virgin in the Meadow* (Fig. 119). They can be seen as rival solutions, each taking up and combining possibilities adumbrated in the sketchbooks.

We have many fewer drawings for the Madonnas of the Roman period, but the great fresco cycles and the studies connected with them tell us how Raphael's power as a composer grows with these fresh tasks. If in the Florentine period the problem he sets himself is mainly that of composition in the sense of a lucid arrangement on the plane, the large perspective stages of the Roman frescoes invited him to pay more attention to the third dimension, to arrange his elements in depth and to create those circling and spiralling groups which together make up the symphonies of the 'Stanze'.[10]

To combine this new-found freedom of movement with the strict discipline imposed by the tondo must have been a challenge such as to please the artist's heart. There is one precious sheet in Lille which shows us a stage at least of this genesis (Fig. 120). The tondo in the centre shows a study for what became the *Madonna Alba* (Fig. 121), now in Washington. The complex movement of the Virgin bending

down to St. John still recalls Leonardo's *St. Anne*. If proof were needed that these motifs were not picked up by Raphael in daily life we could find it on the reverse of the sheet (Fig. 122); for here we have a study from a model, but a model posed according to Perugino's practice, to clarify the turning movement of the central figure which becomes stilled and stable in the final painting of the *Madonna Alba*.

It is on the margin of the Lille sheet that we find the first germ of the *Madonna della Sedia*—a compact group almost filling the frame, which is still envisaged as rectangular. Even this has been claimed by a recent critic to be a sketch from life,[11] but I believe the true source of this idea is much stranger. Once more, I think, Raphael responded to the challenge of a problem he had found in tradition. There is a tondo in Florence, attributed to Leonardo's sculptor friend Gianfrancesco Rustici, which combines the Leonardesque motif of the Virgin with inspirations from Michelangelo's marble tondos (Fig. 123). Now all the three sketches on the sheet in Lille can be interpreted as variations on Rustici's themes—the central figure is the most obvious one, but in a way the upper group comes even closer, if you imagine it inverted. And once more, as in Florence, Raphael creates three rival compositions as if to test the potentialities of the idea; after the Alba Madonna, the *Madonna della Tenda* (Fig. 124) in Munich, which still comes close to the finished group at the top of the Lille sheet but imposes on the Child a Peruginesque upward glance which, to our taste, looks somewhat contrived. At some moment in this process of balancing and rearranging there must have come the inspiration to Raphael which gave us the *Madonna della Sedia*. The main innovation, compared with Rustici and the *Madonna della Tenda*, again concerns the direction of the glance. In only one other case do a Virgin and Child by Raphael look straight at us, in the solemn *Sistine Madonna*. In the earlier Madonnas the formal relationship between mother and child is usually reinforced by a psychological closing of the group, or at least by an inward look which contains the figures in their world. To combine the intimacy of a *genre* group with the hieratic tradition of a direct contact with the beholder was indeed a daring stroke. Perhaps it only became possible because the figures are now so firmly interlocked and anchored in the frame that this additional relationship with the devout beholder could not threaten its unity. There are no other drawings by Raphael for our Madonna that would disclose the stages of this invention, but the picture itself preserves at least one trace of the working process which indicates that the adjustment went on to the very end. There is a *pentimento* at the delicate and all-important point of contact between the Virgin's head and that of the Christ-child which shows us that the exact degree at which the Virgin's head should be turned towards us was a matter of great importance to the artist. For, as so often in Raphael's works of these years, the turning movement is the heart of his solution; the group presents itself so naturally to our view that we hardly notice how little the figures really face us. And once more it is the balance

within the picture which makes us forget this multiplicity of directions. An Italian critic has pointed out that when we cover up the figure of the little St. John we become suddenly much more aware of the raised knee of the Virgin and with it of the difficulty of her posture.[12] We might even begin to believe Crowe and Cavalcaselle, who objected to that attitude because any mother, holding her child, would support it on her raised knee.[13] But it needs the critic's artifice to make us aware of the artist's. For all the thought and work that must have gone into the construction of such a complex configuration disappears from consciousness when we see the finished picture. We are not aware of confronting a *tour de force* in composition; what we admire is an image of serene and relaxed simplicity.

I know no better description of this miraculous emergence of classic form than two stanzas from a poem by Friedrich Schiller, who, perhaps, gave more thought to these mysteries than any other creative artist. They come in his philosophic poem on *Ideal and Life*, and though their beauty is naturally much tarnished in translation I should like to quote them for the thought they express:

> When, to wake a soul in inert matter,
> When, to be a living form's begetter
> Genius burns, on glorious deeds intent,
> Then with every nerve and muscle straining
> Without respite and without complaining
> Let his thought subdue the element.
> Only zeal that shrinks from no endeavour
> Finds the well of truth beneath the rock;
> Only heavy hammerblows will ever
> Shape the hard and brittle marble block.
>
> But as soon as Beauty's realm is gained
> Heaviness which over matter reigned
> Sinks to dust and disappears from sight.
> Not the fruit of toiling and devising,
> Light and lithe, as though from nothing rising
> Stands the image to the eye's delight.
> In triumphant victory have vanished
> All the storms with which the work began.
> The perfection of its form has banished
> All the insufficiencies of man.[14]

One almost envies Schiller the metaphysical religion of beauty on which he could build his description of the artistic process. His poem is based on a Platonic scheme of things, with the realm of ideas or perfect forms in heaven and embodied in the work of art. It is not always realized that nearly everything we say or try to say about these mysteries is couched in a vocabulary which stems from classical aesthetics and carries with it all the metaphysical implications of Greek thought.

For what can we say to describe this feeling of a perfect solution that we have in front of such a masterpiece? I have called it self-sufficient, self-contained, classical, and if you read more about these things you will find books new and old ringing the changes on various synonyms of organic unity and integration.[15] I remember how, when I read the proofs of my *Story of Art*, I discovered to my mortification that I had said of nearly every work of art I particularly admired that it formed a 'harmonious whole'. I tried to ration the phrase in my text, but it has never ceased to haunt me. And this feeling of perplexity may form my excuse for an historical digression into aesthetics to track down the original implications of that term and what it stands for.

For this is not one of those fashionable catchwords which have crept into the jargon of criticism of late. You find it, for instance, in the eighteenth-century English translation of de Piles's *Principles of Painting*. 'It is not enough', says the famous French critic, 'that each part [of a painting] has its particular arrangement and propriety; they must all agree together and make but one harmonious whole'.[16] It is not difficult to see where de Piles has picked up this demand. He has got it from what was, at his time, the most famous book on art, Aristotle's *Poetics*. In Aristotle we not only read that art is imitation, mimesis, but also that it must be an imitation of one thing entire,

the parts of it being so connected that if any of them be either transposed or taken away, the whole will be destroyed or changed; for if the presence or absence of something makes no difference it is not a part of the whole.[17]

It was Aristotle, moreover, who linked this idea of the whole with the idea of visual beauty such as belongs to an organism:

In everything that is beautiful, whether it be a living creature or any organism composed of parts, these parts must not only be arranged in a certain order but must also have a certain size.[18]

A very small creature could not be beautiful because we could not perceive the parts as articulated elements of the order, nor would a very large one since, as Aristotle says, 'in a creature a thousand miles long we could not take in the whole'. Now for Aristotle, the great biologist, the idea of the organic whole is central to his system of thought. It serves him precisely to bridge that gulf which existed for Plato between the world of ideas, perfect, changeless and simple, and the world of matter, shifting, illusory and almost unreal. For in the organism Aristotle thought to have discovered, the idea is not just reflected, it is active from inside. There is not one idea of the perfect oak in heaven of which all individual oaks are but imperfect copies, as Plato thought. The idea or entelechy of oakishness is active in every acorn, it is potentially present in the seed and the process of growth is its unfolding towards its end, purpose, or 'final cause'. It is thanks to this inherent

forming principle that the organism is an individual, something that cannot be divided or broken up.

It is not my purpose here, of course, to expound, let alone to criticize 'il maestro di color chi sanno'. I only want to stress that we take such ideas out of their context at our own peril. There is no harm in using such terms as 'organic unity' as long as we remain aware that we no longer say very much with such metaphors. The very opposition between piecemeal, rigid mechanisms and the self-adjustment of organic life is being challenged by the miracles of engineering.[19] And as to the concept of the whole that is more than a mere sum of its part, its very triumph has rendered it somewhat trivial and useless. An influential school of psychology set out to investigate this riddle of the *Gestalt* and to make war on what it called 'atomistic philosophy'. In a way their victory has been too complete. We would be hard put to it if we had to mention any experience that is not a whole.[20] Every configuration changes as such if you add or remove a part, and so I could not escape the charge of irrelevancy if I were solemnly to attribute to the *Madonna della Sedia* what happens to be true of every wallpaper pattern: that it forms one whole.[21]

It is this fact which has made me increasingly sceptical about the value of what is called 'formal analysis' in art history. Not that I doubt its usefulness as a pedagogic device. It may certainly help to point to symmetries and correspondences within a picture and thus to draw attention to its formal organization as such. It helps even more to take a photograph of a work such as the *Madonna della Sedia* and to explore its organization by marking off parts with a piece of paper, as we did before, or by imposing an imaginary wheel on its centre and admiring the sections which successively emerge between its spokes. But these are methods of increasing our awareness, of focusing attention on parts otherwise overlooked. A sensitive critic may use verbal pointers with a purpose similar to his use of a gesture or an illuminating metaphor. But he will never overrate the importance of such aids nor underrate their dangers. The wisest of the critics who wrote about our picture remained aware of these. Jakob Burckhardt discussed it thus in his lecture on 'Format and Picture':

> To talk of the *Madonna della Sedia* in this connection is supererogatory. It so clearly embodies what may be called the whole philosophy of the roundel as such, that nobody who comes to it with a fresh eye will fail to appreciate what this most difficult of all formats, and indeed what formats altogether, mean for the art of painting.

It is true that Burckhardt did not quite resist the temptation to attempt the supererogatory, but with what restraint and modesty!

> Let the eye travel from the centre, the child's elbow, and follow the light as it spreads through the picture, the charm in the relation between draped and undraped parts, the unrestrained flow of lines, the right effect of the one vertical, the carved post of the chair. It is true that we may find a reference to these things somewhat irksome and pedantic

besides the wonderful soul of the painting; but this soul unites with those apparently superficial excellences into one indissoluble whole.[22]

Like a homing pigeon the critic's thought always comes back to that starting-point, the 'indissoluble whole'. But is it not better, for that very reason, to keep the excursion into description short? Burckhardt knows that the fresh eye sees what he finds essential. Other critics feel tempted to tell us what we see. One example, perhaps not quite fairly chosen, from a German dissertation on the history of the tondo, must suffice:

The curve that starts from the left at the top, swings at the first sweep down into the lower half of the picture, continues across the picture plane, returns to the upper half and finally down again to reach the periphery down on the opposite side. Further curves intertwine with this main curve and each of them responds to the other. Like a stake on the beach, washed by the waves on the fringe of this flood, the stabilising vertical of the chairpost does not impress one as an alien body, despite its special function and material, for it is joyfully received into the fluid element, it is rhythmically so articulated that it is everywhere made part of the entire configuration. All the rest is an inexhaustibly rich play of curves without a beginning and without an end; there is no fold and no dell in the drapery that would not receive an inevitable and necessary function from its role in the service of the total form.[23]

The author brings home, from his long exploration, the observation that the turnery of the chairpost fits in well with the rounded lines of the rest and so contributes to the 'whole' or 'total form'. Another critic, Theodor Hetzer, asks us to admire Raphael's artistic wisdom in slightly flattening the top-knob of that post and in reserving the circular shape, intoned by the tondo, for the left eye of the Christ-child, after which he returns to the obligatory theme of 'organic unity'.[24] But even if that observation were a little less far-fetched, would it not inevitably threaten that very unity it wants to extol? For as soon as you single out a certain relationship of forms you upset precisely that balance between all the relationships of which you want to speak.

But should this inconvenience deter us from a scientific approach? After all, it is the claim of 'formal analysis', as the very term implies, that it can analyse out and reveal the very structure or principle of formal organization to which the work owes its being. I am afraid this very claim still derives its meaning from the same context to which we owe the emphasis on the 'whole'. For according to this Aristotelian tradition, which remained so potent in Western thought, there is some essential principle inside the organism which determines its being and this principle is its 'form', which is also its 'soul' and 'essence'.[25] The idea of the underlying *Gestalt*, the structure of the work of art which determines all its parts, provides no explanation for that mystery of unity we are after. On the contrary, it frequently tricks us into confusing explanation with mere descriptive devices. We stand in front of our

F

lantern slides and talk of diagonals and triangles, of spiralling movements filling the frame. We know all the while that the diagonals are not diagonals, and the triangles not triangles, and we also know that there must be countless pictures organized on such simple principles which are no masterpieces. But do we always make sure that we are not misunderstood?

I hope you will forgive me if I elucidate these qualms of mine by an example which may appear to bring a jarring note into a lecture devoted to a masterpiece of harmony, but which will help me to make my point more quickly. I want to introduce you to a work which is really composed in a spiral and fitted into a tondo—an ingenious poster by Mr. Henrion (Fig. 127),[26] which may have amused you on the hoardings, advertising a brand of dry-shaver. Unlike the Raphael I think it can be analysed, and this analysis helps to bring out the brilliance of Mr. Henrion's design. The poster wants to drive home the 'world-famous rotary action' and it is this rotation which becomes visible in the picture, which whizzes round and round within the confines of the shaving mirror and conveys such an impression of immediate whirlwind efficiency that we even forget to ask whether both arms of the mannikin grow from one shoulder. It is part of that ingenious joke that the distortion of the face appears justified, or at any rate rationalized, by the introduction of the distorting mirror. I have checked the impression in my own shaving mirror and can vouch for its truth.

You see that the poster is a whole—though not necessarily a harmonious whole—not because it is built on a simple geometric scaffolding but because it solves its own problem in a way which could hardly be surpassed. But this problem, let me repeat, is not one of formal organization. Given the modern poster style's tolerance of distortions, it is not very hard to fit a recognizable figure into a given field. A comparison between our poster and Raphael would therefore be quite senseless, and this is precisely my point here. Clearly when we discuss such configurations in classic art we imply that they are achieved within the convention of classic representational styles; that is, without doing violence to the rendering of a beautiful body. Would it not help us sometimes if we spelt out this implication? For if we did we would draw attention to the fact that we have here two mutually limiting demands—that of lifelikeness and that of arrangement. It would be easy to increase either at the cost of the other, but what Raphael does is to find an optimal solution which does justice to both postulates.

Both approaches I have introduced so far—that of the anecdote which sees in the picture the record of a casual encounter with life, and that of formal analysis which sees the secret of its unity and harmony in an interplay of curves—by-pass this achievement. De Piles and the classical tradition of aesthetics would not have done so. I venture to think that in this respect academic art theory was sometimes superior to its more recent successors. Every period and every critic, of course,

has certain paramount demands and is ready, for their sake, to sacrifice or sub-ordinate others. But, unless I misread the signs of the times, we are in danger of cultivating or encouraging a kind of critical monism which may impoverish our awareness of the plenitude of great art. It is the danger of all 'isms' that they go all out for one postulate, and it is the danger of much writing on art, that by singling out one aspect it makes people forget the others.[27] I think that that may be the reason why the concept of the whole has become so elusive.

For if you return to Aristotle you will see that he took it for granted that the perfect work of art, in his case the perfect tragedy, was one which did justice to a variety of such critical demands. He enumerates six of them, 'fable, manners, diction, sentiments, decoration and music', and he makes it clear that the essence of that organic whole which he is concerned with is defined by these constituent parts.[28] Aristotle, the founder of formal logic, set great store by such definitions. To him they grasped the very essence of that formative principle which manifested itself in the species. And so the perfect tragedy, like the perfect oak tree, was some-thing which grew and unfolded. In one short but momentous paragraph of the *Poetics* Aristotle thus adumbrated what became the most influential theory of art history:

Tragedy gradually evolved as men developed each element that came to light and after going through many changes, it stopped when it had found its own natural form.[29]

It is this fully developed tragedy, the one which does justice to all the postulates of the definition, which is the classic one—the model that manifests the idea or entelechy and purpose of the *genre*. It would be interesting to trace the stages by which this classic conception of art became the academic doctrine of later days. I believe we can recognize it by that hall-mark of enumerated constituent parts. You find them applied to rhetoric by Cicero, who popularized the five constituents of oratory—*inventio, collocatio, elocutio, actio, memoria*.[30] Vitruvius gives us five attri-butes of the good building—order, arrangement, proportion, symmetry, and fitness —which together assure that organic unity which he illustrates by the example of the perfect human body, itself the mirror of the greatest and most perfect whole, the universe.[31]

I am not here concerned with those traditions which, following Vitruvius, were led to seek the principle of 'unity' in Pythagorean speculations on commensurate numerical ratios. Their importance for Renaissance aesthetics has been fully inves-tigated by Professor Wittkower.[32] I should rather like to draw attention to the continued awareness of the need to satisfy more than one such demand which Renaissance writers owed to Vitruvius and to the teachers of rhetoric even before the *Poetics* again became popular. Vasari has often been blamed for a mechanical idea of progress in the skill of the 'imitation of nature', but in his famous preface to

the Third Part of his *Lives* he refutes this conception and lists again five categories which determine the perfect work of art: *regola, ordine, misura, disegno*, and *maniera*. He was no theoretician and the list is rather carelessly adapted from architectural contexts. Later academic critics, however, arrived at tidier subdivisions through a conflation with Cicero's. Following Junius,[33] Fréart de Chambray analysed the idea of perfection under the five headings of invention, design, expression, colour, and composition.[34] De Piles, whom we have encountered, follows him in this and in a notorious aberration even decided to give each artist marks in four of them, Raphael getting top marks, 18 out of 20, for expression and design, but only 12 for colour.[35]

It is easy to see how this tradition became discredited, and yet it was consistent within itself. The eighteenth-century gentleman on the Grand Tour who had read his Aristotle and his de Piles knew what he meant when he described the *Madonna della Sedia* as a classic work of art and a harmonious whole. It is classic because the idea or entelechy of the painter's art has here become manifest. The history of painting before that supreme moment is a process of a slow unfolding, in which the inherent potentialities of art are gradually actualized. Given certain initial conditions laid down in the definition of painting, the *Madonna della Sedia* can be described as an optimal solution of the task of creating a devotional image of the Virgin, Christ, and St. John with the maximum formal organization compatible with accurate draughtsmanship.

But is this classical method of criticism more than a solemn type of question-begging? Can anything be gained by first abstracting a definition from a famous work of art and then relegating earlier works to the status of mere stages in the development? I hasten to admit that classical aesthetics did succumb to this temptation and paid the penalty for it. Giotto, for us, is not an imperfect forerunner of Raphael, or Rembrandt an example of decadence. We also know that the notion that works of art can be defined by certain enumerable demands has resulted in paintings which are quite properly known as academic machines. Academic theory certainly overrated the value of rules and definitions, and underrated the creativity of art. We cannot deduce its potentialities beforehand from the nature of the task and the properties of the medium. Each creative discovery upsets previous calculations. Add or withdraw two squares from the chessboard and chess would be a different game. Add light to painting and even Raphael himself has to work out an entirely fresh kind of harmony.

And yet, I think, for all its shortcomings the classical approach is not without value in our quest. The very fact that these enumerated demands sound like technical specifications suggests a functional interpretation of the problem which can dispense with Aristotelian metaphysics. When it comes to designing a tool in a given material there is such a thing as a perfect, a classic, an inevitable solution.

Superfluities fall away and the essential is embodied in a lucid and economical form.

It is not the functional aspect of beauty which interests me in this comparison but the suggestion that the solution of certain problems demands an optimal order of elements. Now when we speak of problem-solving in art we must be careful to avoid the impression that art is a higher form of cross-word puzzle. It is not, and for the simple reason that the puzzle addict knows that there is a solution, if only he can find it. In art there can be no such guarantee. And yet, psychologically, the artist may have the feeling expressed by Schiller that somewhere, in a Platonic heaven, the solution he gropes for is already pre-figured—that once it is found it is inevitable and right. And there may be rational reasons for this intuition. For wherever you set yourself the task of combining a number of orders, even if it is only in a game of patience, the number of possible solutions will decrease with the richness of the order you aim at. Moreover, the resultant order will not only be right but also a 'whole' in a more definite sense of the term. The more complex it is, the more sensitive does it become to any dislocation. Change a word for a synonym in a prose passage and it may hardly be noticed. Do the same in a poem, and rhyme, rhythm and everything may collapse.

I feel that we ought to know more about the way complex orders are created. We assume too easily that what can be analysed by rational methods can also be planned and devised by one reasoning mind. In point of fact, when it comes to complex structures reason is a poor organizer.[36] Its watchword is 'one thing at a time'. Conscious intention pushes in one direction. It finds it difficult to keep two simultaneous and mutually limiting orders in mind and is soon baffled and defeated by greater complexity. Professor Polanyi has recently drawn attention to the impossibility of creating 'polycentric orders' by mere calculation.[37] They can only be approximated step by step by a process of mutual adjustment.

When we looked at the dry-shaver poster we admired a simple but brilliant example of a solution to a concrete problem. We saw how form and message were fused and interlocked by the idea of the shaving mirror. I doubt whether even such a solution can be devised by a calculating mind. It is an inspiration. Now the source of this type of inspiration has been analysed in Freud's book on Wit. He has shown how wit makes use of the tendency of the unconscious mind to condense images, to transpose words and to translate ideas into visual form. From this whirling chaos of the 'id' the 'ego' selects what suits its purpose. Mr. Henrion's poster presents an object lesson in the way the artist can harness the shortcomings of unreason to his purpose. It translates the concept of rotary action, which, after all, applies to the wheels inside the apparatus, into visual terms and applies it, quite illogically but all the more effectively, to the image of the man who sees himself in the convex mirror.[38]

But the flash of inspiration that results in wit illuminates and evaporates. The articulate order which belongs to the higher reaches of art receives the mind within its system where it need never cease to circle and explore. The relationships are so many, and between so many levels of meaning, that the work of art appears closed in upon itself. Order creates order. For each correspondence planned, a whole set of new relationships will become discoverable.

It would be a bold man who would undertake to analyse the creation of such systems of orders within orders as have always been felt to rival in richness the most intricate example of interaction known to man, the living organism. But perhaps, if you cast your mind back on what we have seen of the growth of Raphael's idea, we can still draw a few tentative inferences. You remember that process, not of planning but of gradual adjustment. He never started with a schematic compositional sketch or with a study from life: he began somewhere in between, groping his way simultaneously towards those two mutually limiting orders which I have chosen as examples—compact grouping and life-likeness. And you also remember how these two orders, which I called mutually limiting, cease to conflict and are discovered to interact: the formal symmetries impart a sense of ease to the intricate group which, in its turn, reinforces our feeling of balance. But most of all you will remember the artist's interest in the discoveries of his predecessors. The solutions he found in the work of Leonardo, Michelangelo, or even Gianfrancesco Rustici, are for him as many stepping-stones, orders to enrich and adjust in their turn. We art historians are often accused of looking for 'influences' and thereby missing the essential creativity of great art. But this criticism overlooks the fact that such complex orders can never be the work of one man, even of one genius. It is a matter of experience that great art stands in need of a great tradition. Only an artist who has mastered those principles of order codified and conventionalized in what we call style, whose mind (or 'preconscious') is stored with ordered elements, can join in this working-out process. There are periods when this process is hardly deliberate, when the adjustment and balance is the outcome of tradition which itself presupposes a constant sifting and revision of past achievements. In the Italian Renaissance, art grows aware of the possibility of progress, of its kinship with science and of the glory that awaits a master who surpasses his predecessors.[39] Raphael was destined to pass from the first unreflective phase of his Umbrian years to the second, and even to be tempted by the third when the desire grew to force the pace and make every fresh work of art a new departure in virtuosity. The *Madonna della Sedia* still stands on this side of the last development, which we call 'mannerism'. The dual meaning of that term, which denotes both straining after original forms of complexity and dependence on earlier achievements, reminds us of the limits which are set to the individual's contribution if order is not to collapse into disorder.

These limits account for the continuity and the sense of growth observed by Aristotle and those who followed him. There is such a thing as the history of the tondo which culminates in the *Madonna della Sedia*, despite the fact that the tondo is not an organism which grew and matured but a man-made convention. For, needless to say, history is always born out of hindsight. From our point of vantage we see the steps which led towards a given solution as one coherent story, but that does not mean that there was an inherent necessity, an entelechy driving the tondo, or indeed the art of painting, towards one pre-ordained goal, as some historians would have us believe.[40] Continuity of history does not preclude human freedom, it presupposes it. There are always untold potentialities which do not become 'actual', untold possible artistic problems which do not find their inspired solution and of which we historians, therefore, know nothing. For though tradition, or what we may call the situation in art,[41] presents the genius with the material on which to impress the imprint of his mind, that mind is his own.

If I have here attempted something like a vindication of the academic theory of art I do not therefore wish to imply that we are entitled to neglect those powers of the unconscious mind to which so much attention has been given of late. If art, unlike wit, does not bubble forth directly from the chaos of unconscious strivings, if it must canalize these impulses through pre-conscious habits and conscious skills, it must still be fed from the deepest layers. The old writers spoke of this incalculable, irrational element as grace, the favour from above which cannot be conquered by hard work alone, though it can be simulated in studied ease. They called it the 'je ne sais quoi', the unknown quantity which is yet the vital one.[42] That Raphael had grace abounding has always been felt. For, granted that he had absorbed what he had learned till it became 'second nature' to him, that he set to work on blocks already shaped, the direction in which he adjusted and changed them in his search for the perfect form must have come from the centre of his being. It was given to this prodigy, who had lost his mother when he was eight and his painter-father when he was eleven, to conceive of ever fresh modes of togetherness and mutual response of human beings and of forms, to think of them as pliable and eager to fit into larger groupings with the least show of strain.

Nobody but an artist open to the world of dreams could seize upon the simple symbol of the enclosing round and bring it into perfect unison with the group of mother and child, an embodiment of organic unity. Whether consciously or unconsciously, many sensitive critics have felt the inevitable appeal of the protective gesture of the mother within which the sleepy child, as Fischel says, 'seems to be ensconced like a pearl in its shell. Everything in the frame', he continues, 'gives a sense of concavity'.[43] It is partly a matter of taste and tact how far we want to go in articulating these levels of meaning, for they, like all others, can only be singled out at the risk of tearing that miraculous gossamer web of ordered relationships which

distinguishes the work of art from the dream. Within the traditional polyphonies of religious symbolism the devout could move more freely. A seventeenth-century print of the Madonna quotes underneath the beautiful verse from the Song of Songs: 'Ecce tu pulcher es, dilecte mi, et decorus, lectulus noster floridus est'— 'Behold, thou art fair, my beloved, yea, pleasant: also our bed is green'.

Let this quotation remind us in conclusion that no work of art, even though we may now describe it with a little less diffidence as an 'harmonious whole', can ever be self-sufficient in an absolute sense. It derives its meaning from a hierarchy of contexts which range from the personal and universal to the institutional and particular. Nor is the intimate, psychological meaning more 'essential' than the import and function of the work as a religious symbol. But in these matters I would prefer to leave the last word to one of my fellow *ciceroni* in the Palazzo Pitti who explained that he saw in, or through, the *Madonna della Sedia* 'la divinità della maternità'.

Norm and Form

The Stylistic Categories of Art History and their Origins in Renaissance Ideals

IT is well known that many of the stylistic terms with which the art historian operates began their career in the vocabulary of critical abuse. 'Gothic' once had the same connotation as our 'vandalism' as a mark of barbaric insensitivity to beauty, 'baroque' still figures in the *Pocket Oxford Dictionary* of 1934 with the primary meaning of 'grotesque, whimsical', and even the word 'impressionist' was coined by a critic in derision. We are proud of having stripped these terms of their derogatory overtones. We believe we can now use them in a purely neutral, purely descriptive sense to denote certain styles or periods we neither wish to condemn nor to praise. Up to a point, of course, our belief is justified. We can speak of gothic ivories, baroque organ-lofts or impressionist paintings with a very good chance of describing a class of works which our colleagues could identify with ease. But our assurance breaks down when it comes to theoretical discussions about the limits of these categories. Is Ghiberti 'gothic', is Rembrandt 'baroque', is Degas an 'impressionist'? Debates of this kind can become stuck in sterile verbalism, and yet they sometimes have their use if they remind us of the simple fact that the labels we use must of necessity differ from those which our colleagues who work in the field of entomology fix on their beetles or butterflies. In the discussion of works of art description can never be completely divorced from criticism. The perplexities which art historians have encountered in their debates about styles and periods are due to this lack of distinction between form and norm.

1. *Classification and its Discontents*

There can be few lovers of art who have never felt impatient of the academic art historian and his concern with labels and pigeonholes. Since most art historians are also lovers of art they will have every sympathy with this reaction, of which Benedetto Croce was the most persuasive spokesman. To Croce it seemed that stylistic categories could only do violence to what he so aptly called the 'insularity' of each individual and incommensurable work of art. But, plausible as this argument is, it would clearly lead to an atomization of our world. Not only paintings but even plants and the proverbial beetles are all individuals, all presumably unique; to all

This Essay is based on a lecture delivered in Italian at the Biblioteca Filosofica of Turin University in April 1963.

of them applies the scholastic tag 'individuum est ineffabile': the individual thing cannot be caught in the network of our language, for language must needs operate with concepts, universals. The way out of this dilemma is not a withdrawal into nominalism, the refusal to use any words except names of individuals. Like all users of language the art historian has rather to admit that classification is a necessary tool, even though it may be a necessary evil. Provided he never forgets that, like all language, it is a man-made thing which man can also adjust or change, it will serve him quite well in his day-to-day work. Apparently, however, this is more easily said than done. Man is a classifying animal, and he has an incurable propensity to regard the network he has himself imposed on the variety of experience as belonging to the objective world of things. The history of ideas provides any number of illustrations.

For the Chinese all things can be grouped according to the basic opposition of *yang* and *yin*, which is also the male and female principle and therefore the active and passive. For the ancient world and those that followed its teaching, the distinctions between hot and cold, moist and dry provided in their combinations the four basic categories sufficient to classify the humours of man, the seasons and the elements. It is quite a humbling exercise to study the success of these crude systems and to ponder its reasons. Obviously, any classification or any signpost in the landscape is welcomed for its help in the mastering of an unstructured reality. We have no right in this respect to feel superior to earlier civilizations. Has not our political life been conventionally structured ever since the French Revolution according to the categories of 'right' and 'left'? Do we not frequently encounter new classifications in psychology and sociology such as introvert and extravert, inner-directed and other-directed, that act for a time with a strange power of illumination till they appear to 'wear thin'? I remember a similar effect in my youth in Vienna, when Kretschmer's division of human types into cyclothym and schizothym was the talk of the day till a wit proposed that it was even better to classify all men as tailors or cobblers and all women as cooks or parlourmaids.

Needless to say, we always learn something when we try to apply fresh categories, even the last-named facetious ones. Our attention is focused on certain aspects of human physique and human behaviour that we might otherwise have overlooked, and as long as we also remain critical of our own procedures we will profit from the exercise. The same is certainly true of the categories that have been offered to criticism by Aesthetics ever since the method of 'polarities' became fashionable in the eighteenth century.[1] Burke's 'Sublime and Beautiful', Schiller's 'Naïve and Sentimental' could certainly be used to provide fresh insights into the varieties of literary experience.[2] The question is only whether these conceptual systems did not sometimes do their job too well. They created the illusion in the student that what he was dealing with were 'natural classes', as different and as fixed as the species of animals were believed to be. Yet the proliferation of such 'polarities',

especially in German *Kunstwissenschaft*, should have put the student of art on his guard. Optic and Haptic, Additive and Divisive, Physioplastic and Ideoplastic—during the years of my apprenticeship such new essential divisions were constantly 'discovered' and led to fresh classifications. Each helped no doubt to make us look for fresh characteristics in the art of the past but each also served to render the exclusive claims of the previous one obsolete.

2. *The Origins of Stylistic Terminology*

For the student of style, experimentation with these dichotomies is relevant if it prepares him for the insight that the variety of stylistic labels with which the art historian usually appears to be operating is in a sense misleading. That procession of styles and periods known to every beginner—Classic, Romanesque, Gothic, Renaissance, Mannerist, Baroque, Rococo, Neo-Classical and Romantic—represents only a series of masks for two categories, the classical and the non-classical.

That 'Gothic' meant nothing else to Vasari than the style of the hordes who destroyed the Roman Empire is too well known to need elaboration.[3] What is perhaps less well known is the fact that in describing this depraved manner of a non-classical method of building (Fig. 130), Vasari himself derived his concepts and his categories of corruption from the only classical book of normative criticism in which he could find such a description ready-made—Vitruvius *On Architecture*. Vitruvius of course nowhere describes any style of building outside the classical tradition, but there is one famous critical condemnation of a style in the chapter on wall-decoration, where he attacks the licence and illogicality of the decorative style fashionable in his age (Fig. 129). He contrasts this style with the rational method of representing real or plausible architectural constructions (Fig. 128).

But these [subjects] which were imitations based upon reality are now disdained by the improper taste of the present. On the stucco are monsters rather than definite representations taken from definite things. Instead of columns there rise up stalks; instead of gables, striped panels with curled leaves and volutes. Candelabra uphold pictured shrines and above the summits of these, clusters of thin stalks rise from their roots in tendrils with little figures seated upon them at random. Again, slender stalks with heads of men and animals attached to half the body.

Such things neither are, nor can be, nor have been. On these lines the new fashions compel bad judges to condemn good craftsmanship for dullness. For how can a reed actually sustain a roof, or a candelabrum the ornaments of a gable, or a soft and slender stalk a seated statue, or how can flowers and half-statues rise alternatively from roots and stalks? Yet when people view these falsehoods, they approve rather than condemn.[4]

Turning from this description to Vasari's image of the building habits of the northern barbarians, we discover that the origins of the stylistic category of the *Gothic* do not lie in any morphological observation of buildings, but entirely in the prefabricated catalogue of sins which Vasari took over from his authority.

There is another kind of work, called German . . . which could well be called Confusion or Disorder instead, for in their buildings—so numerous that they have infected the whole world—they made the doorways decorated with columns slender and contorted like a vine, not strong enough to bear the slightest weight; in the same way on the façades and other decorated parts they made a malediction of little tabernacles one above another, with so many pyramids and points and leaves that it seems impossible for it to support itself, let alone other weights. They look more as if they were made of paper than of stone or marble. And in these works they made so many projections, gaps, brackets and curlecues that they put them out of proportion; and often, with one thing put on top of another, they go so high that the top of a door touches the roof. This manner was invented by the Goths. . . .[5]

I do not share that sense of superiority which marks so many characterizations of Vasari. His work amply shows that he could give credit even to buildings or paintings which he found less than perfect from his point of view. We should rather envy Vasari his conviction that he could recognize perfection when he saw it and that this perfection could be formulated with the help of Vitruvian categories—the famous standard of *regola, ordine, misura, disegno e maniera* laid down in his Preface to the Third Part and admirably exemplified in his Lives of Leonardo and Bramante.

These normative attitudes hardened into an inflexible dogma only when the stylistic categories were used by critics across the Alps who wanted to pit the classic ideals of perfection against local traditions. Gothic then became synonymous with that bad taste that had ruled in the Dark Ages, before the light of the new style was carried from Italy to the north.

If Gothic thus originally means 'not yet classic', *barocco* began its career as a similar denunciation of the sin of deviation. Indeed, it is noteworthy that the identical passage in Vitruvius that served Vasari as a pattern for his description of Gothic served Bellori for his condemnation of the corrupt architecture of his time, the architecture of Borromini (Fig. 131) and Guarini:

Each individual thinks up in his own head a new *Idea* or phantom of architecture in his own manner, and then exhibits it in the *piazza* and on the façades—men certainly without any of the knowledge proper to the architect, whose title they vainly hold. So, deforming buildings and whole cities and the monuments of the past, they juggle madly with corners, gaps and twirling lines, discompose bases, capitals and columns with stucco nonsense, trivial ornament and disproportions; and Vitruvius too condemns novelties of a similar kind. . . .[6]

Bellori does not yet use the term *barocco* for this denunciation, but the eighteenth century sometimes used the terms Gothic and Baroque interchangeably as descriptions for such bad or bizarre taste. Gradually the two terms for the non-classical divided their functions, Gothic being increasingly used as a label for the not-yet-classical, the barbaric, and *barocco* for the no-longer-classical, the degenerate.

The introduction, at the end of the eighteenth century, of the word *rococo* to denote a fashion especially worthy of condemnation by the severe and virtuous

classicists added a new facet to a terminology which has remained in use. It still describes for us the very style that Johann Joachim Winckelmann condemned in the middle of the eighteenth century, invoking once more the standard normative passage from Vitruvius:

Good taste in our present-day ornament, which since Vitruvius complained bitterly about its corruption has in modern times been even more corrupted . . . could at once be purified and gain truth and sense through a more thorough study of allegory.

Our scrolls and that ever-so-pretty shell-work, without which no decoration can nowadays be modelled, sometimes has no more of Nature about it than Vitruvius's candelabra, which supported little castles and palaces.[7]

Winckelmann thus singled out the *rocaille* as a characteristic of the style—possibly because of its association with the grotto, a place which favoured excesses of irregularity and whimsy.

The *rococo*, then, was an identifiable type of licence even before the particular word 'rococo' made its appearance, as it seems, in the studio of David, when the master's most extremist pupils condemned one of his paintings as insufficiently severe, and derided it as 'Van Loo, Pompadour, rococo'.[8]

It was in the eighteenth century, too, that the need was felt to distinguish between the various forms of the unclassical that marked the great hiatus between antiquity and the Renaissance, the Middle Ages. English antiquarians in particular developed a historical interest in the architecture of the Middle Ages, and looked for principles of classification. In 1760 William Warburton wrote: 'All our ancient churches are called without distinction Gothic, but erroneously. They are of two sorts, the one built in the Saxon times, the other in the Norman.'[9]

Warburton tried to vindicate the Gothic style by claiming for it an entirely novel principle of construction; it was he also who introduced the comparison with the trees of the forest, whose subsequent fortunes Frankl has traced in his monumental book on *The Gothic*. Like all enthusiasts, Warburton needed a foil against which the newly discovered splendour of Gothic architecture could be set off. He looked for an underdog, and found it not in classical architecture but in that corruption of classical architecture which, in his opinion, the Saxons had indulged in. Saxon architecture was an imitation of 'Holy Land Grecian', but a bad copy of it. Here we have the origin of our category of the *Romanesque*.

Thanks to Frankl's work, we can easily trace the history of this term in English and French.[10] It was William W. Gunn, in 1819, who published his *Inquiry into the Origin and Influence of Gothic Architecture* in the *Quarterly Review*, and there explicitly defended the choice of the term Romanesque as indicating corrupted Roman. The Italian termination *-esco*, he thought, had precisely this connotation. 'A modern Roman, for instance, calls himself *Romano*, a foreign citizen he stigmatizes by the term *Romanesco*. I consider the architecture under discussion in the

same point of view.' A year earlier, in France, Gunn had been anticipated by Gerville, who introduced the term *Roman* and added: 'tout le monde convient que cette architecture lourde et grossière est l'*opus romanum* dénaturé ou successivement dégradé par nos rudes ancêtres . . .'. Romanesque, Gothic, Renaissance, Baroque, Rococo, Neo-classical. It was easy to justify my claim that all these names can be reduced to 'classical' and 'non-classical' according to Vitruvian norms. I shall not here discuss the pedigree of the last term to become fashionable in art history, the term 'mannerism' interposed between Renaissance and Baroque, since I have told its story elsewhere.[11]

3. *Neutrality and Criticism*

It is not my intention to give a full account of the gradual rehabilitation of these various styles or of the forces of historical tolerance and nationalist pride that contributed to the rejection of Vitruvian monopolism. What matters in the present context is only that those who questioned the norm still accepted the categories to which it had given rise. Like Warburton in the eighteenth century, nineteenth-century historians usually acknowledged the unclassical character of the styles they wanted to defend, but they stressed some compensating virtue. Mediaeval styles may have been less beautiful than the Vitruvian norm demands, but they are more devout, more honest or more strong, and surely piety, honesty and strength count for more than mere mechanical orderliness? This is Ruskin's approach.[12] Burckhardt's tentative vindication of the Baroque in the *Cicerone* is not very different when he writes about baroque church façades: '. . . yet they move the beholder sometimes as a pure fiction, in spite of their frequently depraved manner of expression . . .'.[13] The phases by which this tolerance for the unclassical styles became a partiality in their favour belong to the history of taste and fashions rather than to the problems of historiography. What concerns us is the claim which arose in the nineteenth century that the historian can ignore the norm and look at the succession of these styles without any bias; that he can, in the words of Hippolyte Taine, approach the varieties of past creations much as the botanist approaches his material, without caring whether the flowers he describes are beautiful or ugly, poisonous or wholesome.[14]

It is not surprising that this approach to the styles of the past seemed plausible to the nineteenth century, for its practice had kept step with its theory. Nineteenth-century architects and decorators used the forms of earlier styles with sublime impartiality, selecting here the Romanesque repertory for a railway station, there a Baroque stucco pattern for a theatre. No wonder that the idea gained ground that styles are distinguished by certain recognizable morphological characteristics, such as the pointed arch for Gothic and the *rocaille* for the Rococo, and that these terms could safely be applied stripped of their normative connotation.

Even this morphological approach has its roots in Vitruvius. It derives from his treatment of the orders. Doric, Ionian and Corinthian are such repertories of forms, easily recognizable by certain specified characteristics and easily applied by any architect who can use a patternbook. Why should this range not be extended to embrace the Gothic or the Baroque order as well, and thus merely increase the languages of form the architect learns to speak?

As long as the labels for styles were mainly applied to architecture and patterns in such practical contexts things went reasonably well. But the defenders of these styles had higher ambitions. They wanted to advocate the unclassical styles as systems in their own right embodying alternative values, if not philosophies. The Gothic style was superior to the Renaissance not because it built in pointed arches but because it embodies the Age of Faith which the pagans of the Renaissance could not appreciate. Styles, in other words, were seen as manifestations of that spirit of the age which had risen to metaphysical status in Hegel's vision of history.[15] This spirit in its unfolding manifested itself not only in certain architectural forms, it also gained shape in the painting, sculpture and pattern of the age, which pointed to the same outlook that moulded the literature, the politics and the philosophy of the period. To this approach such morphological marks of recognition as the presence of a rocaille for the rococo or the rib for the Gothic appeared hopelessly 'superficial'. There must be something that all works of art created in these distinct periods of human history had in common, they must share some profound quality or essence which characterizes all manifestations of the Gothic or the Baroque. K. R. Popper has taught me to recognize in this demand for an 'essential' definition a remnant of Aristotle's conception of scientific procedure.[16] It was Aristotle, the great biologist, who conceived of the work of the scientist as basically a work of classification and description such as the zoologist or botanist is apt to perform, and it was he who believed that these classes are not created but found in nature through the process of induction and intellectual intuition. Looking at many trees we find some that have structural features in common and form a genus or a species. This species manifests itself in every individual tree as far as resistant matter allows, and though individual trees may therefore differ, their differences are merely 'accidental' compared to the essence they share. One may admit that Aristotle's procedure was a brilliant solution of the problem of universals as this had been proposed by Plato. No longer need we look for the idea of the horse or the pinetree in some remote world beyond the heavens, we find it at work within the individual as its entelechy and its inherent form. But whatever the value of Aristotle's procedure for the history of biology, the grip it retained on the humanities even when science had long discarded this mode of thought provides ample food for reflection. For the discussions which came into fashion during the last hundred years about the true essence of the Renaissance, the Gothic or the Baroque betray in most cases an

uncritical acceptance of Aristotelian essentialism. They presuppose that the historian who looks at a sufficient number of works created in the period concerned will gradually arrive at an intellectual intuition of the indwelling essence that distinguishes these works from all others, just as pinetrees are distinguished from oaks. Indeed, if the historian's eye is sufficiently sharp and his intuition sufficiently profound, he will even penetrate beyond the essence of the species to that of the genus; he will be able to grasp not only the common structural features of all gothic paintings and statues, but also the higher unity that links them with gothic literature, law and philosophy.

The most instructive record of this search is the book by Paul Frankl on *The Gothic*, to which I have already alluded. It came out in 1960 and is the fruit of a long lifetime of research and of thought. There can be few who have read all of its 838 pages, which begin in history and end in metaphysics. For the scrutiny of all the answers ever given to the question 'what is Gothic?' leaves the eminent scholar perplexed. They do not touch the essence. Essence, Frankl sees, is a metaphysical concept; the essence of man, he states, is the significance he has for God and the essence of the Gothic must also be related to the unfathomable mystery of transcendental meaning.[17]

I side with those philosophers who, like Sir Karl Popper, look with suspicion at what he calls Essentialism, but wherever one may stand in this modern battle of realists versus nominalists it is obvious that categories and classes which serve very well for one purpose may break down when used in a different context. The normative connotations of our stylistic terms cannot simply be converted into morphological ones—for you can never get more out of your classification than you put into it. The cook may divide fungi into edible mushrooms and poisonous toadstools; these are the categories that matter to him. He forgets, even if he ever cared, that there may be fungi which are neither edible nor poisonous. But a botanist who based his taxonomy of fungi on these distinctions and then married them to some other method of classification would surely fail to produce anything useful.

I do not imply that the origin of a word must always be respected by those who apply it. The discovery that the Gothic style has nothing to do with the Goths need not concern the art historian, who still finds the label useful. What should concern him in the history of the term, I think, is its original lack of differentiation. The stylistic names I enumerated did not arise from a consideration of particular features, as do Vitruvius' terms for the orders; they are negative terms like the Greek term Barbarian, which means no more than a non-Greek.

If I may introduce a harmless term, I should like to call such labels terms of exclusion. Their frequency in our languages illustrates the basic need in man to distinguish 'us' from 'them', the world of the familiar from the vast, unarticulated world outside that does not belong and is rejected.

It is no accident, I believe, that the various terms for non-classical styles turn out to be such terms of exclusion. It was the classical tradition of normative aesthetics that first formulated some rules of art, and such rules are most easily formulated negatively as a catalogue of sins to be avoided. Just as most of the Ten Commandments are really prohibitions, so most rules of art and of style are warnings against certain sins. We have heard some of these sins characterized in the previous quotations—the disharmonious, the arbitrary and the illogical must be taboo to those who follow the classical canon. There are many more in the writings of normative critics from Alberti *via* Vasari to Bellori or Félibien. Do *not* overcrowd your pictures, do *not* use too much gold, do *not* seek out difficult postures for their own sake; avoid harsh contours, avoid the ugly, the indecorous and the ignoble. Indeed it might be argued that what ultimately killed the classical ideal was that the sins to be avoided multiplied till the artist's freedom was confined to an ever narrowing space; all he dared to do in the end was insipid repetition of safe solutions. After this, there was only one sin to be avoided in art, that of being academic. In our exhibitions today we see the most bewildering variety of forms and experiments. Anyone who wanted to find some morphological feature that united Alberto Burri with Salvador Dali and Francis Bacon with Capogrossi would be hard put to it, but it would be easy to see that they all want to avoid being academic; they would all have displeased Bellori and would have welcomed his condemnation.

It is no accident, therefore, that the terminology of art history was so largely built on words denoting some principle of exclusion. Most movements in art erect some new taboo, some new negative principle, such as the banishing from painting by the impressionists of all 'anecdotal' elements. The positive slogans and shibboleths which we read in artists' or critics' manifestos past or present are usually much less well defined. Take the term 'functionalism' in twentieth-century architecture. We know by now that there are many ways of planning or building which may be called functional and that this demand alone will never solve all the architect's problems. But the immediate effect of the slogan was to ban all ornament in architecture as non-functional and therefore taboo. What unites the most disparate schools of architecture in this century is this common aversion to a particular tradition.

Maybe we would make more progress in the study of styles if we looked out for such principles of exclusion, the sins any particular style wants to avoid, than if we continue to look for the common structure or essence of all the works produced in a certain period.

4. *Critical Polarities in Wölfflin*

Obvious as this reminder is, it still indicates the rock on which the morphology of style suffered shipwreck. By reducing the idea of the classical and the non-classical

G

to a mere morphological distinction of equally justified alternatives the morphologist blurs what is, in my view, the vital distinction among unclassical styles: those which are unclassical from a principle of exclusion and those which are not; or, to put it more clearly, the distinction between the anti-classical, as it is exemplified in its extreme in twentieth century art, and the unclassical for which, perhaps, Chinese art may offer a good example, in so far as the Chinese artists never rejected principles of which they could have no cognizance.

This distinction may look harmless enough, but it threatens the whole idea of a morphology of styles. For exclusion implies intention, and such an intention cannot be directly perceived in a family of forms. The greatest and most successful champion of the morphological approach, Heinrich Wölfflin, was not unaware of this difficulty, and yet his search for objective principles of organisation has tended to obscure its relevance for the teaching of art history.

It was Wölfflin who gave art history the fateful tool of systematic comparison; it was he who introduced into our lecture rooms a need for two lanterns and two screens, for the purpose of sharpening the eye to the stylistic differences between two comparable works of art—let us say a Madonna by Raphael and another by Caravaggio (Figs. 132 and 133). It is a pedagogical device that has helped many teachers to explain to their students certain elementary differences, but unless it is used with care it subtly but decisively falsifies the relationship between the two works. It is legitimate and illuminating to compare the Caravaggio with the Raphael, for, after all, Caravaggio knew Raphael's work. He could even have imitated it, had he wanted to, at least as far as Annibale Carracci did in his immediate proximity. Instead, he clearly rejected this possibility and struck out on a path of his own. The comparison will therefore help us to understand why Bellori objected to Caravaggio and branded his manner as a departure from the classical norm. But when we read the comparison the other way round and contrast the Raphael with the Caravaggio we are on more dangerous ground. We imply that Raphael, too, deliberately rejected the methods of Caravaggio and that his art sets up the value of restraint and the ideal of beauty against the harshness of Caravaggio's naturalism. Bellori might even have agreed with this reasoning, for we have seen that he was concerned with the avoidance of sins. But, if we want to see Raphael in his own terms, we cannot ignore the dimension of time and the horizon of his knowledge. He cannot have rejected what he never knew.

This simple observation helps to account both for Wölfflin's success and for his occasional failure. The sequence of his books reminds us how closely his pretended morphology of style clung to the original normative function of these comparisons.

He began with *Renaissance und Barock* (1888), in which he continued Burckhardt's line of reasoning and ended by vindicating the Baroque against the charges

of classicist critics. His starting point—like Burckhardt's—was the classical ideal of perfection in architecture; he wanted only to plead for more tolerance in the acceptance of alternative procedures. By clarifying these alternatives he hoped the historian would see more clearly what Bramante was trying to do and what alternative values were embodied in Baroque solutions. Prepared in a different way the toadstools are not toadstools, but make a wholesome dish. There is really no departure here from the ideal of classical perfection as a system of values. The system is still used as a touchstone to separate the High Renaissance from a different system of forms.

Having thus discovered for himself the consistency and usefulness of the traditional ideal of the classical, Wölfflin returned to it in his greatest book, *Die klassische Kunst* (1898), in order to circumscribe and explain its working not only in architecture but also in painting and sculpture. His subject is really Vasari's *terza e perfetta maniera*, and his method is again that of contrasting comparison. But this time he describes the classic ideal not against the foil of Baroque deviations but against that of Quattrocento imperfections. In other words he has moved closer still to Vasari's starting point, and the result is a renewed plea for the very ideals which had been enshrined in the Academic tradition, but somewhat discarded and forgotten when nineteenth-century realists and impressionists had turned against this tradition. He wrote for a public who—to quote the Preface to *Die klassische Kunst*—could hardly be blamed if they asked themselves, in front of the *School of Athens*, why Raphael had not rather painted a Roman flower-market or the amusing sight on a Sunday morning when the peasants are being shaved on the Piazza Montanara. It is this bias of the late nineteenth-century art lover which leads Wölfflin to the restatement of the classic norm—not without a sideways glance at the group of anti-realist artists of his time, notably the sculptor Adolf von Hildebrand, whose book on the *Problem of Form* had 'fallen on dry ground like refreshing rain'. It was Hildebrand, as Wölfflin reminds his readers, who had censured art history for its addiction to morphology and its disregard of the inherent laws of art. Harsh as Wölfflin finds this criticism he admits that every art-historical monograph should also be a contribution to aesthetics. *Die klassische Kunst* is a journey of discovery in search of the norms of the Italian High Renaissance.

After thus fortifying his home base Wölfflin returned once more to the contrast between classical ideals and those of the Baroque, this time also in painting and sculpture; the result was his most influential, though scarcely his most cogent book, *Kunstgeschichtliche Grundbegriffe* (1915).[18]

Before I return to the claims of this book I should like to draw your attention to the work which reveals, most convincingly, perhaps, the weakness of Wölfflin's stylistic morphology and the source of this weakness—*Italien und das deutsche Formgefühl* (1932). I was privileged to hear in Berlin in 1930 the lectures on which

this book was subsequently based. I remember the high hopes with which I went to Berlin University and the impression Wölfflin's personality made on me, the tall Swiss with beautiful blue eyes and a firm and self-assured manner of delivery that held the *auditorium maximum* spellbound. I confess that the spell did not work on me for very long. Soon heretical doubts spoilt some of my pleasure, though I was still unable to formulate the reasons for my increasing disappointment. Once more, Wölfflin used the magic of two screens for the exercise of comparisons, once more he used the classic ideal as a touchstone, but this time not to separate an earlier from a later phase of art, but rather to isolate the morphological characteristics of the German feeling for form. Over and again an Italian work of classical poise appeared on the one screen to be contrasted on the other with a German work which lacked these characteristics, and every time we were assured that this lack was not something negative but something merely different; where Titian (Fig. 134) was harmonious, Cranach (Fig. 135), say, was obviously less so, but he nevertheless pleased Wölfflin.

I realize that there is more in the book than I got out of these lectures, from which—if the truth is to be told—I soon stayed away in order to attend Wolfgang Köhler's more exciting accounts of psychology. But I still think that it would be illuminating to go through Wölfflin's book and pick out those formulations of allegedly German traits which could as well be used to describe the characteristics of Spanish, Portuguese, English or even Mexican and Indian art. For all of these can be effectively contrasted with the classic ideals of the Italian Renaissance. The rejection of richness and intricacy for the sake of clarity and simplicity probably presupposes a degree of aesthetic sophistication that can only be found here and, possibly, in Far Eastern art. Thus, far from separating out what is characteristically German—if there is such a thing—Wölfflin's book really leads us back to the problem of the classical ideal.

There is a magic trick which everybody knows—the game 'think of a number'. You ask the child to think of a number, then to put it through a variety of arithmetical operations, adding this and that, subtracting something else, multiplying by four, then dividing by two and once more by two, all in his head, and finally taking away the number he thought of first; after which you can read his thoughts and tell the exact result. Having led us through all these operations with the concept of the classical, Wölfflin in his lectures asked us to deduct it and produced the *maniera tedesca* which Vasari had derided.

The number thought of and then omitted was of course Vasari's idea of perfection, a normative idea. It rests on a firm conviction about the purpose of art and the means of achieving this end. The purpose, to put it briefly, is the plausible evocation of a sacred or at least significant story in all its naturalistic and psychological detail, the means the mastery of representation.[19] Not that Wölfflin was insensitive

to these aims or this achievement; he would not have become the great interpreter of Renaissance painting if he had been. But the theoretical framework he wanted to present to the art historian was to eliminate considerations of this achievement as far as possible. What the art historian was asked to consider, when he compared a work of the Renaissance with one of the Baroque, were five alleged polarities which Wölfflin thought to be purely descriptive. They are the basic conceptual tools or *Grundbegriffe* of *Linear und malerisch, Fläche und Tiefe, Geschlossene Form und offene Form, Vielheit und Einheit, Klarheit und Unklarheit*—linear and painterly, plane and depth, closed form and open form, multiplicity and unity, clarity and obscurity. Wölfflin made it quite clear that he wanted these contrasts to be regarded mainly as principles of order which could apply to patterns no less than to representation. It was his conviction that nature could be represented as well in sharp pencil lines as in broad brushstrokes, in the plane and in depth. His choice of examples and his powers of description are so persuasive that we must focus on the weakest point in his argument. It concerns the relation of these modes of representation to the objective appearance of reality. Clearly a linear art tied to the plane (Fig. 136) will not be able to cope with the kind of motifs Turner or Monet made their own (Fig. 137). Wölfflin is aware of this objection. He explicitly raises the question of whether one might not distinguish between representational and decorative aspects of style, but having faced this question he answers it with an ambiguous 'Yes and no'. The later phase is for him not a more developed mode of representing nature, but simply a different one. 'Only where the decorative feeling has changed, can we expect a change in the mode of representation.'[20] Wölfflin would have replied in the same way to the objection that an art committed to 'closed form' will be less free in the rendering of natural phenomena than an art that can resort to 'open forms'. I shall not go on dissecting his pairs of opposites in any detail. What matters to me is the fact that his polarities are not true polarities at all. We have seen before how fatally easy it is for our minds to see opposing principles where only differences of degree exist. There was a time when cold and heat, moistness and dryness, even light and dark were considered such entities in their own right, just as we still think of negative and positive electricity. But clearly the contrast between heat and cold makes sense only in relation to a norm, mostly the hidden norm of our own body temperature. Science, of course, tries to eliminate this norm and prefers to plot temperature along a scale. A real morphology of forms would have to aim at a similar scale or spectrum of configurations. It is true that a form in nature may be rendered by a line or suggested by its shadow, but there are any number of possibilities in between and beyond, and the habit of thinking in polarities may actually mask these from us. Much has been written in English about the exact meaning of *malerisch* and the best way of translating this elusive word. Looking at Wölfflin's purpose we can safely translate it as a term of

exclusion and call it 'less linear'. Less than what? Less than Wölfflin's hidden norm, the classical.

The same applies to all his terms of opposition. They can all be plotted along various co-ordinates; paintings can be more or less confined to the plane, more or less ordered and more or less unified. But what strikes one about these co-ordinates is that they are not independent, either logically or historically. The nature of their interdependence will become clear immediately if we restore the old critical terms which Wölfflin tried to replace, the term *composition* for all principles of order, and the term *fidelity to nature* for the means of representation in contour and depth. Clearly, the more a painting or a statue mirrors natural appearances, the fewer principles of order and symmetry will it automatically exhibit. Conversely, the more ordered a configuration, the less will it be likely to reproduce nature. It seems to me important to stress at this point that, in my view, both order and fidelity to nature are reasonably objective descriptive terms.[21] Wölfflin was right to think that one can say, within limits at least, which work exhibits more of these characteristics than another. The kaleidoscope presents an orderly arrangement of elements, most snapshots do not. An increase in naturalism means a decrease in order. It is clear, I think, that most artistic value rests among other things on the exact reconciliation of these conflicting demands. Primitive art, on the whole, is an art of rigid symmetries sacrificing plausibility to a wonderful sense of pattern, while the art of the impressionists went so far in its search for visual truth as to appear almost to discard the principle of order altogether.

I have tried to show elsewhere[22] that no purely formal analysis can do justice to that achievement of reconciliation between these two conflicting aims which we call the classical perfection of a Raphael Madonna. I think we can see why. Wölfflin's morphological bias is the bias of a nineteenth-century critic who takes representation for granted. For him, as for all of us, art is a matter of imposing order on chaos. The painter begins where the photographer leaves off. It is true that the photographer too can be an artist precisely when he, too, selects and achieves an ordered composition,[23] but the idea of such a composition he owes to art. Looking at classic art from the vantage point of the late nineteenth century Wölfflin therefore described its achievement mainly in terms of his sensitive feeling for balance and hidden symmetries. It has always puzzled historians that these striking achievements of classic Renaissance art were scarcely discussed by the writers and critics of the Cinquecento. There is no word about composition in Leonardo's *Trattato*, and Vasari hardly uses the term—except when he praises Raphael's skill in composing a *storia* into a complex wall area in the case of the *Liberation of St. Peter* (Fig. 138). Surely Vasari, the pupil of Andrea del Sarto, cannot have been unaware of the compositional devices described by Wölfflin, and of all the visual rhymes and formal harmonies which make for us the achievement of a 'closed form'. After all,

Vasari himself made much use of such formal devices in his own paintings (Fig. 49), poor as they are in other respects. We must conclude that the Cinquecento took the achievement of order for granted because it was a traditional achievement. Even the most rigid and despised work of the *maniera bizantina* would place the Virgin in the centre and the adoring angels or Saints symmetrically on either side (Fig. 140). The problem was not, for these masters, the achievement of some order in their painting but that increasing mastery of representation to which writers devoted all their attention. That this mastery had to function with the minimal sacrifice of order was apparently obvious.

The problem was how far one could go in dissolving symmetry without sacrificing balance. A Piero della Francesca could still dare, in his hieratic *Madonna del Parto* at Monterchi (Fig. 141), to paint the two flanking angels with one cartoon, which he reversed, and Castagno used a similar mirror effect in Sant' Apollonia. Gozzoli and Pollaiuolo were not satisfied with this kind of simple arrangement and introduced the identical model seen from two different sides (Figs. 142-3). But even this rigidity was excluded by the masters of the *terza maniera*, who knew how to create the sense of balance and correspondence with far more subtle means, weaving their figures into patterns without sacrificing either their dramatic meaning or their evocative power.

It is this ideal compromise between two conflicting demands which was subsequently felt to be classical, in the sense of presenting an unsurpassed solution that could only be repeated, not improved upon. Deviation on the one side would threaten the correctness of design, on the other the feeling of order.

Seen from this point of view the 'classic solution' is indeed a technical rather than a psychological achievement. It can be seen, as Vasari saw it, as the result of countless experiments finally coming to fruition. There is according to this conception an optimum solution beyond which one cannot go with impunity.

Two implications of this interpretation deserve emphasis. One is its psychological neutrality. There is no reason to think that those artists who finally achieved a perfect equilibrium in their composition had very well-balanced minds, nor to attribute to those who upset the equilibrium profound mental crises. The history of art as a history of formal solutions can apply Occam's razor and do away with the spirit of the age. Nobody was more aware of the dilemma which an investigation of formal developments presents to the historian than Wölfflin himself. It was to this problem that he turned in the profound and stimulating *Revision* of 1933 which he appended to the *Grundbegriffe* in the edition of 1943 and is still insufficiently known.

The second implication is even more important for our understanding of the role which the classical solution continued to play, even for those who looked for alternatives. It shows that there are limits to historical relativism. Such a morphology of styles as we have we owe to the stability and identifiability of the classic solution.

There is something like an 'essence' of the classic that permits us to plot other works of art at a variable distance from this central point. Is there not a contradiction here? Have I not tried to banish essentialism? I have, but I would plead—and here, too, I have learned from Popper—that there is one kind of essentialism which is innocuous and even legitimate. We have a right to talk in Aristotelian terms when we discuss what Aristotle called 'final causes', that is, human aims and human instruments. As long as painting is conceived as serving such a human purpose, one has a right to discuss the means in relation to these ends. There are indeed quite objective criteria for their assessment. The idea of an 'economy of means', even the idea of perfection, makes complete, rational sense in such a context. One can say objectively whether a certain form serves a certain norm.

It would not be too difficult, I believe, to translate the traditional eulogies of such classical artists as Raphael into a terminology of a great purpose perfectly fulfilled. I have mentioned before that to my mind both the correctness of drawing and the achievement of a balanced composition can be judged by objective criteria, both singly and in their interaction. I would go further and venture to think that even the achievement of a lucid narrative and the presentation of physical beauty are norms that have a permanent meaning. At least, it seems to me that relativism in these matters can easily be exaggerated. I know quite well that ideals of beauty vary from country to country and age to age, but I still think we know what we mean when we call Raphael's Madonnas more beautiful than Rembrandt's, even though we may like Rembrandt's better.

Without this objective core of the classical ideal even the categories of the non-classical could never have been created. What is plausible in Wölfflin and his followers derives its justification from this rational element. But we have seen that this plausibility rests on a particular normative ideal, an ideal moreover far less precise than I may have made it appear for the purpose of its justification. Leonardo's *Last Supper* (Fig. 144) is less symmetrical than Piero's Monterchi *Madonna* or even Pollaiuolo's *St. Sebastian*, but its pattern is still simple compared to the involutions of the *Battle of Anghiari*. Raphael's Florentine Madonnas exhibit all the clarity of Wölfflinian triangular compositions; his later manner, notably the *Battle of Ostia* (Fig. 139), introduces far greater complexity of order and far more daring contortions of the figure. Yet who are we to say where exactly we should draw the line between classical norm and unclassical complexity? Is it not rather natural that artists tried to explore how far they could go in this game of virtuosity? Have we a right to decree that beyond a certain point they were no longer classical or even unclassical but anti-classical—as the mannerists have been called? Was mannerism a principle of exclusion that wanted to avoid order and harmony? Did anyone cry, 'Down with Raphael!' or paint moustaches on the *Mona Lisa*, as real anti-classical movements have done? It is true that in some mannerist work the

reconciliation breaks down and that the complexity of pattern leads to a distortion of bodies or a sacrifice of evocative plausibility in the narrative. But what we witness is perhaps less a new anti-classical norm than a shift in priorities. From this point of view it need no longer cause surprise that even the leading masters and critics of the 'Baroque' frequently testified to their admiration of classical art, that Rubens and Bernini based their style on the study of ancient sculpture, and that Bellori praised masters such as Lanfranco. It was only the eighteenth century with its increasing fear of corruption that established a divide between the norm and what it considered 'excess'. Excess, that is, of virtuoso effects that might distract from the purpose of art.

I hope I need not stress here that I do not think this highly schematic mental diagram can ever do justice to the richness of historical development. I have dwelt on it mainly as an example of what I propose to call the principle of sacrifice, in contrast, that is, to what I have called the principle of exclusion. It will be remembered that the principle of exclusion is a very simple, not to say primitive, principle that denies the values it opposes. The principle of sacrifice admits and indeed implies the existence of a multiplicity of values. What is sacrificed is acknowledged to be a value even though it has to yield to another value which commands priority.[24] But the mature artist will never sacrifice more than is absolutely necessary for the realization of his highest values. When he has done justice to his supreme norm other norms are allowed to come into their own.

I think these two principles which I have here contrasted are so often confused because the partisans of movements in art tend to be *terribles simplificateurs*. Radical exclusion is something everyone can understand. Relative sacrifice is a more complex and more subtle matter. For all critics of the past both Beauty and Truth were acknowledged values. What Caravaggio was accused of—to take up the previous example—was to have sacrificed Beauty to Truth, while the academic tradition was attacked for sacrificing Truth to Beauty. The true accusation in both cases was perhaps that both sacrificed more of the rival value than was absolutely necessary to do justice to their supreme norm.

The historian will frequently find that opposing camps of critics have more in common than they admit. *Rubénistes* and *Poussinistes*, Delacroix and Ingres, Wagner and Brahms, shared so much common ground that their differences concerning certain priorities of value loomed all the more largely. Seen from a distance these differences partly disappear.

The same cannot be said of a true principle of exclusion such as the absence of ornament in functionalism or the absence of symmetry from abstract expressionism. Such extremes may be amenable to a purely neutral morphological description. They could be noticed by an archaeologist from Mars even when life on this planet was extinct. Most stylistic changes have more to do with the mutual adjustment of

conflicting norms which can perhaps be understood but never measured by any objective formal criterion.

To think that they could was only possible to a conception of art that tried to take art out of the context of life and purpose. I agree with Professor Guzzo that no aesthetics can ever be built on such isolation. He shows that there is no necessary conflict between the criticism of, say, an industrial model and a work of art.[25] It is a comparison which I have used myself in order to illustrate the element of a problem solution in art. I should like to return to this aspect in conclusion, because here we have a simple illustration in which normative criticism does not exclude an objective description.

Those who commission a machine or a plant give the designing engineer certain specifications about the performance, size, weight, stability, cost, durability and so on. It is likely, for argument's sake, that size, weight and stability go together but that costs would be higher with either very large or very small machines. Performance may be good in one solution but extreme speed may threaten durability. Those who adjudicate between various rival solutions must make up their minds about these priorities. In addition they may find that there are other unspecified demands that all take for granted, either with or without good reason. The best solution may be inadmissible if it takes so long to complete that the machine would be likely to be obsolete before it comes off the drawing board. The best performance would be useless if it was likely to result in accidents. What I want to stress with this trivial example is only that our more fortunate colleagues in industry usually know the criteria by which they judge solutions, and, what is more, they also know the hierarchy of values and the order of priority which is implied in their norm. What they do not know and cannot predict beforehand is the ingenuity of a solution that questions one of the unspoken specifications and yet does justice to all the demands—an unexpected invention such as the hovercraft, for instance, which neither flies nor runs on wheels, but glides on an air cushion and thus necessitates a re-writing of all previous specifications for vehicles.

Neither normative criticisms nor morphological description alone will ever give us a theory of style. I do not know if such a theory is necessary; but if we want one we might do worse than approach artistic solutions in terms of those specifications which are taken for granted within a given period, and to list systematically, and even, if need be, pedantically, the priorities in the reconciliation of conflicting demands. Such a procedure will give us a new respect for the classical but will also open our minds to an appreciation of non-classical solutions representing entirely fresh discoveries.

Mannerism: The historiographic background

> It is important at this point to state that there is no one definite principle available *a priori* and enabling a classification suitable for every purpose to be made. . . .
>
> The necessity of introducing some classification and the caprice attaching to it is most striking . . . in history . . . the necessity continually arises of making distinctions which are seen on close consideration to be fluid and inadequate. . . . Max Planck[1]

ANYONE who has read through G. N. Fasola's useful paper 'Storiografia del manierismo'[2] or, better still, through the literature she listed or overlooked— and I cannot claim to belong to this second category—will realize how applicable this extract from Max Planck is to our particular problem. In such a Babylonian confusion of tongues it may well be useful, as a preparatory step, to go back to the origins of the concept of Mannerism. The four brief texts I have assembled and translated here are intended to facilitate this orientation.[3] If they seem at first to be out of place in a discussion of recent concepts, I would plead that, as historians, we know how intimately the 'recent' is bound up with the remote. Nowhere, moreover, is this more relevant than in the study of such categories as are represented by our stylistic concepts.

There are historians who are 'realists' in the mediaeval sense of the term. Holding fast to the belief that *universalia sunt ante rem*, they would maintain that Mannerism, for instance, has an existence of its own, and even an 'essence' that might be thrashed out in our discussion or intuited through *Wesensschau*. There are others who are nominalists in the sense of this ancient controversy, and who only acknowledge the existence of individual works of art, dismissing our categories as mere *flatus vocis*. They scorn concepts because they want to get down to facts. I confess that I have more sympathy for their attitude than for that of their opponents, but it has been amply proved that it, too, lands us in insuperable methodological perplexities.[4] Which are our facts? There must be some criterion of relevance, and this can never be found in any particular facts themselves. It follows that stylistic concepts can never be derived from accumulated observations of unselected monuments. It may be said that 'ideally' we should clear our minds of all preconceived ideas and look at one work of art after another produced in a given period or area, noting down diligently what they have in common. But those who approach a problem with an empty mind will inevitably get an empty answer. If you ask a truly unprejudiced investigator to find out what most paintings of a period have in

This paper was a contribution to the Twentieth International Congress of the History of Art at New York in 1961.

common, he may come up with the answer that they all contain carbon. It was to avert this kind of intellectual disaster that Aristotle introduced the distinction between essential and inessential definitions. But with this harmless-looking step he opened the way to the 'realist' belief in the independent existence of 'essences'. It seems that we have, after all, to know what is 'essential' to Mannerism if we want to get hold of examples of Mannerist paintings.

As a matter of fact the deadlock is not so serious as it sounds. It is true that we cannot approach the past without preconceived notions, but nothing forces us to hold on to them if they prove unsuitable. If anyone were convinced that Mannerist paintings are 'entirely devoid of space' (to quote an examination answer I remember), he could probably return with the verdict that no such painting could be discovered between ancient Egypt and Mondrian, and even this negative result would be a result, after all. For, if I may quote a remark Sir John Summerson once made in a discussion on this subject, stylistic categories have the character of hypotheses. We test them in observation. If I try to examine the origins and credentials of the concept, it may help to explain why I believe such a discussion to be particularly important in the case of Mannerism. We shall find, I believe, that, like any such intellectual category, it was created *a priori*, as it were, to meet a historiographic need, and that it finally triumphed as an idea that had as yet scarcely proved its value in contact with the facts of the past. This need not mean that it cannot fit the facts, but it must alert us to the possibility of a radical revision.

The main historiographic pattern which classical antiquity bequeathed to the Western tradition is that of progress towards an ideal of perfection. The advantage of this pattern in giving coherence to the history of any art was demonstrated by Aristotle for the story of Greek tragedy, by Cicero for the rise of oratory and, of course, by Pliny for the rise of painting and sculpture. For the late-born critic, however, the pattern had a grave drawback. It lies in the nature of this conception of the gradual unfolding of an ideal that it must come to a stop once perfection is reached. Within the pattern the subsequent story can only be one of decline—which may be bewailed in general terms but hardly chronicled as an epic of individuals each making his contribution to this dismal story. There is only one way in which a great individual or group can be introduced into this post-classical sequence: by recourse to a second historiographic pattern of even more mythical origin, the idea of rescue and restoration, the return of the golden age through some beneficent agency.

My first text is an example of this technique from the writings of Dionysius of Halicarnassus, which deals with the restoration of oratory to pristine Attic perfection after the debauches of 'Asianism'.

The affinity of this pattern with that of the Renaissance hardly needs elaboration.

The restoration of good letters is a constant theme of the humanists, and Vasari, as we know, applied it not as the first but as the most detailed and persuasive historian to the history of art. The part of the Asian villains is taken by the Goths, and once more Italy came to the rescue and allowed a new cycle towards perfection to begin again, which leads 'da Cimabue in puoi' to the perfection of Michelangelo.

This triumphant imposition of a coherent reading on the history of the arts in Italy presented subsequent generations with the same problem that had faced the post-classical critics of the ancient world. What was there that remained to be told and how could it be subsumed under some intelligible concept? Clearly the only way to describe the history of art after Michelangelo was either in terms of decline and corruption or in terms of some new miraculous rescue. My second and third texts are designed to show that that is what really happened. In the great new upsurge of painting in Rome a generation after Michelangelo's death, Caravaggio is cast in the role of the seducer and Carracci as the restorer of the arts to a new dignity. In between lies the slough of despondency into which the new Asians—the Mannerists—had cast the arts.

But the seventeenth-century critics and historians who wanted to write this story found more descriptive tools in Vasari than this inevitable pattern of rise and fall. For Vasari was not only an historian, he was also a critic, and being himself a painter of the epigonic generation he gave a much clearer idea of the way ahead than he is usually given credit for.

We oversimplify his scheme if we draw attention only to the pinnacle on which he placed Michelangelo. It is true that Vasari saw in Michelangelo the master who had brought the most noble and most central task of art to unsurpassable perfection, the rendering of the beautiful human body in motion. But as a practising painter Vasari shows himself very much aware of the fact that there are other tasks, slightly less exalted perhaps, but no less useful to the painter, and in these Michelangelo had left the field to others, notably to Raphael. If Michelangelo is the highest peak, Raphael is a neighbouring range only slightly less high but much easier of ascent.

It is in the life of Raphael that Vasari adumbrates and anticipates the historiographic pattern his seventeenth-century continuators were to use. For Raphael was, in a sense, the first great artist who lived under the shadow of Michelangelo's achievement and, therefore, the first to show the way to those who came after him.

Well known though these passages are, I still want to quote some extracts, though they lose some of their force when they are not seen in their full context towards the close of that remarkable biography:

Since he could not reach Michelangelo in that field to which he had put his hand, Raphael resolved to see him equalled and perhaps surpassed in the other parts, and thus he did not devote himself to imitate the manner of that master, so as not to waste time in vain in that pursuit, but rather turned himself into a first-class all-rounder in those

other parts mentioned. If only many other artists of our time, who desired exclusively to pursue the study of Michelangelo's work, had done the same! Instead of failing to emulate him and to attain to his perfection, they would not have laboured in vain, nor produced a very harsh manner full of difficulties, without beauty, without colour, and poor in invention [*nè fatto una maniera molto dura, tutta piena di difficultà, senza vaghezza, senza colorito, e povera d' invenzione*], while if they had tried to become all-rounders and to imitate the other aspects, they could have been of use to themselves and to the world.[5]

We also learn how Raphael proceeded towards this goal, how he selected the manner of Fra Bartolommeo as his foundation, 'and mixed it with the best he found in other masters to make out of many manners one single one, which was from then onward considered his own, which was and will always be infinitely esteemed by artists'.

We know that Vasari thought that Raphael did not quite avoid the temptation of competing with Michelangelo and thus doing harm to his reputation. He winds up this assessment with a homily to artists on studying their own bent and natural inclinations, for nobody can do more than nature has endowed him to do. Uccello and Pontormo are named as warning examples of artists who did not know their station, as it were, and who thus toiled in vain.

I have concentrated on this well-known text because I think that it really contains the whole subsequent history *in nuce*. Agucchi, Baglione and Bellori, Passeri and Malvasia, who wanted to continue Vasari's *œuvre* and allocate a proper place of glory to Annibale Carracci, could hardly do otherwise than present him as a saviour from decline who at last understood the importance of Raphael's precept and selected a perfect mixture of styles, thus overcoming the debased and problematic *maniera* of the affected imitators of Michelangelo.

As far as the position of Annibale in this scheme of things is concerned, I can afford to be brief, since a relentless critic of this hypothesis has arisen in Denis Mahon, who has tested the *fable convenue* of his eclecticism against the facts of Annibale's life and art and found it wanting.[6] Mahon has also described how the decline in prestige of the classical theory of art since the days of Romanticism has turned a historiographic pattern originally meant as a eulogistic conceit into a category of abuse. What I want to stress in conclusion is the corresponding swing of taste that turned abuse of Mannerism into eulogy. As the prestige of classical perfection went down, that of any movement that could be seen in contrast to this perfection was bound to go up. In the nineteenth century the revulsion against the real or pretended ideals of Raphael and the Carracci took the form of Pre-Raphaelitism. It was not before the revolutions of twentieth-century taste that the conclusion began to be drawn that if the alleged reaction against Mannerism attributed to the Bolognese was really 'a bad thing', then post-Raphaelite Mannerism may have been 'a good thing' after all. This revision was facilitated by the very scheme of things

imposed by Bellori, who saw the balance of perfection threatened from two sides, from that of vulgar naturalism on the one side, and that of bizarre conventionalism on the other. The extract from Dvořák's lecture of 1920 on Greco—one of the first rehabilitations of Mannerism—shows that twentieth-century critics who participated in the reaction both against Academic *art officiel* and against Impressionism had no difficulties in understanding and applying this tripartite scheme. For them, both Naturalism and Classicism were anathema. Is it surprising that they saw in the rejected alternative of Mannerism the predecessor of an anti-realistic and anti-idealistic modern art, maligned as their friends were maligned?

Add to this the Hegelian dogma, according to which all artistic trends must of necessity be interpretable as manifestations of the dialectic upward movement of the human spirit that manifests itself in all aspects of an age, and you have Dvořák's basic hypothesis—which enthroned Mannerism as the expression of a spiritual crisis and upsurge in which the anti-materialists and the anti-humanists of our age could find their own image.[7]

All this could be inferred without any reference to the works of art themselves. I did not discuss any examples and none are needed for this analysis. For this network of categories and its fate in the hands of critics has a momentum of its own that is rather divorced from the real events of the past. Mannerism has become a vogue-word, but such key monuments of the period as the fresco cycle in the Palazzo Vecchio in Florence (not exactly an unimportant commission) are still unpublished.

Could it be that many works of art produced in the later Cinquecento are less attractive to our critics and historians than is the idea of an anticlassical art? For here, I think, is the salient point. The concept of Mannerism as a separate style and period arose originally from the need to set off certain works from an ideal of classical perfection. It therefore became by itself the label for something considered unclassical. But while the idea of progress towards more accurate imitation of nature has an objective element that can be tested against the facts, the ideal of classical perfection is much more elusive or, if you like, subjective.[8] We have become so used to setting the accent somewhere near the Stanza della Segnatura that we experience any deviation from this particular solution as less harmonious. This leaves us only with the choice of regarding these—to us—unclassical developments as symptoms of decline or of deliberate rebellion. But surely, to those who lived through those years this would have seemed an entirely false and artificial alternative. While they subscribed to the idea of artistic progress, they certainly did not yet subscribe to the idea of a final culmination. On the contrary, I believe, as I have said elsewhere,[9] that certain aspects of Mannerism can be seen as a kind of feedback effect caused by the very idea of artistic progress. Could this effect even have led to an objective

decline? Can it ever be proper to talk in these terms, or should we rather look at each of the works produced in the period as efforts in their own right, created in a given situation? Which concepts of Mannerism put forward in the last few decades can best help us to do precisely this?

TEXTS

I. Dionysius of Halicarnassus. *On the Ancient Orators* (c. 25 B.C.). Dionysii Halicarnasei *Opuscula*, ed. H. Usener and L. Radermacher, I (Leipzig, 1899), pp. 3–5. For a full and more literal translation of the *Proemium* see J. D. Denniston, *Greek Literary Criticism* (London, 1924).

My dear Ammaeus, we must be thankful to our own time both for the progress of other enterprises, as most of all for the great advance made in the study of civic oratory. For in the preceding period the ancient and philosophic rhetoric was flouted, grossly outraged, and debased. Its decline and gradual decay began with the death of Alexander the Great, and in our own generation it reached the verge of extinction. Another rhetoric sneaked into its place—one intolerably showy, shameless, and licentious, without any trace of philosophy or any other liberal art. Craftily it deluded the ignorant mob. It lived in greater wealth, luxury, and grandeur than its predecessor and fastened itself to those positions that should by right have belonged to the philosophic rhetoric. . . . As when a riotous strumpet lords it in a household over a lawful, freeborn, and virtuous wife, spreading confusion on the estate and claiming the property by stealth and intimidation, so the Attic Muse, of ancient and indigenous lineage, was stripped of her dignities and covered with shame in every city and centre, whereas her rival who had but yesterday emerged from the low dives of Asia, a Mysian or Phrygian prostitute or some Carian abomination, presumed to govern Greek states, driving the true queen from the council chamber—the ignorant ousting the learned, the wanton the chaste. . . .

I believe the cause of that great transformation for the better to have been Rome, the mistress of the world, who drew all eyes upon herself, and in particular those who rule in that city, distinguished by their high character and by their conduct of public affairs. . . . I should not be surprised if, thanks to them, that former fashion for raving oratory failed to survive another generation.

II. G. B. Agucchi, *Trattato* (c. 1610). Tr. after the text in Denis Mahon, *Studies in Seicento Art and Theory* (London, 1947), pp. 245, 247.

After Painting had been as good as buried and lost for many centuries, the art had masters in our modern times who brought about a kind of rebirth from those first rude and imperfect beginnings of its origins. It would not have been reborn and perfected so speedily, however, had the modern artists not had the shining example of the ancient statues in front of their eyes, preserved up to our own days. It was from these (as also from the works of Architecture) that they were able to learn that delicacy of design which has, to such an extent, opened the way to perfection. . . .

It is the truth that the aforementioned masters and so many other worthy artists who

followed in their footsteps proceeded to the perfection of art and thus acquired for our age the glory of rivalling the age of antiquity, when an Apelles or a Zeuxis with works of marvellous beauty inspired orators and writers to sing the praises of their brush; it is no less true, however, as will not have escaped persons of sound understanding, that after the times in which the heads of schools or aforementioned styles of our age flourished, and when all the others strove to imitate those masters with good taste and knowledge, it came to pass that Painting declined from the peak it had reached to such an extent that, though it would not have fallen again into the utter darkness of its former barbarism, it became at least changed, corrupt, straying from the true path, so that knowledge of the good was almost entirely gone, while new and different manners arose, remote from the truth and from the plausible, more wedded to appearances than to true substance, with the artists content to feast the eyes of the populace with fine colours and gaudy dresses[10] and making use of things cribbed from all over the place; poor in outline, rarely well composed and indulging in other notable errors, they strayed altogether far from the right path that leads to the best.

But while that beautiful profession was thus infected, as it were, by such artistic heresies and in danger of getting lost completely, there arose in the city of Bologna three persons. . . .

III. G. P. Bellori, 'Vita di Annibale Carracci', *Le vite* . . . (Rome, 1672), pp. 19–21, 79.

It was at the time when Painting was most admired among men and appeared to have descended from Heaven, that the divine Raphael brought its beauty to perfection by the finishing touches of art, bringing it back to the ancient majesty of all the graces and enriching it with all the excellences that had rendered her most glorious in an earlier time among the Greeks and the Romans. But since, down here on earth, nothing ever remains unchanged, and since what has reached a peak must of needs turn and come to a fall, in a perpetual up and down, we find that the arts, which from Cimabue and Giotto onward had little by little advanced in the long course of two hundred and fifty years, were soon seen to decline, and from a royal state become humble and vulgar.[11] For when the happy age waned, all its form dissolved. Artists abandoned the study of Nature and adulterated the arts with manner, that is to say, with a capricious conceit founded on routine rather than on the imitation of reality [. . . *vitiarono l' arte, con la maniera, ò vogliamo dire fantastica idea, appoggiata alla pratica; e non all' imitatione*]. The first germ of that destructive vice showed up in the painting of highly reputed masters and it then struck roots in the subsequent schools. It is incredible to what a degree the arts degenerated, not only in comparison with Raphael, but also of those others who initiated the manner. . . . In that protracted agitation, the arts were assailed by two opposite extremes, one consisting in the complete submission to natural appearances, the other to the imagination. Their originators in Rome were Michelangelo da Caravaggio, and Giuseppe di Arpino. The first simply copied objects as they appear to the eye, without selection; the other did not even look at nature and merely gave free rein to impulse [*seguitando la libertà dell'instinto*] and both of them, favoured by enormous success, were regarded by the world as admirable and worthy of imitation. It was at that point, when Painting was declining towards its end, that more favourable stars looked down on Italy and that it pleased God that in the city of Bologna, Mistress of Science and of Scholarship, there should arise a most elevated genius, and

H

that with him the arts that had fallen and become all but extinct were to rise once more. That man was Annibale Carracci, whose life I now intend to write. . . .

We are obliged to his studies and his erudition, venerating him as the restorer and the prince of the reconstituted art. . . . He showed a way to profit from Michelangelo, which had not been followed by others and which is again neglected today: for he left the manner and the anatomies of the *Last Judgment* on one side and looked instead at the beautiful nudes of the ceiling. . . . He dedicated himself to Raphael, whom he took as his master and guide in narrative painting, but improved on his invention and extended his skill to the rendering of emotions and the grace of perfect imitation. His peculiar style was the fusion of the idea and of nature, gathering up in himself the most worthy excellences of earlier masters. . . .

IV. Max Dvořák, 'Über Greco und den Manierismus' (lecture delivered October 1920), *Kunstgeschichte als Geistesgeschichte* (Munich, 1924), pp. 275–6.

Not many words are needed to explain why Greco was bound to be increasingly forgotten in the subsequent two centuries, the centuries dominated by natural science, materialist thought, belief in causality and technical progress, when civilization was a matter of mechanization, of eyes and brain but no heart. Today this materialist civilization is approaching its end. It is less the external collapse I have in mind, for this was only a symptom, than the internal one that has been discernible for a generation now in all fields of life: in philosophy and intellectual life, where the humanities have again taken the lead, and where even in science the foundations of that old positivism, which were considered so firmly grounded, have been thoroughly shattered; literature and the arts have turned towards spiritual absolutes, as they did in the Middle Ages and in the period of Mannerism, and have turned their backs on fidelity to sensuous nature. There is a uniformity in all these events, which the mysterious law of human destiny seems to guide towards a new, a spiritual and anti-materialist age. In that eternal struggle between matter and spirit, the scales are inclining towards a victory of the spirit, and it is to this turn of events that we owe our recognition of Greco as a great artist and prophetic mind whose glory will continue to shine brightly.

The Renaissance Theory of Art and the Rise of Landscape

THERE exists, I believe, a doctoral thesis on the subject of landscape painting in the Catacombs, the first section of which bears the memorable heading: *The Reasons for the Absence of Landscape Painting from the Catacombs*. The title of this article may well evoke apprehensions about its dealing with a topic of similar magnitude. The space devoted to landscape painting in Renaissance writings on artistic theory is so small that the subject would hardly deserve much attention were it not for one startling fact—that in a good many cases these references precede the practice they purport to describe. I do not remember if the *doctorandus* mentioned above came to the conclusion that Catacomb art had an important influence on the branch of painting so conspicuously absent from its repertoire, but it is certainly the intention of this article to suggest that landscape painting as we know it might never have developed without the artistic theories of the Italian Renaissance.

To remove this assertion from the sphere of paradoxes only one clarification is needed. By landscape painting I do not mean any rendering of the outdoor scene, but the established and recognized genre of art. This important distinction cannot be better illustrated than through the words of a seventeenth-century painter who had been in personal contact with Rubens and Paul Bril. Writing in about 1650, Edward Norgate devoted several pages of his *Miniatura* to landscape, 'of all kinds of painting the most innocent, and which the Divill himselfe could never accuse of Idolatry'.

> . . . it doth not appear that the antients made any other Accompt or use of it but as a servant to their other peeces, to illustrate or sett of their Historicall painting by filling up the empty Corners, or void places of Figures and story, with some fragment of Landscape . . ., as may be seene in those incomparable *Cartoni* of the Acts of the Apostles. . . .
>
> But to reduce this part of painting to an absolute and intire Art, and to confine a man's industry for the tearme of Life to this onely, is as I conceave an Invencon of these later times, and though a Noveltie, yet a good one, that to the Inventors and Professors hath brought both honour and profitt.[1]

The story which Norgate tells of the invention of this new genre will detain us later. What matters here is that landscape painting was felt to be a real discovery. For this distinction between landscape backgrounds and Landscape as 'an absolute and entire Art' has perhaps become a little blurred. Indeed, most historians of the subject appear to take the view that the one developed gradually out of the other.[2]

This paper was one of a collection of essays presented to Hans Tietze on the occasion of his 70th birthday, March, 1950.

We hear how the naturalistic landscape backgrounds of fifteenth-century paint-ings swallow up the foreground, as it were, in the sixteenth century till the point is reached with specialists such as Joachim Patinier, whom Dürer called 'the good landscape painter',[3] where the religious or mythological subject dwindles to a mere 'pretext'. Though sporadic attempts by isolated geniuses such as Lotto and Alt-dorfer to do without a subject altogether are noted, it appears from these accounts that landscape painting in the modern sense was introduced by such minor masters as Jakob Grimme or Herri met de Bles who paved the way for Pieter Breughel.[4]

One may admit the substantial accuracy of this picture and yet feel that something must be missing from it. It somehow fails to do justice to what Norgate called the 'Noveltie' of the *genre* which here seems to emerge through the sheer atrophy of religious painting. Yet of all the '*genres*' which the sixteenth-century 'specialists' began to cultivate in the North, landscape painting is clearly the most revolutionary. *Genre* painting proper remained for a long time wedded to the didactic conceptions of mediaeval art, illustrating proverbs and pointing moral lessons. Even still-life painting could draw its justification from the allegorical and emblematical tradition which sanctioned such motifs as *Vanitas* symbols or representations of the Five Senses. Of course, Landscape too has its traditional themes, such as the *Occupations of the Months* or the *Four Seasons*, but it could hardly point to such isolated themes as its sole *raison d'être*. Yet, after the middle of the sixteenth century, landscape be-came an acknowledged subject for both paintings and prints. In the interiors of art shops and collectors' 'cabinets' painted by Jan Breughel or H. Jordaens (Fig. 145), 'pure' landscapes are shown to belong to the regular stock in trade.[5] It is the period when van Mander devotes a whole chapter of his didactic poem to this important branch of art. Landscape painting had become an institution. It is with this institu-tional aspect, not with the stylistic development, that this paper is concerned. The difference between these aspects may be demonstrated by one famous example: to the stylistic approach Dürer was one of the world's great landscape painters. Yet, as E. Tietze-Conrat has shown,[6] he never took the step into the institution of land-scape painting. He probably regarded his famous topographical watercolours as studies which he could not sell for honest money. Even Lotto, who painted his first pure landscape under the influence of Dürer's art, may have been encouraged to take this step by another institutional tradition—his landscape predella really forms part of a frame, and may thus have been connected in his mind with the intarsia *vedute* on stalls and woodwork. How different is the position after the middle of the sixteenth century. A Lautensack, a Hirschvogel (Fig. 146), or a Coninxloo re-gard it as their trade to produce landscapes, and their products are accepted as a matter of course.

In his fundamental essay on landscape painting, M. J. Friedländer devoted some pages to the emergence of this type of 'specialist'[7]—the artist who no longer

carries out varied commissions from individual patrons but works for a market of anonymous consumers, in the hope that his wares will find favour with the public. It was the competition in this open market, so Friedländer implied, that caused the painters, crowded into the teeming export centre of Antwerp, to resort to the development of new specialities. What had probably been a practice inside the late mediaeval workshop, the division of labour into figure painters, background painters and, say, still-life specialists, now broke up into the various '*genres*' to be cultivated by those most likely to make a living by any given speciality.

The importance of this explanation for our 'institutional' aspect is evident. The landscape specialist is obviously the most tangible representative of this institution, but equally clearly he cannot function without his counterpart, the consumer or collector, who creates the demand. What type of public provided the market for this unprecedented kind of painting—or, to put it as concretely as possible, how could anyone demand landscape paintings unless the concept and even the word existed?

It is in Venice, not in Antwerp, that the term 'a landscape' is first applied to any individual painting. To be sure, the painters of Antwerp were far advanced in the development of landscape backgrounds, but there is no evidence that the collectors of Antwerp had an eye or a word for the novelty. The inventories of Margaret of Austria, Regent of the Netherlands, which may be taken as representative of the most cultured taste of a Northern household in the first decades of the sixteenth century, do not contain a single reference to a painting without a subject—be it landscape or *genre*.[8] But at the very time when these inventories were drawn up Marc Antonio Michiel uses the expression 'a landscape' quite freely in his notes.[9] As early as 1521 he noted *molte tavolette de paesi* in the collection of Cardinal Grimani[10] and the contrast with the Northern inventory is all the more interesting in that these paintings were by the hand of Albert of Holland.[11] We do not know if they were pure landscapes—probably they were not—but for the Italian connoisseur they were interesting as landscapes only. There are various similar entries in Marc Antonio's lists, the reference, for instance, to 'the landscapes on large canvases and others drawn on paper with the pen by the hand of Domenico Campagnola';[12] but the most memorable is perhaps the description of Giorgione's *tempesta* as 'a small landscape [*paesetto*], on canvas, with a thunderstorm, a gipsy and a soldier'.[13] Whatever else the painting may illustrate, for the great Venetian connoisseur it belonged in the category of landscape painting.

Marc Antonio's references to 'landscapes' are by no means isolated in the world of Italian connoisseurs. We hear that in 1535 Federigo Gonzaga of Mantua was offered a collection of 300 Flemish paintings of which he bought 120. 'Among them,' says an eyewitness, 'are twenty which represent nothing but landscapes on fire which seem to burn one's hands if one goes near to touch them.'[14] Thirteen

years later Vasari writes in a well known letter that 'there is not a cobbler's house without a German landscape'.[15] Even if we make allowance for the exaggeration contained in this passage, its importance remains considerable. To Max J. Friedländer it seemed that, while the development of landscape painting in Antwerp was amenable to historical analysis, the sudden appearance of landscape paintings and etchings in the Danube region (Fig. 147) must cause the historian to admit defeat.[16] But if, as this evidence suggests, the development of landscape painting followed a demand that existed in Southern markets, the simultaneous appearance of such works in widely separated areas would no longer look so mysterious. There are, indeed, various indications that this demand was the gift presented by the Renaissance South to the Gothic North.

The first condition for such a demand arising is, of course, a more or less consciously aesthetic attitude towards paintings and prints, and this attitude, which prizes works of art for the sake of their artistic achievement rather than for their function and subject matter, is surely a product of the Italian Renaissance. Fifty years ago, at least, this statement would have been a commonplace. Today the reaction against too facile an acceptance of this very view has led us to insist so much on the religious and symbolic significance of Renaissance art that the balance must perhaps once more be restored. When the same Federigo Gonzaga who bought the Flemish 'landscapes on fire' tried to obtain a work by Michelangelo he told his agent, as any collector would:

> And should he by any chance ask you what subject we want, tell him that we desire and long for nothing but a work by his genius, that this alone is our particular and foremost intention and that we do not think of any one material rather than of another, nor have at heart one subject rather than another, if only we can have an example of his unique art.[17]

Such a radical change in the very concept of art could not and did not develop overnight. We find many traces of it in those sixteenth-century texts which allow us to follow the emergence of the idea of art as an autonomous sphere of human activity. In this atmosphere of art collecting and connoisseurship Flemish art is soon accorded a special place.[18] The very leaders of Renaissance fashion in fifteenth-century Florence were the keenest buyers of Flemish tapestries and paintings,[19] and it is to Facius, a Neapolitan humanist, that we owe the first appreciation of the great Northern masters.

The ground was thus well prepared in Italy for a demand for Northern paintings, to be admired not for their subject matter but for other qualities. And yet it might never have been sufficient to make Northern artists abandon subject matter altogether, had it not been for the fact that Italian artistic theory put the idea of landscape painting on the map.

In Alberti's *Ten Books on Architecture*, written, it is believed, about 1450 and

first printed in 1486, we find a chapter[20] on the decoration of buildings and interiors. There we read:

Both Painting and Poetry vary in kind. The type that portrays the great deeds of great men, worthy of memory, differs from that which describes the habits of private citizens, and again from that depicting the life of the peasants. The first, which is majestic in character, should be used for public buildings and the dwellings of the great, while the last mentioned will be suitable for gardens, for it is the most pleasing of all.

Our minds are cheered beyond measure by the sight of paintings depicting the delightful countryside, harbours, fishing, hunting, swimming, the games of shepherds—flowers and verdure. . . .[21]

There is still, in this astonishing passage, an emphasis on human activity which separates it from the idea of 'pure' landscape. Alberti, one would imagine, was probably as fond of Northern tapestries with their scenes of hunting and hawking as were the Medici at the time when these pages were written. But through his very reflections on these Northern themes the emphasis is subtly changed. He sees these paintings not merely as decorations but as Art to be treasured for its psychological effect. This is made even more explicit in another passage of the same chapter:

Those who suffer from fever are offered much relief by the sight of painted fountains, rivers and running brooks, a fact which anyone can put to the test; for if by chance he lies in bed one night unable to sleep, he need only turn his imagination on limpid waters and fountains which he had seen at one time or another, or perhaps some lake, and his dry feeling will disappear all at once and sleep will come upon him as the sweetest of slumbers. . . .

For Alberti, then, painting is no longer illustration or decoration. In its effects on the human mind it is linked with music, in its categories with poetry. It was out of these hints that Leonardo was to develop the first complete aesthetic theory of landscape painting—even before the first landscape had come into existence.

Leonardo's notes, of course, are crowded with references to landscape painting, but it is not these detailed observations of natural phenomena which seem to me decisive. These, after all, could also be used, and were probably intended to be used, in the treatment of landscape backgrounds. But there are passages in Leonardo which far transcend these technical hints and place the entire conception of painting firmly on that new foundation from which alone landscape painting can be envisaged as an independent activity.

Thus we read in a famous section of the *Paragone*:

If the painter wants to see fair women to kindle his love, he has the power to create them, and if he desires to see monstrosities to arouse his fear, his amusement and laughter or even his compassion, he is their Lord and Creator. And if he wishes to bring forth sites or deserts, cool and shady places in times of heat or warm spots when it is cold, he

fashions them. So if he desires valleys or wishes to discover vast tracts of land from moun-
tain peaks and look at the sea on the distant horizon beyond them, it is in his power; and
so if he wants to look up to the high mountains from low valleys or from high mountains
towards the deep valleys and the coastline. In fact, whatever exists in the universe either
potentially or actually or in the imagination, he has it first in his mind and then in his
hands, and these [images] are of such excellence, that they present the same proportioned
harmony to a single glance as belongs to the things themselves. . . .[22]

The claims made for the painter in this momentous passage exceed everything
that had ever been put forward before. If Alberti looks at painting from the point
of view of its psychological effect on the beholder, Leonardo probes deep into the
motive powers of the creative process itself. If Alberti parallels poetry and painting
for their range of subject matter, Leonardo draws the ultimate conclusions from
the Horatian *Ut pictura poesis* by claiming for the painter the prerogatives of
genius. And what he creates derives its relevance not from any association with
important subject matter but from the fact that—like music—it will reflect the
harmony of the Universe itself.[23]

We do not know how far Leonardo's extreme theories were known or approved
of by the cultured art lovers of Milan or of Venice.[24] But the idea of painting as a
kind of poetry, which had the authority of Horace, was certainly widely accepted.[25]
It may lie behind Bembo's advice to Isabella d' Este not to tie Giovanni Bellini too
closely to a programme as he preferred to follow his own imagination.[26] Once this
attitude had become universal the idea of a 'pastoral' kind of painting must have
suggested itself to many. May we not infer that it was within such a framework
that a Giorgione created his new type of subject matter, that he was accepted by his
Venetian patrons as a painting Sannazaro or Tebaldeo rather than as a mere illus-
trator of obscure classical themes? And can one not imagine Cardinal Grimani
using a similar turn of phrase when explaining his Northern *tavolette di paesi* to a
puzzled visitor? The classical theory had created an atmosphere in which the pro-
ducts of Northern realism appeared in an entirely new and possibly unintended
light.

True, the pastoral genre of Giorgione or Campagnola (Fig. 148) is not yet pure
landscape painting. But if the Renaissance collector looked for authority to justify
his taste for non-illustrative painting, he could also find it in those classical writers
on art who increasingly supplied the vocabulary and standards of criticism.

It was to Pliny and his chapters on classical art that the educated Italian looked
for terms and categories to discuss and conceive the art of his time. And in Pliny
he would not only find the idea of landscape paintings but also the notion of the
specializing artist which remained for so long connected with it.

It might be quite a rewarding subject for a doctoral thesis to trace the applica-
tion of Pliny's sobriquets to one new artist after another in the literature of the

sixteenth and seventeenth centuries. Thus the enormous influence which his char-
acterization of Pyreicus, the proverbial painter of barbers' shops, as a 'filth painter'[27]
had on the subsequent estimation of genre painting in academic theory is familiar
to all students of Italian artistic literature. The label of '*rhyparographos*' was
transferred from master to master and from school to school with monotonous
insistence. But despite the condemnation which it implied, even the influence of
that passage was certainly not entirely detrimental to the development of *genre*
painting. Through it the specialist in that kind of subject had received a place in the
rigid world of artistic theory. And if a painter such as Pieter van Laer was ready to
put up with this identification with the mythical Pyreicus, his position in the world
of art was assured.[28] For does not Pliny concede that his works were full of gay
vitality and that they achieved a higher price than the greatest works of many other
painters?

This process of identifying living artists with figures from Pliny had already
begun in the fifteenth century.[29] In the sixteenth the habit was well established.
The whole world of art was seen through this pre-existing screen. Whatever could
be made to fit—and Pliny's terse and obscure references lent themselves to many
interpretations—could find entry into the collector's consciousness. The utterly
strange and bewildering art of Hieronymus Bosch, for instance, became identified
with the humorous category of the *Grilli*, to which Pliny alludes in rather cryptic
terms—and thus the first Northern 'specialist' was assured a niche in the painter's
pantheon.[30]

Now among the specialists mentioned by Pliny a landscape painter figures rather
prominently. It is the Roman painter Studius (or Ludius), who flourished under the
Emperor Augustus and earned fame, but little money, with wall paintings.

. . . He painted villas, porticoes and parks, groves, copses, hills, fishponds, straits,
rivers, shores, as anyone could wish. And there he painted all kinds of people walking
or going by ship, riding by land towards the villages on donkeys' backs or in carriages,
also fishermen, fowlers, huntsmen or vintagers.[31]

The fact that a master of the Golden Age had made a speciality of this kind of
subject matter could not but influence the appreciation of landscape painting
among the educated public of the Renaissance. Luckily this is a point where we
need not rely on mere conjecture. When Paolo Giovio, the great arbiter of art and
inspirer of Vasari's *Lives*, describes the work of Dosso in the late 'twenties or early
'thirties,[32] we clearly feel that he perceived his art through the medium of Pliny's
account:

The gentle manner of Dosso of Ferrara is esteemed in his proper works, but most of
all in those which are called *parerga*. For devoting himself with relish to the pleasant
diversions of painting he used to depict jagged rocks, green groves, the firm banks of

traversing rivers, the flourishing work of the countryside, the gay and hard toil of the peasants, and also the far distant prospects of land and sea, fleets, fowling, hunting, and all that *genre* so pleasing to the eyes in a lavish and festive style.[33]

Giovio's text is noteworthy for several reasons. First, because it may well be the earliest detailed description of landscape painting in modern times which refers not to a postulate like Alberti and Leonardo, but to actual contemporary work. Second, because in describing this work it uses—again, it seems, for the first time— the word *genus* in this context, *cuncta id genus spectatu oculis iucunda*, showing that to Giovio and his like-minded friends Dosso's landscapes (Fig. 149) did in fact fit into an acknowledged 'kind' or '*genre*' of art. Thirdly, because it shows that even in this early document the place of this new '*genre*' in the hierarchy of values has been settled.[34] Dosso shows his skill not only in his 'proper work', *justis operibus*, but even more in the *hors-d'œuvre* of art, in parerga which appeal to the eye. The term *parerga* or *parergia* is also derived from Pliny, who says that Protogenes, in his famous wall paintings in Athens, had included a number of small warships in 'what the painters call *parergia*' (i.e. accessories), to allude to his past as a ship's painter.[35] In this sense, as denoting landscape background, the term is already used in the North Italian *ambiente* of the Quattrocento—it occurs in one of the descriptions of fictitious paintings in Colonna's *Hypnerotomachia*,[36] thus confirming once more the wide influence of Pliny's descriptions.

Read in the context of Renaissance aesthetics, even the remark that this kind of *parerga* is pleasing to the eyes is somewhat double-edged in character. Great art, of course, must speak to the intellect and not to the senses, it must show invention, symmetry and proportion and lead the mind to the contemplation of higher things. Yet even these pleasing trifles had their function. As Alberti had observed, they could serve as legitimate recreation. Like the 'lighter veins' of poetry and music, they help to restore the tired spirits of the man of affairs.

From the point of view of the artistic theories of the Renaissance, it might thus be said that if such a kind of painting did not yet exist, it had to be invented. But in some form, of course, it did exist in the Northern traditions of realistic painting. Here, then, was a frame into which the admired products of Northern skill and patience could be fitted—and if the frame was a bit too small to admit the whole of these paintings, the 'Gothic' foreground subjects could, after all, be cut away to show the pleasing *parerga* to greater advantage.

It is hard to say when this attitude first reflected back on the art of the North. We can see its impact on an artist reared in the Gothic tradition in Francisco da Hollanda's *Dialogues*. The famous remarks about the 'Flemings' which the Portuguese convert to the academic creed put into the mouth of his 'Michelangelo' may be taken as typical. It is precisely the fault of the Northern masters, so we hear, that they paint to charm the outward eye by an assembly of pleasing objects—

'draperies, green fields, shady trees, rivers, bridges and what they call landscapes (*a que chaman paisagens*)'. But he is quick to add that he does not altogether condemn Flemish art for attempting these things, but only because they want to excel in too many fields, every one of which is sufficiently hard to demand a lifetime of study.[37]

The future course of Flemish painting under the influence of Renaissance prejudices is almost anticipated in this remark. The school, after all, did really split up into those who wanted to vie with the Italians in figure painting[38] and those who preferred to cultivate and exploit their traditional specialities rather than excel in too many fields.

The Renaissance view, in short, that the Flemings had a field of their own, if only in the *parerga* of art, was generally accepted, not only in the South but among the Northerners themselves. The view is neatly expressed in the verses which Lampsonius affixed to the portrait of a landscape 'specialist', Jan van Amstel.[39]

> Propria Belgarum laus est bene pingere rura;
> 　Ausoniorum, homines pingere, sive deos
> Nec mirum, In capite Ausonii, sed Belga cerebrum
> 　Non temere in gnava fertur habere manu
> Maluit ergo manus Jani bene pingere rura
> 　Quam caput, aut homines aut male scire deos. . . .

The implication that Northerners are famous for their good landscape painting because they have their brains in their hands, while Italians, who have them in their heads, paint mythologies and histories shows that Lampsonius accepts the academic prejudice. Yet, he adds, it is better to paint landscapes well than to bungle figures, and Jan van Amstel was right to stick to his last.

There is more in these verses than mere resignation to an inferior position. The idea that each nation and each school of art should do what it can do best is symptomatic of a complete change in the notion of art. The division of labour in the workshop of late Gothic times had served the practical aim of speeding up the work on a given commission. Now the division of labour no longer applies to a concrete painting but to Art as such. It is to Art as an abstract idea that each nation should make its contribution where it is best equipped to do so.

For centuries to come the position of Northern artists in the Italian world of art was determined by general acceptance of this view. From the Flemings whom Titian kept in his workshop to paint landscape backgrounds to Bril, Elsheimer, Claude and even Philip Hackert, the Northern artist in Italy could make a living if he accepted the role of the specialist into which he had been cast by Northern tradition and Southern theory.[40]

There is evidence that this apparent national superiority of the *oltramontani* in a certain branch of art puzzled their Italian colleagues at a relatively early date.

Writing in 1548 Paolo Pino[41] tries to account for it by a theory which deserves to be analysed.

> The Northerners show a special gift for painting landscapes because they portray the scenery of their own homeland, which offers most suitable motifs by virtue of its wildness, while we Italians live in the garden of the world, which is more delightful to behold in reality than in a painting.

What we find here is the first formulation of the idea of the 'picturesque', which is usually associated with the eighteenth century.[42] Italy, Pino says, may be the most beautiful country in the world, but it does not go well into pictures, while the wild tracts of land from which the *oltramontani* hail is the ideal painter's country. Pino obviously believed that the bizarre late Gothic rock formations which he saw in the paintings of Patinier and his followers (Fig. 150) faithfully represented the native land of these artists. But however that may be, his type of explanation survives in a less crude form in many more refined discussions of landscape art. We are referred to the rocks on the upper reaches of the Meuse as an explanation of Patinier's style[43] or to the impression made by Alpine scenery as the mainspring of Altdorfer's, Huber's or even Breughel's art. That elements of such natural scenery are sometimes reflected in the *œuvre* of these masters is quite well attested,[44] but as an explanation of the development of landscape painting these theories seem to me little better than Pino's. For if these examples show anything, they show how long and how arduous is the way between perception and representation. Sixteenth-century landscapes, after all, are not 'views' but largely accumulations of individual features; they are conceptual rather than visual.

It is in this context that Norgate's anecdote about the invention of landscape painting gains significance.

> The first occasion, as I have bene told abroad, was thus. A Gentleman of Antwerpe being a greet *Liefhebber* (Virtuoso or Lover of Art) returning from a long Journey he had made about the Countrey of Liege and Forrest of Ardenna, comes to visit his old freind, an ingenious painter of that Citie, whose House and Company he useually frequented. The Painter he finds at his Easill—at worke which he very dilligently intends, while his newcome freind, walking by, recountes the adventures of his long Journey, and with all what Cities he saw, what beautifill prospects he beheld in a Country of a strange scitiation, full of Alpine Rocks, old Castles and extraordinary buildings &c. With which relation (growing long) the prompt and ready Painter was soe delighted as, unregarded by his walking freind, he layes by his worke, and on a new Table begins to paint what the other spake, describing his description in a more elgible and lasting Character then the others words. In short, by that time the Gentleman had ended his long Discourse, the Painter had brought his worke to that perfection, as the Gentleman at parting, by chance casting his eye that way, was astonisht with wonder to see those places and that Countrey soe lively exprest by the Painter as if hee had seene with his eyes or bene his Companion in the Journey. This first Esay at Lanscape it seemes got the painter Crownes and Credit. This began others to imitate. . . .[45]

There is more in this story than a mere echo of the *Paragone*. As an ideal recon-struction of the 'first landscape' it could indeed hardly be bettered. It drives home the lesson of how little it owed to the painter's eye and how much to his imagination, how much the *Liefhebber* contributed to its origin and also how soon he was ready to recognize in any stock image of an 'Alpine rock', in any stereotype of an old castle or in any imaginary 'prospect' the very thing he had seen on his journey. And there is one more element in the story on which we must insist: the gentleman was an old friend of the ingenious painter. He usually frequented his house and returned to it from the journey with the sole purpose of telling him of all the picturesque sights he had seen. It was his acquaintance with the painter's work—we are free to interpolate—which attuned his mind to the sights of the trip. His enumeration of 'beauty spots' was already conditioned by the images he had seen before in the paintings of his friend.

In other words, I believe that the idea of natural beauty as an inspiration of art, the idea which underlies Pino's no less than more sophisticated writings, is, to say the least, a very dangerous over-simplification. Perhaps it even reverses the actual process by which man discovers the beauty of nature. We call a scenery 'pic-turesque'—as Richard Payne Knight knew long ago[46]—if it reminds us of paintings we have seen. And to the painter, in turn, nothing can become a 'motif' except what he can assimilate into the vocabulary he has already learned. As Nietzsche says of the realistic painter:

> 'All Nature faithfully'—But by what feint
> Can Nature be subdued to art's constraint?
> Her smallest fragment is still infinite!
> And so he paints but what he likes in it.
> What does he like? He likes what he can paint![47]

The origins of landscape painting cannot be understood without constant aware-ness of this truth. Thus if Patinier, for instance, really embodied reminiscences of the Dinant scenery in his paintings, if Pieter Breughel really found the Alpine peaks inspiring, it was because the tradition of their art had provided them with a ready visual symbol for steep isolated rocks which made it possible for them to single out and appreciate these forms in nature.

Admittedly, such questions of priority cannot often be settled empirically. But a few examples from the sixteenth century suggest that the process of 'Art into Landscape' which is so familiar from the eighteenth-century writers on 'picturesque beauties' had already begun at such an early date.

The example of Aretino's discovery of the beauty of Venetian sunsets through the medium of Titian's colour is too well known to bear quotation,[48] but another instance of awakened artistic sensibility may be mentioned here even though it is a little more conjectural.

It will be remembered that the Duke of Mantua bought a large 'set' of Flemish night scenes with burning cities—a motif which probably grew out of the hell landscapes by Hieronymus Bosch.[49] Now, we happen to know that in the years in which this purchase was made a young Italian, Cristoforo Sorte, worked in that city under Giulio Romano. Sorte's rare pamphlet *Osservazioni nella pittura*, published in Venice in 1580,[50] contains the first systematic treatment of landscape painting. The centrepiece of Sorte's attractive little book is a description of a fire he witnessed in Verona in 1541.

Sorte describes how one night he was roused by the pealing of bells and rushed towards the town where a terrible fire was raging. Having reached the Ponte Nuovo he stopped for a while to admire the 'marvellous effects of that fire because the places nearby and far away were at the same time illuminated by three different splendours'. He describes in truly painterly terms the red glow of the flames, the reflection of the scene in the tremulous waters of the Adige and the effect of the moonlight on the billows of smoke which merged with the clouds. 'And as I was a painter at that time I imitated it all in colours.' Describing his procedure in great detail, Sorte adds that his observations may come in useful for painters who want to represent such night scenes as the Burning of Troy or the Sack of Corinth. May we not assume that the sight of the catastrophe he witnessed would not have struck him as 'picturesque' if he had been unacquainted with this category of painting?

Similarly, so it seems, the discovery of Alpine scenery does not precede but follows the spread of prints and paintings with mountain panoramas. One of the first literary appreciations of an Alpine region, at any rate, bears such a striking resemblance to the typical landscape compositions of the period (Fig. 155) that the similarity can hardly be accidental. It was Montaigne who, in 1580, described the Inn valley as 'the most agreeable scenery he had ever seen'.[51]

Sometimes the mountains pressed close together, then again they opened up on our side of the river . . . and gave way to cultivable lands on the slopes of the mountains, where they were not too steep—and then vistas opened up on to plains on various levels, all full of beautiful noble dwellings and churches and all this enclosed and walled in from all sides by mountains of infinite height.

Thus, while it is usual to represent the 'discovery of the world' as the underlying motive for the development of landscape painting, we are almost tempted to reverse the formula and assert the priority of landscape painting over landscape 'feeling'. But there is no need to press this argument to its paradoxical extreme. All that matters in this context is that this movement in a 'deductive' direction from artistic theory to artistic practice, from artistic practice to artistic feeling does in fact deserve to be taken into account. Once this is granted the relevance of all theoretical subdivisions of landscape painting becomes apparent. For these we must turn from Pliny to Vitruvius.

In the seventh book of Vitruvius the Renaissance artist would find the chapter on wall painting in which the classical author bursts out in violent abuse against the 'surrealist' inventions of the decorators of his time[52] whose fantastic designs defied all rules of taste and reason. He contrasts these ancestors of the 'grotesque' with the style of decoration that had been in vogue in earlier times, when the walls of rooms were painted in imitation of theatrical stage decorations while long galleries were often decorated with realistic landscapes.

> . . . galleries, because of their length, they decorated with a variety of sceneries, images depicting the character of certain localities, painting ports, promontories, shores, rivers, fountains, straits, shrines, groves, mountains, cattle and shepherds. . . .[53]

The list of subjects is very similar to that which Pliny gives for the paintings of Studius. But the importance of Vitruvius may lie in his special emphasis on naturalistic prospects which are opposed to grotesque decorations. True, his authority did not suffice to counteract the greater authority of actual classical relics —grotesques continued to be painted in the Renaissance despite the protests of such purists as Daniele Barbaro.[54] But this recommendation of real vistas as wall decorations cannot have been without its effect on the development of the genre in the South, from Peruzzi's illusionist prospect in the Villa Farnesina (Fig. 151) to Veronese's landscape frescoes in the Villa Maser and beyond to the lunettes of Paul Bril and even of A. Carracci,[55] which, in their turn, are usually reckoned among the ancestors of the ideal landscape of Claude.[56] Nor would this connection be quite fortuitous. For Vitruvius' injunction to represent a simulated view on the walls of the Italian country house implied that the painter had to evoke a vision of the garden of the world that lay outside. Thus this 'institutional' necessity may have driven the artists to develop the new vocabulary through which the beauty of the Southern scene could be assimilated and translated into paint. Moreover this new task compelled the painter to abandon the 'conceptual' accumulation of picturesque details that had been developed by the Northern specialists and to study the effects through which an illusion of atmosphere and distance is obtained.[57]

But if this connection between Vitruvius and the creation of 'ideal landscape' must remain somewhat conjectural, the importance of the whole passage for the subsequent history of landscape painting can hardly be doubted. Vitruvius had referred to the practice of adapting the various types of stage scenery to the decoration of rooms.

Turning from the chapter on decoration to the earlier section on theatres, the artist would find this remark elucidated in the famous passage explaining the distinct properties of the tragic, the comic and the satyric scene.[58] The tragic scene is filled with 'regal' objects, such as columns, pediments and statues, the comic scene with 'common' sights such as private buildings, while satyric plays are performed on a stage with trees, caves, mountains and other rural images (Fig. 154).

The parallelism between the dignity of subjects in literature and painting is familiar to us from Alberti's classification. But while Alberti correlated landscape painting as such with the lowest rung in the social ladder, the passage from Vitruvius could serve as a starting point for a subdivision of the landscape genre itself according to social 'degrees'. Thus when Lomazzo in 1585 came to write the first systematic account of landscape painting—five years after Cristoforo Sorte's more technical observations—he was evidently influenced by these distinctions.[59]

Those who have shown excellence and grace in this branch of painting, both in private and public places, have discovered various ways of setting about it—such as fetid, dark underground places, religious and macabre, where they represent graveyards, tombs, deserted houses, sinister and lonesome sites, caves, dens, ponds and pools; [secondly] privileged places where they show temples, consistories, tribunals, gymnasiums and schools, [or else] places of fire and blood with furnaces, mills, slaughterhouses, gallows and stocks others bright with serene air, where they represent palaces, princely dwellings, pulpits, theatres, thrones and all the magnificent and regal things; others again places of delight with fountains, fields, gardens, seas, rivers, bathing places and places for dancing.

There is yet another kind of landscape where they represent workshops, schools, inns, market places, terrible deserts, forests, rocks, stones, mountains, woods, ditches, water, rivers, ships, popular meeting places, public baths or rather *terme*.[60]

Lomazzo's enumeration is anything but logical. What is the difference between his 'privileged places' and his 'bright places'? Why do schools and even bathing places occur in two categories? Systematization is nowhere Lomazzo's strongest point and his distinction of various landscape genres is particularly muddled. Nevertheless, the Vitruvian categories provide a clue to all this. That they were present in Lomazzo's mind is clear from the reference to 'regal objects' such as fill the tragic scene. The 'caves' of the satyric scene were elaborated in his sinister mode, while the comic scene is probably responsible for his last category of realistic landscapes.

In view of the casual and arbitrary origin of these distinctions their subsequent fate is truly astonishing. For Lomazzo's 'privileged places' are clearly turned into the heroic landscape of Poussin, his 'places of delight' become the Pastoral of Claude, his 'sinister dens' the subject matter of Salvator Rosa and Magnasco, and his inns and market places the Dutch *bambocciate*.[61]

Nor, as we know, did the strange career of these categories end there. The process by which they, in turn, were projected into nature has often been told.[62] There are countless passages in eighteenth-century literature like the one from a guide-book through the Lake District promising to lead the tourist

from the delicate touches of Claude, verified at Coniston Lake, to the noble scenes of Poussin, exhibited at Windermere water, and from there to the stupendous romantic ideas of Salvator Rosa, realized in the Lake of Derwent.[63]

Would these lines, one wonders, have been written if Vitruvius had not set the precedent by his distinction of three types of scenes, which became three recognized types of scenery?

For the academic conventions of art, however arbitrary and illogical they may have been, were not only pedantic rules made to cramp the imagination and to blunt the sensibility of genius; they provided the syntax of a language without which expression would have been impossible. It was precisely an art such as landscape painting which lacked the fixed framework of a traditional subject-matter, that needed for its development some pre-existing mould into which the artist could pour his ideas. What had begun as fortuitous modes crystallized into recognizable moods, strains of sentiment which could be touched upon at will. The history of music provides the best parallel for the importance of such a framework for the development of a language. The dance forms of various social strata, for instance, became the vehicles of expression for absolute music. The relatively fixed sequence of moods in the sonata form that grew out of the dance suite proved an inspiration rather than a hindrance to the great masters.

It may be worth recalling that in the very years when Beethoven published his Sinfonia Eroica and his Sinfonia Pastorale, Turner was preparing the hundred plates of his *Liber Studiorum*. Each of its landscape compositions bore a letter referring to the category into which it fitted—H. standing for Historical, Ms. for Mountainous, P. for Pastoral (Fig. 153), E.P. for Elevated Pastoral (Fig. 152). Ma. for Marine and A. for Architectural. This attempted 'classification of the various styles of landscape' as the prospectus put it,[64] may not have been much more consistent than Lomazzo's system some two hundred and thirty years earlier. And yet it was no empty game.[65] The *Liber Studiorum* was meant as a deliberate challenge to the English facsimile edition of Claude's *Liber Veritatis*, in the preface of which Turner could read that Claude 'has not, indeed, in any sort composed in the heroic stile of landscape . . . his stile is altogether the rural stile'.[66] For Turner the way of progress beyond Claude went through a multiplication of categories to embrace more and more aspects of nature. It was to be the last attempt of this kind, for by that time the emotive associations were so firmly imprinted on the face of Nature that no letters, labels or categories were needed. But does not even Constable's struggle for the naïve vision derive its ethos and its pathos from the weight of tradition which had become his heritage?[67]

The Style all'antica:
Imitation and Assimilation

He who imitates must have a care that what he writes be similar, not identical [with his model], and that the similarity should not be of the kind that obtains between a portrait and a sitter, where the artist earns the more praise the greater the likeness, but rather of the kind that obtains between a son and his father. Here, though there may often be a great difference between their individual features, a certain shadow and, as our painters call it, *air* perceptible above all in the face and eyes produces that similarity that reminds us of the father as soon as we see the son, even though if the matter were put to measurement all parts would be found to be different; some hidden quality there has this power. So we too should take care that when one thing is like, many should be unlike, and that what is like should be hidden so as to be grasped only by the mind's silent enquiry, intelligible rather than describable. We should therefore make use of another man's inner quality and tone, but avoid his words. For the one kind of similarity is hidden and the other protrudes; the one creates poets, the other apes.

Francesco Petrarca, *Le familiari*, XXIII, 19, 78–94.[1]

WHEN Dürer was told in Venice that his work was 'not in the ancient manner and therefore no good',[2] he was confronted with the main criterion of exclusion that marks Renaissance criticism in art and letters. To specify the criteria of inclusion that link Renaissance works with Greek and Roman products as a definable family of forms has proved much less easy. These problems are thrown into relief by the first serious attempt to list the specific ancient models of the style *all'antica* in the *Census of Antique Works of Art known to Renaissance Artists* undertaken by the Institute of Fine Arts of New York University (under Phyllis P. Bober) in conjunction with the Warburg Institute of the University of London.[3] The difficulty in defining the exact debt of Renaissance artists to antiquity is twofold: it lies both in the tenacity of the tradition and in its flexibility. Thanks to the tenacity of ancient inventions, many representational formulae remained in circulation throughout the Middle Ages;[4] thanks to their flexibility, they could always be changed and transmuted to suit the needs of a particular composition. Yet neither the traditional formula nor the transmuted motif would necessarily be acceptable into the canon of the style *all'antica*, while fresh inventions might be.

Reference to Renaissance debates on literary style may help to focus these questions afresh.[5] In Latin literary style, too, the classical tradition had never broken off entirely. What the humanists complained of was merely that this tradition had been corrupted and debased by 'barbarisms'. The first step to reform was the exclusion

This paper was a contribution to the Twentieth International Congress of the History of Art at New York in 1961.

of words or formations that could not be documented from 'classical' authors, 'classical', of course, being used here in its original meaning as forming part of the canon of models. While there was general agreement on this point, the demand for positive 'imitation' of these canonical authors proved more contentious and also most elusive. Petrarch, Politian, the younger Pico, and, finally, Erasmus had little difficulty in showing up the flaws in the arguments of the orthodox Ciceronians, for there was clearly a limit to the amount of faithful copying that could be done without degenerating into sheer repetition of the model. Moreover, ancient authority could be quoted against such a narrow conception of *imitatio*. Quintilian opposed the mechanical imitation of one model of style, and Seneca found the formula—frequently repeated—that the imitator must transform his material as the bee transforms nectar into honey, or as the body assimilates its nourishment.[6] He added the happy comparison of a family likeness which Petrarch, in his turn, elaborated in the beautiful passage that I have chosen as a motto for this paper. I know no more striking description of the mysterious elusiveness of physiognomic similarity.

The examples that follow are designed to illustrate this increasing elusiveness in the style *all'antica*, and to draw attention both to the value and also to the limitations of this analogy between literary and representational styles. The extreme of faithful *imitatio* bordering on the copy is exemplified by Bertoldo di Giovanni's battle relief, once in the Medici collection (Fig. 156). Its purpose and *raison d'être* may well have been to reconstruct and restore a classical invention incompletely preserved on a battle sarcophagus in the Pisan Campo Santo (Fig. 157).[7] The detail of the warrior collapsing over his fallen horse is illuminating both for the faithfulness of the copy and for the direction of its slight deviation: the torsion of the body, which is seen more from the back in Bertoldo's version. Now this happens to be a motif which, as Wilhelm Pinder has shown,[8] survived from antiquity in mediaeval art. There are no less than two variations of the formula in one of the battle scenes of the Morgan Bible (Fig. 158), both of which, following the tendency of conceptual styles, turn the body into the plane.

If we could supplement that compilation of a humanist vocabulary, our Census of Antiques known to the Renaissance, with a kind of Du Cange of such surviving mediaeval formulas (especially of such difficult and complex postures), we might see even more clearly what incentives Renaissance masters had to check the traditional pattern against the classical version. One of these incentives, no doubt, was the superior mastery of representation embodied in classical sculpture. Admiration for this mastery and the need for guidance may often have determined the selection of motifs. The motif of a man falling from his mount is a useful example of this need, since such actions are obviously difficult to observe and even harder to pose in the studio. The striking representation of such a fall on Trajan's Column (Fig.[9] 159) was actually used for a different kind of complex movement: Burger has shown

that it served as a model for the lame man raised by St. Peter (Fig. 160) on Nisio's Ciborium for Sixtus IV, that astonishing pastiche of ancient formulae which is too often overlooked when the characteristics of the style *all'antica* are discussed. Here, indeed, we have an analogy to the mosaic technique of those timid humanists whose speeches often turn out to be patchworks of quotations awkwardly adapted to a new purpose. The opposite extreme of a free modification may be briefly exemplified by the use that Donatello seems to have made of the identical figure in his rendering of the wrathful son (Fig. 161). The similarities are certainly greater than are those with the group of Pentheus, torn limb from limb, which Warburg and Saxl connected with this scene.[10] It must be admitted, however, that the assimilation of the motif into Donatello's narrative naturalism is so complete that the derivation could never be proven.

Both these procedures of imitation and assimilation occur in the fully developed style *all'antica*. I have chosen Giulio Romano as a typical representative of this style. His *Battle of Constantine* (Figs. 162, 163, 166), that most ambitious evocation of a Roman battle, welds the traditional motifs into a new unity:

> This work is universally praised for the wounded and dead one can see there, and for the diverse and strange attitudes of the footsoldiers and horsemen who fight in boldly conceived groups . . . it has become a guiding light for all who had to paint similar kinds of battles after him; he learned so much from the ancient columns of Trajan and Aurelius in Rome, where he profited greatly for the costumes of the soldiers, the armour, ensigns, bastions, stockades, battering rams, and all the other instruments of war. . . .[11]

What strikes Vasari is the archaeological knowledge embodied in the painting, which would indeed be worth a special study. Artists preceded scholars in this mastery of *realia* culled from the monuments, and these include not only costume, but also custom. It is well known that Giulio lifted a particularly gruesome action, the display of the enemies' severed heads, from the 'Trajanic Relief' of the Arch of Constantine (Fig. 164) without actually copying it. Other derivations have never been studied, though it was noticed by Ramdohr in the eighteenth century[12] that a sarcophagus now in the Museo Nazionale (Fig. 165) must have been one of Giulio's sources. The dependence is undeniable. Compare, once more, the difficult attitudes of the fallen, so much admired by Vasari, but also their place in the composition, the way they are related to the central figure of the heroic victor on horseback. Both show the tangle of two fallen warriors in the path of the hero, one with his hand and arm on the ground, the other still falling, his foot in the air, while another warrior slides helplessly from a large rearing horse just behind the advancing hero. But striking as these similarities are, the variations that Giulio introduced are even more interesting. The foremost means of masking dependence is reversal, which is an easy process in studio practice, through tracing, *contre-épreuve*, etc. Giulio turned the horse behind the hero around, and this necessitated a change in the

position of the falling enemy. He adopted a similar device for the other falling soldier, and added a shield to disguise the dependence. And just as the stylist who has mastered the laws of Ciceronian grammar may even improve on a Ciceronian phrase, so Giulio felt master enough of anatomy and movement to play his variations on ancient inventions and even improve on them with the aid of studies from nature. There is a striking example of such interaction in this picture which has not, I think, been noticed. Two beautiful sketches from the nude in Oxford (Fig. 169), have long been recognized to be studies for two soldiers in armour, at the extreme right of our painting, who are trying to enter a boat.[13] Now this motif also occurs in the nude on a classical relief which Phyllis Bober has shown to have been frequently copied in the Renaissance (Fig. 170), and if we compare the relief and the sketch there can be no doubt about the dependence. Nevertheless, it seems likely that Giulio checked the borrowed motif against a live model which he posed sitting on the ground, giving it a turn of 45 degrees from the original.

The extent of such modifications, of course, varies with the quality of the prototype and the needs of the composition. If we move to the left side of the painting, the warrior seen from the back, the whole taut figure like a tense arc, is a motif frequent in Amazon sarcophagi[14] (Fig. 167), but once again Giulio has probably absorbed the lesson without slavishly copying any of these figures. More interesting is his procedure in the case of the warrior seen from the back kneeling on his horse. The motif of the figure fighting into the picture, as it were, is very frequent indeed, and could be documented both from tradition and from several battle sarcophagi. But the outline and structure of the torso suggest another exemplar, as popular with the artists of Giulio's generation as the Antique itself: Michelangelo's battle cartoon, or, in the case of Giulio, obviously one of Marcantonio's engravings (Fig. 168), which here served the purpose the live model had served in the other example, that of ensuring representational accuracy. This does not prove that Giulio could not invent a motif, only that he applied the laws of economy.

There is also a suggestive similarity between one of the soldiers in the battle about to stab his opponent on the ground and one of the most ferocious of murderers in the tapestry of the *Massacre of the Innocents* from Raphael's school (Fig. 171), but the cartoons for this set may well have been designed by Giulio himself, so that the drawing may have been available in the studio. The violence of the movement recalls the struggling group on Leonardo's Anghiari cartoon rather than any classical prototype. Here, as elsewhere, the *all'antica* impression is perhaps due less to the individual motif than to the principle of interlacing action, that tangle of human limbs and interlocking bodies piling up so as to create a complete curtain of seething action in front of the beholder. It is this principle that makes up the sarcophagus style which Giulio identified with narrative *all'antica*. Its main rule is to maximize movement within minimal space. Comparing Giulio with

classical prototypes, we soon find that here, too, he has improved on his models; he has increased the complexities of interaction while rationalizing the stage. It is true that he has done it by taking a good many liberties with the capacities of the human body to be tied into knots. But here, again, he did not proceed without authority from what was then a famous antique.

Let us turn in conclusion to Giulio's application of this work, the *Letto di Policleto* (Fig. 173), which Schlosser tried to trace back to Ghiberti's workshop[15] and whose fame is well attested through its use in Raphael's workshop, in the stuccos of the Loggie,[16] and by Michelangelo's entourage in the floor mosaic of the Laurenziana.[17] It seems a useful example because its characteristics are so easily formulated. What I mean is the extreme artificiality of the woman's pose. It is a pose that no artist can have observed in real life, for it is not really possible to sit like that. One of its hallmarks is that the nose turns in the opposite direction to the toes— quite a feat of contortion in any position, but made harder through the approximate confinement of the movement in one plane. It is this artificiality, one may surmise, that accounts for the fame of the work, for this degree of contortion is rare in ancient art. On classical sarcophagi only the supple marine creatures contrive to take up such a pose. Giulio's most obvious adaptation of this human arabesque comes relatively late in his *œvre*, in the *Education of Jupiter* in the National Gallery, London (Fig. 172). The action of the nymph in lifting the veil from the sleeper confirms the derivation. Even so, we would not call it an imitation, since neither the right foot nor the right hand corresponds to the Antique. What Giulio has taken over is, rather, that principle of the elegant torsion which displays the graceful body in an attractive and interesting curve in the plane. He varies it once more in the other figure, which is even further removed from the antique prototype.

If we leaf through Hartt's beautiful monograph, we soon discover that Giulio loved to rely on the authority of this Antique for creating variations on this theme. Sometimes he may have been closer to the nereids, as in the composition of *Hercules and Nessus* for the Sala dei Cavalli of the Palazzo del Tè.[18] Sometimes both the erotic motif and elements of the posture are preserved, as in the fine group of Bacchus and Ariadne from the Sala di Psiche (Fig. 175), which almost anticipates Poussin. Occasionally, again, the extreme contortion of the body is motivated within the tangle of figures through a conflict of movements, as in the figure of Luna (Fig. 174) on the ceiling of the Sala dei Giganti, where the goddess's team of horses shy in the opposite direction to her gaze. The contortion looks its most tortured in some of the more decorative inventions, such as the Victory figure (Fig. 178), whose head is turned by more than 180 degrees, and in the drawing for the tomb of a cardinal.[19]

This brief list must suffice to explain in principle what may be described as assimilation as distinct from imitation. Assimilation demands a degree of generalization. The artist must learn how to create a figure that embodies his idea of the

classical style. The ease with which Giulio did this was proverbial. Like the other great decorators of his time, like Polidoro or Perino, he could cover whole palaces with motifs that impressed his generation as evocations of the Antique, though few were literal quotations. Any one motif of the Palazzo del Tè, such as the conch (Fig. 177) with its six fields and four stucco medallions, not to speak of its frieze with a battle of Lapiths and Centaurs, for which the rapid drawing is preserved (Fig. 176), exemplifies this inexhaustible stream of invention *all'antica*, to which Aretino referred in a typical letter:

For invention and grace the world prefers you to anyone who has ever touched compass and brush. Even Apelles and Vitruvius would agree if they had only had experience of the buildings and paintings you have made and designed in this city, embellished and glorified as it is by the spirit of your conceptions—anciently modern and modernly ancient.[20]

The ideal of assimilation could not be formulated more neatly. There may be, and there are, a few direct quotations from the Antique in this example, but the true problem, it seems to me, is not so much what Giulio copied into his notebooks, as how he and other artists proceeded from copying to this mastery of a language.

How does an artist make this decisive step from the pastiche to the free mastery of a style? What enabled Raphael and his pupils to generalize on their knowledge of a few ancient monuments and create the dazzling variety of the Loggie? How did Polidoro da Caravaggio advance from the study of classical monuments to his famous improvisations *all'antica*, which served in their turn as models for countless imitators and emulators?

It may be well to remember that if we could answer this question with precision we could build a robot Raphael. There is no danger of this ever happening. Even a robot Giulio Romano is an unlikely nightmare. Yet it may help us to see more clearly where our limitations lie if we formulate the problem of *imitatio* less in terms of copying and more in terms of generalization. Rumour has it that computers can be programmed to learn the rules of games and even of musical compositions in specific styles.[21] In literary style, to return to the starting-point of this discussion, there certainly are elements of structure amenable to statistics and even to computation. Quintilian ridiculed those who believed that they wrote Ciceronian Latin if they frequently ended their clauses with his famous and notorious *esse videatur*.[22] He was right. But to study the cadence of this rhythmical close, divorced from the telltale words, and to count the frequency of its occurrence within the texture of Cicero's prose is a very different trick, and one still taught to English schoolboys trained in the strenuous discipline of genuine *imitatio*. It is true that the human brain is often the most reliable computer, and that a gifted stylist and indeed a skilled parodist may be able to catch such characteristic accents of an author more successfully than a plodding statistician. But be that as it may, we art historians

cannot rely on the intuitive methods that certainly guided the creators of works *all'antica*. If we want to formulate what they saw in the Antique, we must be able to describe some of their modes of procedure.

Before the turn of the century Aby Warburg tried for the first time to do precisely this, when he described Botticelli's fluttering hair and garments, his *bewegtes Beiwerk*, as such a principle intended to give the impression of the Antique. Later, in 1905, in his paper on Dürer, he coined the expression *Pathosformel* to describe those figures in movement which became one of the hallmarks of the style *all'antica*.[23] Fruitful as these first formulations proved to be, I do not think we can rest content with repeating them, for, as it stands, his hypothesis is both too narrow and too wide. But I am sure that Warburg was right, that we should look for some general principle that Renaissance artists tried to distil from their study of classical monuments. I do not think we would be far from his intentions if we called one of these principles 'the illusion of life'. Renaissance artists were narrators who had a horror of all that looked rigid, stiff, and dead, as the conceptual art of the Middle Ages appeared to them. Of course, the Donatello of the San Lorenzo pulpits, the Leonardo of the *Last Supper*, and the Michelangelo of the Sistine ceiling chose other ways towards this supreme goal than either imitation or assimilation of the style *all'antica*. But those who first turned to the Antique for guidance in problems of naturalistic representation, and came to admire the art of the ancients for its vaunted fidelity to nature, must soon have discovered that it also held the secret of that higher fascination: the illusion of movement and life. This coveted illusion, as any photographer knows, depends on more than mere fidelity to surface appearances. Too much of this fidelity may even counteract the illusion of life and movement. The first lesson was indeed to create a maximum of movement and tension, and so banish all memories of more primitive pictographs. Even a few ancient sarcophagi of indifferent quality could give plenty of hints on what to avoid and what to do. To ask the further question of why the most assiduous learners of these lessons sometimes produced the impression of a frozen immobility, and how a Rubens finally liberated the spark of life dormant in this style, would encroach on other sections of this Congress.

Reynolds's Theory and Practice of Imitation

Three Ladies adorning a Term of Hymen

It is in vain for painters or poets to endeavour to invent without materials on which the mind may work . . . Sixth Discourse

THERE is nothing in Reynolds's teaching more alien to our present taste and creed than the constant insistence on the value and even necessity of 'imitation'. Critics have therefore tended to concentrate on the more modern and unorthodox aspects of his artistic outlook. But if critics have every right to choose their way of approach to art, the historian is bound to the standards of the period and of the artist. In the case of the *Three Ladies adorning a Term of Hymen*[1] (Fig. 180), we are fortunate enough to know exactly the terms and circumstances of the commission. By disentangling the various threads of tradition which he has woven into a perfect texture we can watch the artist at work, applying his own principles of 'imitation' and thus narrow the rift which for many observers still exists between Reynolds the teacher and Reynolds the artist.

Northcote has preserved for us the story of the commission. In May 1773 Sir Joshua received a letter from Dublin, written by the Right Hon. Luke Gardiner, M.P. to introduce his fiancée, the beautiful daughter of the Scottish jurist Sir William Montgomery, M.P.

This letter will be delivered to you by Miss Montgomery, who intends to sit to you with her two sisters, to compose a picture, of which I am to have the honour of being the possessor. I wish to have their portraits together in full length, representing some emblematical or historical subject; the idea of which, and the attitudes which will best suit their forms, cannot be so well imagined as by one who has so eminently distinguished himself by his genius and poetic invention.

After assuring the master that his sitters are prepared to devote any time required to his work he cannot resist commending the task still more by stressing the honour the artist would acquire 'in conveying to posterity the resemblances of three sisters so distinguished for different species of beauty'.

Some weeks later the painter replied and referred to his interview with the young Miss Montgomery, who had meanwhile become Mrs. Gardiner. He seems genuinely enthusiastic about the task, which must have meant to him a very welcome change from routine portrait painting:

This was an article in *The Burlington Magazine*, 1942.

You have been already informed, I have no doubt, of the subject which we have chosen; the adorning of a Term of Hymen with festoons of flowers. This affords sufficient employment to the figures, and gives an opportunity of introducing a variety of graceful historical attitudes. I have every inducement to exert myself on this occasion.

Although he does not feel equal to so high a task he is sure 'it will be the best picture I ever painted'.

The subject of a rite of worship to the God of Wedlock which the painter had chosen in conversation with his sitter was certainly most suitable for the portrait of a young bride commissioned by the bridegroom. In itself it was not entirely new within the painter's *œuvre*. Twelve years earlier he had painted another well-known beauty, *Lady Elizabeth Keppel* (Fig. 179), performing the same rite. But at that time the marriage to be commemorated was not that of the sitter. Lady Elizabeth was one of the twelve bridesmaids to Princess Charlotte Sophie at her marriage to George III, on September 8, 1761.[2] To commemorate her function in this great pageant of State the painting shows her performing a classical sacrifice to Hymen, who holds in one hand his torch, in the other the royal crown. As a footnote, as it were, the picture bears an inscription culled from Catullus' famous *Hymenaeus*:

Cinge tempora floribus
Suavolentis amaraci.
Adsis, O Hymenaee Hymen!,
Adsis, O Hymenaee![3]

This vesting of a royal ceremony in the garment of classical mythology is fully in line with the tradition of courtly festivals of the baroque period. Reynolds's formal treatment of the portrait also links up with the tradition of baroque grandeur. The setting of the full-length figure before the rich curtain and motives such as the negro slave in attendance are freely borrowed from the stage effects of court painting in the Van Dyckian vein.[4]

On the surface it might appear that Reynolds's 'poetic invention' for Mr. and Mrs. Gardiner was, in fact, merely a clever and politely allusive adaptation to a private occasion of a memorial appropriate to a public pageant. It is true that the full subtlety of the emblematical conception could only appeal to the intimate circle of the family. Who else could be expected to appreciate that of the two ministrants to the conjugal sacrifice, Ann, the youngest sister, who had actually married a week before Mr. Gardiner had composed his letter to the artist (she was now Viscountess Townshend), is represented as having passed the image of Hymen while the eldest of the three, who was not married till a year later (when she became the Hon. Mrs. Beresford), is shown as still engaged in collecting flowers for the rite?

But if we look at the commission and the painter's reply more carefully we find that the beholder's attention is not meant to be focused on these emblematical

hints. The three sisters were meant to sit to the painter to compose 'a picture . . . representing some emblematical or historical subject'. What Mr. Gardiner desired and what the painter undertook with so much pleasure was therefore less a portrait group than a historical picture in which the three renowned beauties, well known, like Gardiner himself, as amateur actors of great charm, should pose as models.

'The adorning of a Term of Hymen with festoons of flowers', as Reynolds called the selected motive, is indeed a self-sufficient subject for a 'historical picture'. Poussin himself, that great authority of the 'grand manner', had sanctioned it. His painting now in São Paulo (Fig. 181) shows many nymphs worshipping the god and wreathing his image with festoons of flowers. Poussin's subject is derived from the *Hypnerotomachia Poliphili*, that curious pseudo-classical romance of the Quattrocento. Its Latin text describes in detail such a sacrifice to Hymen and the accompanying woodcut shows a Priapean rite (Fig. 182).[5] This work, then, which was generally accepted as a vein of authentic archaeological learning, seems the ultimate source of the iconographic tradition with which Reynolds linked his portrait group—or, more correctly, it contributed to the stores of 'material on which his mind could work'. For a simple sacrifice to the pagan God of Fertility— even if toned down to the respectable God of Wedlock—was hardly the happiest thought in a picture for which the sisters Montgomery were to pose as models. The painting itself does, indeed, suggest another name, that which was adopted by the National Gallery, where it is listed in the catalogue as *Three Graces adorning the Term of Hymen*. True, there is no documentary evidence to show that Reynolds intended to allude to the obvious flattery which dubbed the three Montgomery sisters the 'three Irish Graces'.[6] But though direct evidence is lacking the title seems supported by another trend of iconographic tradition. In a famous picture, now at Glasgow, Rubens had expressed the thought of *Nature attired by the Three Graces* (Fig. 183). By replacing Rubens's Nature—a female genius of fertility in the shape of the Ephesian Diana—by her male counterpart, Reynolds fused the two iconographic motives into one graceful idea: 'Hymen attired by the Three Graces'. It is a subject fit for the occasion, standing equally well by itself.

Once more we must return to that brief correspondence between the artist and his employer. In his reply Reynolds assures Mr. Gardiner that the subject chosen would 'give opportunity of introducing a variety of graceful historical attitudes'. That means, if we understand him rightly, attitudes such as befit the exalted standards of 'history painting' rather than the formulae of portraiture.[7]

He had not far to go to find 'material for invention' for the formal treatment of the subject. Lady Keppel's portrait could again serve him as a starting-point: the negro slave's function could be taken over by one of the sisters, while a third figure was welcome to balance the slightly lopsided composition. But the similarity to the earlier work again stops short at the surface. It would serve for the broad outline

but could not lift the painting into the sphere of Great Art. The nymphs in Poussin's *Sacrifice to Hymen* were also unsuited to provide a pattern, but another work by the same master of the grand manner gave him all he wanted. In one of Poussin's most accomplished compositions, the *Bacchanal* (Fig. 184),[8] the Maenad wreathing a term of Bacchus—who also occurs in a fresco by Giulio Romano in the Palazzo del Tè (Fig. 185)[9]—is mirrored in the pose of Reynolds's central figure, while the ecstatic Maenad at her side—the arms raised in excitement—was evidently transformed by him into the elegant pose of Viscountess Townshend.

The attitude of Reynolds's third figure, Ann Mortimer gathering flowers, is no less 'historical' in that metaphorical sense. In Reynolds's sketch-book from Italy, which he often consulted for useful patterns, we find a similar figure marked '*ignoto*'[10] (Fig. 186). Unfortunately its author is still unknown, but iconographic and formal tradition is so closely interlinked in the art of the past that it is not difficult to ascertain the original setting for such a figure. She must be one of Proserpina's attendants who was gathering flowers and now looks up in amazement to see her companion carried away in Pluto's chariot. It is her activity, picking flowers, which must have led the artist to make use of that pattern. 'It often happens,' he says in the Twelfth Discourse, 'that hints may be taken and employed in a situation totally different from that in which they were originally employed.'[11]

The reader who has followed us on this tortuous path, and has seen with us elements of Reynolds's *Lady Keppel*, of Poussin's *Sacrifice to Hymen* and Rubens's *Three Graces*, of Poussin's *Bacchanal* and of an anonymous *Rape of Proserpina* all as parts of the master's 'material', may well be reluctant ever to look at the outcome of this synthetic process again for fear that, once dissected, the painting may never be restored again to its former unity. To us it seems almost incredible that this wealth of academic erudition should not have marred the vision of the artist. And yet the picture bears witness to his powers of turning the 'attitudes' which he 'borrowed' into living gestures and linking them together in a graceful chain of movement that unfolds like a rising melody of singular beauty. Even the severest judge must accept Reynolds's plea that 'Borrowing or stealing with such art and caution will have a right to the same lenity as was used by the Lacedaemonians, who did not punish theft but the want of artifice to conceal it' (Sixth Discourse).

But here, I think, we would do well not to take the artist's words quite at their face value. Borrowing clearly meant more to him than a pedagogic device or a comfortable short cut to pleasing effects. The derivation of the central figure from a famous Poussin motive can hardly have escaped the connoisseurs at the Academy exhibition, nor can it have been meant to do so any more than the skilful adaptation of a classical quotation in a contemporary ode was meant to go unnoticed.[12]

It is this deliberate display of the 'quotation' rather than the practical use of

traditional types and formulae that distinguishes a work like Reynolds's *Three Ladies* from earlier cases of adaptation. We may well see in this the same programmatic emphasis that pervades the treatment of 'imitation' in the discourses. In these statements and re-statements of the case for imitation as the best way to invention the polemical element can indeed hardly be overlooked. Nor does Reynolds conceal the object of his criticism. Time and again he warns his pupils against the alluring creed of 'natural genius'.[13] It is the creed which in 1759 had crystallized in Young's letter to Richardson on 'original composition', which contained the challenging thesis: 'An adult genius comes out of nature's head as Pallas out of Jove's head, at full growth and mature', and, consequently, 'Illustrious examples engross, prejudice and intimidate.'[14]

Seen before this background we can perhaps feel something of the memorable issue in which Reynolds fought on the losing side. For we now know that, however great the gain, something was indeed irretrievably lost in the development which started with this new conception of art, and which has not yet come to an end: an accepted set of symbols and forms which guaranteed a common standard and thus provided the basic elements for a communication between the artist and his public.

Reynolds's doctrine and Reynolds's art—or at least that aspect of his doctrine and art that we are dealing with—therefore represent the conservative programme in the true meaning of the word. But what it wants to conserve—the artistic conceptions of the past, handed down in an unbroken chain from generation to generation —is already fading away like an elusive dream. The past cannot be retrieved by 'imitation'. Whoever converses more intimately with the picture will feel that the dualism already inherent in the commission pervades the work as a whole. The two worlds of portraiture and of history, of realism and imagination are held in a perfect, if precarious, balance. For if Gardiner spoke of the honour Reynolds would acquire in 'conveying to posterity the resemblance of three sisters so distinguished for different species of beauty', posterity is tempted to bestow honours for different reasons. Though the sisters are just different enough to make them look like individuals they are all assimilated to the same ideal of classical beauty. 'It is very difficult,' Reynolds writes, 'to ennoble the character of a countenance but at the expense of likeness (Fourth Discourse) . . . when a portrait is painted in the historical style . . . it is neither an exact representation of an individual, nor completely ideal' (Fifth Discourse).

It would be difficult to describe the intrinsic tension of the work in more exact terms. For the world of the 'ideal', in which the patterns 'borrowed' by the master could be conceived and could grow, has also become threadbare in this clash with reality. The resounding language of classical coinage which Poussin had made his natural idiom has become a graceful play. Its forms and ideas are lightly

superimposed on a *coin de la nature*, trimmed by taste and fashion. The very subject matter is less an 'imitation' of a classical motif than an adaptation. The boisterous Maenads have become elegant Graces; the pagan rite of fertility has become a respectable occasion. The sisters Montgomery are posing in a graceful 'tableau vivant' representing some imaginary masterpiece of bygone Academic Art. At any moment the curtain may fall—three smiling amateur actresses will resume their social duties.

NOTES

Notes

THE RENAISSANCE CONCEPTION OF ARTISTIC PROGRESS AND ITS CONSEQUENCES

1. Ferdinandus Fossius, *Monumenta ad Alamanni Rinuccini vitam contextendam* (Florence, 1791), pp. 43 ff. Fossius does not give the date of the letter which is, however, preserved in the contemporary copy in the Magliabecchiana, cf. Appendix.

2. This idea of the revival of the arts has been extensively discussed in connection with the recent debate on the Renaissance concept. Cf. W. K. Ferguson, *The Renaissance in Historical Thought* (Cambridge, Mass., 1948). F. Simone, 'La coscienza della Rinascita negli Umanisti', *La Rinascita* 2, 1939, and 3, 1940, and H. Weisinger, 'Renaissance Theories of the Revival of the Fine Arts', *Italica*, xx, 1943. And see now E. Panofsky, *Renaissance and Renascences in Western Art* (Stockholm, 1960), Chapter I. Among statements preceding Rinuccini, Valla's reference to painting in the introduction to the *Elegantiae* was probably the most influential. The link between the arts and letters is made particularly explicit by Eneas Silvius in a letter to Niklas von Wyle of July 1452. Cf. R. Wolkan, *Der Briefwechsel des Eneas Silvius Piccolomini*, III (Vienna, 1918), vol. I, letter 47, and see now my 'Art and Scholarship', reprinted in *Meditations on a Hobby Horse* (London, 1963), pp. 106–19.

3. L. B. Alberti, *Della pittura*, ed. Mallè (Florence, 1950), pp. 53 f.

4. Quintilian, *Institutio Oratoria*, xii, x, and see now my 'Vasari's *Lives* and Cicero's *Brutus*', *Journal of the Warburg and Courtauld Institutes*, xxiii, 1960, 309–11.

5. *Purgatorio* xi, 91 ff., cf. J. v. Schlosser, *Präludien* (Vienna, 1927), p. 248. For Dante subsequent decline rather than a 'contribution' is the prerequisite of fame. This is still the interpretation of C. Landino in the Dante edition of 1481. 'Che benche alchuno sia il primo in una scientia, o virtu, o arte, nientedimeno dura pocho tempo esser primo; perche viene dipoi qualchuno altro piu excellente di lui. . . .' The arts after Giotto are explicitly exempted from this remark. Giotto still remains unsurpassed but only *pro tem.*:

'cosi forse verra in un altro tempo, chi vincera Giotto'.

6. Cennino Cennini, *Il libro dell'arte*, ed. D. V. Thompson Jr. (New Haven, 1933).

7. J. P. Richter, *The Literary Works of Leonardo da Vinci* (Oxford, 1939), Nr. 498— Cod. Forster III, 66b.

8. It is a translation of the first aphorism of Hippocrates, frequently quoted in the Middle Ages, cf. the introduction to Guy de Chauliac, *La Grande Chirurgie*, translated in J. B. Ross and M. M. McLaughlin, *Medieval Reader* (New York, 1949).

9. E. Zilsel, 'The Genesis of the Concept of Scientific Progress', *Journal of the History of Ideas*, vi, 1945. I cannot accept Zilsel's tenet that the idea of progress is only present where writers explicitly state that others who come after them will build on what they have done. But even this occurs in Archimedes, as was pointed out by L. Edelstein in the same *Journal*, xiii, 1952, p. 575. Moreover most Greek philosophical writings imply the idea of progressive problem-solutions. Cf. K. R. Popper, 'Towards a rational Theory of Tradition', now reprinted in *Conjectures and Refutations* (London, 1963). An interesting discussion of scientific progress from the seventeenth century is to be found in Daniello Bartoli, *De' simboli trasportati al morale* (Bologna, 1677), pp. 260 ff. The Jesuit author has collected a number of relevant passages from classical writers which those interested in the problem raised by Zilsel may find useful.

10. The idea that 'art' stands higher than individual works of art is prefigured in Ficino's letter to an artist, *Opera Omnia* (Basle, 1576), p. 743. 'Nunquam satisfacit arti cui semper artificium satisfacit'.

11. J. v. Schlosser, *Leben und Meinungen des florentinischen Bildners Lorenzo Ghiberti* (Basle, 1941), says that this competition followed an old usage, but I have been unable to trace a genuine precedent. May it not have been influenced by the example of the competition for Ephesus in which five famous sculptors took part, according to

Pliny, *Hist. Nat.* XXXIV, 53 ? It seems to me possible, at least, that it was prompted by the same upsurge of pride in Florence, the equal of the ancient cities, that inspired Bruni's *panegyricus* on Florence in these very years and is so strong in many of Salutati's utterances. Cf. Th. Klette, *Beiträge zur Geschichte und Litteratur der italienischen Gelehrtenrenaissance* (Greifswald, 1888), and see now also Hans Baron, *The Crisis of the Early Italian Renaissance* (Princeton, 1955).

12. Cf. I. Falk and J. Lányi, 'The Genesis of Andrea Pisano's Bronze Doors', *The Art Bulletin*, XXIV, 1943.

13. R. Krautheimer, 'Ghiberti and Master Gusmin', *The Art Bulletin*, XXIX, 1947, and *Lorenzo Ghiberti* (Princeton, 1956), pp. 62–67. For Ghiberti's account of Gusmin, see *Lorenzo Ghiberti, Denkwürdigkeiten*, ed. J. v. Schlosser (Berlin, 1912), II, pp. 43–4.

14. J. v. Schlosser, *loc. cit.* and *Lorenzo Ghiberti, Denkwürdigkeiten* (Berlin, 1912).

15. *Carteggio di Giovanni Aurispa*, ed. R. Sabbadini (Rome, 1931), pp. xvii, 13, 51, 67, 69, 70, 72, 168.

16. *Ed. cit.*, II f. and 63.

17. The documents printed by H. Brockhaus, *Forschungen über florentiner Kunstwerke* (Leipzig, 1902), have been interpreted by L. Planiscig, *Ghiberti* (Florence, 1949), in a way I find difficult to accept. The ten stories and 24 pieces of frieze cast before April 1436 must be the same mentioned in the document of 1437 when 'Cain and Abel' was nearly finished, 'Moses' nearly finished, 'Jacob and Esau' finished, the story of Joseph half finished and that of Solomon begun. Ghiberti was a slow worker and completed the first door at about half the pace he had promised, doing an average of three reliefs in two years. This corresponds well with the state of the work reached twelve years after the contract for the second door, the planning and modelling of a little less than one relief a year.

18. The picture is confirmed by Ghiberti's description of Lorenzetti's 'Cosmografia': 'Non c' era allora notitia della Cosmografia di Tolomeo, non è da maravigliare s' ella sua non è perfetta' (*ed. cit.*, p. 42).

19. Pliny, *Hist. Nat.* XXXIV, 61, 65.

20. C. Robert, *Archäologische Märchen* (Berlin, 1886), pp. 28 ff.

21. 'Statuariae arti plurimum traditur contulisse capillum exprimendo, capita minora faciendo quam antiqui, corpora graciliora siccioraque, per quae proceritas signorum maior videretur, non habet Latinum nomen symmetria quam diligentissime custodit nova intactaque ratione quadratas veterum staturas permutando vulgoque dicebat "ab illis factos quales essent homines, a se quales viderentur esse".' It is noteworthy that the metaphor of 'rebirth' which Ghiberti introduced to the 'Renaissance' was taken by him from the same chapter of Pliny, who speaks of the revival of bronze casting after a decline.

22. Printed by Brockhaus, *loc. cit.*, p. 37.

23. *Ed. cit.*, pp. 48–9. We may never know why Bruni's advice was not followed but it should be noted that in May 1426 soon after giving his opinion he left for Rome until November 1427, where he stayed as the Ambassador of the Republic.

24. *Ed. cit.*, pp. 24–5.

25. 'Piacque a Protogine quella tavola dove erano fatte le linie di mano d' Appelle ovvero conclusioni appartenenti alla pictura fosse vedute da tutto el populo e spetialmente de' pictori et dagli statuarij et da quelli erano periti' (*ed. cit.*, p. 25, word order amended).

26. *Kleinere kunsttheoretische Schriften*, ed. H. Janitschek (Vienna, 1877), pp. 67, 81, 228–9.

27. Both the triumph of art over 'base' material and the inherent nobility of bronze are favourite topics of Alberti (*Della pittura*, II, *De re aedificatoria*, VII). I have discussed some general aspects of this new hierarchy of values in a paper on 'Metaphors of Value in Art', republished in *Meditations on a Hobby Horse* (London, 1963), pp. 12–29. The contrast between the rough surface of Donatello's works and the polish of his predecessors is discussed with great acumen in Vasari's life of Luca della Robbia. It is characteristic of this new scale of values that when the gilding of the doors was recovered from under the uniform grime during the war, public opinion in Florence was divided on the effect.

28. I have myself expounded this view in my article on 'Botticelli's Mythologies', *Journal of the Warburg and Courtauld Institutes*, VIII, 1945.

29. *Le vite . . .*, ed. G. Milanesi, III (Florence, 1878), p. 38.

30. He painted the *Adoration of the Magi* for the Servi of S. Donato a Scopeto after Leonardo had failed to finish his *Adoration* for the same monastery. This incident makes Vasari's story even more plausible, for Filip-

pino must have felt himself under a certain moral obligation towards Leonardo.

31. *Treatise on Painting, Codex Urbinas Latinus 1270*, ed. A. P. McMahon, II, Facsimile (Princeton, 1956), fol. 32 r.

32. Cf. my review of Hauser, *The Social History of Art*, reprinted in *Meditations on a Hobby Horse* (London, 1963), pp. 86–94.

33. Cf. 'Norm and Form', p. 81 above.

34. 'Die Kunst hat sich erst in anderthalbhundert Jahren wieder angespunnen. Und ich hoff, sie soll fürbass wachsen, auf dass sie ihr Frucht gebär, und sunderlich in welschen Landen, das dann zu uns auch mag kummen.' A. Haseloff, 'Begriff und Wesen der Renaissancekunst', *Mitteilungen des deutschen kunsthistorischen Instituts in Florenz*, III, p. 373.

35. Cf. 'The Renaissance Theory of Art and the Rise of Landscape', p. 107 above.

36. Herder writes (*Kritische Wälder*, III, 1769), 'Ein Kunstwerk ist der Kunst wegen da; aber bei einem Symbole ist die Kunst dienend', *Werke*, ed. B. Suphan (Berlin, 1877,) III, p. 419. I know no earlier formulation of the slogan 'L'art pour l'art'.

37. H. Read, *Contemporary British Art* (Harmondsworth, 1951), p. 19.

38. W. Hazlitt, 'Why the Arts are not progressive' from *The Round Table*, Jan. 1814, printed in *Selected Essays*, ed. G. Keynes (London, 1948).

39. See now my 'Tradition and Expression in Western Still Life', reprinted in *Meditations on a Hobby Horse* (London, 1963), pp. 95–105.

Appendix

Extracts from Alamanno Rinuccini's panegyric of his age[1]

Ad illustrem principem Federicum Feretranum Vrbini comitem. Alamanni Rinuccini in libros Phylostrati de vita Apollonii Tyanei in latinum conversos praefatio incipit.

Cogitanti mihi saepenumero, generosissime princeps Federice, et aetatis nostrae viros cum veteribus conferenti, eorum opinio perabsurda videri solet, qui veterum quaeque dicta factave pro maximis celebrantes, non satis digne ea laudari posse arbitrantur, nisi temporum suorum mores accusent, ingenia damnent, homines deprimant, infortunium denique suum deplorent quod hoc seculo nasci contigerit, in quo nulla probitas, nulla industria, nulla (ut ipsi putant) bonarum artium studia celebrantur.

Cuius rei causam plerique in naturam referentes senescentis mundi vitio et iam ad interitum vergentis id ipsum putant evenire. Queruntur enim et etates hominum breviores, et corpora imbecilliora, et ingenia ad res praeclaras hebetiora, nunc a natura proferri, quam olim fuerint cum illi viguerunt, quos tantopere laudant et admirantur. Horum ego sententiam nec penitus falsam dixerim, nec omnino ex parte comprobaverim. Nam quae de priscorum virtutibus opinantur . . . sunt in aperto . . . quod autem de mundi senectute atque aetatum brevitate queruntur, cum diurno testimonio tum rerum usu et experientia facile confutantur . . .[2]

Mihi vero contra gloriari interdum libet qui hac aetate nasci contigerit, quae viros pene innumerabiles tulit, ita variis artium et disciplinarum generibus excellentes, ut putem etiam cum veteribus comparandos.

Atque ut ab inferioribus profecti ad maiora tandem veniamus. Sculpturae picturaeque artes iam antea Cimaboi, Iocti, Taddei Gaddi ingeniis illustratas qui aetate nostra claruerunt pictores, eo magnitudinis bonitatisque perduxere ut cum veteribus conferri merito possint. Nostrae autem aetati proximus Masaccius naturalium quaecumque rerum similitudines ita pingendo expressit ut non rerum imagines sed res ipsas oculis cernere videamur.[3] Quid vero Dominici veneti picturis artificiosius ? quid Philippi monaci tabulis admirabilius ? quid Iohannis ex predicatorum ordine imaginibus ornatius ?[4] Qui omnes varietate quadam inter se dissimiles, certis tamen excellentia et bonitate simillimi putantur.[5]

Sculptores autem quamvis multos afferre possim, qui pro summis habiti essent si paulo ante hanc aetatem nasci contigisset,[6] adeo tamen omnes Donatellus unus superavit, ut pene solus in hoc genere numeretur. Non contempnendos tamen fuisse Luccam robiniensem, et Laurentium bartolucii praeclara ab eis aedita opera testantur.

Architecturae vero et machinarum cum bellicarum tum quae magnis trahendis ponderibus valeant facultatem ita ad summum perductam arbitror, ut nihil a veteribus nostri superentur.

In qua duo praecipue claruerunt summis ingeniis homines, et omnis antiquitatis indagatores accuratissimi. Unus quidem Philippus Brunelleschi scribae filius Florentinae basilicae architector, alter autem Baptista Albertus vir et familiae nobilitate et ingenii praestantia claris-

K 2

simus qui etiam de picturae architecturaeque praeceptis libros aliquot scripsit accuratissime....

Iam veteris eloquentiae et incorruptus latinae loquutionis usus paulo ante nostram aetatem exortus aetate nostra adeo excultus et expolitus est, ut nunquam post Lactantii aut divi Ieronimi tempora sic floruerit. Quod facile ex eorum scriptis intelligi licet, qui medii inter has quas diximus aetates[7] multarum magnarumque rerum scientiam consecuti, in scribendo tamen asperiores fuere, quod illis propterea contigisse non miror, quia Ciceronis plerique libri in occulto latentes imitandi facultatem illis adimebant.

Primus autem Coluccius Salutatus paulum se erexit, et elegantius quoddam adumbravit dicendi genus, qui multum profecto laudis meruit, quod tam longis temporibus praeclusum aditum ad eloquentiam patefecerit et posteris viam qua gradiendum esset ostenderit. Hunc secuti Poggius et Leonardus aretinus intermissam et pene abolitam eloquentiam in lucem revocarunt, qui cum epistolis tam orationibus et dialogis scribendis ciceronianum dicendi caracterem egregie sunt imitati.

APPENDIX NOTES

1. This transcript is taken from the Codex in the Biblioteca Nazionale, Fondo Italiano, Magl. II–III–48, which corresponds in all essentials with the version published by F. Fossi in 1791. There is another MS. in the Biblioteca Laurenziana 827 cod. XXI, and a copy in the Bibl. Nazionale, II, IX, 14. fol. 139 ff. giving both the date of the letter and of the copy: 'Florentiae, iiij kalendis maias 1473, perscriptum florentiae fuit hoc proemium mense decembri 1474 anno salutis'. The beautiful dedication copy is in the Biblioteca Vaticana, Cod. Urb. lat. 441. A variorum text is printed by V. Giustiniani, *Alamanno Rinuccini, Lettere ed orazioni* (Florence, 1953), pp. 104–8.

2. The general argument is taken from the introduction to Alberti's *Della pittura* which the author subsequently refers to; he counters the argument about greater longevity in earlier times by remarking that neither Thales nor Pythagoras, Plato nor Aristotle lived longer than ninety years, an age not infrequent with both men and women of his own time. For a discussion of similar texts, especi-

ally B. Accolti's *Dialogus de praestantia sui aevi*, cf. now G. Margiotta, *Le origini italiani de la querelle des anciens et des modernes* (Rome, 1953).

3. It is typical of the purely literary character of Rinuccini's eulogy that his praise of Masaccio is lifted almost bodily out of Boccaccio's praise of Giotto (*Decamerone*, Giornata VI, Novella 5) 'niuna cosa dà la natura . . . che egli . . . non dipignessi si simile a quella che non simile, anzi piuttosto dessa paresse . . .'

4. The choice of the three painters after Masaccio deserves a word of comment. Like Landino after him, Rinuccini would not have mentioned artists who were still alive. This may explain the omission of Uccello, who died in 1475. Of other candidates the most conspicuous absentee is Andrea del Castagno, but Rinuccini probably wanted to produce a trias also for stylistic reasons (cf. below note 5). It is noteworthy that our text is the third Quattrocento document which couples the names of these three particular masters. The first is Domenico Veneziano's own letter to Piero de' Medici asking for a commission and explaining that neither Fra Angelico nor Fra Filippo would be available, thus indicating that he considered the two his only serious rivals. The second is Bonfigli's contract at Perugia in 1454 mentioning the names of these three masters as arbiters in case of disagreement. Unfortunately Rinuccini's literary style does not allow us to draw any conclusions from the epithets chosen for the three great masters, though it may not be without significance that he calls Fra Angelico 'ornatus', a technical term from rhetoric which contrasts with Landino's description of Masaccio as 'sanza ornato'.

5. This phrase is also an adaptation of a literary *topos*; it is taken from Cicero's *De Oratore* III, viii, 26. 'Una est ars ratioque picturae, dissimilique tamen inter se Zeuxis, Aglaophon, Apelles'. For subsequent adaptations of this phrase cf. now Denis Mahon, 'Eclecticism and the Carracci', *Journal of the Warburg and Courtauld Institutes* XVI (1953), p. 312.

6. This is an elaboration of the Dante passage quoted above under note 5.

7. This appears to be one of the earliest recorded references to the 'middle ages'.

APOLLONIO DI GIOVANNI

1. Florence, Bibl. Naz. MS. cl. XXXVII, cod. 305; Strozziano, pp. 107–13. Spogli e scritture dello Spedale di S. Maria Nuova di Firenze.

2. A. Warburg, *Gesammelte Schriften* (Leipzig/Berlin, 1932), p. 188.

3. Paul Schubring, *Cassoni* (Leipzig, 1915), pp. 430–7.

4. Wolfgang Stechow, 'Marco del Buono and Apollonio di Giovanni', *Bulletin of the Allen Memorial Art Museum* (Oberlin College, June 1, 1944).

5. The name 'Virgil Master' is used by R. Offner, *Italian Primitives at Yale University* (New Haven, 1927), that of 'Master of the Jarves Cassoni' by B. Berenson, *Pitture italiane del Rinascimento* (1936).

6. Alfonso Lazzari, *Ugolino e Michele Verino* (Turin, 1897).

7. Ugolini Verini, *Flammetta*, ed. Lucianus Mencaraglia (Florence, 1940), Book II, no. 8. The poem on Apollonio was first published in *Carmina illustrium poetarum Italorum* (Florence, 1724), p. 398.

8. For the original text cf. Appendix, p. 26 above.

9. For these cf. *Katalog der Gemälde alter Meister in der niedersächsischen Landesgalerie, Hannover*, edited by G. von der Osten (Hanover, 1954), nos. 186 and 187.

10. Best reproduction in *Bulletin de la Société Française de Reproductions des Manuscrits à Peintures* (Paris, 1930), 13ᵉ année; cf. also Schubring, *op. cit.*, nos. 225–44, and V. Ussani and L. Suttina, 'Virgilio', supplement to the *Illustrazione Italiana* (1930), p. 45.

11. September 27, 1465. Cf. Thieme-Becker, s.v. *Apollonio* (entry by Warburg).

12. Karl Frey, *Michelagniolo Buonarroti* (Berlin, 1907).

13. Schubring, *loc. cit.*

14. In 1452. There are also 23 entries for 1446, but not all of them need refer to cassoni. There are 22 for 1447; the average declines to some 9 commissions per year after 1455.

15. Schubring overlooked the most important clue concerning this point. Cino di Filippo di Cino, in recording the expenses of his marriage to Ginevra Martelli, notes: 'Adi 18 Luglio 1461 fior trentatre si fanno buoni a Appollonio [*sic*] dipintore per un paio di forzieri dipinti e mesci coll' arme nostra e de' Martelli; quali ebbi da lui fino a di 6 do quando menai la Ginevra a casa' (G. Aiazzi, *Ricordi storici di Filippo di Cino Rinuccini*, etc., Florence, 1840, p. 251). The commission is indeed listed in the workshop records as the last before 1461: 'Figlia d' Ugolino Martelli a Cino di Filippo Rinuccini Fl. 36'. Since the price is only a little above the average and we know that a pair of cassoni was delivered we must assume the same for most of the commissions listed. It may be significant, incidentally, that Cino mentions Apollonio rather than Marco del Buono.

16. *Op. cit.*

17. Where Schubring, in his discussion of the cassone, refers to the members of the Council, in whose honour the tournament was held, Warburg wrote on the margin: 'wo sind sie denn?'

18. Reproduced in Van Marle, x, p. 553 (reversed) as 'ex-Holford Collection'. Sold by F. Drey in 1948. I am indebted for information to Mrs. F. Drey and for the photograph to the Witt Library.

19. Formerly in the Chamberlin Collection, sold at Christie's on February 25, 1938. I am indebted for information to Mr. W. Martin and Mr. J. Bacri; for the photograph to the Witt Library.

20. Berenson, *loc. cit.*, s.v. 'Master of the Jarves Cassoni'.

21. Schubring, No. 142. For a similar example cf. *Münchner Jahrbuch*, v, 1910, p. 187.

22. Reproduced in the *Illustrated London News*, February 28, 1948, where it is dated (on heraldic evidence) 1472 and attributed to Utili da Faenza.

23. If Apollonio still designed the Queen of Sheba cassone at Yale, some of the other versions of the same theme look both later and more derivative. This applies, for instance, to the cassone in the Victoria and Albert Museum (Schubring, No. 193) which preserves the sense of pageantry but not the liveliness and energy of the Yale version. Marco del Buono, born in 1402, died only in 1489. I see no valid case for identifying him with the 'Marchino' Vasari lists among the pupils of Andrea del Castagno, as Thieme-Becker does, following Milanesi. He would have been 21 years older than his master.

24. For a comparable style, cf. N. Rasmo, 'Il codice palatino 556 e le sue illustrazioni', *Rivista d' Arte* (1939), xxi.

25. The device of the left-hand side, which looks like a figure with an hour-glass, recalls that of Lorenzo de' Medici's joust of 1469, *le tems revient*, but such a late date would exclude Apollonio as the author. The right-hand device has never been correctly described. The Lady looks at a cage, scratched into the gesso, in which appears a fettered youth. She holds a large key on her lap.

26. Cf. the illustrations in the Italian fourteenth-century romance *Meliades*, Brit. Mus. MS.

Add. 12228, described in H. L. D. Ward, *Catalogue of Romances in the Dept. of MSS. in the Brit. Mus.* (London, 1883). Fig. 39 is only one of several suggestive examples.

27. For the views of Rome cf. H. C. Hülsen, 'Di alcune prospettiche di Roma', *Bollettino della Commissione Archeologica Comunale di Roma*, XXXIX (1911). The same view occurs on the triumph of Caesar (Fig. 30) and on that of Aemilius Paulus in the Fitzwilliam Museum, Cambridge (M. 29). Views of Constantinople occur in the Oberlin cassone and on the 'Strozzi chest' in the Metropolitan Museum, New York.

28. A possible exception is the man adding a faggot to Caesar's pyre (Fig. 41), whose gesture recalls that of the Meleager sarcophagus, borrowed by Michelangelo. However, the gesture may also have been taken from real life, as it is described by Leonardo. Cf. my note on 'A classical quotation in Michelangelo's Sacrifice of Noah', *Journal of the Warburg Institute*, I, 1937. The charming figure of Apollo certainly betrays no acquaintance with classical representations of the god.

29. Life of Eugenius IV, cf. the note to A. Warburg, *Gesammelte Schriften, ed. cit.*, p. 389.

30. Lazzari, *op. cit.*, p. 168. A publication of the *Carliades* was announced by N. Juhász but has not materialized.

31. The former on his tomb in S. Maria sopra Minerva in Rome, the latter in an inscription of the Pisan Camposanto.

32. *De illustratione Urbis Florentiae* (Paris, 1583). For the date of the first version (*c.* 1487) cf. Lazzari, *op. cit.*, p. 186. A slightly later version (Michele Verino is dead but Lorenzo de' Medici seems alive) exists in autograph in Paris, Bibl. Nat. cod. nov. lat. 1030. It already contains the passage on Florentine artists as in the published version. This latter has been translated and annotated in A. Chastel, *Marsile Ficin et l'art* (Geneva, 1954), pp. 195–6. For Verino's earlier epigram in praise of Florentine artists (before 1485, cf. Lazzari, p. 105), see H. Brockhaus, in *Festschrift zu Ehren des Kunsthistorischen Instituts in Florenz* (Leipzig, 1897), pp. iii f.

33. 'Io considero che le 20 historie della nuova porta, le quali avete deliberate che siano del vecchio testamento, vogliono avere due cose principalmente, l' una che siano illustri, l' altra che siano significanti. Illustri chiamo quelle, che possino ben pascere l' occhio con varietà di disegno. Significanti chiamo quelle, che abbino importanza degna di memoria . . . bisognerà, che colui, che l' ha a disegnare, sia bene instrutto di ciascuna historia, si che possa ben' mettere e le persone e gl' atti occorrenti, e che habbia del gentile, si che le sappia ben' ornare' (H. Brockhaus in *Forschungen über Florentiner Kunstwerke* (Leipzig, 1902), p. 37. It is interesting to compare this appreciation of what is pleasing with 'Manetti's' admiration, a generation later, of Brunelleschi's trial piece for the first door because it is 'difficult'. I have discussed this significant approach to art in 'The Renaissance Conception of Artistic Progress and its Consequences', pp. 1–10 above.

Leonardo Bruni's granddaughter, incidentally, appears among Apollonio's customers in 1446.

34. Schubring, nos. 156, 157, 184, 185, 289, 290.

35. The biological foundation of this belief is sanctioned by the story of Jacob's ruse in Gen. XXX. 37–42. A typical story from classical antiquity is in the *Aethiopica*, where the white complexion of the negress Chariclea is explained by her mother having seen a painting of the nude Andromeda. For a similar story cf. Dionysius of Halicarnassus, *Op. Omn.* (Leipzig, 1775), V, 416. Ficino alludes to this belief in 'De immortalitate animae', *Opera Omnia*, (Basle, 1576), I, p. 284. Cf. also Schubring, *op. cit.*, p. 12 (the reference to Vives is erroneous).

36. Cf. my article 'Icones Symbolicae', *Journal of the Warburg and Courtauld Institutes*, XI, 1948, esp. pp. 177 and 185.

37. Cat. no. 270.

38. Cat. no. 1974.

39. Schubring, nos. 298, 299, and T. Borenius, *Catalogue of the Pictures and Drawings at Harewood House* (Oxford, 1936).

40. *De casibus virorum illustrium*, lib. III, p. 6.

41. Orosius, I, 21, 15 makes Pericles and Sophocles two war leaders against Sparta and Asia. S. Antoninus in his *World Chronicle* (titulus IV, cap. I, par. 55) follows Eusebius in placing Pindar, Sophocles and Euripides into the period of Xerxes and Themistocles. Putting these two sources together Pericles becomes a contemporary of Xerxes.

42. G. Rucellai had a branch office in Constantinople. What remains a topical allusion in the Oberlin cassone becomes an overt illustration on the so-called Strozzi chest,

Schubring, nos. 283–5. Here we find a representation of the Turkish advance on Greece, also with Constantinople, the Black Sea and the Bosphorus in the background. Schubring saw in this piece, which clearly comes from Apollonio's workshop, a representation of the fall of Trebizond in 1461, but though that place is marked, it cannot have been the intention of the painter simply to represent a Greek disaster. A fresh study of this extraordinary piece, now in the Metropolitan Museum, New York, would seem eminently desirable.

From a similar point of view the 'significance' of the Caesar panels (Figs. 27, 40, 41) also assumes fresh interest. The 'casus' of another proud mortal who had failed to heed the fool's warning in his hour of triumph had an ominous application to Florentine conditions in the decades preceding the Pazzi conspiracy. Our workshop's list of customers includes a sufficient number of names to stimulate such speculations, e.g. 6 Pitti, 6 Pazzi, 4 Soderini, 8 Strozzi.

43. For a full summary cf. Lazzari, *op. cit.*, pp. 167 ff.

44. Lazzari, *op. cit.*, p. 158.

45. Cf. Appendix II (a).

46. Verino's piety was such that he began every fresh page of his draft for the *Carliades* with the invocation ' + iesus maria raphael ieronimus'.

47. Schubring, nos. 151, 158, and 160. For the latter cf. T. Borenius, 'Unpublished Cassone Panels, VI', *The Burlington Magazine*, XLI, 1922.

48. G. Poggi in *The Burlington Magazine*, XXIX, 1916.

49. The current interpretation, that we see here the 'Healing of the Leper', goes back to Steinmann, in *Repertorium für Kunstwissenschaft*, XVIII, 1895. Unfortunately it does not stand up to a critical examination. The centre of this rite, as described in Leviticus xiv, is a repeated washing and shaving of the former sufferer. Steinmann's explanation that the running water, prescribed, must be imagined behind the standing crowd belongs to the curiosities of iconography. The problem has recently been discussed by L. D. Ettlinger, *The Sistine Chapel before Michelangelo* (London, 1965), pp. 78–88, who identifies the rite as an Old Testament blood sacrifice and as a reference to St. Paul's Epistle to the Hebrews, where such a sacrifice is compared with the Eucharist.

50. In the drawings for the *Disputa* this influence is clearly discernible.

51. Appendix II (b). This is the version as it appears in the beautiful dedication copy for Charles VIII with Verino's portrait on the opening page. The wording is almost identical in Laur. Plut. 39, 41 and (but for the change in the artist's name) in the earlier MS. in Paris, Bibl. Nat. Nouv. Fonds lat. 10, 234.

52. Cf. H. Brockhaus, in *Festschrift*, *op. cit.*

53. I am indebted for this observation to Prof. Gertrud Bing.

54. C. Gould, 'Leonardo's Great Battle-Piece', *The Art Bulletin*, XXXVI, 1954, p. 121 n. The author compares the episodic treatment planned by Leonardo with that of the cassone but stresses that the difference in artistic quality precludes a direct influence. True, but may not the traditional rendering have influenced the terms of the commission?

RENAISSANCE AND GOLDEN AGE

1. This paper was read at the Tenth Historical Congress in Rome in 1955, a brief advance summary having been published in the *Relazioni del Congresso Internazionale di Scienze Storiche*, VII (1955), pp. 304–5. My paper on 'The Early Medici as Patrons of Art', for which see pp. 35–57 above, and above all Mrs. Alison M. Brown's study of 'The Humanist Portrait of Cosimo de' Medici, Pater Patriae' published in the *Journal of the Warburg and Courtauld Institutes*, XXIV (1961), pp. 186–221, now provide a somewhat firmer setting for this sketch.

2. *Relazioni*, IV, p. 327. Plans for the publication of Lorenzo de' Medici's *Epistolario* have meanwhile far advanced under the joint auspices of the Istituto Nazionale di Studi sul Rinascimento, The Renaissance Society of America, and the Warburg Institute. A check-list, *Censimento delle lettere di Lorenzo di Piero de' Medici* (Florence, 1964), has been published by the Editors, P. G. Ricci and N. Rubinstein.

3. E. R. Curtius, *European Literature and the Latin Middle Ages* (London, 1953); C. K. Burdach, *Reformation, Renaissance, Huma-*

nismus (Leipzig, 1926), p. 53 and pp. 59 ff.

4. W. K. Ferguson, *The Renaissance in Historical Thought* (Cambridge, 1948).

5. A. Chastel, 'Vasari et la légende médicéenne', *Studi vasariani* (Atti del Convegno Internazionale per il IV Centenario della prima edizione delle *Vite* del Vasari) (Florence, 1952).

6. H. P. Horne, *Alessandro Filipepi* (London, 1908).

7. *Der Lebensraum des Künstlers in der florentinischen Renaissance* (Leipzig, 1938).

8. F. Gilbert, 'Bernardo Rucellai and the Orti Oricellai', *Journal of the Warburg and Courtauld Institutes*, XII (1949), pp. 101 ff.

9. *Carmina*, ed. I. Fógel and L. Juhász, (Leipzig, 1932).

10. Printed in Roscoe, *The Life of Lorenzo de' Medici*, 4th ed. (London, 1800), Appendix L, p. 285.

11. M. Eliade, *Le Mythe de l'éternel retour* (Paris, 1949); F. Kampers, *Vom Werdegange der abendländischen Kaisermystik* (Leipzig, 1924);

K. Borinski, *Die Weltwiedergeburtsidee in den neueren Zeiten* (Munich, 1919).

12. Roscoe, *op. cit.*, p. 289.

13. *Selve*, II, 122.

14. C. Landino, *Carmina*, ed. Perosa (Florence, 1939), p. 135.

15. U. Verino, *Flametta*, ed. L. Mencaraglia (Florence, 1940), p. 107.

16. Naldo Naldi, *Elegiarum libri III*, ed. L. Juhász (Leipzig, 1934), p. 89, lines 349–50.

17. *De Monarchia*, I, xiii; Kampers, *op. cit.*; Burdach, *op. cit.*; P. E. Schramm, *Kaiser, Rom und Renovatio* (Leipzig, 1929); R. Bonnaud Delamare, *L'Idée de paix à l'époque carolingienne* (Paris, 1939); F. A. Yates, 'Queen Elizabeth as Astraea', *Journal of the Warburg and Courtauld Institutes*, X (1947), pp. 27 ff.

18. *Relazioni*, p. 341.

19. In Giovanni Lami, *Deliciae Eruditorum*, XII (Florence, 1742), p. 146.

20. *Relazioni*, pp. 536–9.

21. *Ed. cit.*, p. 49.

THE EARLY MEDICI AS PATRONS OF ART

1. Th. Klette, *Beiträge zur Geschichte und Litteratur der italienischen Gelehrtenrenaissance*, II (Greifswald, 1889), p. 32, after Bruni, Epistolae, ed. Mehus, lib. VII, ep. iv.

2. Ernst Robert Curtius, *European Literature and the Latin Middle Ages* (London, 1953).

3. Cf. 'Renaissance and Golden Age', p. 29 above.

4. Marcello del Piazzo, *Protocolli del carteggio di Lorenzo il Magnifico* (Florence, 1956), and now P. G. Ricci and N. Rubinstein, *Censimento delle lettere di Lorenzo di Piero de' Medici* (Florence, 1964).

5. Giovanni Gaye, *Carteggio inedito d' artisti*, I (Florence, 1839), p. 209.

6. Letters from Pietro Cennini to Lorenzo, Archivio Mediceo avanti il Principato, Filza XXXIII, 461 and 766, of September 1476.

7. P. O. Kristeller, 'The Modern System of the Arts', *Journal of the History of Ideas*, XII, October 1951, XIII, January 1952.

8. *Op. cit.*

9. Alfred von Reumont, *Lorenzo de' Medici* (Leipzig, 1883).

10. E. Muentz, *I precursori e propugnatori del Rinascimento* (Florence, 1902).

11. Martin Wackernagel, *Der Lebensraum des Künstlers in der florentinischen Renaissance* (Leipzig, 1938), a book missing from S.

Comerino's eminently useful *Bibliografia Medicea* (Florence, 1940).

12. D. Moreni, *Memorie storiche dell' Ambrosiana Basilica di S. Lorenzo di Firenze* (Florence, 1817); C. v. Fabriczy, *Filippo Brunelleschi* (Stuttgart, 1892).

13. A. Doren, 'Das Aktenbuch für Ghibertis Matthaeus-Statue', *Italienische Forschungen*, I (Berlin, 1904).

14. R. Krautheimer, *Lorenzo Ghiberti* (Princeton, 1956), Docs. 138 and 151.

15. Ottavio Morisani, *Michelozzo architetto* (Einaudi, 1951).

16. Vespasiano de' Bisticci, *Vite di uomini illustri*, ed. P. d' Ancona and E. Aeschlimann (Milan, 1951); there is an English translation under the title *The Vespasiano Memoirs* (London, 1926), by W. George and E. Waters.

17. R. de Roover, *The Medici Bank* (Cambridge, 1963).

18. Iris Origo, *The Merchant of Prato* (London, 1957).

19. Origo, *op. cit.*, p. 149.

20. In a letter attributed to 'Franciscus cognomento padovanus', preserved in the *zibaldone* of B. Fontius in the Riccardiana, cod. 907, fo. 141 f., 'eleganter qui tum deo jocaretur dicere solebat, patientiam domine

habe in me et omnia reddam tibi'.

21. W. Roscoe, *The Life of Lorenzo de' Medici*, Appendix XII.

22. Curt S. Gutkind, *Cosimo de' Medici* (Oxford, 1938), p. 196.

23. Printed in G. Lami, *Deliciae Eruditorum*, XII (Florence, 1742), pp. 150–68.

24. G. Savonarola, *Prediche italiane*, ed. R. Palmarocchi (Florence, 1930–5), III, i, p. 391.

25. *Antonii Benivienii* ΕΓΚΩΜΙΟΝ *Cosmi*, ed. Renato Piattoli (1949), p. 56.

26. *Le vite...*, ed. G. Milanesi, II (Florence, 1878). For Vasari's dependence on Vespasiano cf. A. Siebenhüner and L. H. Heydenreich, 'Die Klosterkirche von San Francesco al Bosco', *Mitteilungen des kunsthistorischen Instituts in Florenz*, V (1937–40), p. 183.

27. Antonio Averlino Filarete, *Tractat über die Baukunst*, ed. W. von Oettingen (Vienna, 1890).

28. E.g. U. Verino, *Flametta*, ed. L. Mencaraglia (Florence, 1940), pp. 104–10, B. Fontio, *Carmina*, ed. Fógel and L. Juhász (Leipzig, 1932), p. 11, C. Landino, *Carmina Omnia*, ed. A. Perosa (Florence, 1939), pp. 119–22, Naldo de Naldi, *Elegiarum Libri III*, ed. L. Juhász (Leipzig, 1934), p. 88.

29. Morisani, *op. cit.*, p. 90. Walter and Elisabeth Paatz, *Die Kirchen von Florenz*, III (Frankfurt-am-Main, 1952), pp. 8 ff.

30. *Ed. cit.*, II, pp. 440–1.

31. R. G. Mather, 'New Documents on Michelozzo', *The Art Bulletin*, XXIV (1942).

32. Moreni, *op. cit.*, II, pp. 346–7.

33. A. Manetti (attributed to), *Vita di Filippo di Ser Brunelleschi*, ed. E. Toesca (Florence, 1927). Fabriczy, *op. cit.*

34. Gaye, *op. cit.*, I, pp. 167 ff.

35. *Il libro di Antonio Billi*, ed. C. Frey (Berlin, 1892), who attributed the second project to Filarete.

36. A. Warburg, 'Der Baubeginn des Palazzo Medici', *Gesammelte Schriften* (Leipzig-Berlin, 1932).

37. Venturi, *Storia dell' arte italiana*, VIII (Milan, 1923), p. 273. This structure is here shown in the pen drawing by E. Burci (Fig. 61), reproduced by C. Ricci, *Cento vedute di Firenze antica* (1906), Plate 83. The dormitory, in the centre of the drawing, bears the Medici arms.

38. *Op. cit.*, I, p. 558.

39. Alberti Advogradii Vercellensis, *De Religione et Magnificentia . . . Cosmi Medicis*, Libri ii. Lami, *Deliciae Eruditorum*, XII (Florence,

1742), pp. 117–49. Lami's version, by the way, is hopelessly corrupt in places, as is Cod. Plut., liv, 10, of the Laurenziana which was his source. In the light of the correct text offered by Cod. Laur. Plut., XXIV, 46, I have discussed other sections of the poem in 'Alberto Avogadro's Descriptions of the Badia of Fiesole and of the Villa of Careggi', *Italia Medioevale e Umanistica*, V (1962), pp. 217–29.

40. *Ed. cit.*, p. 142.

41. Published by Fabriczy, *op. cit.*, pp. 586 ff.

42. *Op. cit.*, pp. 676–7.

43. 'Alberto Avogadro's Descriptions of the Badia of Fiesole and of the Villa of Careggi', *loc. cit.*, p. 223.

44. *Ibid.*, p. 224.

45. Gaye, *op. cit.*, I, p. 136.

46. *Ibid.*, I.

47. *Ibid.*, p. 140.

48. *Ibid.*, p. 141.

49. *Il Buonarroti*, serie ii, vol. IV (Rome, 1869).

50. Gaye, *op. cit.*, I, p. 158.

51. Morisani, *op. cit.*, p. 94.

52. Wackernagel, *op. cit.*, p. 245.

53. Gaye, *op. cit.*, I, pp. 191–4. See now also A. Grote, 'A Hitherto Unpublished Letter on Benozzo Gozzoli's Frescoes in the Palazzo Medici-Riccardi', *Journal of the Warburg and Courtauld Institutes*, XXVII (1964), pp. 321–2.

54. J. Marcotti, *Guide Souvenir de Florence* (Florence, 1888).

55. Alessandro d' Ancona, *Origini del teatro italiano* (Turin, 1891), I, p. 277.

56. I am indebted for this observation to Mrs. Stella Pearce-Newton.

57. *Op. cit.*, pp. 666 f.

58. Paolo d' Ancona, *La miniatura fiorentina* (Florence, 1914).

59. *Op. cit.*, pp. 668–9.

60. E. Muentz, *Les Collections des Médicis* (Paris, 1888).

61. Wackernagel, *op. cit.*, pp. 346 f.

62. *Ed. cit.*, IV, p. 174.

63. According to the *protocolli* published by Piazzo, Lorenzo spent a few weeks in the Spedaletto in September 1487, in July 1489, and again in September 1491 (*op. cit.*, p. xlvi). For the letter recording their work at Spedaletto, see Horne, *Alessandro Filipepi* (1908), p. 353.

64. Roscoe, *op. cit.*, Appendix LXXVI.

65. *Ibid.*, Appendix LI.

66. The document is reprinted in M. Cruttwell, *Verrocchio* (London, 1904), pp. 242 f.

67. For the following examples cf. Wackernagel, *op. cit.*, p. 268, Alfred von Reumont, *Lorenzo de' Medici* (Leipzig, 1883), pp. 136 ff.

68. Gaye, *op. cit.*, I, pp. 256 f.

69. *Ibid.*, II, p. 450.

70. *Ed. cit.*, III, p. 270 n.

71. *Ibid.*, III, p. 469.

72. L. Ettlinger, 'Pollaiuolo's Tomb of Pope Sixtus IV', *Journal of the Warburg and Courtauld Institutes*, XVI (1953), 249, 258.

73. Gaye, *op. cit.*, I, p. 300.

74. *Ibid.*, p. 274.

75. *Ibid.*, p. 1.

76. E. Armstrong, *Lorenzo de' Medici* (London, 1896), p. 393.

77. Lami, *ed. cit.*, XII, p. 198.

78. Roscoe, *op. cit.*, ch. ix.

79. Gaye, *op. cit.*, I, pp. 354 ff.

80. Reumont, *op. cit.*, p. 146.

81. Roscoe, *op. cit.*, Appendix LXVI.

82. Wackernagel, *op. cit.*, p. 268.

83. W. Haftmann, 'Ein Mosaik der Ghirlandajo-Werkstatt aus dem Besitz des Lorenzo Magnifico', *Mitteilungen des kunsthist. Instituts in Florenz*, VI (1940–1).

84. E. Kris, *Meister und Meisterwerke der Steinschneidekunst* (Vienna, 1929).

85. W. von Bode, *Bertoldo und Lorenzo dei Medici* (Freiburg, 1925).

86. Piazza, *op. cit.*, p. 480. For a reinterpretation of Bertoldo's letter, see now A. Parronchi, 'The Language of Humanism and the Language of Sculpture', *Journal of the Warburg and Courtauld Institutes*, XXVII, 1964, pp. 129–36.

87. A. Chastel, 'Vasari et la légande medicéenne', *Studi vasariani* (Florence, 1952), a paper which, as the author kindly acknowledges, partly arose out of a conversation in which I had voiced my suspicions of Vasari's account.

88. A. Condivi, *Vita di Michelangiolo*, ed. Maraini (Florence, 1927).

LEONARDO'S METHOD FOR WORKING OUT COMPOSITIONS

1. *The Drawings of the Florentine Painters* (Chicago, 1938), vols. 1–3.

2. 'O tu componitore delle istorie non membrifficare con terminati lineamenti le membrifficationi d' esse istorie che t' entervera come a molti e vari pittori intervenire suole li quali vogliano che ogni minimo segno di carbone sia valido e questi tali ponno bene acquistare richezze ma non laude della sua arte, perche molte sono le volte, che lo animale figurato non a li moti delle membra apropriate al moto mentale e havendo lui fatta bella e grata membrifficatione ben finita li parra cosa ingiuriosa a trasmutare esse membra piu alte o basse o piu indietro che inanzi e questi tali non sonno merittevoli d' alcuna laude nella sua sientia.' (*Treatise on Painting*, Codex Urbinas Latinus 1270, ed. A. P. McMahon, II, Facsimile (Princeton, 1956), fols. 61 v–62 r).

3. *Le vite*, ed. G. Milanesi, I (Florence, 1878), p. 383.

4. The line is not quite unaided as it is based on a preliminary tracing from which it deviates slightly, but even the earlier one shows no *pentimenti*.

5. Cennino Cennini, *Il libro dell' arte*, edited by D. V. Thompson Jr. (New Haven, 1932). Apparently only the apprentice should rub out his fumbling beginnings (*loc. cit.*, p. 17).

6. R. Oertel, 'Wandmalerei und Zeichnung in Italien, die Anfänge der Entwurfszeichnung und ihre monumentalen Vorstufen', *Mitteilungen des kunsthistorischen Instituts in Florenz*, V (1940), pp. 217–314.

7. B. Degenhart, *Italienische Zeichnungen des frühen 15. Jahrhunderts* (Basle, 1949).

8. Even such a slight adjustment as that on Filippo Lippi's drawing of the Crucifixion in the British Museum (A. E. Popham and Philip Pouncey, *Italian Drawings in the Department of Prints and Drawings in the British Museum, The Fourteenth and Fifteenth Centuries* (London, 1950), no. 149) appears to be rather exceptional.

9. Cf. A. E. Popham and Philip Pouncey, *op. cit.* nos. 87 or 261. On the drawing here illustrated, see B. Degenhart in *Münchner Jahrbuch der bildenden Kunst*, I (1951), 114–115.

10. 'Hor, non ai tu mai considerato li poeti componitori de lor versi alli quali non da noia il fare bella lettera ne si cura di canzellare alcuni d' essi versi riffaccendoli migliori adonque pittore componi grossamente le membra delle tue figure e' attendi prima alli movimenti apropriati alli accidenti mentali de li animali componitori della storia, che alla bellezza e bonta delle loro membra . . .' (*ed. cit.*, fol. 62 r).

11. 'Il bozzar delle storie sia pronto, e 'l membri-ficare no' sia troppo finito, sta contento solamente a' siti d' esse membra, i quali poi a' bel' aggio piacendoti potrai finire' (*ed. cit.*, fol. 34 r).

12. For the background of this development, cf. E. Gombrich and E. Kris, 'The Principles of Caricature' in E. Kris, *Psychoanalytic Explorations in Art* (New York, 1951).

13. 'per che tu hai a' intendere che se tal componimento inculto ti reussira apropriato alla sua inventione tanto maggiormente sattisfara essendo poi ornato della perfettione apropriata a' tutte le sue parte. Io ho gia veduto nelli nuvoli e' muri machie, che m' anno deste a belle inventioni di varie cose le quali machie anchora che integralmente fussino in sə private di perfectione di qualondue membro non manchavano di perfectione nelli loro movimenti o altre actioni' (*ed. cit.*, fol. 62 r).

14. 'una nova inventione di speculatione . . . a destare le ingegnio a varie inventioni' (*ed. cit.*, fol. 35 v).

15. E. Kris, *loc. cit.*, p. 53.

16. I have discussed some implications of this invention in 'Meditations on a Hobby Horse', reprinted in the volume of that title (London, 1963), pp. 1–11, and also in *The Story of Art* (London, 1949), p. 219.

17. Marilyn Aronberg, 'A new facet of Leonardo's working procedure'. *The Art Bulletin*, XXXIII (1951), p. 235. We may well owe the preservation of many of Leonardo's rough sketches to this habit, inconceivable to earlier workshop practice where only the usable pattern was preserved.

18. Luca Beltrami, *Documenti e memorie riguardanti la vita e le opere di Leonardo da Vinci* (Milan, 1919), no. 107.

19. K. Clark, *A Catalogue of the Drawings of Leonardo da Vinci . . . at Windsor Castle*, no. 12591.

20. 'S' el pittore vol vedere belleze che lo innamovino egli n' e signore di generarle . . .' (*ed. cit.*, fol. 35 r).

21. K. Clark, *Leonardo da Vinci* (Cambridge, 1939), esp. p. 66. I have dealt with one aspect of this problem, Leonardo's caricatures, in 'Leonardo's Grotesque Heads. Prolegomena to their study', in *Leonardo, saggi e ricerche* (Rome, 1954), pp. 199–219.

22. 'perche nelle cose confuse l' ingegnio si desta a' nove inventioni, ma fa prima di sapere ben fare tutte le membra di quelle cose che voi figurare come le membra delli animali come le membra de paesi cié sassi piante e' simili' (*ed. cit.*, fol. 35 v).

23. 'Quello maestro il quale si dessi d' intendere di potere riservare in se tutte le forme, e' li effetti della Natura certo mi parrebbe che quello fussi ornato di molta ingnorantia conciosia cosa che detti effetti son' infiniti, la memoria nostra non e di tanta capacitàe' che basti' (*ed. cit.*, fol. 38 v).

24. 'attenderai prima col dissegno a' dare con dimostrativa forma al ochio la intentione, e la inventione fatta in prima nella tua imaginativa di poi va levando e' ponendo tanto che tu ti sadisfacia di poi fa aconciare homini vestiti, o nudi, nel modo che in sul' opera hai ordinato e' fa che per misura e' grandezza sotto posta alla prospettiva che non passi niente del' opera che bene non sia considerata della ragione e' dalli effetti naturali . . .' (*ed. cit.*, fol. 38 v).

25. *Ed. cit.*, fol. 43 v.

26. I have discussed this problem in *Art and Illusion* (London, 1962), 3rd ed., chap. III.

27. *Ed. cit.*, fol. 36 v.

RAPHAEL'S *MADONNA DELLA SEDIA*

1. Inv. no. 151; diameter 71 cm. (*c.* 28 in.).

2. A. Malraux, *The Voices of Silence* (London, 1954), p. 450.

3. G. K. Nagler, *Künstler Lexikon*, 1835–52, XVI, p. 403. For the following see also M. Hauptmann, *Der Tondo* (Frankfurt, 1936), pp. 262 f.

4. Wilhelm Hoppe, *Das Bild Raffaels in der deutschen Literatur* (Frankfurter Quellen und Forschungen) (Frankfurt, 1935).

5. Lithographed in 1839. His contemporary J. M. Wittmer also painted the subject.

6. A. P. Oppé, *Raphael* (London, 1909), p. 189.

7. For the context of this letter see now F. Ulivi, *L' imitazione nella poetica del Rinascimento* (Milan, 1959), pp. 26–36.

8. Nuvolara to Isabella d' Este; Luca Beltrami, *Documenti . . . riguardanti . . . Leonardo da Vinci* (Milan, 1919), no. 107.

9. Cf. 'Leonardo's Method of working out Compositions', p. 58 above.

10. Frederick Hartt, 'Raphael and Giulio Romano', *The Art Bulletin*, XXVI (1944) especially p. 68.

11. C. Gamba, *Raphael* (Paris, 1932), p. 87.

12. Ortolani, *Raffaello* Bergamo, 1945) p. 53 (discussing a remark by Marangoni).

13. J. A. Crowe and G. B. Cavalcaselle, *Raphael* (London, 1883), p. 228.

14. Wenn, das Todte bildend zu beseelen,
 Mit dem Stoff sich zu vermählen,
 Thatenvoll der Genius entbrennt,
 Da, da spanne sich des Fleißes Nerve,
 Und beharrlich ringend unterwerfe
 Der Gedanke sich das Element.
 Nur dem Ernst, den keine Mühe bleichet,
 Rauscht der Wahrheit tief versteckter
 Born;
 Nur des Meißels schwerem Schlag
 erweichet
 Sich des Marmors sprödes Korn.

 Aber dringt bis in der Schönheit Sphäre,
 Und im Staube bleibt die Schwere
 Mit dem Stoff, den sie beherrscht, zurück.
 Nicht der Masse qualvoll abgerungen,
 Schlank und leicht, wie aus dem Nichts
 gesprungen,
 Steht das Bild vor dem entzückten Blick.
 Alle Zweifel, alle Kämpfe schweigen
 In des Sieges hoher Sicherheit;
 Ausgestoßen hat es jeden Zeugen
 Menschlicher Bedürftigkeit.

15. E.g. Susanne K. Langer, *Feeling and Form* (London, 1953), pp. 88 f.; H. Osborne, *Theory of Beauty* (London, 1952), p. 203; H. E. Rees, *A Psychology of Artistic Creation* (New York, 1942), pp. 69 ff.; Paul Klee, *On Modern Art* (London, 1949).

16. De Piles, *The Principles of Painting* (translated into English by a painter) (London, 1753), p. 69.

17. Aristotle, *The Poetics*, translated by W. Hamilton Fyfe (Loeb Classical Library) (London, 1927), VIII. 9.

18. *Op. cit.*, VII, pp. 8–10.

19. W. Slukin, *Minds and Machines* (Harmondsworth, 1954).

20. For a systematic criticism of Holism cf. K. R. Popper, 'The Poverty of Historicism', London, 1957.

21. It is indeed consistent and most welcome that the most forceful criticism of the idea of purely formal balance in art has now come from the Gestaltist camp; cf. R. Arnheim, *Art and Visual Perception* (Berkeley and Los Angeles, 1954), pp. 21 f.

22. Jakob Burckhardt, *Kulturgeschichtliche Vorträge* (Leipzig, n.d.); the lecture was given in 1886.

23. M. Hauptmann, *loc. cit.*

24. Th. Hetzer, *Gedanken um Raffaels Form* (Frankfurt, 1931), pp. 22–3, 36, 43 f. In his later book *Die sixtinische Madonna* (Frankfurt, 1947), p. 56, the same author stresses the impression of simplicity made by the *Madonna della Sedia*.

25. For the link between Aristotle and 'essentialism' cf. K. R. Popper, *The Open Society and its Enemies* (London, 1945), especially chap. XI. ii.

26. Reproduced by permission of Philips Electrical Ltd.

27. Cf. D. F. Tovey, *The Integrity of Music* (Oxford, 1941), especially Lecture II.

28. *Poetics, ed. cit.*, VI.

29. *Ed. cit.*, IV, p. 16.

30. Cicero, *De Partitione Oratoria* (Loeb Classical Library) (London, 1960).

31. Vitruvius, *De Architectura*, book I, chap. 2, and book III, chap. 1.

32. R. Wittkower, *Architectural Principles in the Age of Humanism* (Studies of the Warburg Institute) (London, 1949).

33. Franciscus Junius, *De Pictura Veterum* (Amsterdam, 1637).

34. Fréart de Chambray, *Idée de la perfection de la peinture* (Le Mans, 1662).

35. R. de Piles, *Cours de peinture par principes* (Paris, 1708).

36. This point is well brought out by A. Ehrenzweig, *The Psychoanalysis of Artistic Vision and Hearing* (London, 1953), e.g. in his discussion of such intricate musical devices as 'mirror' inversions (p. 109). The fact that my answer somewhat differs from his should not obscure my indebtedness to his presentation of the problem.

37. M. Polanyi, *The Logic of Freedom* (London, 1951).

38. For the application of these ideas to 'graphic wit' cf. E. Kris, *Psychoanalytic Explorations in Art* (New York, 1952), especially chaps. 6, 7 (written with E. H. Gombrich), and 8. The author further touches on the central topic of this lecture in his discussion of Leonardo's achievement (p. 19), in chap. 10 (written with A. Kaplan), which pays special heed to the aspect of 'problem-solving', and in chap. 14, which stresses the importance of 'preconscious mental processes'. See now also my 'The Cartoonist's Armoury', reprinted in *Meditations on a Hobby Horse* (London, 1963), pp. 127–42.

39. Cf. 'The Renaissance Conception of Artistic

Progress and its Consequences', p. 1 above.

40. Cf. K. R. Popper, *The Poverty of Historicism*, *loc. cit.*, and I. Berlin, *Historical Inevitability* (London, 1954).

41. E. H. Gombrich, 'Psychoanalysis and the History of Art', *Meditations on a Hobby Horse* (London, 1963), pp. 30–44.

42. Cf. Vasari's formulation in the Preface to the Third Part '. . . nella regola una licenza, che, non essendo di regola, fusse ordinata nella regola, e potesse stare senza fare confusione o guastare l' ordine'. For the further history of this idea cf. G. Baumecker, *Winckelmann in seinen Dresdner Schriften* (Berlin, 1933), pp. 17 ff.

43. O. Fischel, *Raphael* (London, 1948), p. 132. Cf. also the bold but beautiful passage on the Madonna in Ortolani, *op. cit.*, pp. 52–3.

NORM AND FORM

1. I quote only the recent bibliography which will refer the student also to earlier works: Paul Frankl, *The Gothic*, Literary Sources and Interpretations through Eight Centuries (Princeton, 1960). Erwin Panofsky, *Renaissance and Renascences* (Stockholm, 1960). *Manierismo, barocco, rococo: concetti e termini*, Convegno Internazionale, Roma, 21–4 Aprile 1960. *Accademia Nazionale dei Lincei*, Anno CCCLIX (1962), Quaderno No. 52. Otto Kurz, 'Barocco: storia di un concetto' in *Barocco europeo e barocco veneziano*, ed. V. Branca (Venice, 1963).

2. There is a convenient list of these polarities in P. Frankl, *op. cit.*, pp. 773–4.

3. Augusto Guzzo, *Il gotico e l' Italia*. Edizioni di Filosofia (1959).

4. Vitruvius, *On Architecture*, VII, 5, trans. F. Granger (London, 1934), II, p. 105. What Vitruvius is referring to is discussed by Ludwig Curtius, *Die Wandmalerei Pompejis* (Leipzig, 1929), pp. 129 ff.

5. *Le vite*, Introduzione, Dell' architettura, Capitolo III.

6. *Le Vite* (Roma, 1672), p. 12.

7. *Gedanken über die Nachahmung der griechischen Werke in der Malerei und Bildhauerkunst* (Dresden und Leipzig, 1755), pp. 166–167.

8. Fiske Kimball, *The Origins of Rococo* (Philadelphia, 1943).

9. William Warburton, *Pope's Moral Essays* (1760), quoted from P. Frankl, *The Gothic*, pp. 867–8.

10. *Loc. cit.*, pp. 507–8.

11. 'Mannerism: The Historiographic Background', p. 99 above.

12. Especially in the famous section on 'The Nature of Gothic', in *The Stones of Venice*, II (London, 1853), p. 2.

13. 'als reine Fiktion ergreifen sie den Beschauer doch bisweilen, trotz der so oft verwerflickten Ausdrucksweise.' For Burckhardt see also, apart from the literature quoted, Wilhelm Waetzoldt, *Deutsche Kunsthistoriker*, II (Leipzig, 1924).

14. *La Philosophie de l' Art*, I (Paris, 1865), 3.

15. For a brief sketch of this development see my chapter 'Kunstwissenschaft' in *Das Atlantisbuch der Kunst*, ed. Martin Huerlimann (Zürich, 1952).

16. K. R. Popper, *The Poverty of Historicism* (London, 1957) and, by the same author, *The Open Society and its Enemies* (London, 1945), chap. XI, and *Conjectures and Refutations* (London, 1963), see Index s.v. *essentialism*.

17. *Op. cit.*, p. 826.

18. Croce's criticism is reprinted in *Nuovi saggi di estetica* (Bari, 1926).

19. Cf. Svetlana Leonticf Alpers, 'Ekphrasis and Aesthetic Attitudes in Vasari's *Lives*', *Journal of the Warburg and Courtauld Institutes*, XXIII (1960).

20. *Kunstgeschichtliche Grundbegriffe*, 8th ed. (Munich, 1943), pp. 29–31.

21. The limits of relativism with regard to representation are discussed in my book *Art and Illusion* (New York, 1960).

22. 'Raphael's *Madonna della Sedia*', p. 164 above.

23. Cf. Augusto Guzzo, *L' arte* (Torino, 1962), p. cxxxi.

24. Cf. 'The Renaissance Conception of Artistic Progress and its Consequences', p. 1 above.

25. *Op. cit.*, pp. xli ff.

MANNERISM: THE HISTORIOGRAPHIC BACKGROUND

1. Max Planck, *The Philosophy of Physics*, tr. W. H. Johnston (New York, 1936), pp. 11, 14.

2. *Scritti . . . in onore di Lionello Venturi* (Rome, 1956), I, pp. 429–47.

3. See Appendix, pp. 104–106 above.
4. K. R. Popper, *The Logic of Scientific Discovery* (London and New York, 1959).
5. *Le vite . . .*, ed. G. Milanesi, IV (Florence, 1879), p. 376.
6. *Studies in Seicento Art and Theory* (London, 1947).
7. I have criticized this tendency in my review of A. Hauser's *The Social History of Art*, republished in *Meditations on a Hobby Horse* (London, 1963), pp. 86–94.
8. For the justification and limitation of this view, see 'Raphael's *Madonna della Sedia*', p. 70 above.
9. 'The Renaissance Conception of Artistic Progress and Its Consequences', p. 10 above.
10. Cf. Boccaccio on Giotto: 'He brought back that art to light which had lain buried for many centuries because of the errors of some who painted rather to charm the eyes of the ignorant than to appeal to the understanding of the wise'. *Decameron*, 6th Day, 5th Story.
11. Cf. Text 1 of this paper: '. . . driving the true queen from the council chamber . . .'.

THE RENAISSANCE THEORY OF ART AND THE RISE OF LANDSCAPE

1. Edward Norgate, '*Miniatura*' *or the Art of Limning*, ed. by Martin Hardie (Oxford, 1919), pp. 44 f. For Norgate and his context, see H. V. S. and M. S. Ogden, *English Taste in Landscape in the Seventeenth Century*, Ann Arbor (1955), published since this article was originally written.
2. Sir Kenneth Clark, *Landscape into Art* (London, 1949), M. J. Friedländer, *Essays über die Landschaftsmalerei und andere Bildgattungen* (The Hague, 1947), Otto Pächt, 'Early Italian Nature Studies and the Early Calendar Landscape', in *Journal of the Warburg and Courtauld Institutes*, XIII (1950), pp. 13–47, and Charles Sterling, *La Nature morte* (Paris, 1952), with which my review reprinted in *Meditations on a Hobby Horse* (London, 1963), pp. 95–105 may be compared.
3. Diary, May 5, 1521. Cf. Lange-Fuhse, *Dürers schriftlicher Nachlass* (Halle, 1893), p. 160.
4. For summaries of this development see: E. H. Korevaar-Hesseling, *Het Landschap in de Nederlandse en Vlaamse Schilderkunst* (Amsterdam, 1947); cf. also L. v. Baldass, 'Die niederländische Landschaftsmalerei von Patinir bis Brueghel', *Jahrbuch der Kunsthistorischen Sammlungen des allerh. Kaiserhauses in Wien*, XXXIV (1918); Joseph Alexander Graf Raczyński, *Die flämische Landschaft vor Rubens* (Frankfurt a.M., 1937), and Cornelis van de Wetering, *Die Entwicklung der niederländischen Landschaftsmalerei vom Anfang des 16. Jahrhunderts bis zur Jahrhundertmitte* (Berlin, 1939).
5. Cf. J. Denucé, *Inventare von Kunstsammlungen zu Antwerpen im sechzehnten und siebzehnten Jahrhundert* (Antwerp, 1932).
6. E. Tietze-Conrat, 'Das erste moderne Landschaftsbild', *Pantheon*, XV (1935).
7. M. J. Friedländer, *op. cit.*, pp. 58 f.
8. 'Inventar des Kunstbesitzes der Margarete von Oesterreich, 1524–1530', *Jahrbuch der Kunsthist. Sammlungen des allerh. Kaiserhauses in Wien*, III (1885), pp. xciii–cxxiii.
9. *Der Anonimo Morelliano*, ed. Th. Frimmel, in *Quellenschriften zur Kunstgeschichte* (Vienna, 1888).
10. *Loc. cit.*, p. 102. Cf. also the inventory of Grimani's bequest drawn up in 1528: *Quadretti duo sive tavolette de paesi*. C. A. Levi, *Le collezioni veneziane* (Venice, 1900), II, p. 3. Grimani, of course, had a special predilection for Northern works. Apart from the Breviary that still bears his name he owned, for instance, two Patiniers and one Bosch with a seascape. (The word *Fortuna* used by the Anonimo means storm, not the Goddess Fortuna as Frimmel and others have translated.)
11. Usually identified with Albert Ouwater, by whom, however, no landscape is known.
12. *Loc. cit.*, p. 30.
13. *Loc. cit.*, p. 106.
14. Rezio Buscaroli, *La pittura di paesaggio in Italia* (Bologna, 1935), p. 56.
15. Letter to Benedetto Varchi concerning the *paragone* between painting and sculpture, first printed in Bottari-Ticozzi, *Raccolta*, I, p. 52, with Benvenuto Cellini as addressee.
16. M. J. Friedländer, *loc. cit.*, p. 80, 'In den Niederlanden können wir allenfalls das Keimen und Erblühen der Landschaft als einen geschichtlichen Vorgang verfolgen werden mindestens angeregt, es zu versuchen, vor der süddeutschen Produktion streckt der Historiker die Waffen'.
17. Cf. A. Luzio, *La Galleria Gonzaga venduta a l' Inghilterra* (Milan, 1913).
18. Cf. Jakob Burckhardt, *Beiträge zur Kunstgeschichte von Italien* (*Die Sammler*) (Berlin 1911), pp. 360–74.

19. A. Warburg, *Gesammelte Schriften* (Leipzig/ Berlin, 1932), I, pp. 209 f.

20. Book IX, chap. 4.

21. In view of the importance of the text I give the passage from the edition of 1486: 'Cumque pictura et poetica varia sit: alia quae maximorum gesta principum dignissima memoratu: alia quae privatorum civium mores: alia quae aratoriam vitam exprimat. Prima illa quae maiestatem habet publicis at praestantissimorum operibus adhibebitur. Ultima hortis maxime conveniet, quod omnium sit ea quidem iucundissima. Hilarescimus maiorem in modum animis cum pictas videmus amoenitates regionum, et portus, et piscationes, et venationes, et natationes, et agrestium ludos, et florida et frondosa.'

22. *Treatise on Painting, Codex Urbinas Latinus 1270*, ed. A. P. McMahon, II, Facsimile (Princeton, 1956), fol. 5 r. Cf. Irma A. Richter's edition of the *Paragone* (London, 1949), pp. 51 f.

23. For the application of the Neo-Platonic theory of music to painting cf. my 'Icones Symbolicae', *Journal of the Warburg and Courtauld Institutes*, XI (1948).

24. That they were rejected by some appears from Leonardo's famous reference to Botticelli's views on landscape (*ed. cit.*, fol. 33 v). To the mediaevalizing Botticelli, landscapes were tantamount to fortuitous blots of colour, lacking the dignity of a content and thus of art. Leonardo's insistence on the universality of painting, incidentally, had a paradoxical effect on his school. At any rate, it may be no mere coincidence that the first notice of a collaboration between a figure painter and a landscape painter reaches us from Leonardo's circle. Lomazzo's story that Cesare da Sesto and the mysterious Bernazzano (probably a Northerner) collaborated on a *Baptism of Christ* is borne out by stylistic evidence. (Cf. W. Suida, 'Leonardo da Vinci und seine Schule', *Monatshefte für Kunstwissenschaft* (1920).) If this really happened before 1510 it certainly precedes the collaboration between Patinier and Quentin Massys. Those who lived under the shadow of this universal genius could only hope to satisfy his standards by teamwork.

25. Cf. R. Lee, 'Ut pictura poesis', *The Art Bulletin*, XXII (1940).

26. First published by Yriarte in the *Gazette des Beaux-Arts*, XVI (1896).

27. *Historia Naturalis*, XXXV, 112.

28. Cf. H. Gerson, *Ausbreitung und Nachwirkung der holländischen Malerei des siebzehnten Jahrhunderts* (Haarlem, 1943), pp. 153 f.

29. Cf. Ugolino Verino's characterization of Leonardo in: *De illustratione Urbis Florentiae* (Paris, 1790), p. 130.

Et forsan superat Leonardus Vincius omnes;
Tollere de tabula dextram sed nescit, et instar
Protogenis, multis unam perficit annis.

The reference is to Pliny, XXXV, 80.

30. Cf. Don Felipe de Guevara's characterization of Bosch, quoted by Ch. de Tolnay, *Hieronymus Bosch* (Basle, 1937), p. 75. In Van Dyck's *Iconographie* it is A. Brouwer who is called *Grillorum pictor*.

31. *Historia Naturalis*, XXXV, 116, 117.

32. Printed in Tiraboschi, *Storia della letteratura italiana* (Florence, 1712), vol. VII, p. 1722. For Dosso as landscape painter see V. Lasareff, 'A Dosso problem', *Art in America*, XXIX (1941).

33. 'Doxi autem Ferrariensis urbanum probatur ingenium cum in justis operibus, tum maxime in illis, quae parerga vocantur. Amoena namque picturae diverticula voluptuario labore consectatus, praeruptas cautes, viventia nemora, opacas perfluentium ripas, florentes rei rusticae apparatus, agricolarum laetos fervidosque labores, praeterea longissimos terrarum marisque prospectus, classes, aucupia, venationes et cuncta id genus spectatu oculis jucunda, luxurianti ac festiva manu exprimere consuevit.'

34. The final elaborate hierarchy is to be found in A. Félibien's *Conférences de l'Académie Royale de Peinture et de Sculpture pendant l'année 1667* (Paris, 1669), where only the fruit and flower painters are below the landscapist.

35. *Historia Naturalis*, XXXV, 101.

36. p. d. iii, '. . . cum gli exquisiti parergi, Aque, fonti, monti, colli, boscheti, animali'. Cf. R. Buscaroli, *loc. cit.*, p. 26.

37. 'Francisco da Hollanda's Gespräche über die Malerei', ed. J. de Vasconcellos(*Quellenschriften zur Kunstgeschichte*) (Vienna, 1899), p. 29, cf. also Hans Tietze, 'F. da Hollandas und Don Giannottis Dialogue . . .', *Repertorium für Kunstwissenschaft*, XXVIII (1905).

38. Cf. *Lamberti Lombardi apud Eburones pictoris celeberrimi vita* (Bruges, 1565), p. 21, where

the 'humanist' approach to painting is defined with admirable clarity: 'Nam de solo corpore humano meritò in hoc quidem argumento loquor, propterea quod ut universae philosophiae est perfecta hominis cognitio, quia in eo tanquam parvo quodam mundo tota rerum universitas continetur: ita graphices et sculpturae finis est hominem ponere, quia hominis externa species omnes omnium rerum adspectabilium vel in lineis vel in coloribus formositates complectitur. . . .' ['I am justly speaking in this discussion only of the human body, since the perfect knowledge of man is the business of all philosophy, the whole universe of things being contained in him in microcosm: so the end of painting and sculpture is to set man out for our consideration, because his outward form embraces all the beauties of all visible things, whether of line or of colour. . . .']

39. *Pictorum aliquot celebrium Germanicae inferioris effigies* (Antwerp, 1572), *De Ioanne Hollando pictore.*

40. Cf. G. J. Hoogewerff, *Vlaamsche Kunst en italiaansche Renaissance* (Amsterdam), S. A. Gerson, *loc. cit.,* and R. A. Peltzer, 'Die niederländisch-venezianische Landschaftsmalerei', *Münchner Jahrbuch,* N.S. I (1924).

41. Paolo Pino, *Dialogo di pittura* (Venice, 1946), p. 145.

42. Christopher Hussey, *The Picturesque* (London, 1927).

43. M. J. Friedländer, *Die altniederländische Malerei,* IX (Berlin, 1931), p. 104.

44. Cf. G. J. Hoogewerff, 'Joachim Patinier in Italie', *Onze Kunst,* XLIII (1926).

45. Norgate, *loc. cit.,* pp. 45–6.

46. Cf. N. Pevsner, 'Richard Payne Knight', *The Art Bulletin,* XXXI (1949).

47. *Fröhliche Wissenschaft (Scherz, List und Rache,* 55), in *Werke,* V (1900), p. 28.

'Treu die Natur und ganz!'—Wie fängt er's an:
Wann wäre je Natur im Bilde abgetan?
Unendlich ist das kleinste Stück der Welt!
Er malt zuletzt davon, was ihm gefällt.
Und was gefällt ihm? Was er malen kann!

See also my *Art and Illusion* (London, 1962), 3rd ed., chap. II.

48. *Il terzo libro delle lettere* (Venice, 1546), p. 47.

49. Cf. above, p. 109. According to Vasari and Guicciardini, Lancelotto da Brugia, prob-

ably Lancelot Blondeel, specialized in such night pieces.

50. Now re-edited in *Trattati d' arte del cinquecento,* I, ed. P. Barocchi (Bari, 1960), pp. 271–301.

51. Quoted by Eduard von Jan, *Die Landschaft des französischen Menschen* (Weimar, 1935).

52. Cf. 'Norm and Form', reprinted in this volume, pp. 81–98 above.

53. Book VII, chap. 5.

54. *I dieci libri dell' architettura di M. Vitruvio, traduti et commentati di Monsignor Barbaro* (Venice, 1556), p. 188. G. P. Lomazzo, *Trattato dell' arte della pittura, scultura ed architettura.* Book VI, ch. XLIX, defends the use of grotesque decorations. For the general importance of this Vitruvian passage to Renaissance aesthetics, cf. K. Borinski, *Die Antike in Poetik und Kunsttheorie,* I (Leipzig, 1914), pp. 180 f.

55. For the history of this type of decoration, cf. Joseph Gramm, *Die ideale Landschaft* (Freiburg im Br., 1912), p. 238.

56. Kurt Gerstenberg, *Die ideale Landschaftsmalerei* (Halle, 1923).

57. The difference is well characterized by Mancini, who describes P. Bril's change of manner on his arrival in Italy: '. . . lasciando quel modo fiammengo accostandosi più al vero, non refacendo l' orizzonte così alto come usa nei fiamenghi, che cosi per il loro paessaggio è piuttosto una Maestà scenica che prospetto di paese', and by Baldinucci, who says of the Flemings in the same context 'onde poteasi lodare in loro piuttosto una bella maniera di far paesi, che una perfetta imitazione de' veri paesi', cf. R. Buscaroli, *loc. cit.,* pp. 72, 73.

58. For the influence of this passage on Renaissance aesthetics, cf. R. Krautheimer, 'Tragic and Comic Scene of the Renaissance', *Gazette des Beaux-Arts,* XXXIII (1948).

59. I am greatly indebted to Professor Charles Mitchell, who drew my attention to this connection.

60. Lomazzo, *op. cit.,* Libro VI, ch. LXII.

61. The nomenclature of landscape varies a little in the seventeenth and eighteenth centuries but the principal distinctions remain the same. The chapter in Roger de Piles, *Cours de peinture* (Paris, 1708), p. 200 f. gives a good idea of the way Lomazzo's methods were carried on:

'The heroic style is a composition of objects, gathering all from art and nature which can produce a grand and extra-

ordinary effect. The sites, there, are all agreeable and surprising, the fabrics nothing but temples, pyramids, classical tombs, altars, sacred to the Gods, or pleasure dwellings of regular architecture. And if nature is not represented as chance may represent her to our eyes every day, she is at least represented as one fancies that she *ought* to look.

'The rural style is a representation of a country which looks less cultivated and adorned but rather abandoned to the bizarre effects of nature herself. She shows herself in all simplicity, without paint and artifice, but with all those adornments instead, which she can procure much better for herself, when she is left in freedom and not violated by art . . . sometimes it is spread out wide to attract tramps and shepherds, sometimes rather savage and deserted, a safe refuge for wild beasts. . . .'

For Gérard de Lairesse, the distinction is rather between the Antique and the Modern style, but his enumeration of 'ingredients' follows a similar pattern.

62. Elizabeth Wheeler Manwaring, *Italian Landscape in XVIII Century England* (New York, 1925), C. Hussey, *loc. cit.*

63. Thomas West's *Guidebook* (publ. in 1778), quoted by C. Hussey, *loc. cit.*, p. 126. At that time, in fact, the process of identifying the English scenery with picturesque beauty was so far advanced that we witness an amusing repetition of Pino's argument:

The article *Paysage* in the *Grande Encyclopédie* (which came out in 1765), says: 'As to the artists of Great Britain, since there exists

nothing as delightful as the fields of England, many a painter makes a happy use of the charming prospects which present themselves everywhere. Landscape paintings are very much the fashion there and very well paid, so that this *genre* is cultivated with great success. Not many of the Flemish or Dutch artists are very much superior to the landscape painters who now enjoy a high reputation in England.' A remarkable testimony from a period when Wilson had allegedly died in neglect and Gainsborough was forced to paint portraits because his landscapes found no public.

64. Cf. Alexander J. Finberg, *The History of Turner's* 'Liber Studiorum' (London, 1924).

65. Turner only applied the aesthetic rules laid down by W. Gilpin in his poem on Landscape Painting which for the last time sums up the whole tradition:

Who paints a landscape, is confined by rules,
As fixed and rigid as the tragic bard,
To *unity of subject*. Is the scene
A forest, nothing there, save woods and lawns
Must rise conspicuous . . . etc.

(I quote from the third edition of *Three Essays on Picturesque Beauty* (London, 1808), p. 106.)

66. Richard Earlom's engravings of the *Liber Veritatis*, publ. by John Boydell (London, 1777), p. 8.

67. I have since discussed this point more fully in chapter XI of *Art and Illusion* (London, 1962), 3rd ed.

THE STYLE *ALL'ANTICA*: IMITATION AND ASSIMILATION

1. 'Curandum imitatori ut quod scribit simile non idem sit, eamque similitudinem talem esse oportere, non qualis est imaginis ad eum cuius imago est, que quo similior eo maior laus artificis, sed qualis filii ad patrem. In quibus cum magna sepe diversitas sit membrorum, umbra quedam et quem pictores nostri aerem vocant, qui in vultu inque oculis maxime cernitur, similitudinem illam facit, que statim viso filio, patris in memoriam nos reducat, cum tamen si res ad mensuram redeat, omnia sint diversa; sed est ibi nescio quid occultum quod hanc habeat vim. Sic et nobis providendum ut cum simile aliquid sit, multa sint dissimilia, et id ipsum

simile lateat ne deprehendi possit nisi tacita mentis indagine, ut intellegi simile queat potiusquam dici. Utendum igitur ingenio alieno utendumque coloribus, abstinendum verbis; illa enim similitudo latet, hec eminet; illa poetas facit, hec simias.'

2. '. . . es sei nit antikisch Art, dorum sei es nit gut' (to Pirkheimer, February 7, 1506), K. Lange and F. Fuhse, *Dürers schriftlicher Nachlass* (Halle, 1893), p. 22.

3. For the history and progress of this undertaking, see the Annual Reports of the Warburg Institute from 1949 to the present.

4. A. Goldschmidt, *Das Nachleben der antiken*

Formen im Mittelalter (Vorträge der Biblio-thek Warburg, I, 1921–2); Wilhelm Pinder, 'Antike Kampfmotive in neuerer Kunst', *Münchner Jahrbuch der bildenden Kunst*, N.S. v (1928), pp. 353–75. See also Richard Krautheimer and T. Krautheimer-Hess, *Lorenzo Ghiberti* (Princeton, 1956), ch. VIII and Appendix; H. W. Janson, *The Sculpture of Donatello* (Princeton, 1957), esp. p. 100; H. Ladendorf, *Antikenstudium und Antiken-kopie* (Berlin, 1953).

5. H. Gmelin, 'Das Prinzip der Imitatio in den romanischen Literaturen der Renaissance', *Romanische Forschungen*, XLVI (1932); F. Ulivi, *L' imitazione nella poetica del Rina-scimento* (Milan, 1959).

6. Seneca, *Ad Lucilium, Epistulae morales* letter 84.

7. For illustration and discussion, see J. Pope-Hennessy, *Italian Renaissance Sculpture* (London, 1958), p. 101.

8. *Op. cit.*

9. F. Burger, 'Das Konfessionstabernakel Sixtus' IV und sein Meister', *Jahrbuch der preussischen Kunstsammlungen* (1907), pp. 95–116, 150–67.

10. F. Saxl, 'Die Ausdrucksgebärden der bilden-den Kunst', *Bericht über den 12. Kongress der deutschen Gesellschaft für Psychologie in Ham-burg von 12.–16. April 1931*.

11. G. Vasari, *Le vite . . .*, ed. G. Milanesi, v (Florence, 1880), pp. 529–30.

12. F. W. B. Ramdohr, *Ueber Mahlerei und Bildhauerarbeit in Rom* (Leipzig, 1787), II, p. 219. The opinion is endorsed by Th. Schreiber, *Die antiken Bildwerke der Villa*

Ludovisi in Rom (Leipzig, 1880), no. 138. For the sarcophagus and its relatives, see B. Andreae, *Motivgeschichtliche Untersuchun-gen zu den römischen Schlachtsarkophagen*, Berlin, 1956.

13. Frederick Hartt, *Giulio Romano* (New Haven, 1958), I, p. 50.

14. Roman Redlich, *Die Amazonensarkophage des 2. und 3. Jahrhunderts* (Berlin, 1942), Pl. 12, H1.

15. J. von Schlosser, 'Über einige antiken Ghibertis', *Jahrbuch der kunsthistorischen Sammlungen des allerhöchsten Kaiserhauses*, XXIV (1903), pp. 125 ff.

16. T. Hofmann, *Raffael als Architekt* (Zittau, 1911), IV, pl. XLIX.

17. L. Goldscheider, *Michelangelo Drawings* (London, 1951), figs. 143, 146.

18. Hartt, *op. cit.* II, figs. 184, 221.

19. *Ibid.*, fig. 438.

20. Pietro Aretino, *Il secondo libro delle lettere*, ed. F. Nicolini (Bari, 1916), II, 2, p. 186: 'Preponvi il mondo ne la invenzione e ne la vaghezza a qualunche toccò mai compasso e pennello. E ciò direbbe anche Apelle e Vitruvio, s' eglino comprendessero gli edifici e le pitture che avete fatto e ordinato in cotesta città, rimbellita, magnificata da lo spirito dei vostri concetti anticamente moderni e modernamente antichi.'

21. Lejaren A. Hiller, Jr., 'Computer Music', *Scientific American*, December 1959.

22. Quintilian, *Institutio oratoria*, X, 2, 18.

23. A. Warburg, *Gesammelte Schriften* (Leipzig, 1932). See the Index, especially under *Antike: Wirkungen*, and *Beiwerk, bewegtes*.

REYNOLDS'S THEORY AND PRACTICE OF IMITATION

1. This is the title under which Reynolds ex-hibited the painting at the Academy Exhibi-tion of 1774. For these and other data see A. Graves and W. Cronin, *A History of the Works of Sir Joshua Reynolds* (London, 1899), F. Hilles, *Letters of Sir Joshua Reynolds* (London, 1929).

2. Horace Walpole, who was present at the ceremony and describes it in detail in a letter to Sir Horace Mann, Sept. 10, 1761, singles her out as 'very pretty'. Three months later he writes to George Montagu 'Reynolds . . . has just finished a pretty whole length of Lady Elizabeth Keppel in the bridesmaid habit, sacrificing to Hymen'. See E. K. Waterhouse, *Reynolds* (London, 1941), pl. 76.

3. To get the right setting for such a quotation it must be realized that on occasions like this the air reverberated with classical Hymenaei. On this same occasion there appeared the luxuriously printed volumes of *Epithalamia Oxoniensia* and *Gratulati-ones Academiae Cantabrigiensis* which are crammed with variations on this simple theme:

Hymen, to thee our prayers ascend
To thee fair Albions Sovereigns bend
Thy fragrant roses strow . . .

or, more ambitiously:

Ite felices Hymenis ministri
Regiam dignis cumulate donis!

4. Cf. for instance the Portrait of Henrietta Maria, Queen of England (Munich, Pinakothek).

5. Cf. F. Saxl, 'Pagan Sacrifice in the Italian Renaissance', *Journal of the Warburg Institute*, II (1938–9).

6. The allusion occurs in the very first mention of the picture. The critic of the Academy exhibition speaks of the 'whole length portrait of the Irish Graces, Mrs. Gardiner, Lady Viscountess Townshend and Miss Montgomery'. That the master himself was not above the emblematic use of similar flatteries is shown in a later portrait of Viscountess Townshend, this time alone. She leans on a pedestal on which is a basrelief of the *Judgment of Paris* which, to the initiated, must have conveyed the clever compliment to her husband and herself: 'Among the three fair goddesses, you, Paris, have chosen the fairest'.

7. The hierarchy of the *genres* accepted by Reynolds in his discourses was first drawn up in detail by A. Félibien, *Conférences de L'Académie Royale . . . pendant l'année 1667* (Paris, 1669).

8. The picture exists in two versions: one at Rheims (Fig. 184) and one at Sudeley Castle. There is a study for it at Windsor (11905).

9. A Poussin drawing at Bayonne clearly shows his dependence on this motive which, in turn, goes back to a classical relief.— Reinach, *Rep. Rel. II*, p. 284, shows a male servant in a similar pose.

10. I am indebted for this observation to Dr. Erna Mandowsky.

11. See E. Wind and F. Antal, 'The Maenad under the Cross', *Journal of the Warburg Institute*, I (1937–8), and E. Wind, 'Borrowed Attitudes in Reynolds and Hogarth', *Journal of the Warburg Institute*, II (1938–9).

12. This is the line of defence along which Walpole chose to defend Reynolds against the charge of plagiarism 'a quotation . . . with a novel application of the sense has always been allowed to be an instance of parts and taste'. *Anecdotes of Painting . . .* ed. Warnum I, (London, 1849), p. xviii.

Reynolds's rival Nathaniel Hone was naturally less lenient. In 1775, the year after the *Three Ladies* had been shown to the public, he exhibited in the Academy a skit on Reynolds, *The Pictorial Conjurer, displaying the whole Art of Optical Deception*. It represented Reynolds clothing models with garments taken from well-known pictures which float about the room. See Leslie and Taylor, *Reynolds*, II (London, 1865), p. 122.

13. 'The purport of this discourse, and, indeed, of most of my other discourses, is to caution you against that false opinion, all too prevalent among artists, of the imaginary powers of native genius and its sufficiency in great works' (*6th Discourse*). See also the beginning of the *7th Discourse* and the *Ironical Discourse* of 1791, published since I wrote this article in *Portraits by Sir Joshua Reynolds*, ed. F. W. Hilles (London, 1952), pp. 127–44. It is this opposition to Neoplatonic metaphysics in art theory which fundamentally distinguishes Reynolds's teaching from the Academic doctrines of the seventeenth century, in particular Bellori.

14. See E. J. Morley, *Edward Young's Conjectures on Original Composition* (London, 1918). Reynolds quotes Young's conjectures in the *9th Discourse*: 'He that imitates the Iliad, says Dr. Young, is not imitating Homer'—For the general philosophical trends which are embodied in Reynolds's conception of portraiture as opposed to that of Gainsborough, see E. Wind: "Humanitätsidee und Heroisiertes Porträt in der Englischen Kultur des 18. Jahrhunderts', *Vorträge der Bibliothek Warburg*, 1930–31 (Leipzig/Berlin, 1932).

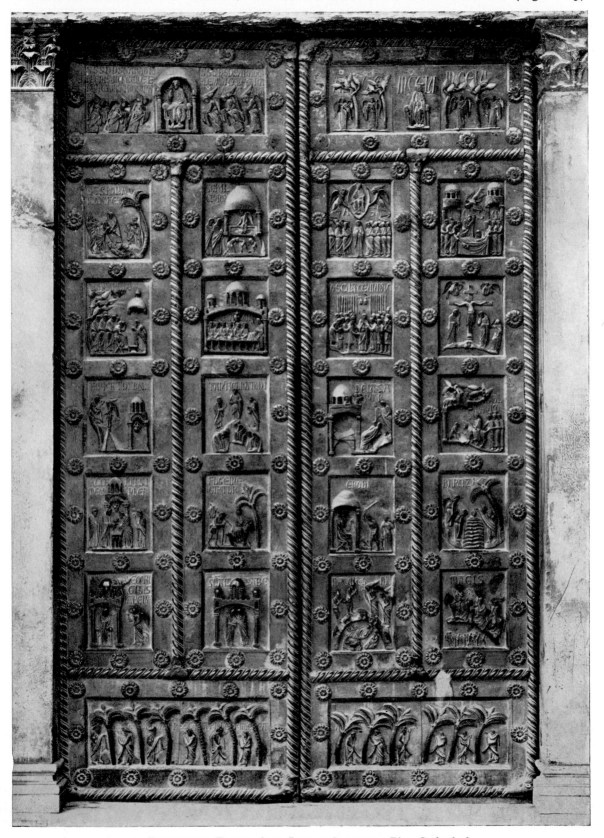

1. BONANNUS: Bronze door. Late 12th century. Pisa, Cathedral

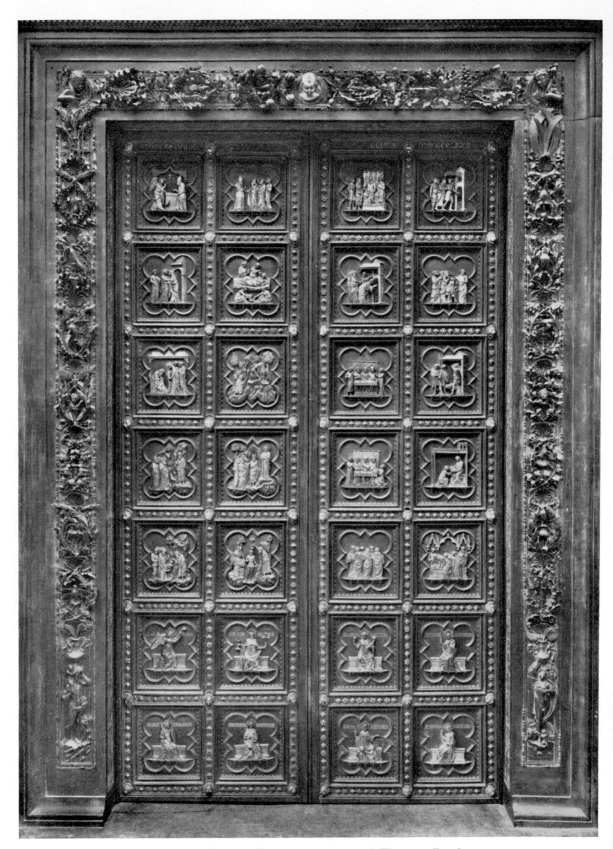

2. ANDREA PISANO: Bronze door. 1330–36. Florence, Baptistry

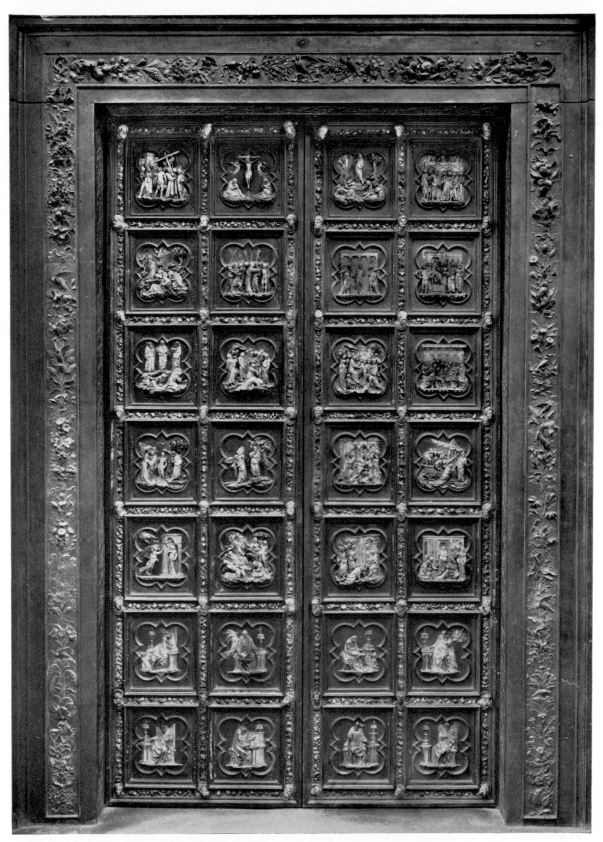

3. GHIBERTI: First bronze door. 1403–24. Florence, Baptistry

4. ANDREA PISANO: *The Baptism of Christ. Detail from Fig. 2*

5. GHIBERTI: *The Baptism of Christ. Detail from Fig. 3*

6. GHIBERTI: *The Creation of Eve*. Detail from Fig. 13

7. ANDREA PISANO: *The Creation of Eve*. About 1340–43.
Florence, Campanile

8. *St. John in the Wilderness*. Mosaic. Late 13th century. Florence, Baptistry

9. ANDREA PISANO: *St. John the Baptist in the Wilderness*. Detail from Fig. 2

10. Burgundian sculptor: *Virgin and Child*. Second half of the 14th century. Paris, Louvre

11. GHIBERTI: Detail from *The Road to Calvary*. First bronze door

12. GHIBERTI: Detail from *The Story of Isaac*. Second bronze door

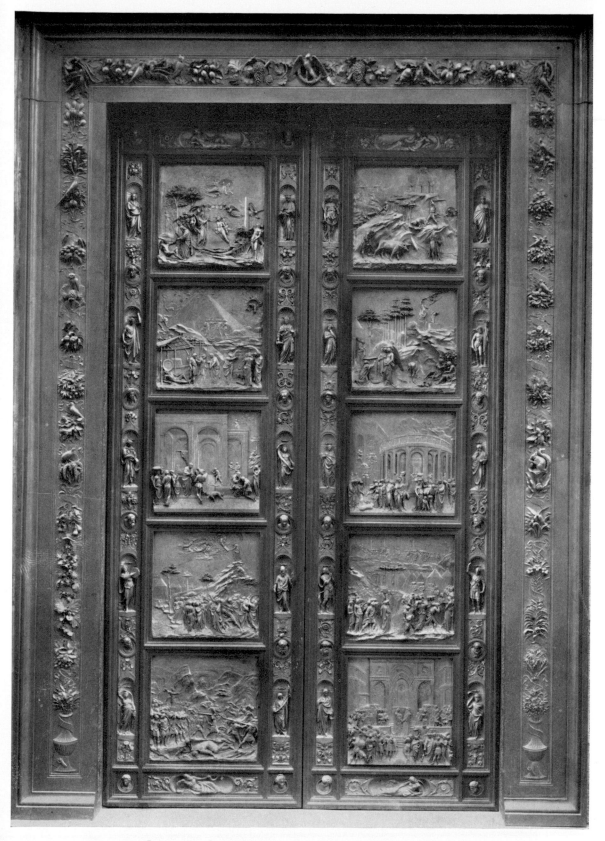

13. GHIBERTI: Second bronze door. 1425–52. Florence, Baptistry

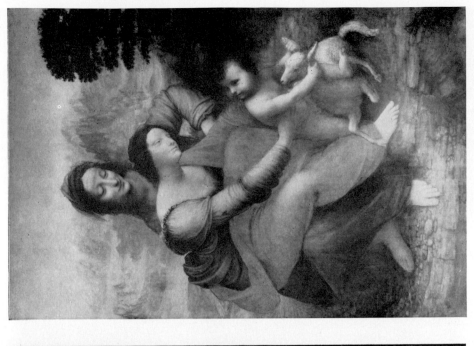

15. LEONARDO DA VINCI: *The Virgin and Child with
St. Anne.* About 1500–07. Paris, Louvre

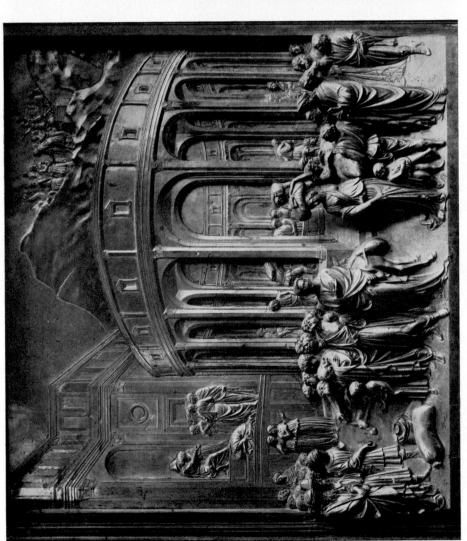

14. GHIBERTI: *The Story of Joseph.* Detail from Fig. 13

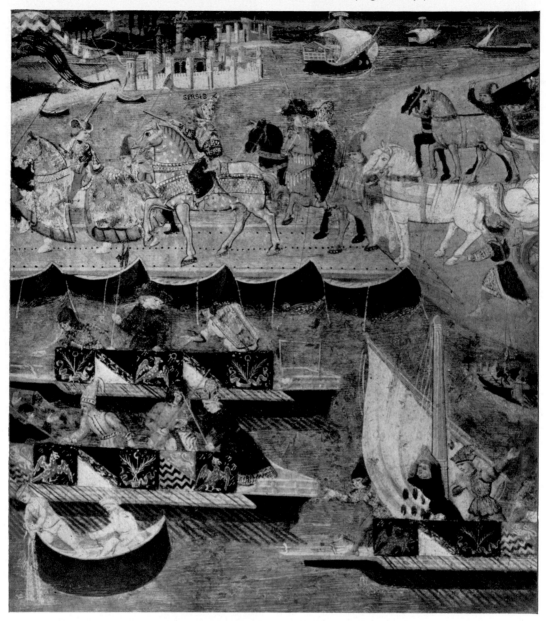

16. Detail from Fig. 18

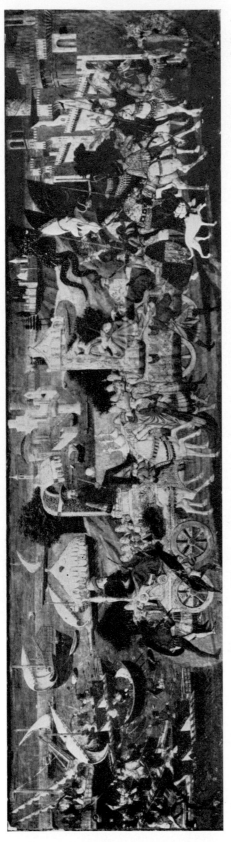

17. Workshop of APOLLONIO DI GIOVANNI: *The Triumph of the Greeks over the Persians*. Cassone panel. 1463. Destroyed; formerly E. Wittmann Collection

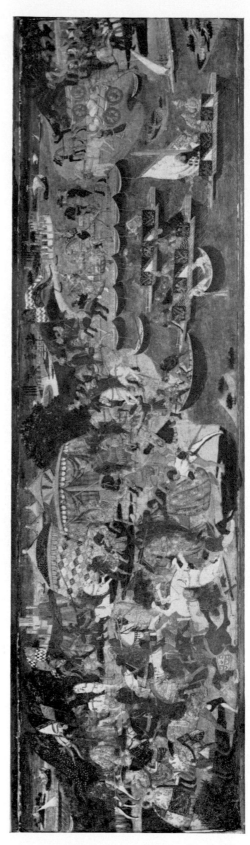

18. Workshop of APOLLONIO DI GIOVANNI: *Xerxes' Invasion of Greece*. Cassone panel. 1463. Oberlin, Ohio, Allen Memorial Art Museum

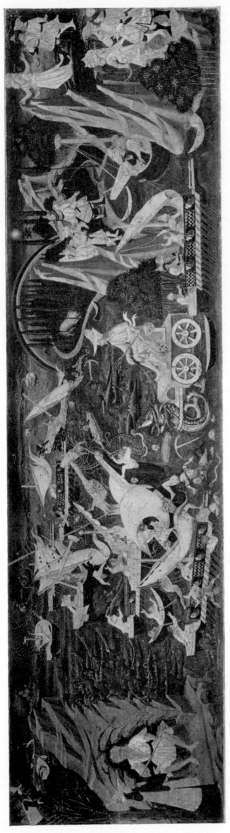

19. APOLLONIO DI GIOVANNI: *Scenes from Virgil's Aeneid*. Cassone panel. New Haven, Conn., Yale University Art Gallery, Jarves Collection

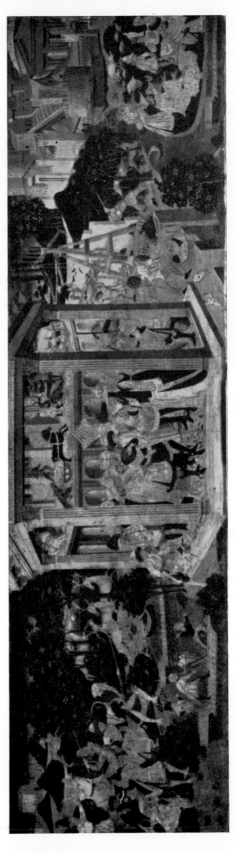

20. APOLLONIO DI GIOVANNI: *Scenes from Virgil's Aeneid*. Cassone panel. New Haven, Conn., Yale University Art Gallery, Jarves Collection

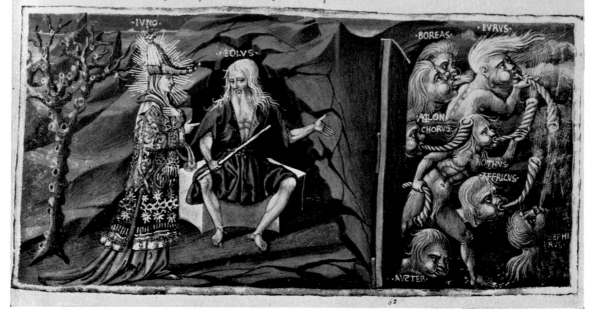

I naite uim uentis. submersaq. obrue puppes.
A ut age diuersos et dissice corpora ponto.
S unt mihi bissepteum prestanti corpore nimphe

21. APOLLONIO DI GIOVANNI: *Juno visits Aeolus*. Miniature from Cod. Ricc. 492, fol. 62r.
Florence, Biblioteca Riccardiana

R estitit eneas. claraq. in luce refulsit.
O s humerosq. deo similis: namq. ipsa decoram
C esariem nato genitrix / lumenq. iuuente
P urpureum / et letos oculis afflarat honores.

22. APOLLONIO DI GIOVANNI: *Dido receives the Trojans*. Miniature from Cod. Ricc. 492, fol. 72v.
Florence, Biblioteca Riccardiana

23. APOLLONIO DI GIOVANNI: *The Sack of Troy*. Miniature from Cod. Ricc. 492, fol. 84r.
Florence, Biblioteca Riccardiana

24. GENTILE DA FABRIANO: *The Presentation in the Temple*. 1423. Paris, Louvre

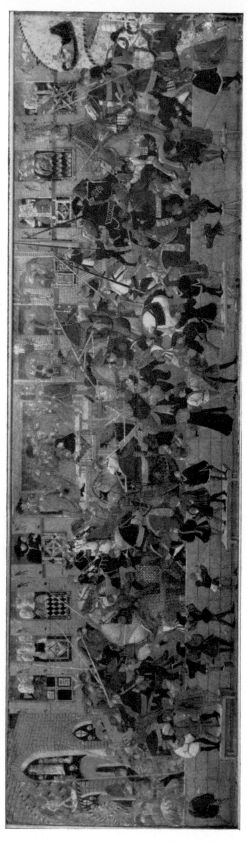

25. Workshop of APOLLONIO DI GIOVANNI: *Tournament on the Piazza di S. Croce*. Cassone panel. New Haven, Conn., Yale University Art Gallery, Jarves Collection

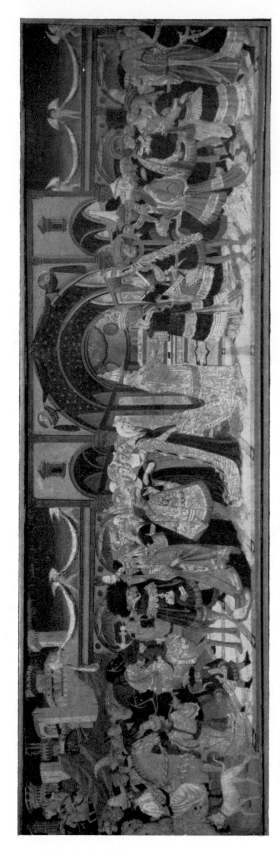

26. Workshop of APOLLONIO DI GIOVANNI: *The Meeting of Solomon and the Queen of Sheba*. Cassone panel. New Haven, Conn., Yale University Art Gallery, Jarves Collection

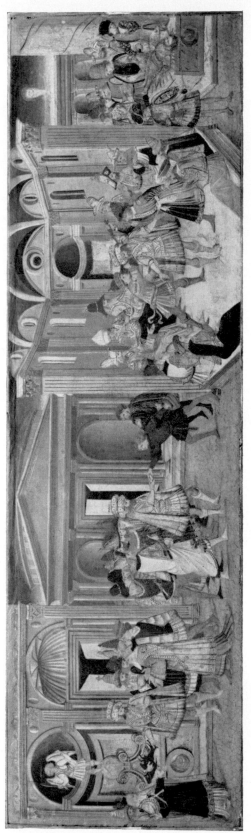

27. Workshop of APOLLONIO DI GIOVANNI: *The Murder of Julius Caesar*. Cassone panel. Oxford, Ashmolean Museum

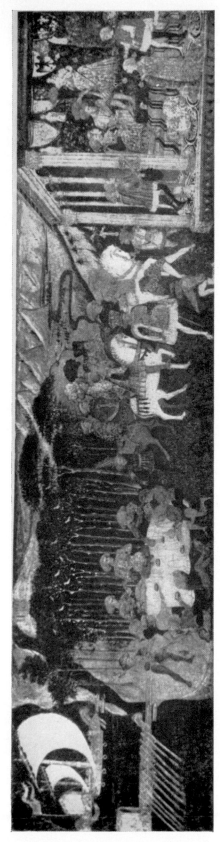

28. *The Trojans arrive in Latium*. Cassone panel. Formerly Holford Collection

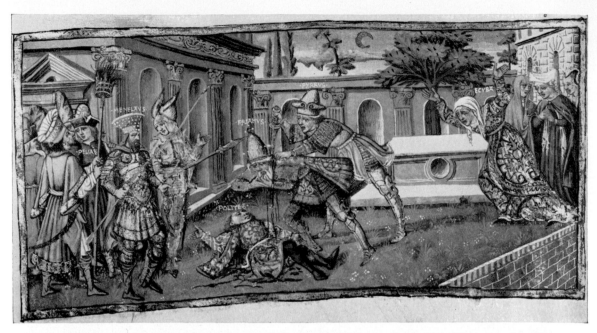

29. APOLLONIO DI GIOVANNI: *Pyrrhus kills Priam*. Miniature from Cod. Ricc. 492, fol. 86v.
Florence, Biblioteca Riccardiana

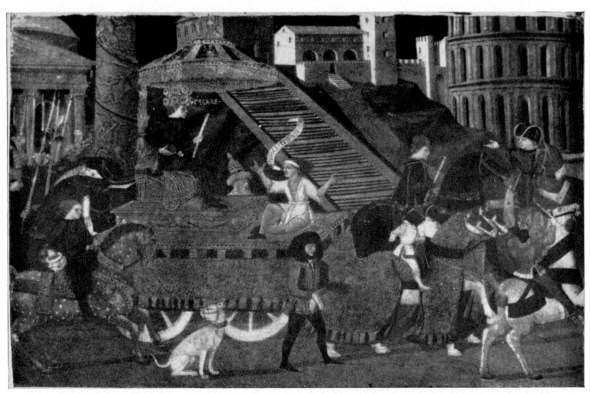

30. Workshop of APOLLONIO DI GIOVANNI: *The Triumph of Caesar*. Fragment of a cassone panel.
Formerly Chamberlin Collection

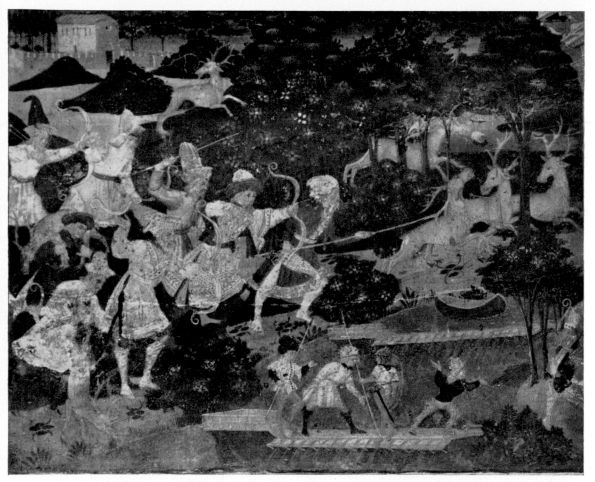

31. APOLLONIO DI GIOVANNI: *The Trojans hunting*. Detail from Fig. 20

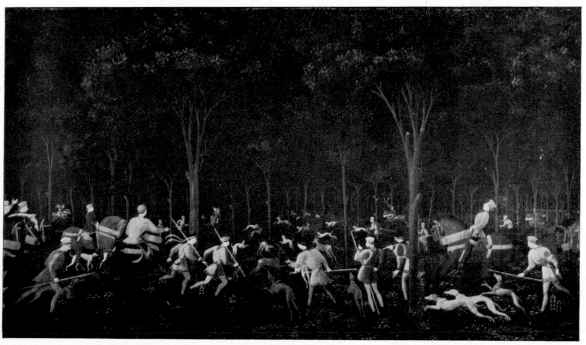

32. PAOLO UCCELLO: *The Hunt* (detail). Third quarter of the 15th century. Oxford, Ashmolean Museum

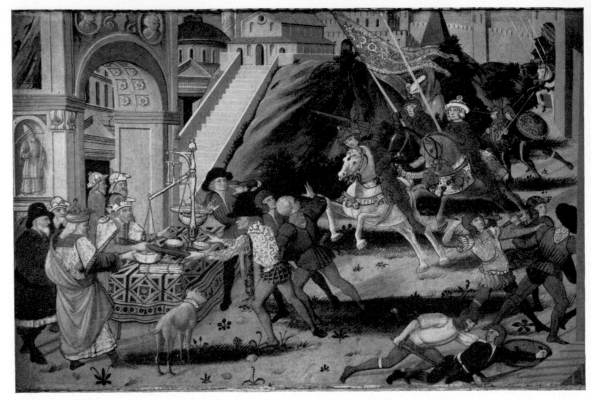

33. *Brennus in Rome*. Detail from a cassone panel. London, Courtauld Institute Galleries

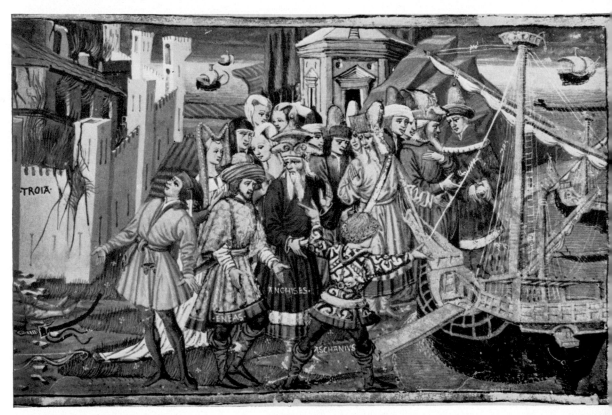

34. APOLLONIO DI GIOVANNI: *Aeneas embarking from Troy*. Miniature from Cod. Ricc. 492, fol. 91r.
Florence, Biblioteca Riccardiana

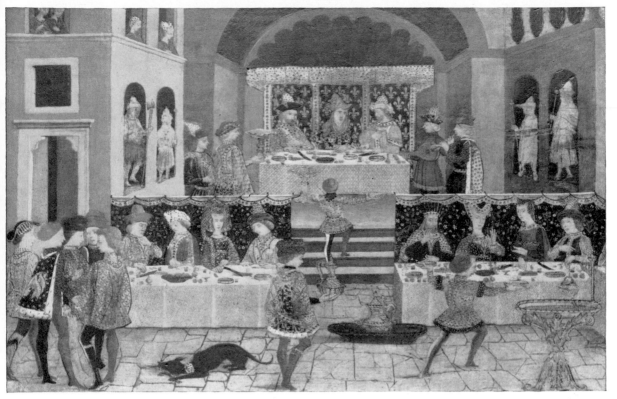

35. *Dido's Banquet*. Detail from a cassone panel. Hanover, Landesgalerie

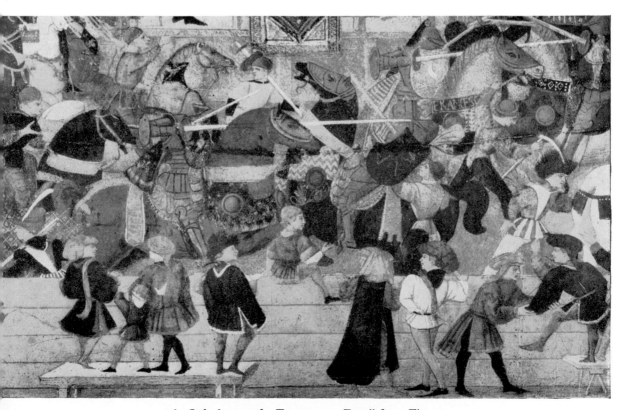

36. *Onlookers at the Tournament*. Detail from Fig. 25

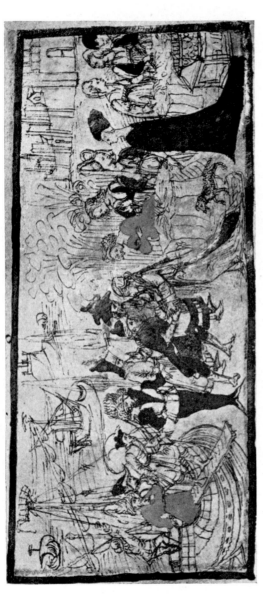

37. APOLLONIO DI GIOVANNI: *Aeneas meets Andromache.* Unfinished miniature from Cod. Ricc. 492, fol. 97r.
Florence, Biblioteca Riccardiana

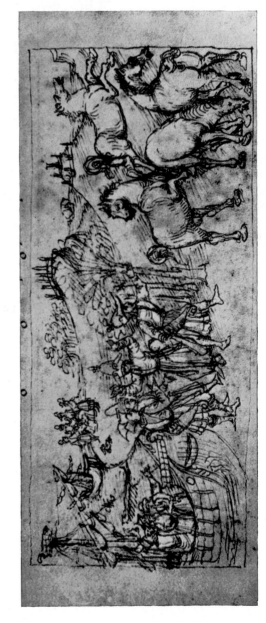

38. APOLLONIO DI GIOVANNI: *Anchises sees the four mares.* Unfinished miniature from Cod. Ricc. 492, fol. 101v.
Florence, Biblioteca Riccardiana

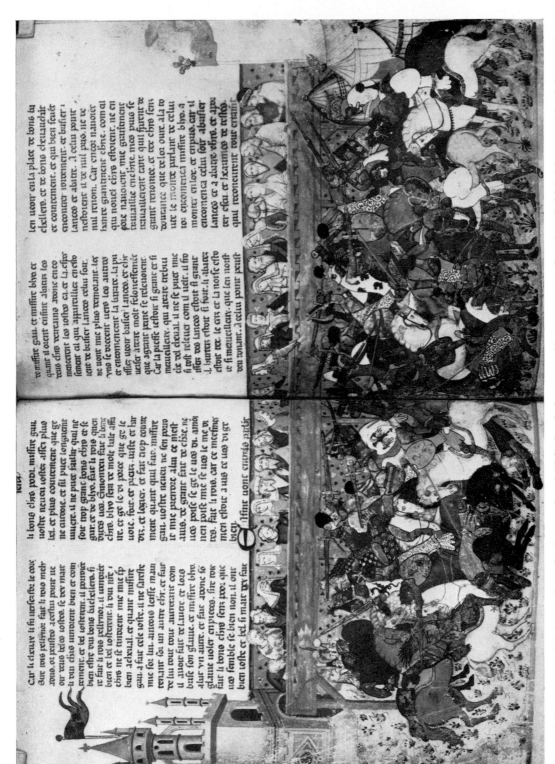

39. *A Tournament*. Miniature from *Le Roman de roi Meliadus de Leonnoys*. About 1355–60. London, British Museum, Ms. Add. 12228

40. The Altar of Apollo. Detail from Fig. 27

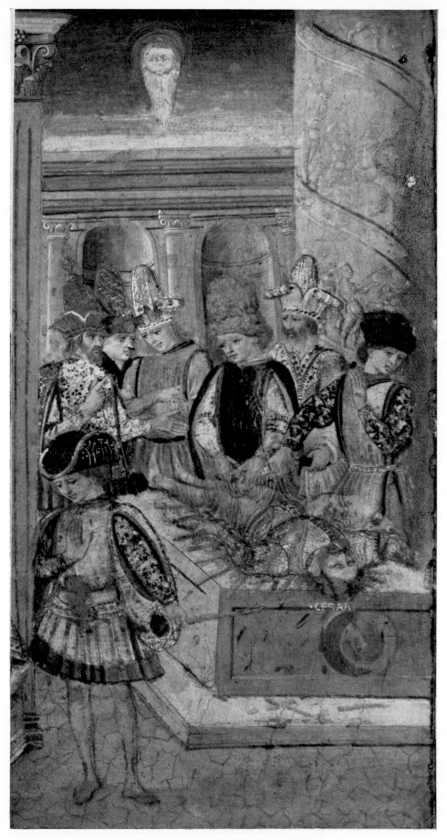

41. Caesar's Funeral. Detail from Fig. 27

42. Cassone with nude female figure inside the lid. Copenhagen, Royal Museum of Fine Arts

43. Cassone with nude male figure inside the lid. Copenhagen, Royal Museum of Fine Arts

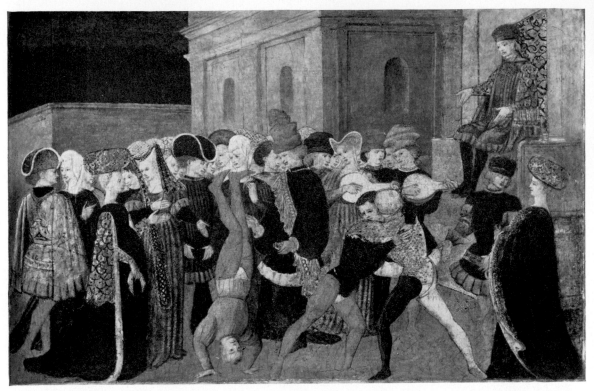

44. Workshop of APOLLONIO DI GIOVANNI: *The Romans entertaining the Sabines*. Fragment of a cassone panel. Oxford, Ashmolean Museum

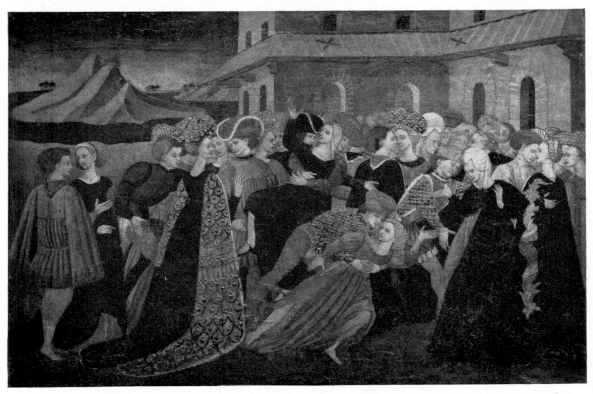

45. Workshop of APOLLONIO DI GIOVANNI: *The Rape of the Sabines*. Fragment of a cassone panel. Edinburgh, National Gallery of Scotland

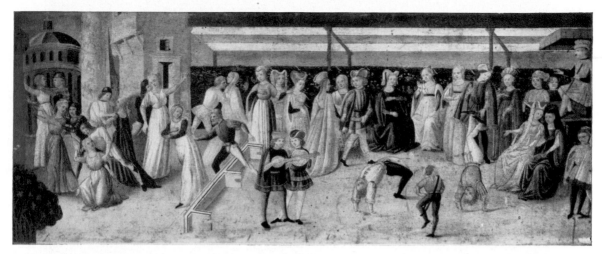

46. *Acrobats and onlookers*. Detail from a cassone panel with the *Rape of the Sabines*. Collection of the Earl of Harewood

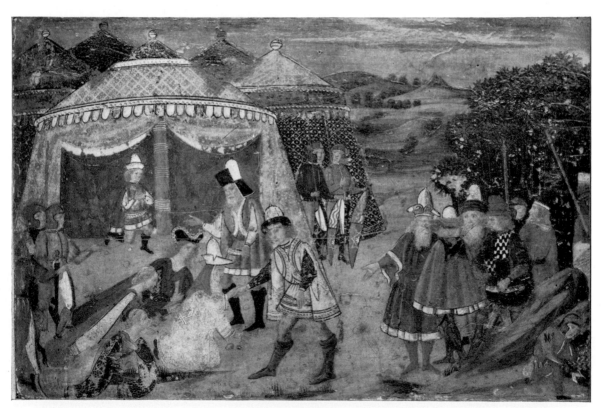

47. Workshop of APOLLONIO DI GIOVANNI: *Alexander and the Family of Darius*. Detail of a cassone panel. London, British Museum

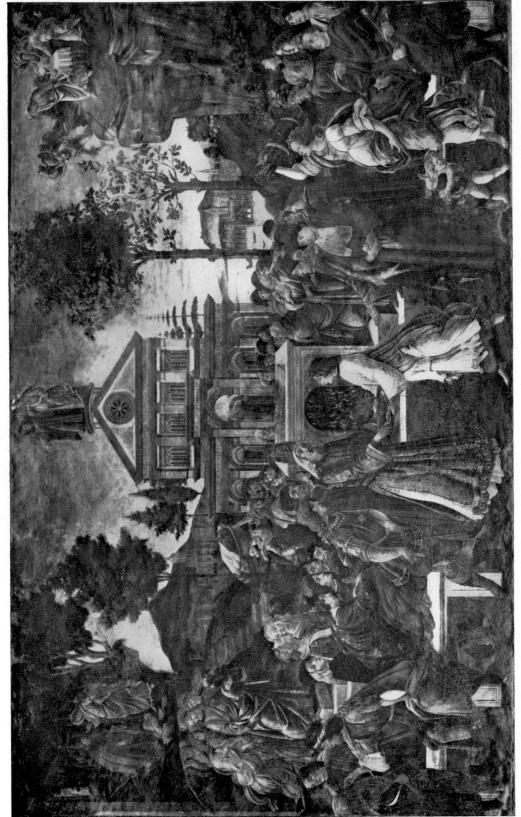

48. BOTTICELLI: *The Temptation of Christ.* 1481/2. Rome, Sistine Chapel

49. GIORGIO VASARI: *Cosimo de' Medici with the Philosophers*. About 1555–58.
Florence, Palazzo Vecchio, Sala di Cosimo il Vecchio

50. FRANCESCO FURINI: *Lorenzo il Magnifico and the Platonic Academy*. About 1640.
Florence, Palazzo Pitti, Sala degli Argenti

51. FRANCESCO FURINI: *The Apotheosis of Lorenzo il Magnifico*. About 1640.
Florence, Palazzo Pitti, Sala degli Argenti

52. *Cosimo de' Medici, Pater Patriae*. Medal, obverse and reverse. About 1465.
Washington, National Gallery of Art, Samuel H. Kress Collection

53. BRUNELLESCHI: The Sacristy of San Lorenzo, Florence. 1418–28

54. GHIBERTI: *St. Matthew.* 1419–22. Florence, Or San Michele

55. MICHELOZZO: San Francesco al Bosco, Mugello. About 1427

56. The Loggia of the Badia of Fiesole. Middle of the 15th century

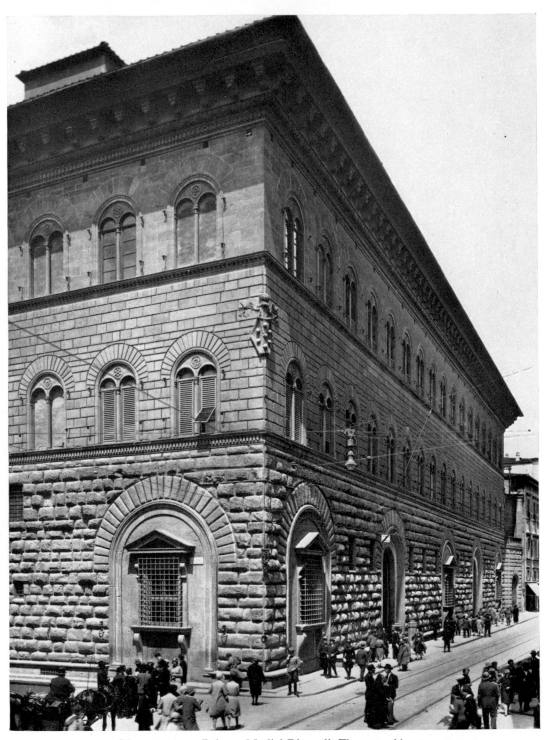

57. MICHELOZZO: Palazzo Medici Riccardi, Florence. About 1440

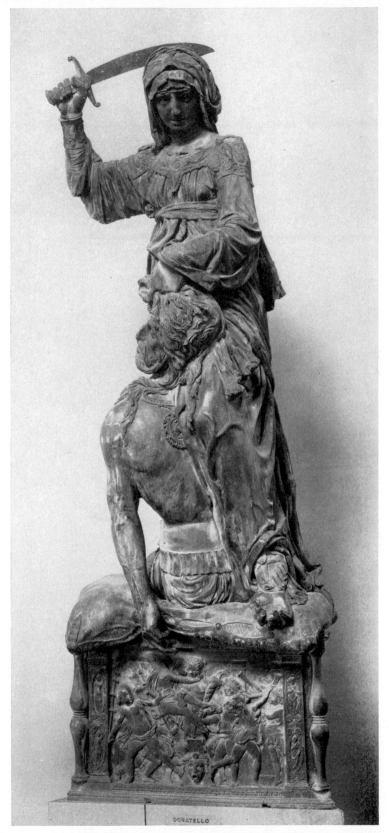

58. DONATELLO: *Judith*. About 1456–57. Florence, Museo Nazionale del Bargello

59. GIORGIO VASARI: *Cosimo de' Medici receives the model for San Lorenzo*. About 1555–58. Florence, Palazzo Vecchio

60. San Lorenzo, Florence. Begun 1418

61. S. Croce with the Dormitory of the Novices. Pen drawing
by Emilio Burci (1811–77). Florence, Uffizi

Veduta della Piazza di S. Marco

1.Chiesa, e Convento delle Monache di S.ᵗᵃCaterina. 2. Casino di S.M.I. 3.Compagnia dtto Scalzo. 4.Chiesa di S.Marco de'PP.ᵗⁱDomenicani. 5.Convento de'
detti PP.ᵗⁱ 6.Cappella di S.Antonino in d.ᵗᵃ Chiesa de SS.ᵗⁱ Duchi Salviati. 7.Stalle di S.M.I. vo.Serraglio dlle Fiere.9.Chiesa dltte S.ᵗⁱ Annonziata. 10.Spedale di S.Matteo
11.Monache di S.Lucia

62. San Marco, Florence. Engraving from Giuseppe Richa, *Notizie istoriche delle chiese fiorentine*, 1758

63. The Badia of Fiesole. 1460–67

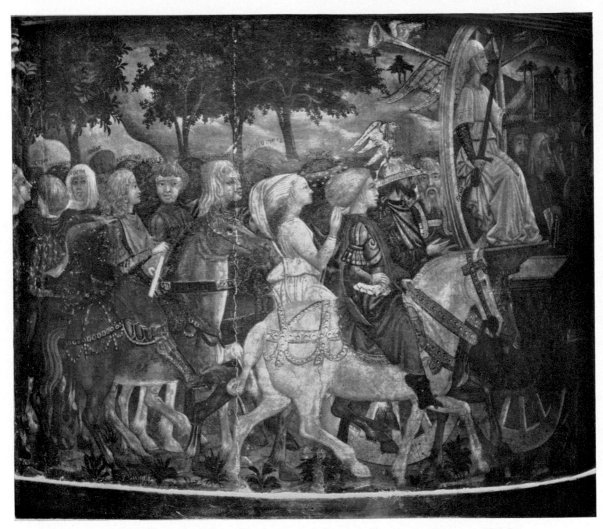

64. *The Triumph of Fame*. From a round chest of about 1450. Florence, Uffizi

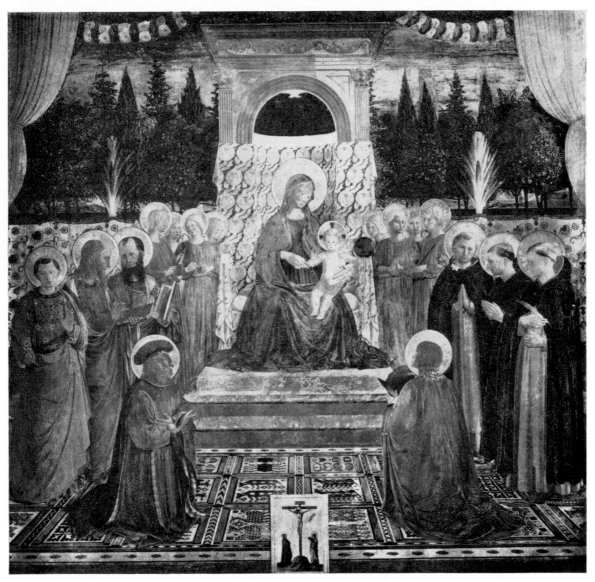

65. FRA ANGELICO: *The Virgin and Child enthroned with Saints and Angels.* About 1440.
Florence, Museo di San Marco

66. The Tabernacle of San Miniato al Monte, Florence. 1448

67. The Marble Tabernacle of SS. Annunziata, Florence. About 1450

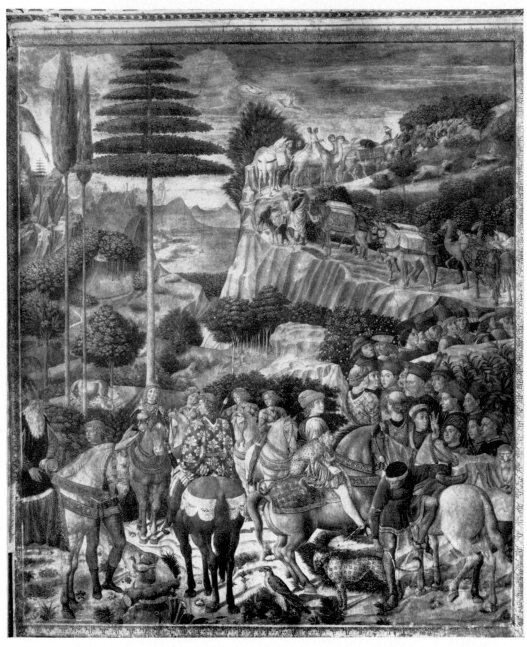

68. BENOZZO GOZZOLI: *The Journey of the Magi*. 1459–61. Florence, Palazzo Medici Riccardi, Cappella Medici, left wall

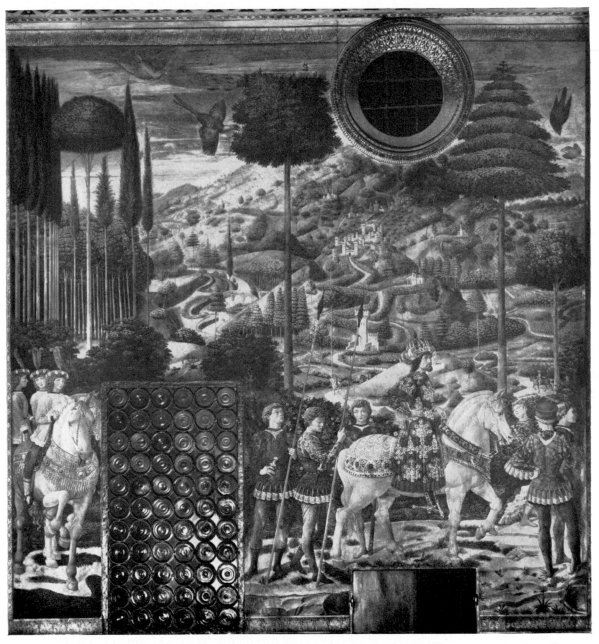

69. BENOZZO GOZZOLI: *The Journey of the Magi*. 1459–61. Florence, Palazzo Medici Riccardi, Cappella Medici, centre wall

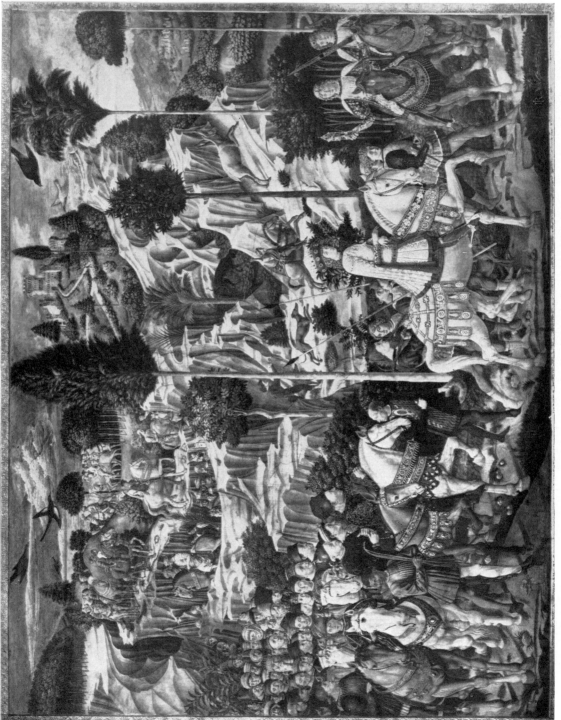

70. BENOZZO GOZZOLI: *The Journey of the Magi.* 1459–61. Florence, Palazzo Medici Riccardi, Cappella Medici, right wall

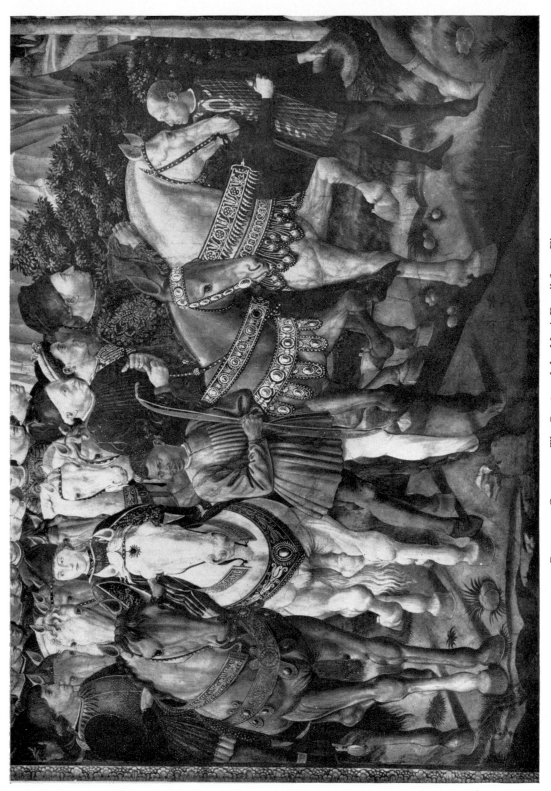

71. BENOZZO GOZZOLI: *The Cortège of the Magi.* Detail from Fig. 70

72. Head of Cosimo de' Medici in a manuscript of Aristotle, *Opera varia*. Third quarter of the 15th century. Florence Biblioteca Laurenziana, Plut. 84.1, fol. 2r.

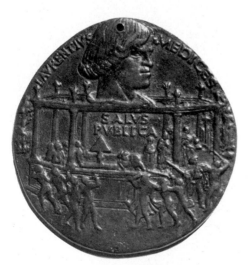
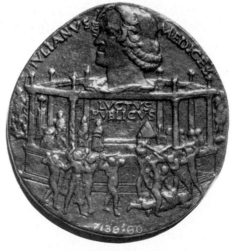

73. BERTOLDO DI GIOVANNI: Medal commemorating the Pazzi Conspiracy, with Lorenzo de' Medici on the obverse and Giuliano de' Medici on the reverse. 1478. London, British Museum

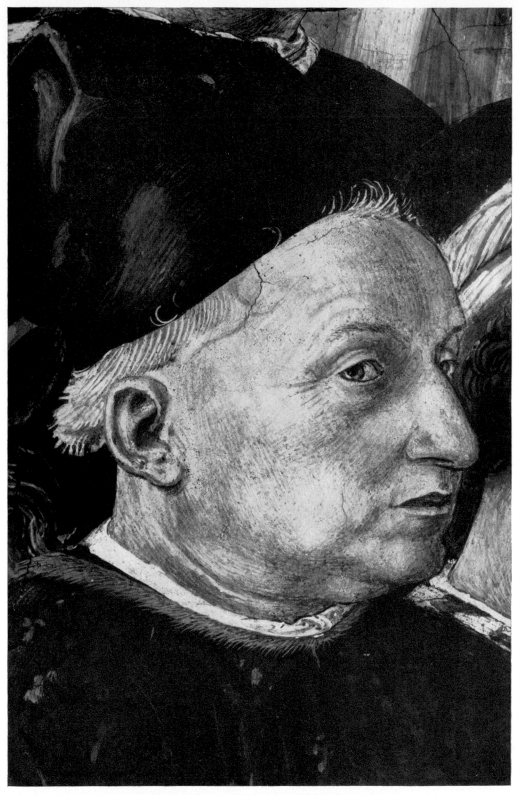

74. Head of Cosimo de' Medici. Detail from Fig. 70

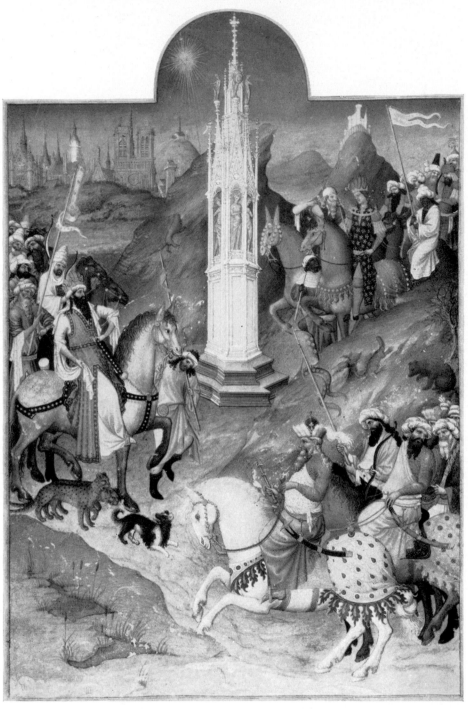

75. *The Journey of the Magi*. Miniature from the *Très Riches Heures du duc de Berri*.
About 1411–15. Chantilly, Musée Condé

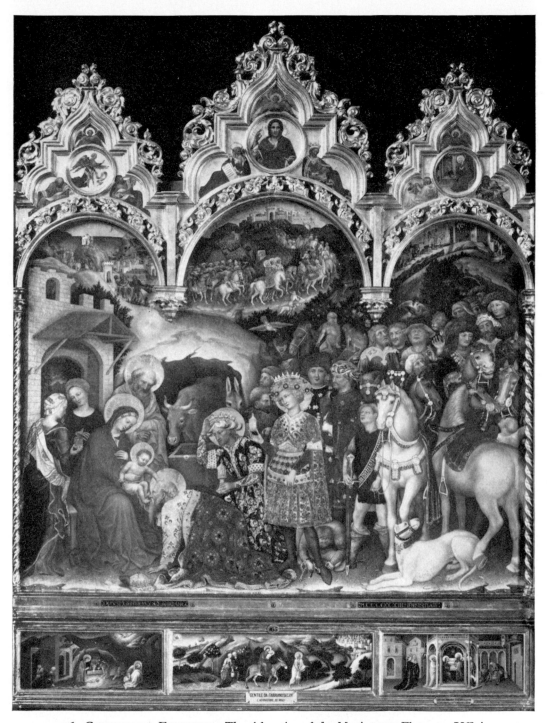

76. GENTILE DA FABRIANO: *The Adoration of the Magi.* 1423. Florence, Uffizi

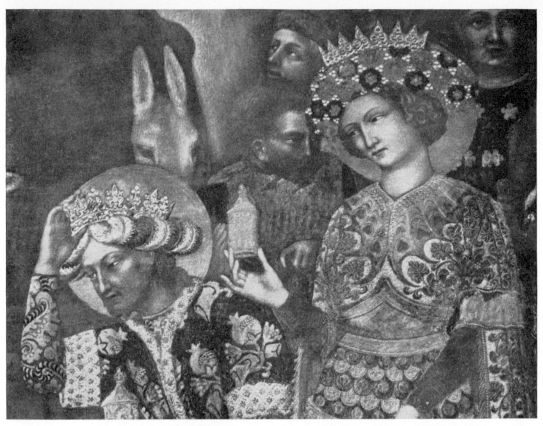

77. GENTILE DA FABRIANO: *Heads of two Magi*. Detail from Fig. 76

78–79. BENOZZO GOZZOLI: *Heads of two Magi*. Details from Figs. 69 and 70

80. Detail of the ceiling of the Cappella Medici. 1459–61.
Florence, Palazzo Medici Riccardi

81. Detail of Fig. 68

82. Title-page of Josephus, *De bello iudaico*. Third quarter of the 15th century. Florence, Biblioteca Laurenziana, Plut. 66, 8

83. Title-page of Pliny, *Historia naturalis*. Third quarter of the 15th century. Florence, Biblioteca Laurenziana, Plut. 82, 3

IOHANNES ARGYROPYLVS : NO

BILISSIMO ATQVE DOCTISSIMO

VIRO PETRO MEDICI : INCOLV

MITATEM : BONAM FORTVNÃ

PERPETVAMQ; FOELICITATEM .

NSTITVI NOBILISSIME
atq; doctissime petre nonul
los aristotelis libros elegan
tius in latinam linguam
traducere. Nam id quidé.
& aristoteli ipsi. si quis est
ei sensus. pergratum sane
uidebitur. si qualem sese apud suos uo
luit esse. talem & apud latinos tandem
uiderit euasisse. Et his quorum ista est
lingua. non inutile fuerit ut existimo
quippe cum facilior illo pacto. perceptio
philosophie fieri possit. atq; iis tandem
uerbis eoq; stilo : que neq; ab elegantia

84. Page from Aristotle, *De interpretatione*. Third quarter of the 15th century. Florence, Biblioteca Laurenziana, Plut. 71, 18

VEMADMODVM INORBIS TERRE SITV
DESCRIBENDO HISTORICI SOLENT VT AD
quem ipfi cognitione afpirare non poffint. extremif
tabularum partibus fupplementif quibufidam adficiunt loco
unt loco effe uaftof arenofof & cælo terraq penuriam aquarum
riam aquarum. aut fumum infuperabilem ut montem
tem fcythicum aut aftrictum frigore pontum ita &
nobif in hac uirorum collatione perpetua rerum hi
ftoria quantum probabili oratione affequi potuimuf diif quof fupra memora
muf uirif tempora percurrentibus uere licuit affirmare. Que uero antiquio
ra ac uetuftiora funt tragica & monftruofa poetæ & fabulofi rerum fcriptoref
occupant nec ultra fidem ullam nec certitudinem præfe ferunt. Cum igitur
licurgi legum fatorif & numæ regif ref geftaf litterif mandauerimuf haud ab
re fuerit ad romulum orationem conuertere cum & hiftoria ipfa ad cuif tem
pora & prope acceffimus. Sed mihi diu cogitanti huic uiro ut inquit efchiluf
quif conueniret quem illi opponerem quif dignuf fecum in comparatione
coniungi poffet uifum eft tandem faciendum effe ut a quo celebrata athen
enfium ciuitaf amplificata eft cum gloriofiffime atq inuictiffime urbif romæ
parente conferrem & compararem. Licet aut nobif reiectif fabulif ad ipfam
claram hiftoriæ lucem & ueritatem accedere. Quod ficubi neceffitaf coget
nof ab hac parumper digreffof ad id quod uerifimile conferre fit a quo fortaf
fe hiftoria abhorreat nec admittat ullum cum probabilitate comertium æqf
auditoribus opuf erit quiq benigne & humane uirtutn orationif exaudiat
atq approbent. Videtur igitur thefeuf multif de caufif romulo & fimillimuf ex
titiffe ambo enim cum fpiritu & obfcuri forent extimati funt a diif immortali
bus procreati effe. Ambo etiam bellicofi ac manu ftrenui hoc quidem omnef fci
muf ut qta maxima fieri potuit prudentia præftiterunt. Ex duabuf quoq cla
riffimis ciuitatibus roma & athenif alteram hic condidit alteram ille nouif colo
nif impleuit. Feminarum prætterea raptuf de utroq feruntur. Nec eorum qtq
domefticam cladem & crimina fuorum effugit fed poftremo ambo dicuntur
in inuidiam & offenfionem ciuium incidiffe. Siquid igitur ex hif quæ minuf
tragice dici uidentur ad ueritatem concludit. Thefei quidem paternum ge
nuf in erecteum ac primof indigenaf referebatur. Maternum uero in pelopem

85. Page from Plutarch, *Vitae*. Third quarter of the 15th century. Florence,
Biblioteca Laurenziana, Plut. 65, 26

86. The Tazza Farnese. Antique cameo. Naples, Museo Nazionale

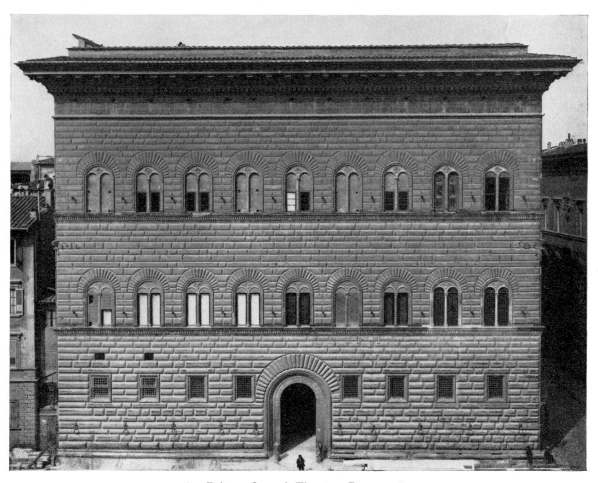

87. Palazzo Strozzi, Florence. Begun 1489

88. Andrea del Verrocchio: *David*. Before 1476. Florence, Museo Nazionale del Bargello

89. ANDREA DEL VERROCCHIO: Sketch model for the Forteguerri Monument. 1476.
London, Victoria and Albert Museum

90. BERTOLDO DI GIOVANNI (d. 1491): *Battle relief*. Florence, Museo Nazionale del Bargello

91. PISANELLO (1395–1455/6): *Hawk*. Paris, Louvre, Vallardi 2452, fol. 265
92. VILLARD D'HONNECOURT: *Swan*. Middle of the 13th century.
Paris, Bibliothèque Nationale, MS. Fr. 19093, fol. 7

93. North Italian artist, about 1400: Studies for an Annunciation. Paris, Louvre,
Cabinet des Dessins, R.F. 1870, fol. 419v.

94. LEONARDO DA VINCI: *Study for the Virgin with St. Anne.* About 1500.
London, British Museum

95. LEONARDO DA VINCI: Verso of Fig. 94 with tracing of the Virgin and St. Anne

96. LEONARDO DA VINCI: *Studies of the Virgin and Child.* About 1478. London, British Museum

97. RAPHAEL: *Studies of the Virgin and Child*. About 1505. London, British Museum

98. LEONARDO DA VINCI: *The Virgin and Child and other studies.* About 1478.
Windsor Castle, Royal Library

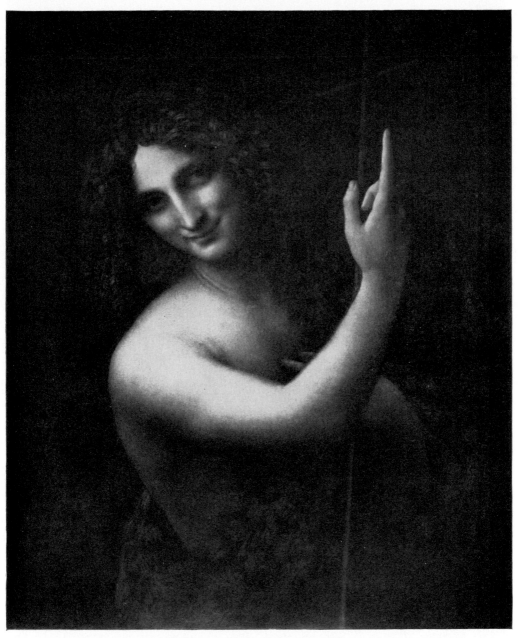

99. LEONARDO DA VINCI: *St. John the Baptist*. About 1515. Paris, Louvre

100. LEONARDO DA VINCI: *Study for the Battle of Anghiari.* About 1503. Windsor Castle, Royal Library

102. LEONARDO DA VINCI: *Girl with a Unicorn.*
About 1478. Oxford, Ashmolean Museum

101. LEONARDO DA VINCI: *Virgin and Child with a Cat.*
About 1478. London, British Museum

104. LEONARDO DA VINCI: *Study of Michelangelo's David.* About 1504. Windsor Castle, Royal Library

103. LEONARDO DA VINCI: *Study for the Battle of Anghiari.* About 1503. Venice, Accademia

105. LEONARDO DA VINCI: *Neptune*. About 1504. Windsor Castle, Royal Library

106. LEONARDO DA VINCI: *The Deluge*. About 1514. Windsor Castle, Royal Library

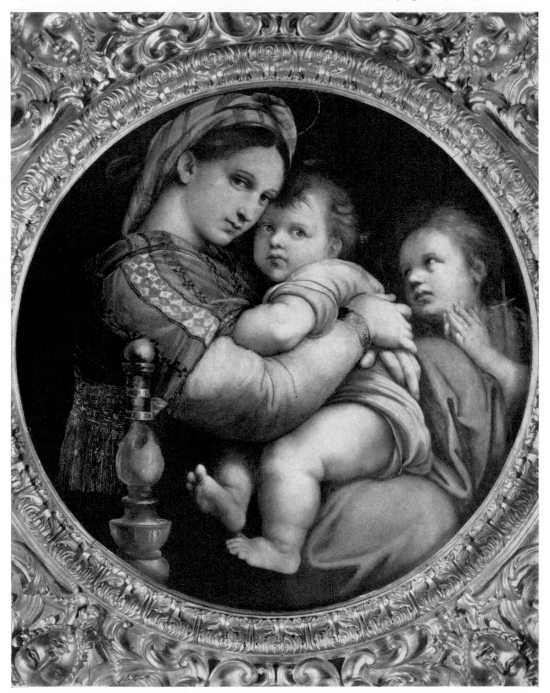

107. RAPHAEL: *Madonna della Sedia*. About 1516. Florence, Palazzo Pitti

108. AUGUST HOPFGARTEN: *Raphael painting the Madonna della Sedia*. Lithograph, 1839

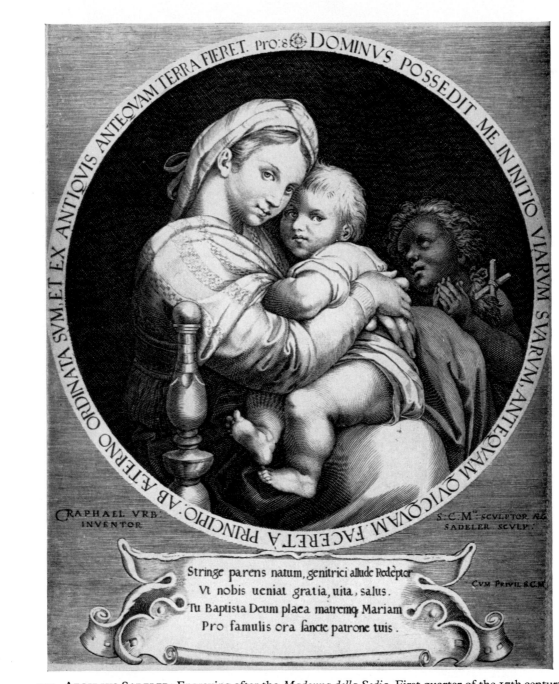

Around the oval border:

PRO:8 DOMINVS POSSEDIT ME IN INITIO VIARVM SVARVM. ANTEQVAM QVICQVAM FACERET A PRINCIPIO. AB ÆTERNO ORDINATA SVM ET EX ANTIQVIS ANTEQVAM TERRA FIERET.

RAPHAEL VRB
INVENTOR

S:C:Mᵗⁱˢ SCVLPTOR Æ
SADELER SCVLP:

CVM PRIVIL S.C.M.

Stringe parens natum, genitrici allude Redeptor
Vt nobis ueniat gratia, uita, salus.
Tu Baptista Deum placa matremq Mariam
Pro famulis ora sancte patrone tuis.

109. AEGIDIUS SADELER: Engraving after the *Madonna della Sedia*. First quarter of the 17th century

110. PERUGINO: *The Archangel Raphael and Tobias.* 1499. London, National Gallery

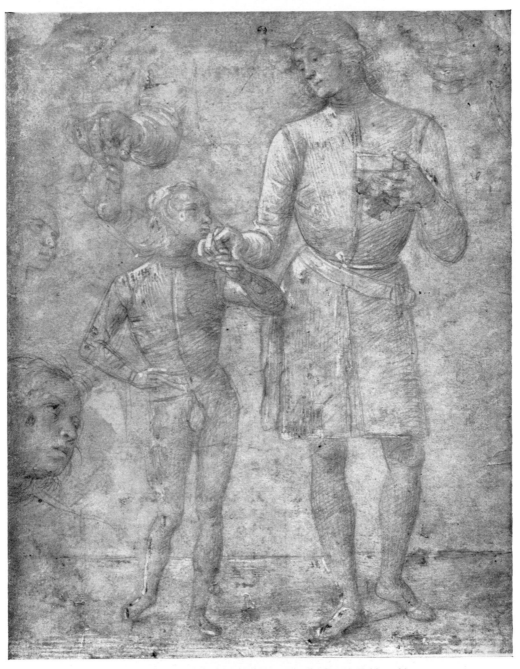

III. PERUGINO: *Study for an Archangel Raphael and Tobias*. About 1499.
Oxford, Ashmolean Museum

113. RAPHAEL: *Study for an Angel.* About 1503.
Oxford, Ashmolean Museum

112. RAPHAEL: *Head of St. James.* About 1503.
London, British Museum

115. RAPHAEL: *Studies of the Virgin and Child.* About 1505.
Vienna, Albertina

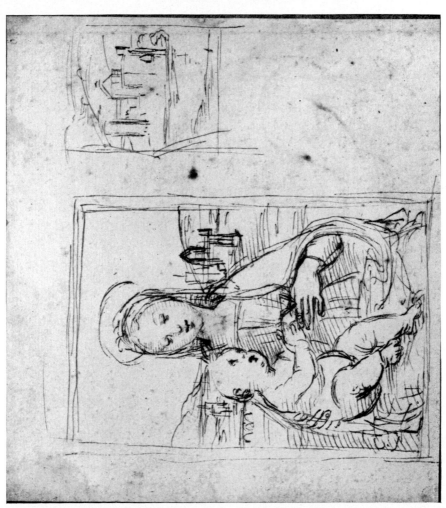

114. RAPHAEL: *Virgin and Child.* About 1502–3. Oxford, Ashmolean Museum

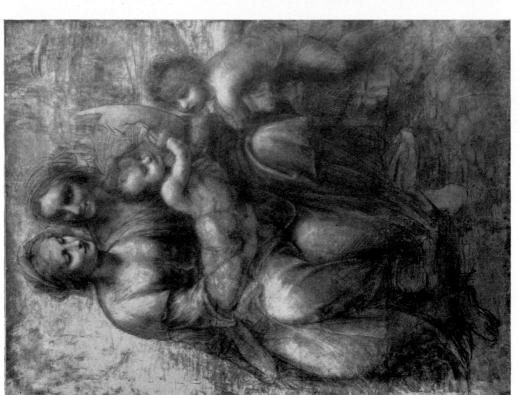

116. LEONARDO DA VINCI: *Cartoon for the Virgin and Child with St. Anne.* About 1500. London, National Gallery

117. RAPHAEL: *La Belle Jardinière.* About 1507. Paris, Louvre

119. RAPHAEL: *The Virgin in the Meadow*. About 1505.
Vienna, Kunsthistorisches Museum

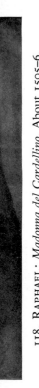

118. RAPHAEL: *Madonna del Cardellino*. About 1505–6.
Florence, Uffizi

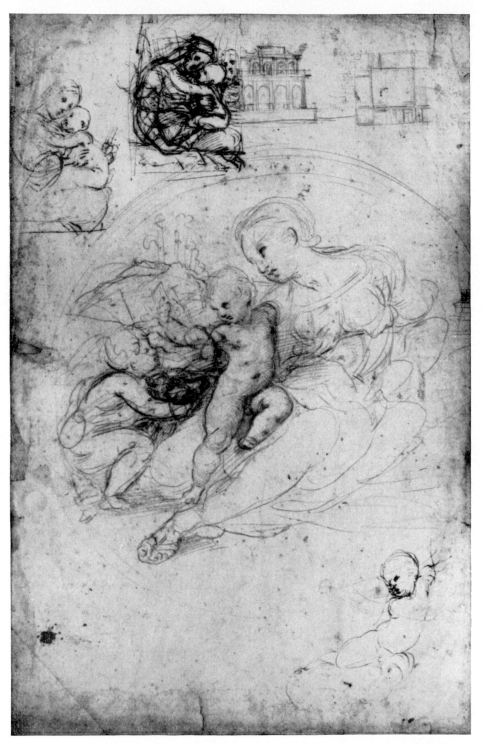

120. RAPHAEL: *Study for the Madonna Alba.* About 1508. Lille, Musée Wicar

121. RAPHAEL: *The Madonna Alba*. About 1508–10. Washington, National Gallery of Art,
Mellon Collection

122. RAPHAEL: *Study for the Madonna Alba*. About 1508. Lille, Musée Wicar

123. GIOVANNI FRANCESCO RUSTICI: *Virgin and Child with St. John*. First quarter of
the 16th century. Marble relief. Florence, Museo Nazionale del Bargello

124. RAPHAEL: *Madonna della Tenda*. About 1516. Munich, Alte Pinakothek

125. RAPHAEL: *Detail from the Mass of Bolsena*. About 1511–14. Rome, Vatican

127: HENRION: Philips Philishave Poster

126. Engraving after the *Madonna della Sedia*. The Penny Magazine, 1833

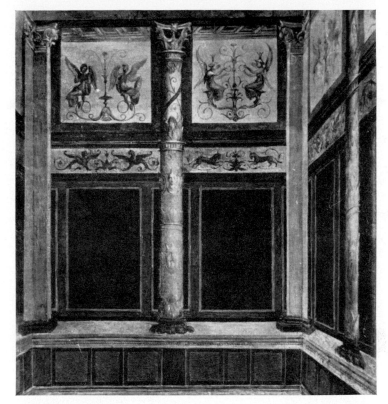

128. Reconstruction of the Sala dei Fregi Alati in the Casa di Livia, Rome.
From G. E. Rizzo, *Le pitture della Casa di Livia*, 1936, Fig. 8.

129. Detail of an engraving after a lost wall-painting in the Tempio di Iside, Pompeii.
From F. M. Avellino, *Tempio d'Iside*, 1851, Pl. VII, i.

130. S. Maria della Spina, Pisa. About 1323

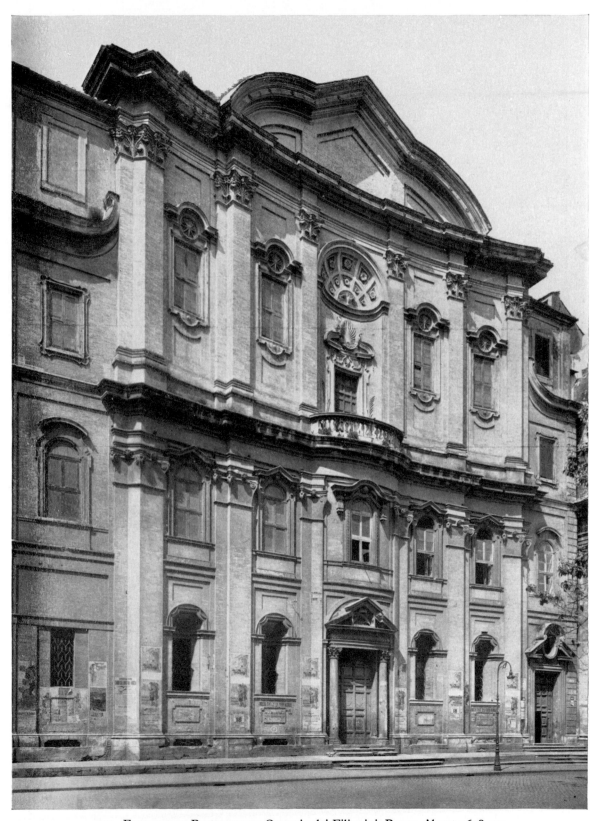

131. FRANCESCO BORROMINI: Oratorio dei Filippini, Rome. About 1638–50

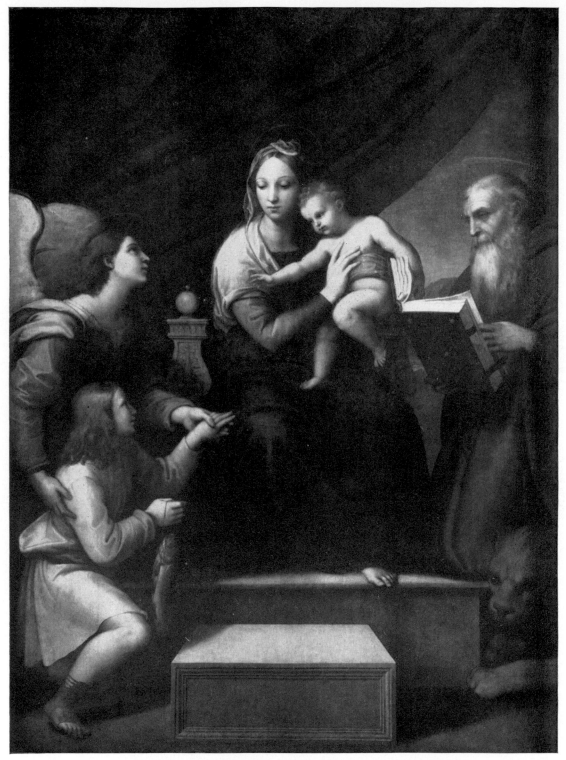

132. RAPHAEL: *Madonna with the Fish*. About 1513. Madrid, Prado

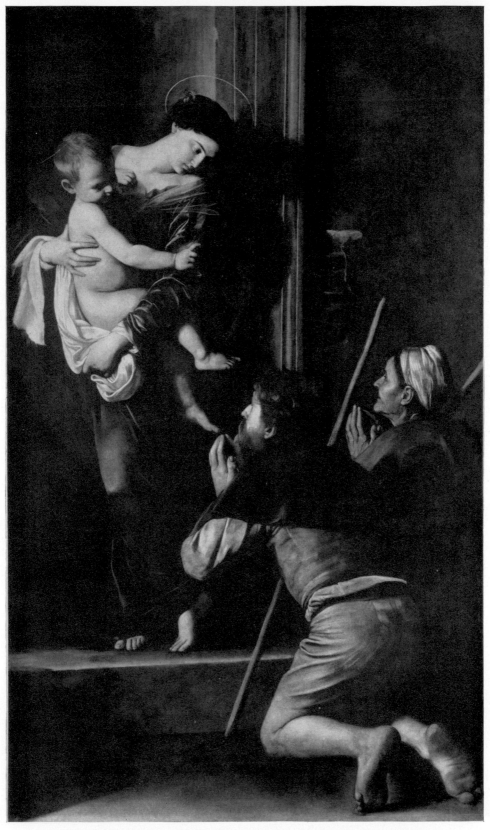

133. CARAVAGGIO: *Madonna di Loreto*. About 1604. Rome, S. Agostino

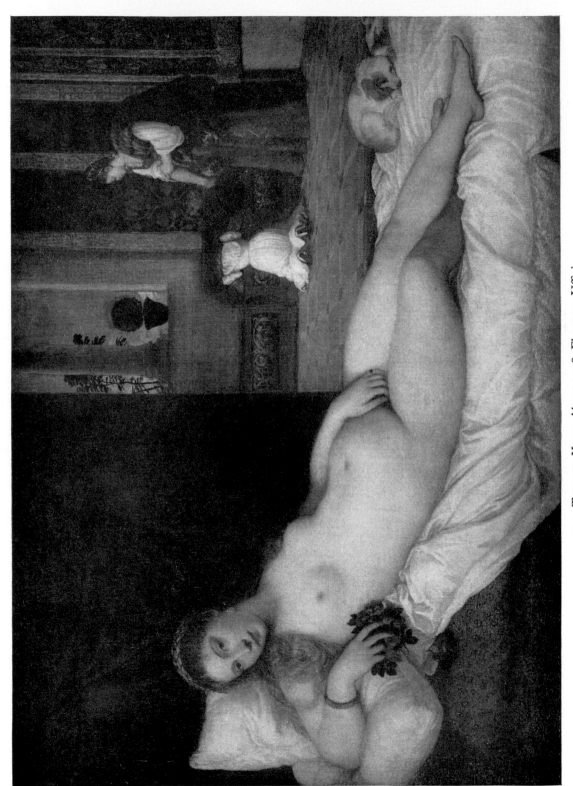

134. TITIAN: *Venus*. About 1538. Florence, Uffizi

FONTIS NIMPHA SACRI SOMNVM NE RVMPE QVIESCO

135. CRANACH: *Nymph.* 1518. Leipzig, Museum der bildenden Künste

136. Jan van Eyck: *St. Barbara*. 1437. Antwerp, Musée des Beaux-Arts

137. CLAUDE MONET: *Rouen Cathedral, Tour d'Albane, Early Morning.* 1894. Boston, Mass.,
Museum of Fine Arts

138. Raphael: *The Liberation of St. Peter*. About 1511–14. Vatican, Stanza dell' Incendio

139. RAPHAEL: *The Battle of Ostia*. About 1514–17. Vatican, Stanza dell' Incendio

140. Tuscan artist, middle of the 13th century: *Virgin and Child between St. Peter and St. Paul.*
Panzano near Florence, S. Leolino

141. Piero della Francesca: *Madonna del Parto*. About 1450–60. Monterchi, Municipio

142. BENOZZO GOZZOLI: *The Martyrdom of St. Sebastian.* 1466. San Gimignano, Collegiata

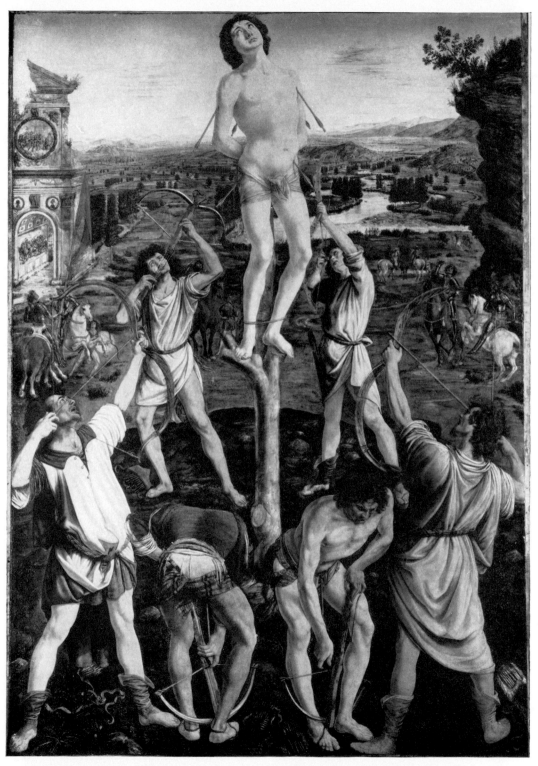

143. ANTONIO AND PIERO DEL POLLAIUOLO: *The Martyrdom of St. Sebastian.* 1475.
London, National Gallery.

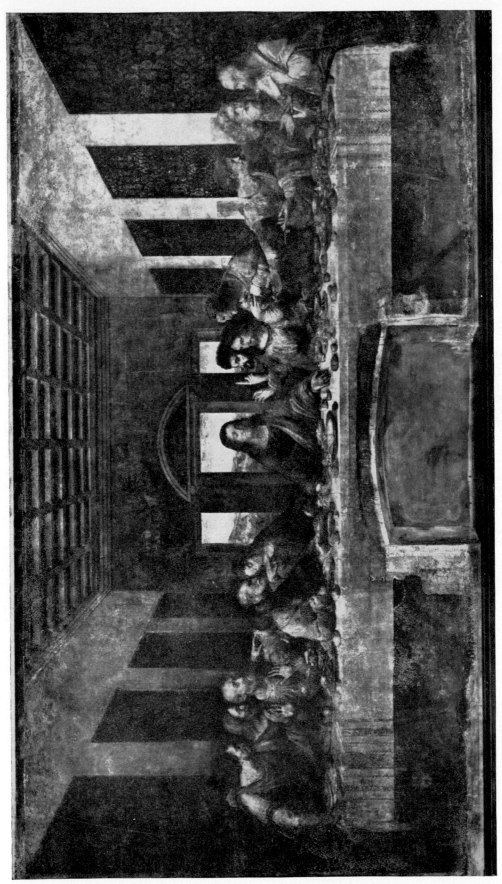

144. LEONARDO DA VINCI: *The Last Supper*. About 1497. Milan, S. Maria delle Grazie

145. HANS JORDAENS III (d. 1643): *A Collector's Cabinet*. London, National Gallery

146. AUGUSTIN HIRSCHVOGEL (1503–53): *Landscape*. Etching, B.73

147. ALBRECHT ALTDORFER (about 1480–1538): *Landscape*. Etching, B.67

148. DOMENICO CAMPAGNOLA: *Landscape with Shepherds*. About 1517–18. Etching, B.9

149. DOSSO DOSSI (d. 1542): *Mythological Landscape*. Moscow, Pushkin Museum

150. JOACHIM PATINIER (d. 1542): *St. Jerome in a rocky landscape*. London, National Gallery

151. BALDASSARE PERUZZI: *Prospect*. 1511–18. Rome, Villa Farnesina

152. J. M. W. TURNER: *Scene in the Campagna*. Elevated Pastoral from the 'Liber Studiorum' (1808–19). London, British Museum

153. J. M. W. TURNER: *Young anglers*. Pastoral from the 'Liber Studiorum' (1808–19). London, British Museum

154. SEBASTIANO SERLIO: *The satyric scene*. Woodcut from
Il secondo libro di perspettiva, Venice, 1560

MAGDALENA POENITENS·

155. PIETER BREUGHEL THE ELDER: *Landscape with St. Mary Magdalen*. Engraving. About 1555

156. BERTOLDO DI GIOVANNI (d. 1491):
Battle relief. Detail of a fallen warrior.
Florence, Museo Nazionale del Bargello

157. *Battle sarcophagus*. Detail of a fallen
warrior. Pisa, Camposanto

158. *Saul and his sons fall before the Philistines*. French miniature. 13th century.
New York, Pierpont Morgan Library, MS. 638, fol. 34v.

160. PIETRO PAOLO DE ANTONISIO: *St. Peter raising the lame man.*
Detail from the Ciborium of Sixtus IV. About 1480. Vatican, Grotte

159. Trajan's Column, Rome. Detail of a man falling

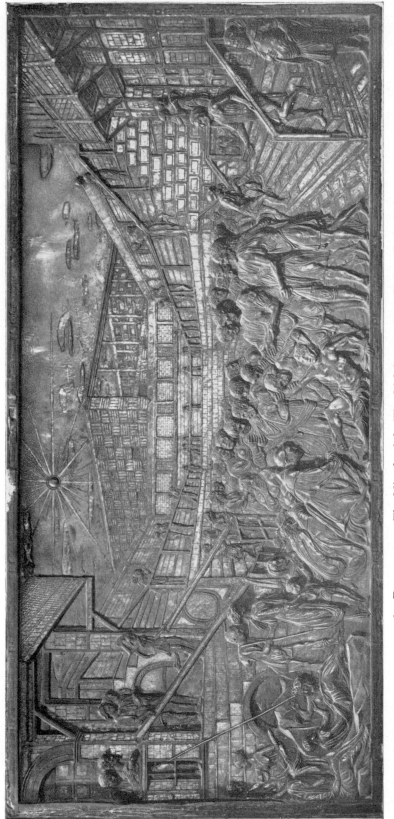

161. DONATELLO: *The Miracle of the Wrathful Son*. 1446–50. Padua, S. Antonio

ANNO DÑI
MDLXXXV

162. GIULIO ROMANO: *The Battle of Constantine and M*

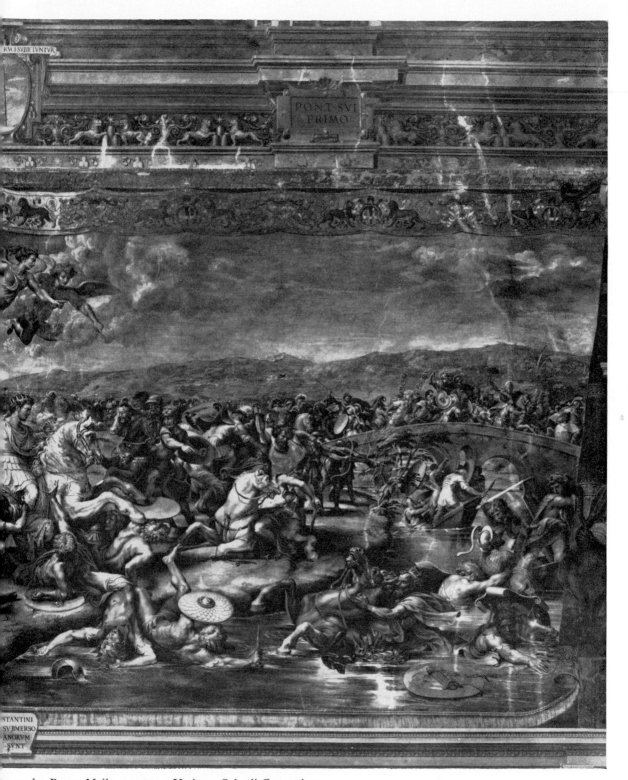

...s at the Ponte Molle. 1523–24. Vatican, Sala di Costantino

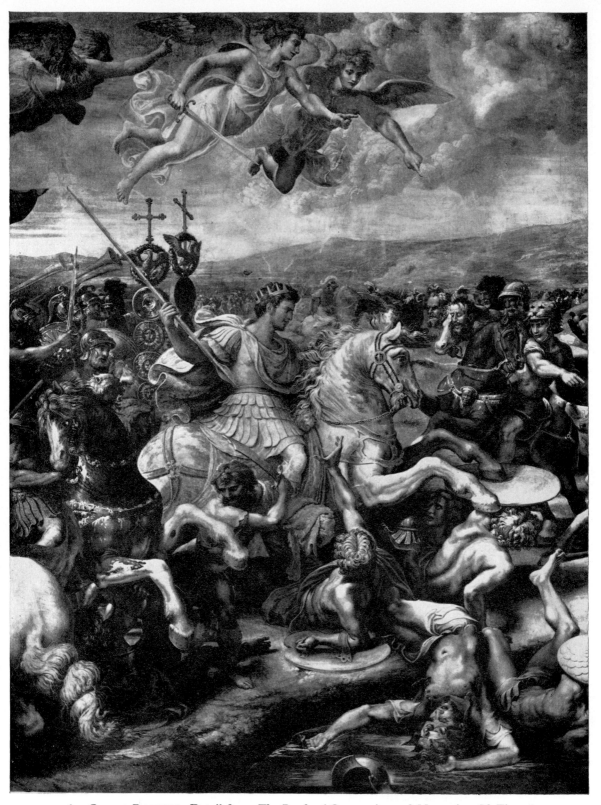

163. GIULIO ROMANO: Detail from *The Battle of Constantine and Maxentius*. Cf. Fig. 162

164. Arch of Constantine, Rome. Trajanic battle relief

165. *Battle sarcophagus*. Detail. Rome, Museo Nazionale

166. GIULIO ROMANO: Detail from *The Battle of Constantine and Maxentius*. Cf. Fig. 162

167. *Amazon sarcophagus*. Detail. Vatican, Cortile del Belvedere

168. MARCANTONIO RAIMONDI: Engraving after Michelangelo
The Battle of Cascina (1504), B.488

169. GIULIO ROMANO: Studies for *The Battle of Constantine and Maxentius*. About 1523.
Oxford, Ashmolean Museum

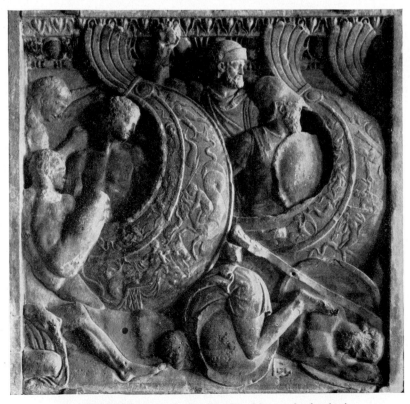

170. *Sea-battle sarcophagus*. Venice, Museo Archeologico

171. FOLLOWER OF RAPHAEL: *The Massacre of the Innocents*. Tapestry. Commissioned 1524.
Vatican Museum

172. GIULIO ROMANO: *The Infancy of Jupiter*. About 1533. London, National Gallery

173. *Letto di Policleto*. Marble relief after an antique carving known during the Renaissance.
Rome, Palazzo Mattei

174. GIULIO ROMANO: *Luna*. Detail of the ceiling fresco in the Sala dei Giganti. About 1532.
Mantua, Palazzo del Tè

175. GIULIO ROMANO: *Bacchus and Ariadne*. About 1528. Mantua, Palazzo del Tè, Sala di Psiche

176. GIULIO ROMANO: *Study for a frieze with the Battle of the Centaurs and Lapiths.* About 1527. Chatsworth, Devonshire Collection

177. GIULIO ROMANO: Detail of the fresco in the Sala delle Aquile. About 1527–28. Palazzo del Tè, Mantua

178. GIULIO ROMANO: *Two Victories and a barbarian prisoner*. About 1532. Modello for a lost fresco.
Paris, École des Beaux-Arts

179. REYNOLDS: *Lady Elizabeth Keppel*. 1755–57. Woburn Abbey, Duke of Bedford

180. REYNOLDS: *Three Ladies adorning a Term of Hymen.* 1774. London, National Gallery

181. NICOLAS POUSSIN: *Dance of Nymphs*. About 1638–40. São Paulo, Museu de Arte

182. *Sacrifice to Priapus*. Woodcut from the *Hypnerotomachia Poliphili*.
Venice, 1499

183. RUBENS: *Nature attired by the Three Graces*. About 1615. Glasgow, Art Galleries and Museum

184. NICOLAS POUSSIN: *Bacchanal*. About 1638–40. Rheims, Musée des Beaux-Arts

BIBLIOGRAPHICAL NOTE
LIST OF ILLUSTRATIONS
INDEX

L

Bibliographical Note

Details of the previous publication of the papers in this volume are as follows:

THE RENAISSANCE CONCEPTION OF ARTISTIC PROGRESS AND ITS CONSEQUENCES. *Actes du XVIIᵉ Congrès International d'Histoire de l'Art,* Amsterdam, 23–31 juillet, 1952; The Hague, 1955, pp. 291–307.

APOLLONIO DI GIOVANNI. A FLORENTINE CASSONE WORKSHOP SEEN THROUGH THE EYES OF A HUMANIST POET. *Journal of the Warburg and Courtauld Institutes,* XVIII, 1955, pp. 16–34.

RENAISSANCE AND GOLDEN AGE. *Journal of the Warburg and Courtauld Institutes,* XXIV, 3–4, 1961, pp. 306–9.

THE EARLY MEDICI AS PATRONS OF ART. *Italian Renaissance Studies. A tribute to the late Cecilia M. Ady,* ed. E. F. Jacob; Faber & Faber, London, 1960, pp. 279–311.

LEONARDO'S METHOD FOR WORKING OUT COMPOSITIONS. Originally published in French translation as 'Conseils de Léonard sur les esquisses de tableaux' in *Actes du Congrès Léonard de Vinci—Études d'Art,* Nos. 8, 9 and 10, Paris—Algiers, 1954, pp. 177–197.

RAPHAEL'S MADONNA DELLA SEDIA. Charlton Lecture on Art delivered at King's College in the University of Durham, Newcastle-upon-Tyne. Oxford University Press, London, 1956.

NORM AND FORM. Originally published in Italian translation as *Norma e forma* in *Filosofia,* XIV, 1963, pp. 445–464.

MANNERISM: THE HISTORIOGRAPHIC BACKGROUND. *Studies in Western Art; Acts of the Twentieth International Congress of the History of Art,* II, Princeton University Press, Princeton, 1963, pp. 163–73.

THE RENAISSANCE THEORY OF ART AND THE RISE OF LANDSCAPE. Originally published as 'Renaissance artistic theory and the development of landscape painting', in *Gazette des Beaux-Arts,* 6ᵉ Période, XLI, 1953, pp. 335–60.

THE STYLE *ALL'ANTICA*: IMITATION AND ASSIMILATION. *Studies in Western Art; Acts of the Twentieth International Congress of the History of Art,* II, Princeton University Press, Princeton, 1963, pp. 31–41.

REYNOLDS'S THEORY AND PRACTICE OF IMITATION. *The Burlington Magazine,* LXXX, 1942, pp. 40–45.

The original publishers are in each case thanked for their kind permission to reprint this material.

185. GIULIO ROMANO: *Nymph wreathing a Term.* About 1527–28. Detail from the ceiling fresco in the Sala delle Aquile. Mantua, Palazzo del Tè

186. REYNOLDS: *Girl picking flowers*. From the Italian Sketchbook, 1750–52.
London, British Museum

List of Illustrations

REYNOLDS'S THEORY AND PRACTICE OF IMITATION

INDEX